A Happy Man

OTHER BOOKS BY LYNN FLORKIEWICZ

Lynn is the writer of a series of cosy mysteries featuring amateur sleuth, Lord James Harrington. For further details on these books, please visit:
www.lordjamesharrington.com

Lynn has also written a mature romance, *You Will Meet a Stranger*.
Details of this books can be found on the website that accompanies this biography:
www.rbrazzi.com

A Happy Man

Man

In Conversation with

Rossano Brazzi

AN AUTHORISED BIOGRAPHY BY
LYNN FLORKIEWICZ

The Book Guild Ltd

First published in Great Britain in 2024 by
The Book Guild Ltd
Unit E2 Airfield Business Park,
Harrison Road, Market Harborough,
Leicestershire. LE16 7UL
Tel: 0116 2792299
www.bookguild.co.uk
Email: info@bookguild.co.uk
X: @bookguild

Cover Image Acknowledgements
Rossano Brazzi in South Pacific: Courtesy of Daniel Bouteiller, TCD
Head and shoulders painting: Courtesy of Carlo Fiorentini
Author photo: Courtesy of Robert Erskine

Typeset in 12pt Minion Pro

ISBN 978 1835740 460

British Library Cataloguing in Publication Data.
A catalogue record for this book is available from the British Library.

To Carlo,

Without your input and contribution to your uncle's story, I would never have been able to bring him fully to life. My thanks go to you, my friend. I hope this book makes you and your family proud.

Foreword

BY CARLO FIORENTINI

First, I want to express my deep gratitude to Lynn for inviting me to participate in the preparatory stages of her biography about my uncle, Rossano Brazzi.

In reality, opportunities for me to share meaningful moments with my uncle, from which to extract memories of events along his life and career were actually few, although significant enough to fish out a few hidden personality traits and highlights of his and his wife Lydia's daily lives. My sister Maria-Lidia, his favourite niece, who was much closer to him and both his wives, would have certainly been a richer source of stories, photos and advice for Lynn. I am sure, for instance, that a possible partnership between my sister and Ilse (his second wife) would have brought in a good number of fresh interpretations of my uncle's life, but unfortunately, Maria-Lidia is no longer with us, and Ilse could not be tracked down for this project, although she would have been very happy with it. Nevertheless, I have found solace in participating on their behalf.

As a new personal experience, I found the conversational style of Lynn's writing to be an amazingly powerful and entertaining means to depict the couple's behind-the-scenes conversations; she makes them come back to life so well.

Finally, through Lynn's research I learnt and revived particulars of my uncle's deeds and nature, so all in all, the process of reading, listening and remembering has reshaped my vision and memory of Uncle Rossano into that of an even more real, exceptional person.

Foreword

BY BEN, SEAN AND EAMON KENNY

We are so proud that Great-Uncle Rossano is part of our family history. We knew he adored his sister (our grandmother), Franca. And he and our mother (Maria-Lidia) were very close. It's such a shame that she is not here to help Uncle Carlo contribute to the memories and anecdotes. However, we know that both our mother and grandmother would be as excited about the book as we are.

Reading about his exploits and adventures has been wonderful and, in some cases, surprising, as Lynn uncovered some things we didn't know. The conversational style Lynn has chosen really brings Rossano and Lydia to life. We feel as if we're with him as he takes us around Italy and the places that meant so much to them both.

Thank you, Lynn, for putting his story together. It's something very special for our family.

INTRODUCTION

B oxing Day 2020. I am at home, idly watching the film *South Pacific* and something strange is about to happen. It isn't the first time I've seen it; it's one of my favourite films and I felt like watching it again. Twenty-five minutes in, the actor appears. Rossano Brazzi. His voice is beautiful. I know him not only from this film but also from *The Italian Job*, where he drives a sleek red Lamborghini in the Italian Alps. He's stylish. He's handsome.

On this occasion, though, I find myself thinking, *you're actually a good actor.* Suddenly, I'm curious to know more about him.

The obvious thing to do is buy a biography of him. Only there doesn't seem to be one, which is surprising. My curiosity is whetted all the more. Over the course of the next year I embark on a quest to track down information about Rossano, to come to some understanding of what made him the actor he was, what made him tick.

The quest, triggered by that moment of idle curiosity, becomes a passion, an obsession, an ongoing project that involves countless hours of movie-watching, purchasing film magazines and newspapers from the 1950s and 1960s, reading memoirs of film stars and directors. Internet searches yield all sorts of intriguing facts and yet there are many gaps too. Rossano, it turns out, is a man who is hard to pin down even though he spent much of his life in the public eye.

I need more. I need to hear from those who knew him. I need to talk to his family, not only to discover more about him, but to get their blessing, as it were, on this project. For I have decided that if anyone is going to write Rossano's biography, that person has to be me.

There are only a handful of Brazzi family members remaining and it takes investigation worthy of a Sherlock Holmes story to track down Rossano's nephew, Carlo, and his three great-nephews, Ben, Eamon and Sean. They start to fill in those gaps in Rossano's life story. As they offer personal anecdotes, photographs and snippets of information heard from their parents and grandparents, they become as excited about this project as I am.

Another door opens for me when I become an Executive Producer during the restoration and rerelease of a classic Rossano Brazzi film, *We the Living*. I'm proud to play a small part in returning it to the screen where it can find new audiences.

This is the story of a fascinating, paradoxical, vibrant man who was part of the story of cinema in the twentieth century, the *dolce vita* era and the golden age of Hollywood. He was a man who was more than a heart-throb, though Hollywood only ever saw him as that. He was a man proud of his art and of his nation. In him, I have discovered extraordinary levels of heroism blended with self-interest, some naivety, sexual playfulness and secret dealings on the fringes of corruption. In his company I have been charmed, amused, shocked, irritated, seduced – and never bored.

In my quest to understand the essence of the man, I have learnt about the Italian and American film industries, the history and politics of the time, and traced Rossano's encounters with the great and good – and the not so good. I have discovered hidden truths and have had to accept that many aspects will always be unknowable, especially in respect of his extensive career on the Continent.

How to Introduce Rossano Brazzi to You

I did not want to write a dry, detached documentary outlining the bare bones of his career. I wanted his personality. Everything within these pages is based on my research and meetings, but as I am a novelist by trade, I have relished the opportunity to bring him to life through a series of encounters in the places he knew and loved, where I imagine conversations with him. With Carlo's help, I have imitated Rossano's speech patterns, intonations and phrasing.

Imagine he is speaking to you in his rich, Tuscan accent. Walk the streets of Rome and Florence with us. Meet his extraordinary wife Lydia, his family, friends and his agent. Hear about the risks he ran in wartime, watch him filming in the glorious *dolce vita* days in Italy, see how he charms his way through a series of "indiscretions".

As the English actress Glynis Johns once commented, 'I can't say much about the real Rossano, because I can't make up my mind which of the many Rossanos is the real one.'[1]

You'll meet many versions of Rossano Brazzi in the pages that follow – not one of them will be anything other than fascinating.

BEFORE I INTRODUCE YOU...

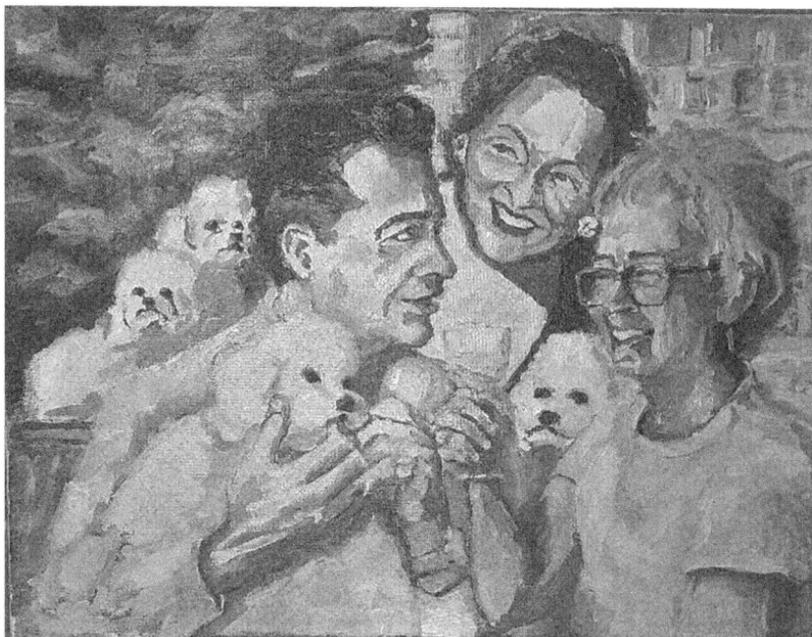

Rossano, Lydia and the author as imagined and painted by Rossano's nephew, Carlo. (Courtesy of Carlo Fiorentini.)

The dialogue between myself, Rossano and Lydia is a mix of imaginary conversations and accounts, ones which are rewrites of source material and ones which are directly quoted from articles, interviews and books.

Those imagined have been written with the help of Rossano's nephew, Carlo, to ensure I am as accurate and authentic as possible. To do this, it was necessary to read between the lines of many interviews and put it into Rossano's way of speaking. You will find that I weave in and out of an imagined series of visits and excursions with Rossano (and his wife and friends) and a more conventional narrative chronologically reviewing his life and career.

Every effort has been made to search for copyright ownership of certain quotations. This has been difficult because many publications sourced are now long out of print. Although the majority of anecdotes are non-verbatim, I welcome information from anyone who knows who owns copyright for those where I could not find a source. Even where small portions of original source materials have been used non-verbatim in this book, I have still referenced the source material and author wherever possible.

Note: There is a website that accompanies this biography: www.rbrazzi. com. On this site are additional photographs, information and occasional extras. Please do visit this to enhance your reading experience.

Chapter One

FIRST STOP, BOLOGNA

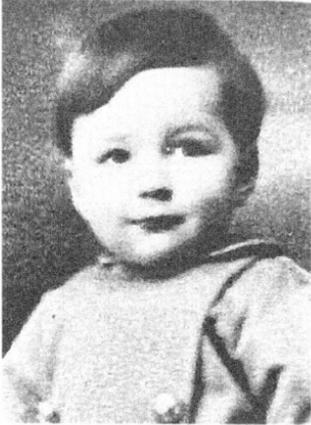

Rossano wastes no time in introducing me to Bologna, the town of his birth. It lies in the northern part of Italy, at the foot of the Apennine mountain range. It's the capital of the Emilia-Romagna region, with a population of around 400,000. The first thing that strikes me about this place is the architecture: grand columns, cobbled streets, a multitude of statues, solid buildings with arched windows, pale lemon houses with terracotta tiles and exquisite courtyards displaying vibrant flowers. It's delightfully charming.

Rossano, aged around two. (Courtesy of Carlo Fiorentini.)

He wears an immaculately tailored light grey suit, soft black leather shoes and a pale-yellow tie. He stands around six foot tall and his hair is greying at the temples. He is bronzed by the sun and his eyes are as blue as the Mediterranean. He has a determined chin, an aura of extreme confidence and strolls beside me, his thumbs hooked into each of his trouser pockets.

I am about to learn my first lesson. Rossano Brazzi is extremely well-read and knows his history. His voice is rich and resonant, and the Tuscan accent endearing.

'Bologna has the oldest university in Europe and, for such a small place, we have had a number of scholars and artists born here: Marconi; the poets Carducci and Dante; Cassini, the mathematician. And, of course,' he adds, as if this was the most important fact, 'I was born here.'

It is an incredibly historic city and, like many across Italy, can trace its roots back to the ancient Romans. If you stripped away the signs of modernity, you could easily imagine yourself in the fifteenth century, roaming the streets and examining the wares on offer from the various merchants.

We've entered the expansive Piazza Maggiore, a cobbled square the size of two football fields, dominated by the Basilica of San Petronio. Surrounding it are ancient buildings and a row of porticoes, a unique feature of Bologna.

'You know, we have over sixty kilometres of porticoes in this city?' Rossano says to underline what a unique feature they are.

We stop and study the Basilica in front of us.

'It doesn't look finished.'

'It isn't finished,' he says. 'You see that the lower half is covered in marble, Verona marble; but, above that, just stone. Pope Pius IV stopped the building work because he wanted the funds for something else, so it stayed like that.'

We move further along to an elaborate fountain.

'Here, this is the statue of Neptune. When they originally displayed him naked, the church wanted him covered; but the people here, they didn't want that, so they left him with everything on show.' He gestures at Neptune's genitalia. 'Can you guess which part is photographed the most?' He grins and winks.

Another trait that his family, friends and associates speak of is his mischievous sense of humour and I am to come across this often during my time with him.

He points to a large building to the left of Neptune. Carved into the brickwork is an alcove with colonnades either side of it. Taking centre stage is a bronze statue flanked by the Italian and European flags.

'That statue is Pope Gregory, the man who introduced the Gregorian

calendar. He was at university here, too.' He steers me away. 'Here, come this way.'

We wend our way to a maze of cobbled streets with a number of open-air cafés; the aromas of coffee beans and baking fill the air. Numerous delis tempt passing trade with prosciutto, salami and cheeses; mature hams hang by the dozen; various Italian breads are piled behind the tills. I see row upon row of bottles: balsamic vinegar, olive oil, red and white wines; wheels of Parmesan cheese are stacked high in the windows. There are fish shops displaying fresh seafood on ice. Grocers have laid out stunning varieties of fruit and vegetables – some of which I don't recognise. Family trattorias serve traditional Bolognese dishes.

As we are jostled along the busy street, Rossano nudges me to a café which has rickety wooden seats that wobble on the uneven cobbles. He summons a waiter.

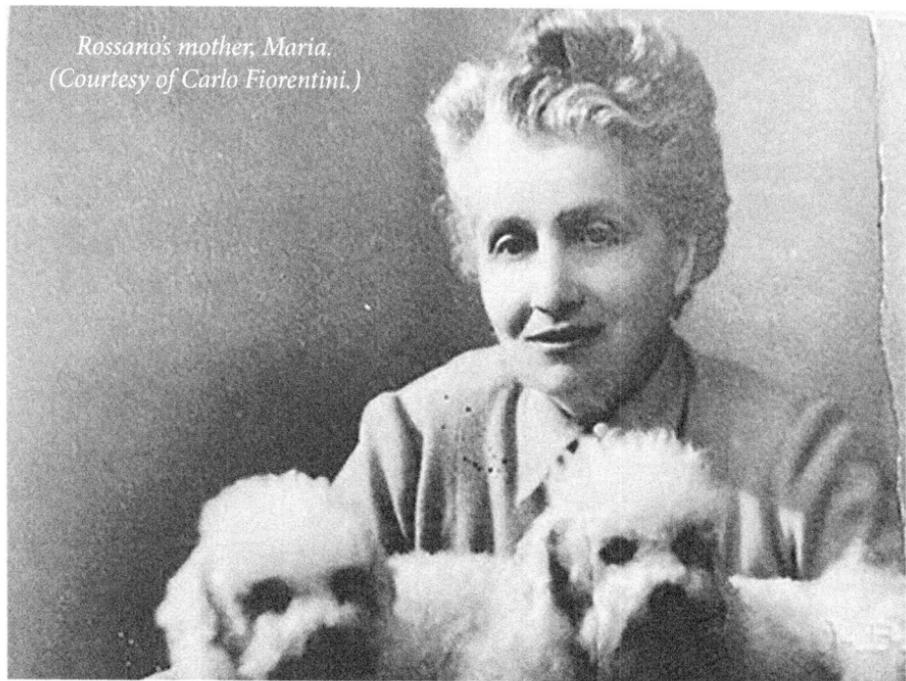

Rossano's mother, Maria. (Courtesy of Carlo Fiorentini.)

'*Un caffè e un caffè latte, per favore.*' He straightens a trouser seam.

'I was born here on 18 September in 1916. My mother, Maria, had already lost a son during childbirth. Then she had a little girl,

Mortella, but she died at just one year old. When I was born, I was loved very much – probably too much – but my parents were, I think, terrified of losing another child. The only grandparent I remember is my grandmother, Stella. I was very fond of her and my blue eyes, I think, are from her. My handsomeness, although I didn't see it for some time, was in me as a child. I know this because my mother entered me in to one of those contests, you know, for beautiful baby and I won it!'[2]

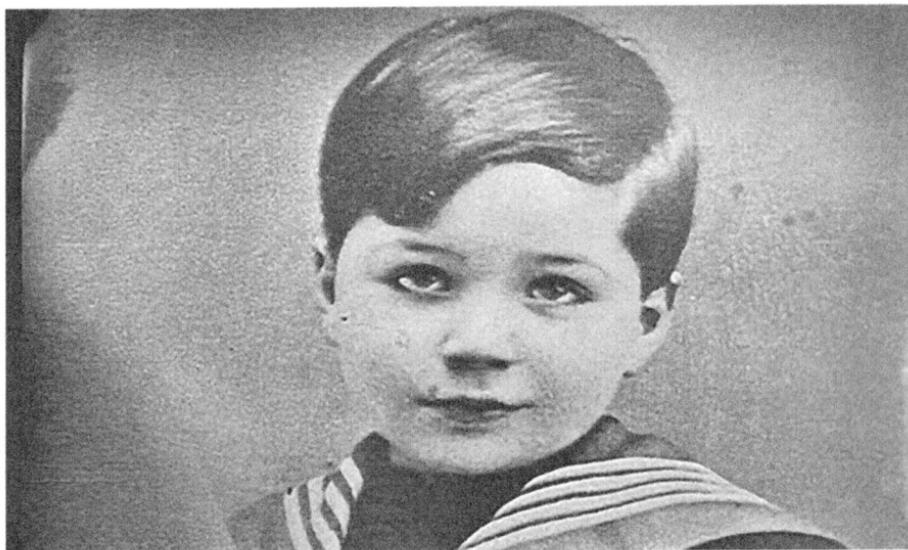

Rossano, aged around two. (Courtesy of Carlo Fiorentini.)

The coffee arrives. Rossano lights a cigarette and settles back.

'My father, his name was Adelmo, he was stationed in Rossano Veneto during the Great War, and I was named after that town. It is about two hours from here. The name Brazzi originates elsewhere. There were not many Brazzis in Italy at that time. We have some Yugoslavian connection and I have some cousins in South America, I know that. My father's parents, they escaped to Italy from Albania when my father was a child. He had eight brothers.'

'Do you remember Bologna at that time?' His expression suggests that he doesn't.

'Very little, because we moved from here when I was about two years

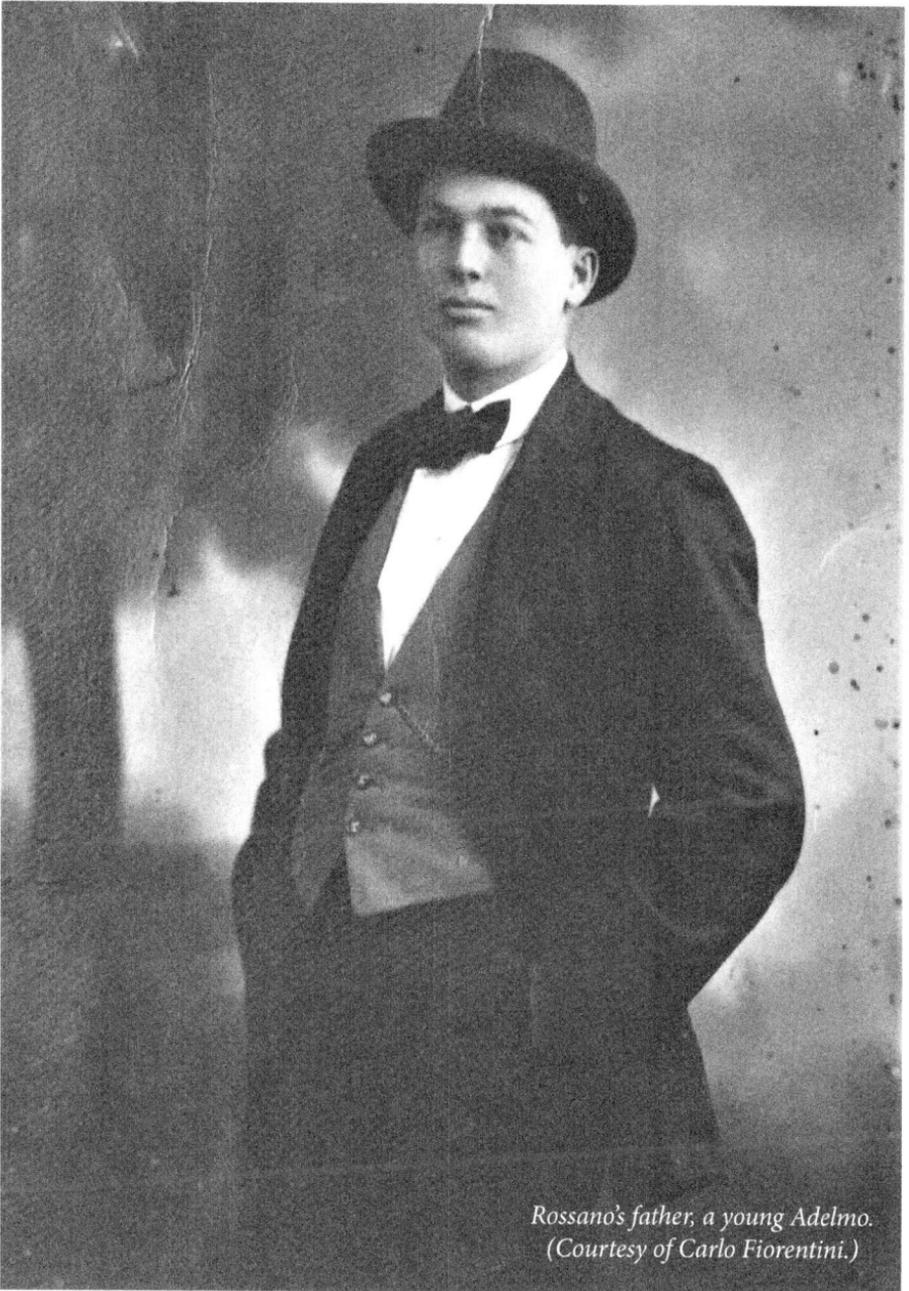

Rossano's father, a young Adelmo.
(Courtesy of Carlo Fiorentini.)

old. I would visit when I got older. It is a very historic city and easy to walk around. Have you seen the towers?'

'Yes, I have.'

The two towers of Asinelli and Garisenda, built in the twelfth

century, rise up from a crowded central piazza not far from where we are sitting. There were once, apparently, over one hundred of these towers in Bologna and they were seen as a sign of status. The two that remain were built by opposing families in competition with each other. Unfortunately, building on one tower was stopped as it began to lean heavily. It has remained like that ever since.

To be surrounded by so much history during his upbringing may have contributed to Rossano's love of the classics, art and antiques.

'In 1916, all there was of Bologna was this historic part. There wasn't really anything outside of the old city walls, just farmland, agriculture. Of course, Bologna is well known for its food. It is home to *tagliatelle*, *ragù*. Our fellow Italians call us *La Grassa*. That means "the fat". They also call us *La Dotta*, "the learned". I like that. And, of course, back then we got around on foot, by bicycle or horse and cart.'

'But the Brazzis were quite affluent, weren't they?'

'Yes. We were quite wealthy. My father was a craftsman, a shoemaker. My grandfather, and great-grandfather, they too were shoemakers. And my mother, Maria, she helped design shoes.' He points to a tiny alleyway about three metres away. 'The street there, the Via Calzolerie, that's where traders sold leather goods. *Calzolerie* means shoemaker in English. The streets here were divided up, you know, depending on your trade and that street was where you went for shoes – for leather.'

It is a narrow thoroughfare, and the shoe shops are long gone. These days, the main trade is food and drink.

Before Rossano began school, his father moved the family to Florence. No reasons are given for this but, on the political front, one wonders if Adelmo (a vocal anti-Fascist) was swayed by what was happening in Bologna itself. Benito Mussolini, the soon-to-be leader of the Fascist movement, had made a couple of speeches in the city that would, a few years later, lead to the March on Rome and Mussolini's rise to power.

Alternatively, Adelmo could simply have seen a better future for his family. At that time, Bologna was a small town. Florence was much larger by comparison and offered more opportunities to expand.

But Rossano would still visit Bologna regularly as a teenager.

'In the late 1920s, about two miles from where we are now, they built the football stadium for FC Bologna and, next door to that, an open-air swimming pool. I used to come up here sometimes to go swimming.'

I visited the pool and it is an impressive structure, Olympic sized and built in the classic Art-Deco style. Unfortunately, the modern roof is not in keeping with the architecture. It must have been a fantastic place to visit in Rossano's time.

He stubs out his cigarette.

'My brother, Oscar, he was born here in Bologna just eighteen months after me. Once he was born, my father moved us to Florence.'

He pays for the coffees.

'That's where we should go next.'

Chapter Two

GROWING UP IN FLORENCE

Florence is a forty-minute train ride from Bologna. The train takes passengers through acres of farmland and the rolling Tuscan countryside, but you see little of it because of the number of tunnels. (The line cuts its way through the Apennine mountain range.) I know from exploring this area that there are many family businesses up in the hills above us which are renowned for their cheeses, oils and tomatoes. Bologna is certainly the place to sample Tuscan food, but I am to find myself saying that about Florence by the end of my visit.

Again, Rossano wastes no time in leading me to specific areas that are important to him.

We are standing in front of a long three-storey building that I can only describe as majestic: The Palazzo Pitti. Its stones are bathed in sunshine, giving the whole structure a golden glow. We're viewing it from the road; it's about one hundred metres in the distance, across a gravelled area where tourists and locals use the space to enjoy ice cream and have a drink or two.

Either side of this area are two sweeping pathways that lead to the entrance. The palace was named after its original owner, a Florentine banker called Pitti; the building later passed to a number of Italian dynasties, including the Medici family.

Opposite this grand Renaissance structure are shops, cafés and restaurants with apartments above them. Each building in this long

terrace is immaculately painted in various shades of cream and all have shuttered windows. Leading off the piazza is a labyrinth of narrow alleyways that beckon you in to explore their secrets.

Rossano, hands in pockets, wearing an open-necked shirt and with a jumper over his shoulders, stops in the middle of the piazza and waves a hand toward the shops.

Rossano and his brother, Oscar, with their father, Adelmo, in Florence. (Courtesy of Carlo Fiorentini.)

'My father, he had several leather factories in this area.' He holds up a finger. 'When I say factory, I don't mean like a warehouse or something like this, I mean shops; but we call them leather factories and he was making a good living with this. The Queen of Greece, she was an occasional customer for my father before the war. We were comfortable and had a good home just across the river.[3] And, after a few years, my sister was born, Franca – she is eight years younger than me. Here, come this way.'

He leads me down a narrow, cobbled road and we quickly arrive at the exquisite Ponte Vecchio which crosses the Arno River. If you visit Florence, you cannot leave without walking across this bridge at least once and, as in Bologna, the sense of history seeps into your bones. Being in this city is like walking through a living Renaissance. All the outlets on this bridge are jewellery shops and, as the sun shines down, the place resembles a treasure chest, its gold, diamonds and various gems sparkling in the light.

'You know, all of this used to be butcher shops but, the Medici family, they had this walkway above the bridge and all they could smell was meat, so they moved the butchers to another area and the jewellers moved in. That was in the fifteenth century, I think.'

At the end of the Ponte Vecchio, we turn left along the Arno River, a wide expanse of water with many bridges spanning it. Every building I pass appears ancient and untouched for centuries. The first bridge we come to is the Santa Trinita. Statues, representing the four seasons, stand guard at each corner. We move on to the bridge and lean on the stone wall to take in the view.

'My sister Franca had to cross this bridge every day to get to school. Me and Oscar, our school was this side of the river. Behind us here on Via Tornabuoni, this is where we lived. We were very close, our family, and Oscar, Franca and I were inseparable.'

He smiles.

'I have to confess that me and Oscar were a little disappointed that Franca wasn't a boy. We wanted someone to play football with and she wasn't interested in that. It didn't really matter, we loved her all the same.'

He lets out a small chuckle.

'You know that once, me and Oscar told her that if she sat on the toilet for long enough and allowed the vapours, you know, the smell to rise up it would help make her hair curly.'

He throws his head back and laughs.

'We used to tease her a lot, but she took it well. She's wonderful. I used to call her the Egyptian because she had beautiful jet-black hair and eyes similar to those from the Asian continent.'[4]

We look back at the Via Tornabuoni, which is a wider avenue than most roads in this area.

'Our apartment was big. We had a bedroom each but, Oscar and I, we got on so well we shared a bedroom. He remained my best friend throughout my life. We were always in and out of each other's houses. Franca, she eventually moved to Argentina but visited often and we socialised together as much as we could.'[5]

And Via Tornabuoni looks pretty modern compared to where we've just been.

'Unfortunately, during the war, our place was bombed; this whole area was destroyed. My family moved in with their friends, Nello Carapelli and his companion, Nina.' [Nello was Rossano's first drama

teacher.] 'I was living in Rome at the time, and they had to rebuild this street. The bridge is old, though, yes?'

'Yes. I think the bridge is very old.'

He strokes the rough stone and becomes serious and thoughtful.

'This is one of our oldest bridges; it is, I think, about 1650. Look at the architecture here, it is a wonderful structure and these ancient stones and cobbles – you can sense the history of this place; the millions of people who have walked across it over the centuries – and those statues, still standing after all these years. It's incredible, don't you think?'

'Yes, I do think that.'

He is both convincing and believable. I have no reason to doubt what he is telling me except for the mischievous glint in his eye.

'I'm sorry, I am teasing you – the bridge is not so old. During the war, it was destroyed by the Germans. All the bridges were, except for the Ponte Vecchio. I haven't misled you completely, though. You know, the people that rebuilt it, they recovered the stones from the Arno and examined the original plans so what you are seeing is almost the same.'

My research has confirmed that he was known for his storytelling and for bending the truth, sometimes wildly. On the whole, it was good, harmless fun but it would occasionally get him into trouble as we will later discover. I am already learning that he will try to find the fun in something wherever he can.

His nephew, Carlo (Franca's son), remembers his uncle's humour well and this is one of the memories he kindly shared with me. He and his cousin, Fabrizio (Oscar's son), were invited by their aunt and uncle to dinner at a trattoria. Rossano and his wife Lydia were hosting an American, Mr Watson, who was the CEO of IBM at that time.

Seated at the table were Rossano, Lydia, Carlo, Fabrizio, Mr Watson and the Brazzis' chauffeur. Their poodles, who went everywhere with them, were also present. Carlo, a teenager at the time, takes up the story.

'I remember there was a brief debate over the nationality of the steaks we'd ordered. Mr Watson insisted that beef was not typically Italian and bragged about American beef being the best. Then Aunt Lydia monopolised the talking. She blitzed us with jokes in an English that nobody but her understood. Uncle Rossano signalled when it was

time to laugh and, of course, he was quite intentionally inaccurate. Finally, Uncle's controversial "Italian" steaks were served. At this point, Uncle Rossano turned to what he did best – acting. He wanted to make his case about Italian beef versus American beef. He straightened his posture and started to recite a line for Mr Watson. The prospect of aggressive humour woke me up. "You know," my uncle said, staring as Watson slashed at his meat, "these come from special cows raised in Toscana, high up in the mountains. They are fed directly from the hand of the *contadino* [farmer]." My uncle was very serious, very intense and very believable. As he continued talking, Watson hummed assertions between chomps and slurps of red wine.

'I have to say that I slightly hated Mr Watson. I wanted to spend time with my aunt and uncle and, for me, this man was intruding on a quality family meal. I knew what was happening, though, and I started to celebrate the imminent outcome with a taste of wine as my uncle continued. Uncle Rossano put his cutlery down as if to strengthen his argument. He fixed Watson with his gaze.

"'And you want to know the secret of why the meat is so tender and tasty?" Watson, still chomping, nodded eagerly, fascinated by what my uncle was telling him. "It's all psychological." There was a pause.

'Everyone stared. With his eyes half closed, a waving motion of the hand and switching his face into a dreamy expression, my uncle finally said, "Because he caresses the tit of the cow as she chews…" The mouthful of red wine I'd taken had to go somewhere! Unfortunately for Mr Watson, I couldn't hold it. Watson was wearing a very elegant white shirt…'

I remind Rossano of Carlo's anecdote as he steers me off the bridge. He chuckles.

'I remember that. The waiters, they were running around trying to put things right. It was very amusing.'

He lights a cigarette and we wander along Via Tornabuoni. Completely demolished during the war, it was rebuilt with consideration and in keeping with the area.

'This was still a building site, even in the 1950s. It took some time before my country got back to normal after the war – like yours, in England, no?'

'I agree. But let's get back to your childhood. What about away from Florence. Did your family take holidays?'

'Of course. I treasure memories of the family holidays. When we were children, our parents took us to the beach in Forte dei Marmi and sometimes we took trips to the countryside in Roveta. You know, Italy shuts down in August, so we spent that month, every year, in Viareggio, a long, long beach that stretches on forever. That is about ninety minutes from here. They were happy days. We had a good upbringing; I cannot complain about it. Mamma and Papà, they got on well together. There were moments, on my father's part, of indiscretion but it didn't spoil the marriage.'[6]

I will later learn that Rossano was to inherit his father's "Italian marriage" philosophy.

'When my father wasn't working, he took my brother and me to football and then on to the theatre. I loved both of those pastimes and that's where I got my passion for performing. My father loved the opera, and he knew all the lyrics by heart.'[7]

Rossano's brother Oscar approaches and they embrace with a kiss on each cheek. He is a stocky man with an easy smile, a little shorter than Rossano, with darker hair. They clearly have a genuine affection for each other. Rossano listens with a wry smile as Oscar brings his vivid memories of their childhood to life.

'Since my brother was five, he showed talent in acting and singing. Do you remember, Rossano? You always recited poetry for Father's friends who dropped by in the evenings and on every occasion at friends' reunions you placed yourself in the centre and recited poetry and sang, while all the company consumed sandwiches and canapés. And at the end, there was nothing left for you. You kept up your acting and singing and I kept up my eating.'[8]

Rossano smiles as he recollects those early days. Oscar has things to do. He smiles a farewell to both of us and dashes off.

'Since I can remember, I have been a show-off,' Rossano says, 'but I was shy, too. When my father's friends applauded, I always ran to my mother. I think reciting these poems suggests that I was quite a serious boy and I suppose I was. I didn't like anything too infantile back then –

except when teasing Franca! And I was good at school, except for maths. I hated that subject.'[9]

This love of performing was not limited to the home. Wherever he could, he would grab an opportunity to sing. He joined the chapel choir as a child and, as a student, he was a tenor in the San Marco University choir.

'Your brother mentioned reciting poems. Can you recall what they were?'

'Oh yes. I remember reciting at my nursery school for Christmas. I was five years old. Even at three years old, I was reciting La Fontaine. You know La Fontaine?'

I'm aware that La Fontaine was a French writer of fables and poems, born in the seventeenth century. An unusual writer for a three-year-old. Indeed, his favourite poets throughout those young years were quite literary for a boy at such a tender age.

'When I was six, I began reciting Carducci.'[10]

At ten years old, Rossano had moved on to Victor Hugo, most famous for his novel *Les Misérables*.

This love of poetry stayed with him his whole life and when visiting his home in Rome later, I will discover a library of literary works, not just poetry but a range of scholarly tomes, from Dante, Homer and Shakespeare to the entire works of Casanova. Unlike many owners of collections of this ilk, he had read them all. He considered Casanova's memoir an artistic gem.[11]

We are back by the river and he stops me at a four-storey building, one of the oldest in Florence. It is here that I learn of something we both have in common. We were both obsessed (and I still am) with the Apollo 11 moon landings.

'You know,' he says, 'I believe in reincarnation and when I come back, I want to be able to walk on the moon – go into space and find out what is out there. I find all of that very interesting. But we'll talk about my beliefs another time.'[12]

The building in front of us is the Galileo museum. It was opened in 1930 and Rossano, with an interest in both astrology and astronomy, visited this place.

Not stopping for a minute, he leads me down another cobbled alleyway. We stop briefly in the Piazza del Mercato Nuovo where the raised cobbled area is a hive of activity. There is a permanent market of around thirty leather factories here, each one displaying beautiful handbags, rucksacks and belts, accompanied by the unmistakable aroma of leather.

To the side of the market is Il Porcellino, the famous bronze boar, whose nose you must stroke for good luck.

Rossano hands me a coin. 'You must place the coin in the boar's mouth, make a wish and stroke its nose.'

I do so. The golden nose is shiny and pale from centuries of wear. We wander on.

'I can't remember a time when I didn't love poetry. I think it is something born in me. You know, when I was very famous, around the late 1950s, the record company, RCA, they offered me a recording contract. They wanted me to sing but I wanted to read the love letters of prominent poets from history. I'm sorry this never came to fruition. I would have enjoyed doing that.'

He has a deep, resonant voice, ideal for speaking and reciting. It's a shame that he was not given the same opportunities as his friend, British actor Richard Burton, another man with a wonderfully rich voice who, alongside his stage and film career, recorded a number of books and plays, most notably *Under Milk Wood* and *The War of the Worlds*.

But Rossano waves this missed opportunity away. Glynis John's, his co-star in the 1956 film, *Loser Takes All*, made a telling comment about his personality in the film's press release. StudioCanal kindly gave me permission to quote the following. She said, 'He doesn't seem to dwell on things that haven't happened and lives solely in the present.' I will witness this often during our conversations.[13]

He is keen to highlight another of his favourite poets. 'Leopardi, he is another everyone should read.' He stops and swings me around to face him. His manner is intense, dramatic and serious. He holds my forearms. His blue eyes stare into mine as he quotes, '*Silvia, do you remember those moments…*' He continues on with the full verse.

He grins, lets me go and continues walking. I chase to catch him up, somewhat overwhelmed by the recital and seriousness of it.

'That is Leopardi's *To Sylvia*,' he says.

This man does not stand still. He's keen to show me everything and he leads me down another narrow alleyway. It's cool. The high walls block out the rays of the sun. We are now standing outside the Dante museum, on the site of what was once the Dante family home. Rossano has a great love of this man and has read all of his work.

As an example of this passion, Carlo remembers his uncle visiting them in the 1960s. Rossano was filming in South America and wasted no time in spending a few days with Franca and her family in Argentina.

'I remember,' Carlo says, 'that my uncle was invited on to a chat show to talk about the film he was making. Somehow, they got on to poetry and Uncle Rossano recited about ten to fifteen minutes of Dante's *Inferno* without any prompt – nothing.'

'Has this love of performing always been with you?'

'I think so, yes, but I was not thinking of this as a profession. I enjoy showing off, you know, performing and getting applause. I studied hard at school and I loved playing sports; but I also loved reading plays. I remember speaking parts aloud, you know, in my bedroom. I didn't always have an audience, I just enjoyed playing out the roles.'[14]

The stage, however, began to be a constant throughout his young life. At the age of twelve, he was the lead in a school operetta called *Il Visconti la Pampini*. The play was put on in aid of charity and was supposed to run for just two or three days. However, it was so successful that it toured Tuscany for three months, including a stint at the magnificent Teatro Verdi in Florence. He would perform there several times during his lifetime. This is Tuscany's biggest Italian-style theatre, with 1,500 seats and six tiers of individual boxes. I was fortunate enough to be given a private tour of the theatre. Entering such an arena almost takes your breath away. What a place in which to begin your theatrical career! And at such a young age! Rossano remembers this with great fondness.

'I enjoy this very much and I remember that I was very professional with my performance and the local newspaper said that I was the star of Florence.'[15]

Stage acting and sports dominated his childhood. There wasn't a sport that he didn't enjoy but football and boxing were his two great

loves. One constant challenge that he never tired of was iron-arm wrestling. Rossano cites only one man who could beat him at this.

'Who was that?'

'Easy. My father. He was very strong. You know, he was the handsome one. Women admired him all the time. All of my memories of him are good. I remember he was always very relaxed, masculine, very open-minded. He was respectful of other people's thoughts and religions. I learnt so much from him. It was my father who introduced me to the arts, to the theatre. He made me who I am.[16] [17]

'He died in 1942. He was very young. No age. Before that, he had put on a lot of weight and eaten too much before going into the sea for a swim and had a stroke. That was just before the war. He was paralysed down one side and walked with a cane. Because our house had been bombed, he, Mamma and Franca went to live in the countryside.

'He started attending church after this. He said that Jesus had appeared to him when he lost control of his

Rossano's father, an older Adelmo.
(Courtesy of Carlo Fiorentini.)

body and told him, "What will you do now without me?". He lived for a few years more but then he left us. I was filming in Rome when I heard the news. That hit me very hard, and I missed him for the rest of my life.'

'And your mother?'

'She was a truly wonderful lady, so beautiful and graceful, with a wonderful sense of humour – a funny lady. I was a typical Italian boy who loved his mamma more than anything. She stayed with us until the 1970s when she died from cancer. I loved them both very much. They were very happy together.'

As a teenager, the attractiveness of the man was becoming apparent. He was tall and slim, with strong features, his wavy hair swept back off his face and intense blue eyes. Although he was striking, he claims he

was not aware of his effect on the opposite sex. At school and university, an infinite number of girls flirted with him.

'It is only later, when I look back to myself as a young man that I saw I was handsome. I didn't see at the time. I do know that I fell in love very easily and I did throughout my adult life.' He shrugs. 'I'm Italian and that, I think, is what Italians do, what they are known to do.[18]

'My first love was when I was very young, six or seven-years-old and the girl I loved was around twenty! We were on holiday at one of those beach resorts and I was ill for a while. The doctor, he ordered me to stay in bed and there was a girl that used to visit me there. I thought she was wonderful. She didn't know anything about it because I never told her – I was too shy.[19]

'My first kiss was as a teenager and, of course, I fell in love with her. I wanted to marry her. My father, he told me not to be stupid and to get on with my studies. You know, I was quite heartbroken about that, but I was not at an age where I could argue with my father about such things.[20]

'My first serious relationship, sexual, I was around fourteen and the girl was eighteen. We would spend time together, you know? I think my father was right to drag me from these women. I fell in love very easily – I always did. But I did what my father asked. I studied, but I also continue to play on the stage.[21]

'I had not studied drama but the friend of the family, Nello Dante Carapelli, who my parents stayed with during the war, he was very encouraging to me. He used to put on shows. I enjoyed that very much.' (Carapelli went on to star in a handful of Italian films with Rossano and, later, became godfather to Rossano's nephew Carlo.)[22]

Aside from his studies, sports and the theatre, Rossano was learning that outside influences weighed heavy on the family. He agreed wholeheartedly with his father's politics and hated the Fascist regime and the continuing rise of Mussolini's popularity. Because his father was so vocal in his dislike of it, the family was constantly watched by the regime and Rossano would take that hatred of dictatorships a step further during World War II.

But, for the time being, he had decided to study law.

'Was being a lawyer something you dreamed of?'

We are entering the Piazza San Marco, another huge, cobbled square dominated by the thirteenth-century Basilica San Marco. I anticipate another history lesson, but Rossano waves it aside as if bored with it.

'It's another old church with old paintings. This is a nice place to sit; it's always a little quieter and the San Marco University buildings are around this area.'

We find a bench.

'At first,' he says, picking up on my question about whether he had dreamed of being a lawyer, 'I wanted to be an opera singer, but my father was set against this. He wanted me to follow him as a shoemaker. I used to help him occasionally, so did Oscar and Franca. We argued about my career, but Mamma stepped in. She told me to try for the career I wanted and, if it didn't work out, then I would do something else and, in the end, I decide not to pursue opera.[23]

'I wanted to enjoy my life and I thought I would enjoy being a lawyer so that's what I become. I pass my school exams and I go to San Marco University, here in Florence, to study law.'

San Marco was the precursor of the present-day University of Florence. Many of its buildings are still in the San Marco area and, like the University of Bologna, the institution is centuries old and its architecture ornate and beautiful.

His time at university was to be enjoyable and productive. Not only was he building the foundations of a good career, but he was also making use of all of the facilities the university offered. He continued with sports and became both a boxing and tennis champion at San Marco. He also excelled at swimming and basketball. At one point, a friend wondered

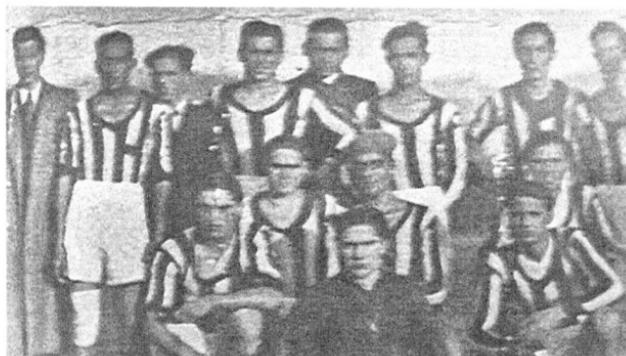

Rossano, during his student days, played goalkeeper for FC Fiorentina (amateur level.) Bottom, centre, in a dark shirt. (Courtesy of Carlo Fiorentini.)

whether he would become an athlete instead of a lawyer. Another was certain he would become a professional boxer.

Rossano's childhood friend, Dr Giovanni Zanelli, joins us briefly, grinning as he sees his old friend. He is a slight man, considerably shorter than Rossano and his jacket appears a little too big for him. He has a broad smile, with blond, wavy hair swept off his forehead and a trim moustache. He turns to me, remembering a bet Rossano once made as a joke.

'Rossano, he participated in all kinds of sports. Many sports. He was a goalie,' [at amateur level] 'for La Fiorentina and a tennis champion and once, on a bet, he entered a boxing tournament, and he won the amateur lightweight boxing title of Tuscany.'[24]

Rossano is quick to play that achievement down. 'Gio, I wasn't that good a fighter; the others were simply terrible!'

After Giovanni leaves, we continue strolling around the city.

I have read in numerous magazines that he loved boxing, but an incident during one match prompted him to hang up his gloves. He was (allegedly, as I can find no real confirmation) fighting someone he knew; Rossano struck his opponent on the jaw so hard that he tumbled through the ropes, landed on his head and was knocked unconscious. It was touch-and-go whether he would survive. Fortunately, the man made a full recovery. Rossano, devastated by the thought of what could have happened, vowed never to box again, preferring instead to be a spectator.[25]

Some thought football might be his career path, although football in those days paid very little so this was not something he pursued.

However, the performing bug remained a big part of his life. Although he had decided against a career in opera, he studied the form and took lessons to develop his voice, described later by his singing coach as a rich tenor and, later still, as a baritone. He also joined the university theatre group and regularly appeared in student productions.

His acting skills began to be noticed and he won first prize as best actor in a student production and an award for a comedy performance. In his last year at university, his roles gained the attention of a Florence newspaper which raved about his acting skills.

Looking back on this period of his life, he realised he had crammed a lot into his time and had learnt a great deal.

'I learnt very quickly. I think I must have a photographic memory or something. Later, when I read film scripts I learnt them in a week; not just my part but everyone else's. Katherine Hepburn, she is the same, always she learnt the complete script. Back then, I already had several languages that I could speak, and I could read ancient Greek and Latin. English was the last language I learnt. I did not study that until I went to America. That was in 1947 or 1948.'

Turning the corner from Via Martelli, I am confronted by the gigantic Duomo which almost shocks you by its size and proximity.

In Rossano's film, *Light in the Piazza*, I recall one of the characters stating that 'In Italy, everything is too…'

I understand, now, what she meant. This cathedral could be described as too big, too beautiful, too ornate and too elaborate.

Rossano leads me to a vendor and orders a gelato for both of us. 'I can't give you a tour of Florence without you seeing Il Duomo.'

I'm glad he did. Everything about it casts a spell. The pink, green and white marble panels that cover the entire building; the statues of saints and apostles; the beautiful rose window and the many mullioned windows either side of it and, of course, the elaborate gold doors depicting intricate scenes from the Old and New Testaments.

Not only am I trying to take this in, but I am also trying to get over the size of the bell tower. Giotto's Tower, the guidebook informs me, is 280 feet high. In front of the cathedral, there is the eleventh-century Baptistery which Florentines say is the oldest building in the city. All of it is so well preserved and ornate, it feels as if it should be part of a film set.

Although I am overwhelmed by it all, I notice that Rossano is more concerned with searching the crowds.

'Of course, the most important person in my life at this time was Lydia.'

Now he has my attention. Lydia is the girl he was to fall in love with and eventually marry. She would become the foundation of his life, contributing in no small way to his success.

He has spotted someone. He holds a hand up to attract their attention and pays for a third gelato at the nearest vendor's kiosk.

'Lydia was at San Marco with me, and I met her in that first year. I was sixteen. She studied literature but we both loved the theatre, and we were in the same drama club. I liked her straight away. She had a nickname, *Poppe d'oro*.' He laughs. 'Golden boobs. She has large breasts. Many of my friends admire her breasts and, you know, one day she collided with me in the corridor, and I had a face full of those things. She has nice legs, too. And ankles.' He grins. 'Actually, I liked everything about her. But, you know, she didn't like me to begin with. Ask her.'[26][27]

I'm about to; she is walking toward us.

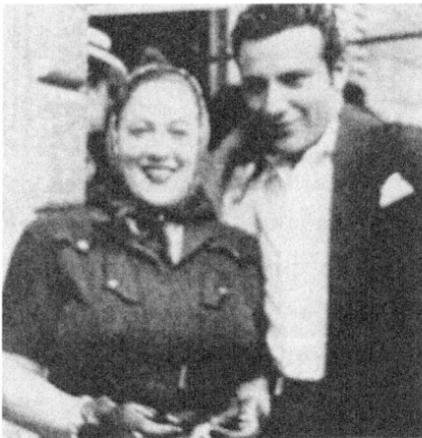

Rossano and Lydia just after the war. (Courtesy of Carlo Fiorentini.)

Lydia is not the sort of woman you expect a man like Rossano to have married. Here was a screen lover, handsome and incredibly fit, who could have chosen the most beautiful woman in the world to be on his arm. Lydia is far removed from the traditional wife of a sex symbol.

Two people expressed what many people noticed and experienced where Rossano and Lydia were concerned. They were Gene Lerner and his business partner, Hank Kaufman, who represented Rossano in the 1950s as his agents. In their book, *Hollywood sul Tevere*, they described them as an incongruous couple: Lydia was unashamedly overweight and exuberant and Rossano was handsome and flirtatious. Both, in their own ways, loved to show off. One thing the agents were quick to highlight was the couple's huge sense of fun and their ability to laugh at themselves. They enjoyed witty sparring contests and entertained everyone around them with their very public dramas.[28]

Carlo added his own observations, stating that those who knew them well could see, by the way they looked at each other, that they

often had a shared, intuitive version of the jokes and arguments that were happening in private.

I had already experienced Rossano's gentle humour and was looking forward to getting a glimpse of the couple's sense of fun, along with their arguments, both public and private.

Lydia is a large, buxom woman, pretty but not beautiful, with short, fair hair, a ready smile, plenty of jewellery (something she adores), dressed in a flattering summer dress with cleavage on show. She wears a genuine smile that lights up her face. She skips lightly toward Rossano. With a grin, he hugs her and asks her to describe her first impressions of him.

Taking the gelato from him, she goes straight to the point. 'I thought he was most undesirable.'

Rossano, as a young man, was described as beautiful and pretty by fellow students. There were plenty of women on campus who would have gladly gone out with him but, unfortunately, he fell for the one woman who was not one bit enamoured of him: Lydia Bertolini. He made several attempts to ask her out and she declined each and every one. But, he would not be dissuaded. It took several months for him to win her over.

Lydia describes that turning point. She speaks with a strong accent. 'We were on a short tour outside of Florence getting ready to perform a play. I saw Rossano in a small side room. Do you remember, Rossano? You were in a panic trying to find a shirt and getting more and more upset. He never packed for himself, that is why. His mother always packed for him. I felt sorry for him – he looked so lost and desperate, and I went to help. He was in such a state he didn't see the shirt. It was right in front of him. I calmed him down, helped with his shirt. I helped him dress that evening.'[29]

Rossano has a sheepish grin on his face. 'And, you know, all that did was make me love her even more. That broke the ice with us, and she grew fond of me. So, we started to date – but in secret.'

'In secret?'

'Yes. Because Lydia was from nobility, wealthy nobility, and I was not. Her family thought I was not good enough for her. My family thought

she would distract me from studying and that we were too young. I didn't have much money. I couldn't treat her the way I wanted to, but we liked each other and we went out together.[30]

'I remember one time, I had only a few lire in my pocket, and we went for a carriage ride. I knew it would cost more than I had so, when the carriage reached a point where I couldn't afford to go further, I told the driver to stop and I turned to her and said, "Why don't we walk from here." That way, I wouldn't be embarrassed. And she didn't distract me. I qualified and earned my degree.'[31]

Lydia's family, however, were supporting a potential engagement to another man, a qualified lawyer (a stuffy lawyer, in Rossano's opinion), who they felt was more suitable for their daughter. We will later learn that this would not deter the young lovers.

When he left San Marco University, Rossano's father sent him to Rome where a friend ran a law practice, and this is where Rossano would serve his apprenticeship. It was necessary for him to work for at least six months before getting his licence. He planned then to open his own law firm. Monies earned through acting would help him achieve that. Rossano snakes an arm around Lydia's shoulders.[32]

'I was upset to be leaving Lydia, but I was very happy with my father's decision to send me there. I could work on building my legal career but, you know, Rome was the centre of Italian theatre, and I knew I would have some opportunities there.'

With his formal education behind him, Rossano purchased a third-class rail ticket in Florence, bade a sad farewell to Lydia, and headed to Rome.[33]

Rossano turns to me. 'I think that, now, we should take the trip to Rome.'

Chapter Three

WHEN IN ROME...

I have boarded a train travelling from Florence to Rome. It's a scenic journey and the passing views probably haven't changed much since Rossano made that first trip to begin working as a lawyer.

Once clear of Florence, the traveller enters the Tuscan countryside with its grassy fields, isolated farms and rambling houses sporting brightly coloured terracotta tiled roofs. The terrain changes from flat to undulating every few miles and I spot a few sleepy villages dotted here and there as we speed along.

He must have been excited as he looked out at this same view, contemplating his plans: a future with Lydia, a career as a successful lawyer and a lucrative hobby performing on the stage.

Roma Termini is predictably vast. Hundreds of trains come and go from its thirty-plus platforms every day. Tannoy announcements are constant, and it feels as if half the population of the city is here – all in a rush.

Rossano loved travelling by train and this journey to begin his professional career as a lawyer saw him arrive here in 1937. He greets me at the station. He is wearing another beautifully tailored suit, black polished shoes and a pale blue tie. He has a cigarette in one hand.

After a few pleasantries, we exit onto the streets of Rome.

Wherever I look, and this will be the case throughout my visit to the Eternal City, I am confronted by history. In between two hotels, a

cavernous excavation displays Roman ruins. Around a corner, a statue. Indeed, around most corners, something catches my eye. Tucked down a side street, an ornate church. As we wander through one arched walkway, Rossano gestures for me to look up. Above me, the walls are covered with ancient, peeling frescoes. By the end of my time here, I will have fallen in love with this place and the people.

Rossano leads me down Via Cavour, a long, wide road that opens onto the Via dei Fori Imperiali, where stands the imposing Victor Emmanuel monument, the Altare della Patria by the Piazza Venezia. The locals apparently call this massive, curved white building 'the wedding cake' and, wherever you are in Rome, it's likely that you will catch a glimpse of the magnificent chariots that are perched high up on it.

'And what was the first thing you did when you arrived in 1937?'

'Found my room and explored.'

The family had no idea where he was first living. I think we have to assume that, with little money in his pocket, he would have lived quite frugally at this time.

'I began my job as an apprentice lawyer, and I was delighted. I was working at something I thought I would enjoy and, you know, our clients were mainly people from the stage.' He grins. 'I think this excited me as much as being a lawyer.'[34]

His first court case, apparently, entailed successfully defending a woman accused of stealing a chicken.[35]

In between preparing briefs and shadowing his mentor in court, he made enquiries about theatre groups he could join and was quick to locate one that suited him.

'The one that interested me was the *Dopolavoro Ferroviario*, which means "After-work Railway". It was a group of amateur performers who, after work, would tour various theatres by train to perform plays. Out in the suburbs.

'This was good for me. This showed me the discipline needed to be a stage actor and, you know, it was hard work. Companies like this, similar to your repertory companies in England, were putting on a play every week, every month.[36]

'If you have a part, you are learning your lines for the play you are in and, while you're performing that, you're learning lines for the next one. While you're doing that, you're reading about the one that will come after! But I enjoy the process very much. I played a number of roles and began to learn about developing character and working with props, that sort of thing.'

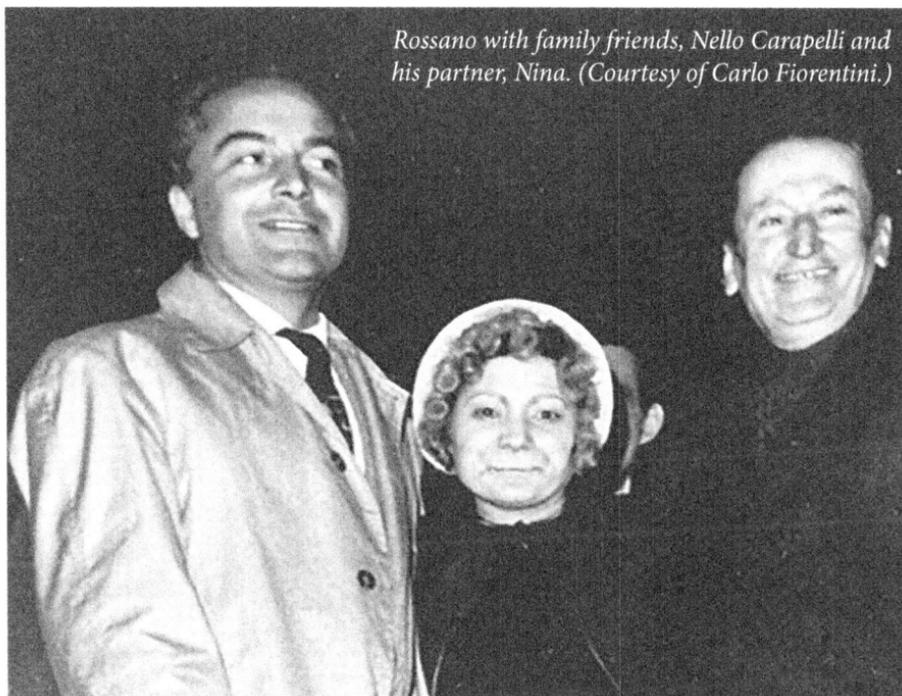

Rossano with family friends, Nello Carapelli and his partner, Nina. (Courtesy of Carlo Fiorentini.)

The family friend, Nello Carapelli, who had helped Rossano in Florence, was part of that company and selected him for several plays. It was while appearing in *Campo di Maggio* that Rossano caught the attention of Emma Gramatica, a renowned Italian film and stage actress who happened to catch his performance and was impressed by what she saw.

He steers me off the main Piazza and we join the Via Nazionale, another long, wide avenue, lined with impressive buildings.

'To join Emma's company, I had to pass an audition and that took place in the Hotel Quirinale, just up the road here.'

Half a mile from the Piazza Venezia stands the Hotel Quirinale and we waste no time in going through the revolving doors and into the

foyer. I wander around the adjoining rooms, all of them opulent and stylish. There are a couple of wingback seats in the corner, and we take this opportunity to sit down.

'You know, I was so nervous at this audition. I didn't think I would do so well. Emma Gramatica was a big star in Italy, the biggest, and this was my first audition. But, I pass that audition. She taught me so much. She worked closely with Eleonora Duse.'[37]

Eleonora Duse was probably the biggest star in Italy at the turn of the last century and herself a big influence on Emma Gramatica.

Both women were trailblazers; fiercely independent, they set up their own theatrical companies and managed and directed productions. Duse introduced a form of acting called the "elimination of self".

Acting techniques in Duse's time tended to be overdramatic, with exaggerated expressions and gestures making the performers appear unrealistic; indeed, this sort of acting could be seen globally. Under Duse and Gramatica, actors were taught to opt for subtlety – to be more convincing and naturally human.

Rossano was keen on this method and, very early in his career, came to blows with a director who demanded that he be more histrionic. Rossano felt his role called for a calmer intensity. He had an Italian temperament, and this surfaced now and again in his professional career.

'I told him that the audience were intelligent, they don't need to see melodramatic, they know what is going on. We argued and I threw my contract back at him and walked out. I was still thinking about it late at night, because now I had thrown away an opportunity, but this was important to me. Then, later, he offered me the part back. I played it how I thought it should be played and it was a success for me.'[38]

Although this was a minor argument, he'd proved to his peers and himself that he was taking his acting seriously. He thought hard about how to bring the best out of the part he was playing and would not be pushed into portraying a role in a specific way if it didn't feel right.

Joining Gramatica's repertory company was his stepping stone to success. Whether he realised that at the time is not clear, but law had become his secondary career as he was constantly drawn toward the stage and fast becoming known in theatrical circles as an up-and-coming

talent. Still in the late 1930s, he took time off from his legal work to tour Italy and Germany with Gramatica's company.

'Another influence was Ermete Zacconi. He was a stage and screen star here in Italy and he became a mentor for me. Like Duse and Gramatica, he placed emphasis on realism and encouraged me to think about my role.'

Zacconi pushed Rossano, teaching him to study a character's motives; were they acting out something innate or as a result of their environment? Rossano absorbed this training and put it into every performance. He and Ermete became close and, when Ermete began filming *Plato's Dialogues*, he chose Rossano for the part of Cebete. They would later star together in one of Rossano's first motion pictures, *The Trial and Death of Socrates*.

'But, you know, I had my legal career to think about and my relationship with Lydia was serious and that was important to me. We had become engaged, and I had to think about us as a couple, not just me and, of course, if we had children, I had to think of the future like that, too.

'I was torn into becoming a professional actor but, you know, the life of an actor is precarious. I was aiming to open my own law firm. Lydia was still in Florence, and we had talked about getting married and that was a challenge because our parents were still against this union.

'Of course, Lydia was engaged to that stuffy lawyer before me but she'd called that off. We wrote many letters to each other, and I told her to run away and come to me here, in Rome.'[39]

For the time being, however, Lydia remained in Florence.

In the meantime, during one performance with the Gramatica company, Silvio D'Amico and Renato Simoni were in the audience. D'Amico was a leading theatre critic; Simoni, too, was a critic but also a renowned and respected playwright, journalist, writer and impresario, known for his collaboration work on Puccini's *Turandot*. These were men at the top of their profession and Rossano's performance had impressed them; so much so, that Simoni visited the law firm where Rossano was working and offered him a role.[40]

'This was just a small part. I was only twenty, but I remember this clearly, even the date, 7 June 1937. It was a play called *I Giganti Della Montagna* [The Giants of the Mountain] by Luigi Pirandello. It was shown in the Boboli Gardens in Florence, not far from where my family lived. I didn't have a big part, but this was being put on by Renato Simoni. I would take anything he gave – he was one of the most influential people in Italian theatre at that time.'

I had visited the Boboli Gardens when I was in Florence. They lay behind the magnificent Pitti Palace. Behind the palace, it is necessary to climb a number of shallow steps to reach the gardens. Ahead of you is a wall but, make your way to the other side of that wall and there, in front of you, is the amphitheatre. It's a breathtaking moment.

The auditorium has just five or six rows of stone seating, but it stretches for some distance before curving toward the rear. Above the seating area and surrounding the entire theatre are numerous statues. In the centre, there is an obelisk and an expanse of lawn. There is a gap at the back that allows people to walk uphill to a large fountain depicting Neptune and, beyond, there are smaller gardens that offer extensive views of the Tuscan countryside.

The amphitheatre backs onto the rear of the Pitti Palace and, to the side of this, the audience is treated to far-reaching views across the rooftops of Florence, with its various domes and spires.

What a wonderful place to perform in!

Although this was a minor role, Rossano was being given a taste of success in a different league to the one he'd been used to, and he loved it. He continued to play on the stage and hone his craft, while any monies earned were put aside for his future.

Rossano and I now leave the Hotel Quirinale and stroll along the streets of Rome. The traffic runs freely and pedestrians take their lives in their hands as they cross the roads. Most simply wander across, with a hand held up in the hope that drivers will stop. We do the same and I am relieved to get to the other side.

Two years after *I Giganti Della Montagna*, Rossano was handed an opportunity that he couldn't refuse, and it would make him think seriously about the career he had chosen.

'Renato gave me the part of Aminta in the play of the same name by Tasso. I took a break from my work as a lawyer to play this role. [41] It was shown during The Maggio, in Florence; that is a very well-known and respected music festival – opera.'

At that time, Renato Simoni was the head of the Venice Biennale and the Maggio Musicale Fiorentino, so this would have been a huge opportunity for him. The festival had been founded several years before and ran during the summer months, showing a number of operas within the city. It is still very much a part of the festival season today.

The year was 1939.

Aminta, written by Torquato Tasso in 1573, is a typical "pastoral" drama of the time, similar to *As You Like It* by Shakespeare or *Comus* by Milton and it was considered a masterpiece. Like many pastoral dramas, it is set in a mythical world where the shepherds tending sheep on the hillside are content to sing lyrical songs and pursue love. The characters are either nymphs, poetical shepherds or noble courtiers.

'This was good for me. I performed this work well and it was incredibly successful, for me and for Renato.'

He has a habit of boasting but he says this more in surprise than with any ego.

There is a bravado about him which is, in some respects, endearing, but I know he has a reputation for bending the truth so that's another thing I have to keep an eye on. Anything he says, I really have to double-check. Where his performance in *Aminta* was concerned, however, I know he is right.

I was able to locate Renato Simoni's book, *Il Grande Eclettico*. With the kind permission of the University of Florence, anything shown below in italics are direct quotes from that book between pages 261 and 273.

Critics, locally and internationally, praised its stylistic unity, the scenic functionality and the balance between text and interpretation. In their reviews they highlighted the performances of the two very young protagonists, Rossano Brazzi and Micaela Giustiniani.

And it wasn't just the acting that impressed. Costumes, lighting and scenery depicting a mythical land with waterfalls, rolling fields and

royal courts, all of which played their parts. The run coincided with the full moon which only added romance to that particular evening.

Decades later, Raffaela Monti, the celebrated Italian director, playwright, actor and critic, remembered Aminta as "one of the most glorious chapters in the history of the Maggio Musicale Fiorentino and of modern Italian theatre".

Aminta was the final show of the festival, staged at Palazzina della Meridiana-Boboli Gardens in June 1939. This was a wide area to the side of the main amphitheatre, still with the Pitti Palace as its backdrop.

We've stopped at a family café and Rossano orders coffee for us. He gazes at the sky, deep in thought, then turns to me.

'You know, during this particular festival, there were many European sovereigns who gathered in the city to celebrate the wedding of Princess Irene of Greece. Yes, the one who bought shoes from my father's shop. She was marrying the Duke of Spoleto. They attend the performance of *Aminta*. Not only was I performing at this wonderful festival, but I was performing in front of royalty.'

The attendance of this couple and their guests, dazzlingly elegant, wearing magnificent jewels, brought Tasso's pastoral tale back to its original and rightful context – in front of aristocracy.

At such a young age, Rossano and his co-star Micaela must have felt very privileged to perform in such an arena with the bonus of heads of state, sovereigns and nobility attending.

Simoni had taken a chance on casting Rossano and Micaela in these roles, especially at such an important festival. These were two very young actors, admittedly flanked by professionals, playing parts of enormous importance. The show was unanimously applauded by audiences and critics and celebrated as one of Simoni's best productions and of the Italian open-air theatre as a whole. One review of the time stated that "Brazzi sang the lamentations of the

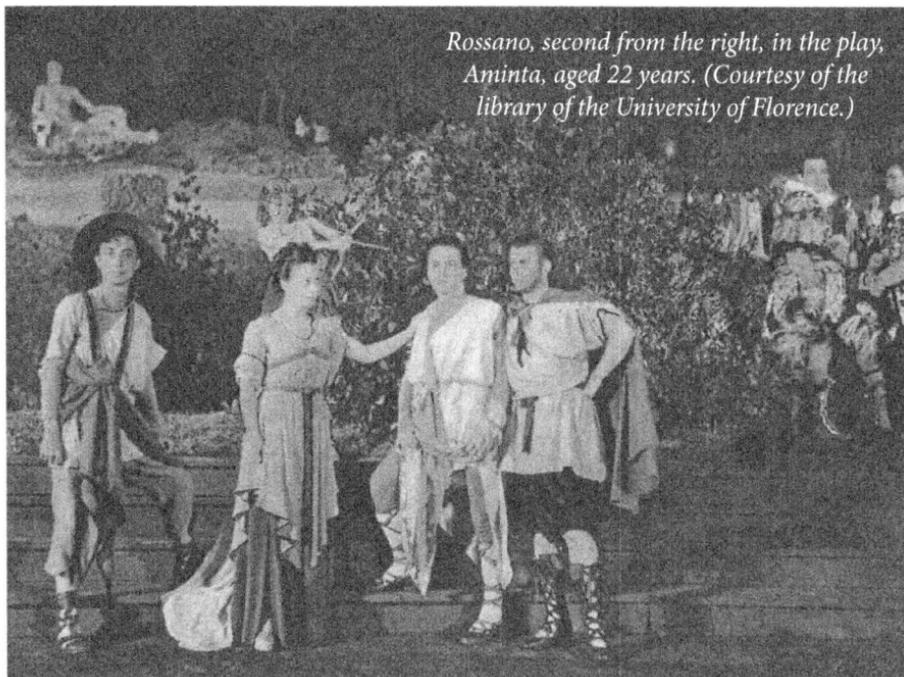

Rossano, second from the right, in the play, Aminta, aged 22 years. (Courtesy of the library of the University of Florence.)

afflicted and sighing shepherd with sincere abandon, with isolated inner rhythm".

Even as late as 1952, this play was still being hailed as the most important contribution to Italian theatre by actor, writer and member of the Venice Film Festival jury, Giulio Cesare Castello.

The critics were won over and Rossano was, in their opinion, the future star of the stage. The public felt the same: Rossano was *the* actor to see.

Simoni cast Rossano in a further play, *Il Ventaglio*, at the Venice International Theatre Festival, shown over several days in July 1939.

'I was twenty-two at the time and new to the theatre compared to who I was working with and the adulation I was receiving from these people was overwhelming, you know, but very exciting for me.'

Now a favourite with Renato Simoni, he found himself performing alongside the best stage actors in Italy at that time: Gino Cervi, Arnoldo Foa and Rina Morelli. Reviews were constantly citing him as one of the best hopes for the theatre.[42]

After the summer of 1939, he returned to Rome to continue his work as a lawyer and he moved from Emma Gramatica's company to that of Annibale Ninchi, an Italian actor and teacher from Bologna, who would go on to star in some of Fellini's films, including *La Dolce Vita*. Under his instruction, Rossano honed his acting skills.

I obtained a letter dated August 1939 written by Giannini Guglielmo. In later years, he became a politician but, in 1939, he was a playwright, director and a leading light in the Italian theatre.

He offered Rossano a six-month contract for 120 lire with the option to extend this to a maximum of two years with numerous increments in pay. Travel costs were added to the contract for Rossano to visit Lydia who, at that point, was engaged to him and living in Florence.

Rossano is also advised that he must give notice if he has offers from the film industry while he is under contract and confirm that he will leave the Ninchi theatre group. There is no evidence that he signed for Guglielmo, however, it gives us an idea of the salary he commanded at this time. (120 lire, for six months work, equated to approximately $250/£220 at the time. Not a bad salary for a twenty-two-year-old in 1939!)

That same year, he secured a role in *Cesare* by Gioacchino Forzano, which was being staged in Rome. The lead of Brutus was to be played by Renato Cialente, a leading Italian film actor at that time. Unfortunately for Cialente, he was delayed in getting to Rome and missed the first rehearsal.

Rossano grins. 'The director, Forzano, he asked me to audition for him and I did. I don't know why but he gave me a specific part to show him, so I did as I was told. Then, you know what? He called Cialente and told him that he no longer had the lead, and he gave that role to me. I played Brutus.'[43]

Around this time, Rossano received a phone call from Michele Scalera, head of Scalera Film Studios. Scalera had seen the production of *Aminta* and wanted him to audition. Rossano remembers those first screen tests with a wince.[44]

'They were dreadful. I thought, when I was auditioning, that this was not going so well. Acting on stage is different to acting in front of

a camera. I hated it. It was disappointing because I was excited to try film.'[45]

But, not one to give up easily, he accepted an invitation to a further audition with Scalera and this proved successful. He finishes his coffee and gives me a knowing look.

'I think that audition was more to do with someone who had convinced Scalera that I could be a film actor. He took a chance on me.'

'What did the legal firm think about this?'

'This was during August, when everything shuts down, so I would not have taken time from them, but I realised that I was taking some liberty with my workplace.'

Rossano once described the start of his career as a fortunate accident and, yes, some of it was all about being in the right place at the right time or the right people being in the audience to witness his performance.[46]

But let's not forget Rossano's dedication to learning his craft. As a boy and teenager, he was constantly reading and studying classic plays, prose and poems, reciting them, performing them (sometimes to himself). He studied under and alongside some of the most famous and influential stage actors and directors at the time. He had a driving ambition to conquer the Italian stage and conquer it he did.

He was ambitious and the new challenge of acting in movies was an enticing one. But he was also a lawyer, a profession he had studied hard for and one that provided security. He had a decision to make, not just for himself but for Lydia, too.

Chapter Four

TO ACT OR NOT TO ACT?

'As a teenager and throughout my younger years, I was too attractive.' Rossano often said this when looking back on himself as a young man.[47]

This statement could not be thought of as big-headed, as most Italian producers and directors said the same thing: 'He's too pretty,' 'He's too good-looking,' 'He's too beautiful.' His looks would prove to be a double-edged sword throughout his life, and he bemoaned the fact that he would get pigeonholed into certain roles because of his face.[48]

We are standing outside the iconic Cinecittà film studios. It's a thirty-minute train ride from the centre of Rome and, apart from the surrounding area being more built up with a main road right on its doorstep, very little has changed. The entrance remains exactly as it was – a small Art-Deco structure, behind which are numerous sound stages.

'The studio opened in 1937 and there was nothing here at that time. I remember a market stall or something like this was outside selling fruit. All of this was just fields, farmland.'

He leads me through to a landscaped green that separates the entrance from the studio's sound stages. There are some wooden seats dotted about and we take the opportunity to sit in the sunshine.

'Mussolini had this built for propaganda films. His son, Vittorio, he was an integral part of this studio. The Scalera studio does not exist now

so I thought it would be good to meet here to give you some idea of the way the studios were set up. I filmed here many times.'

Scalera Film had given Rossano a three-year contract to sign. He had not thought about going into films full-time because he loved, and was happy with, his stage career. However, this was an opportunity he felt he should take.

It was January 1940; the world was at war, and it was time to make a life choice.

He was making his mark on Italian theatre and Lydia, at his insistence, had joined him in Rome so they could marry. This came with its own drama.

'I had told Lydia to come to Rome, and she arrived here the evening before we married. She said to me, are you sure that you want to marry me, you may be sorry. She asked me that often when we were engaged. I told her, I want to marry you and I won't have any regrets. Well, the next day we were due to meet at a church on the Appian Way, early in the morning, and I didn't wake up in time.' He rolls his eyes. 'I can't believe I did that. When I woke up, I ran to the church and she was waiting for me.[49] [50]

'This was painful for me – for us. Our family were still against this union. We wanted their blessing, but we did not have it, so it was a little bittersweet to start our life under a cloud like this. I felt that this was my life, our life, and we wanted to be with each other, so we married without the family in attendance. And, you know, I was right. We had a wonderful marriage.'[51]

Rossano and Lydia exchanged vows on 25 January 1940. Although the family stayed away, the ties between them were not broken. Rossano and Lydia remained in touch with them – it would just a take a little time for their parents to accept the situation.

'We exchanged gold rings, but we did not keep them. Of course, we were now at war, so we gave our rings to the war effort. Most Italians were doing this with their gold. In return, we receive metal rings and on the way home, from the ceremony, do you know what happened?'

'No. Tell me.'

'I lost my ring. I hadn't even got home! I looked everywhere but I couldn't find it. I only had a wedding ring for twenty minutes. I was

going to replace it, but I never did. This ring, here, this I always wear, this has a story that I will tell you about another time.'[52]

Rossano is referring to a large ring on his little finger. He wears it every day and only takes it off if directed to do so in a film. He has large hands and the ring is chunky, showing the three faces of Greek theatre: joy, anger and tragedy. I know, from inquiries, that this has a "spiritual" significance for Rossano and we will later learn about his belief system which, in those days, was quite unusual.

'Honeymoon?'

'No, no honeymoon. No one had a honeymoon – we were at war and, you know, I didn't even have my first night with Lydia. I had to go to begin filming on location in Spoleto so I had a train to catch. We didn't even have a day together. Lydia refused to go to bed with me until we were married. I tried, all the years we were courting, but she refused me. Now, on the day we are married, I have to go away! But we are digressing...'[53]

Yes. Decision time. The law firm had been accommodating in allowing him time to pursue his acting interests, but he could no longer take advantage of that. Should he continue in a secure profession or throw away that career and take a chance on being a full-time actor?

'I told you, I had Lydia to think about, too. We were married now, so this was not my decision to make alone. We had to make it together. I had a serious career, one that I worked hard for. We talked about it and, you know, it was not so difficult. I would be making more money for one film than I would over ten years as a lawyer. It was a risk I was willing to take. Lydia was supportive of that. And being a lawyer, well, I thought it was a joke. It is all about telling lies and I tell lies well.'[54]

This is the only time I hear him admit to lying and although those lies, on the whole, never hurt anyone, this trait would land him in hot water occasionally.

Earning money was important at that time. They didn't have any, for a start, and Lydia (being from nobility) was used to the good things in life, with a penchant for expensive jewellery. Rossano wanted very badly to give her those things.

He turned his back on the legal profession.

'My first few films, I was just in the background. I didn't have a part to play as such, not a speaking part, but my fourth or fifth film, directed by Alessandrini, was called *Il Ponte di Vetro* [Bridge of Glass]. I played the commandant, Mario Marchi, in this.'

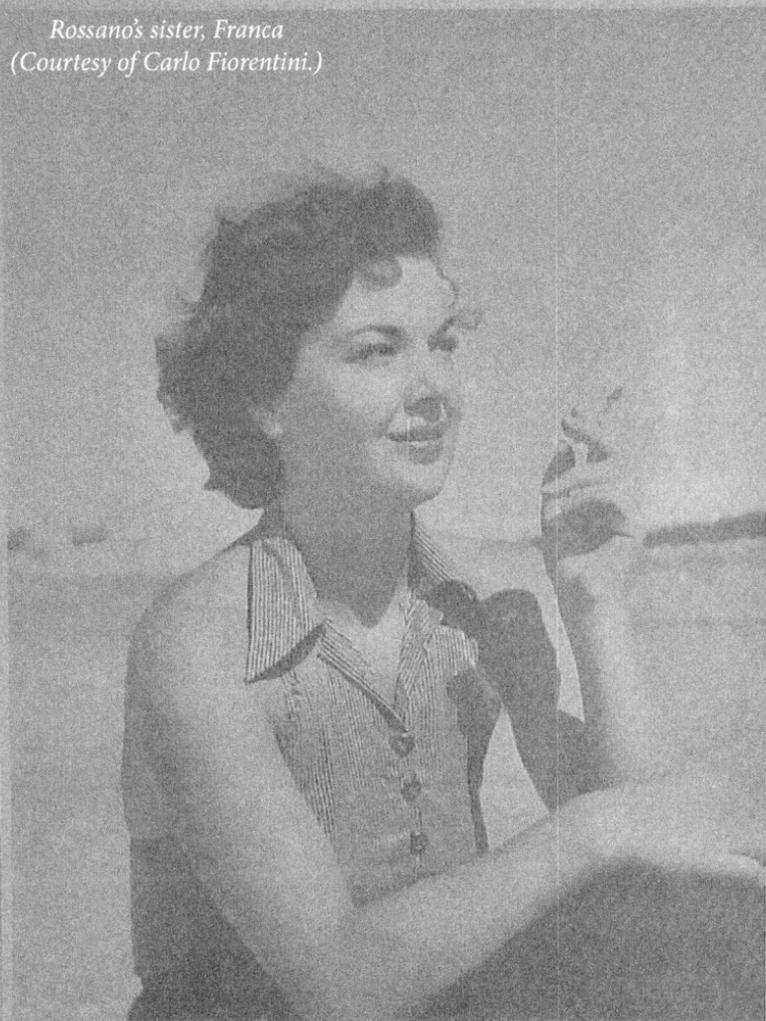

Rossano's sister, Franca
(Courtesy of Carlo Fiorentini.)

He suddenly laughs. 'I have to tell you a funny story – about my sister, Franca. This film was released in early 1940 and Franca took our

father to the cinema to watch it. He was disabled at that time, because of his stroke. There is a scene in this film where I am flying a plane through a bad storm, and they were laughing at this because they knew how it had been filmed. I was in a wooden box and it was being rocked by the crew to simulate the turbulence. But that was not the funny thing. I had a line in this scene: *La carta, dammi la carta.* (The map, give me the map.)

He grins at me.

'I tell you, Florentines, they have a sense of humour, you know, and it is not unusual for a Florentine audience to shout out a comment at a particular scene or a line in a film. It is usually rude or sarcastic. Well, the word *carta*, in English, means paper and a man in the audience had decided that this meant toilet paper. So, in his mind I was shouting "Toilet paper, I need toilet paper", and he shouted out loud, "Hey! He is shitting in his pants."

He laughs.

'Franca, she was about fifteen or sixteen and, of course, at that age you can be sensitive and embarrassed. She thought they were being rude to me, personally. She ran out of the theatre leaving Papà on his own – in a wheelchair. When she got home, she went straight to her room and Oscar went to find out what happened. He had to go back to the theatre to rescue our father.' He chuckles and shakes his head. 'We never let her forget that.

'And, you know, when we started filming I had a bad accident. Something from the overhead beam fell on my head and I had to go to hospital for a week. But that film received good reviews.'[55]

Lydia has joined us. Rossano offers and lights a cigarette for them both. I then get a taste of the bickering they are famous for.

'I don't want to go out tonight,' she says.

'What!'

'I have nothing to wear.'

Exasperated, he turns to her. 'What are you talking about? You have plenty to wear. You arranged this – you can't cancel so late.'

'You go on your own.'

'I don't want to go on my own and you have plenty to wear.'

'Everything is too tight.'

'Nothing was too tight last night – you managed to go out then.' He turns to me. 'You know, she is the social one. I would prefer to stay at home and play Canasta.'

She gives vent to an Italian puff. 'We would never go anywhere if I left it up to you. Are you talking about yourself again?'[56]

He grins. The fight stops as quickly as it started.

'*Cicci*, we are just talking about my first few films and *Il Ponte di Vetro*.' (*Cicci*, pronounced "chichi", is a very intimate and affectionate term of endearment and the couple use this frequently with each other.)

'And your next film, Rossano, was very successful,' says Lydia. '*Kean*. Remember?'

'Of course, I remember. Why would I forget that?'

Is the sparring about to restart? No. He draws on his cigarette.

'I enjoyed that part. That was a challenging role. That's the sort of role I like to take on.'

Though he'd done just one film with a predominant speaking part, Scalera took a chance and cast him in the title role of Edmund Kean in the film, *Kean* (1940). This was based on a play by Alexandre Dumas. Rossano played the part of the real-life actor, Edmund Kean; a role that other actors were wary to take on, actors who had turned Scalera down because of the challenges. Rossano wanted and needed this to prove to directors what he was capable of and that he wasn't just a pretty face.

'Edmund Kean was a nineteenth-century Shakespearean actor who had a chaotic life, you know, a lot of upheaval, and was widely known as being mentally unstable. He was married but then divorced and, when the newspapers reported this, his audience went against him. When he appeared on stage, they threw food at him. They did the same in America when he went to play there.

'He was a good actor but unstable. He became an alcoholic and his talent diminished over the years. It was a wonderful part to play. There were so many sides to that role and I could always reach in and find something more to him. I like that.'

Critics proclaimed Rossano's portrayal of Kean to be sensitive, awe-

inspiring, passionate and intelligent. They soon hailed him as one of the best new actors in Italian cinema. Rossano was twenty-four years old and relatively new to film. Reviewers were stunned that such a young man could have taken on this role and made a success of it.

Not only was he making an impact on the critics, but the public were also taking note of him, especially the female half. Fan mail began pouring in. This is, of course, because the man was so handsome but there is a sense of Rossano's frustration.

'This was annoying for me because I showed, in *Kean*, what I am capable of. My stage roles, they showed that I can act. Unfortunately, the studios just saw my face and cast me in heroic roles, not character roles, which is what I prefer.'[57]

'Is there much difference between acting on stage and screen?'

'There are some. On the film, you are seeing a person's expression, all of the time, the camera is focussing on expression, the message in that expression – there are many shots, with people, that are from close range. On the stage, the audience is seeing everything as a whole so looks and expression are not so important – whereas the character is. I chose to do films, so I do them. During my three-year contract I made twenty-four films.'

'Twenty-four films in three years!'

'Yes, I'll take you on a tour of the studio in a little while and you'll see how we managed that. Scalera occasionally rented sound stages here. I hated Mussolini but I have to give him credit for how the studio was set up.'

Most of his roles during this period were swashbuckling adventures where he played the devil-may-care hero rescuing the damsel in distress. These were similar to those made by Douglas Fairbanks Jr. around the same time and, later by Errol Flynn; films where the dashing male lead galloped in on horseback, fighting and duelling in an action-packed story. The plot lines rarely changed but Rossano admits that he loved this period. He was young, enjoying life, making good money and fast becoming the idol of Italian cinema. Five years after leaving university, Rossano had become one of the highest earning actors in Italy.

Lydia, with a smile, is quick to remind him that *she* was the first of

the pair to be given a professional acting role. Rossano, with a roll of the eyes, concedes that this was true and invites her to tell me.

'We were in the Caffè Castellino, in Rome,' she says, 'wondering how to pay the rent. This was before Rossano was earning the big salary.'

'That place, you know, it always sold cheap coffee and that's all we could afford.'

The Caffè Castellino continues to be a very sparse café in the centre of the city.

Lydia continues.

'A man kept looking across to us and then a friend came to our table and told us that the man was a director and wanted to talk. We immediately think that he wanted Rossano and Rossano went over to talk with him; then he came back and he said, "He doesn't want to talk to me, he wants to talk to you!"'[58]

'And she took the role,' Rossano says, 'not because she wanted it, but we needed the money… but, she didn't enjoy it.'

Lydia's expression confirms this. 'I am not an actress – that is Rossano's thing, not mine. Him with his pretty face and admirers.'

He closes his eyes and lets out a laugh. 'I was getting hundreds of letters a week. I didn't understand it, I tell you. I didn't see what they saw. I only saw my handsomeness when I got older, you know. When I look back, I see I was quite attractive. With these films, I was getting paid well. We were at a point where, financially, we were very secure, and we bought a house in the Parioli.' The Parioli is a very affluent area in Rome.[59]

Fortunately, after *Kean*, one or two directors saw beyond the swashbuckling roles and gave him more challenging ones. In 1940, filming began on the dramatisation of the opera *Tosca* by Puccini. Interestingly, renowned French director Jean Renoir began work on this film after being requested to do so by the French government. It was hoped by having a French director, it would help to sway Italy to remain neutral in the war. Italy, however, joined forces with the Germans and Renoir returned to France. Although he directed many scenes, he was uncredited. The German director, Carl Koch, finished the film.

The role of Mario Cavaradossi was one that he relished. He was a huge opera fan and was strongly motivated to play this part. The world

was now at war and Italy was under the Fascist rule of Mussolini, whose dictatorship Rossano and his family loathed and fought against.

Mario Cavaradossi, a painter, is a man fighting a dictatorship and known to the secret police as a sympathiser. He is also in love with Tosca and she with him. He helps an escaped prisoner, an ally for their cause, and shelters him. When he is eventually found out, Mario is tortured by the police to give information on where the prisoner is hiding. Mario endures the torture, refusing to give them information about where the prisoner is hiding. Tosca cannot bear to see Mario suffer; her decision to speak leads to dire consequences for all of them.

It's a fantastic film which uses the popular songs from the opera to accompany the scenes. For anyone who wants an introduction to opera, this is the perfect film, weaving just a few songs into the drama of the plot.

Watching Rossano in this film, one can see that he has been influenced by Duse, Gramatica and Ninchi. The rule of being subtler and less melodramatic is evident in the torture scene. In films of this time, if a red-hot poker were being used to torture someone, the actor in question could be directed to scream straight away and overact.

Here, it is more realistic. Mario knows what is coming; he can see the man heating the iron poker in the fire. We see him psyching himself up to endure imminent pain. When that pain comes, the camera is fixed on his expression. All this time, we see him reacting, gritting his teeth, determined not to give in. He holds the pain in, but we know exactly what is happening by watching his eyes. The only time he cries out is when he faints from the pain and the poker is applied while he is semi-conscious. He's not ready for it.

'That is the elimination of self. Some actors are directed to cry out from the very beginning of a scene like this. If you start out that way, you have nowhere to go when you're acting. You end up overacting and that becomes melodramatic. Mario, he knows that Tosca is nearby. He would not want her to hear what was happening to him. You have to be real.

'When I take a character on, I don't take it. It takes me. When I look at a role, I need him to step into me, wrap his skin around me. Mario's traits, mental and physical, need to come into me and I need to adapt

to accommodate him. I change the way I stand, the way I walk, my expressions, my thinking. For me, Mario was strong enough to fight a dictatorship so he would not cry out if he was being tortured. He would stay strong for as long as he could, you know, in defiance.'[60]

Little did Rossano know at the time just how close he would come to the real thing only a couple of years later.

Tosca was critically acclaimed; Rossano had notched up another success in his fledgling film career.

But whereas *Kean* and *Tosca* had impressed both critics and cinema-goers in Italy, his next film would cement him as one of the best actors in Italian cinema.

Chapter Five

A TOUR OF CINECITTÁ

Rossano with Alida Valli in We the Living. *(Courtesy of Duncan Scott Productions.)*

I make no apologies for spending time on this specific movie as it is his best film in respect of his acting skills. And the story behind the film, along with its rediscovery and restoration, is as enthralling as the movie itself. I'd like to thank Duncan Scott, the man in charge of restoring this film, for his permission to use so much information provided on his website (wethelivingmovie.com) for this section of the book.

We leave the bench close to the entrance of Cinecittá. Lydia has seen some people she knows and is immediately up on her feet to go speak with them.

'Don't forget that we are going out tonight. No excuses,' demands Rossano.

'You shut up,' she retorts, skipping away with a smile.

Rossano, with an amused *tut*, leads me toward the sound stages that stand within the ninety-nine-acre site. They are all about thirty metres high but of various dimensions in respect of floor space.

He opens a door to the one closest to us. 'This is the smallest at the studio. There is no one filming here so you can get an idea of what directors come in to.'

The building is the size of six tennis courts, and this is the smallest!

'What the director will do is adapt it to whatever they are filming. When we filmed some of the swashbuckling films, the designers, they'd add a castle here, a forest there, a farm over there. There are wires and cables all over the place for spotlights and sound – the whole place was transformed.'

'Oh, yes, and you were surprised at how many films I made in three years.'

Rossano explains the set-up as we exit the building and continue. He points to a number of smaller, low-level buildings.

'Each sound stage had its own services around it. The buildings around this one, for example, housed make-up, costumes, rehearsal rooms, a canteen, dubbing rooms – all of those things. That way, films could be shot on every sound stage at the same time without any inconvenience to anyone else.'

We arrive at the largest sound stage – number five which has 31,000 square-feet of space. It's immense. Rossano explains that this was similar to the sound stage used for *We the Living*. Having seen the film several times, I can understand why they would have needed such a large facility.

This was one of the most important films to be released in Italy during this era and the world is fortunate enough to be able to see it. This is thanks to the efforts of a handful of very dedicated enthusiasts who managed to track down the original reels and restore them. Everything

about this movie is of interest: the film itself, the circumstances behind making it and how it was rediscovered. As late as 1959, at the height of his international fame, Rossano had this to say about *We the Living* to the *Saturday Evening Post*:

'This is the film I am most proud of. This is still the best picture that I have ever done.'[61]

It was based on a book of the same name by writer and philosopher, Ayn Rand. She cited this as being as close to an autobiography as she would ever write. Although she died in 1982, her books still sell tens of thousands of copies every year.

'I read the book. It is very powerful. Ayn Rand, she grew up in Soviet Russia and was around twelve years old at the time of the Revolution and, you know, even then, at such a young age, she could see what was happening in her country and how people were suffering.'

Rand witnessed the near starvation of friends and family, the diseases rife at the time and was horrified that those who spoke out against the State were exiled to Siberia, in all likelihood never to return. She herself was outspoken against Communism; so much so that she was surprised not to have been arrested.

Remarkably, her application to leave Russia was granted. She obtained a visa to travel to the United States, arriving in the early 1920s. There, she began working on *We the Living*, describing it as a story of Man against the State. It was published in 1936.

It is an incredibly powerful, well-written novel that draws you into Soviet Russia from the very first page. It's full of heartbreak, despair, passion, desire and love; of individuals fighting a system; of their being constantly worn down mentally and physically by the State.

Set in the turbulent years following the Russian Revolution, *We the Living* tells the story of Kira (played by Alida Valli), an independent and strong-willed student who loathes the new Communist regime and openly defies those who do. Kira encounters Leo (played by Rossano), a young aristocrat who is hiding from the secret police due to suspected anti-Bolshevik activities. Kira and Leo begin meeting secretly and fall in love. Desperate to flee the regime, they try to escape the country but fail.

Kira's vocal anti-Bolshevik sentiments are heard by Andrei (played by Fosco Ghiacetti), a senior secret-police official who scolds her for her opinion. But a mutual respect form between the two.

Now living together and expelled from university, Kira and Leo struggle under the regime. With only hard labour work available to him, Leo develops tuberculosis. The sanatoriums won't take him because of his aristocratic background.

Andrei, meanwhile, confesses his love to Kira. Willing to do anything to save Leo's life, Kira pretends to reciprocate that love, using the gifts and money given to her to help Leo.

In the powerful climax, Kira, Leo and Andrei confront the despairing consequences of life under this regime.

Due to the war, the circumstances of making *We the Living* were somewhat unusual and certainly unethical. There were restrictions on what movies could be made. The industry itself was ruled by the Fascists. The only movies being shown were Italian or German and only then with the approval of the government.

The novel, *We the Living*, had proved to be popular with Italians, including the daughter of the head of Scalera Studios.

Rossano and I begin to amble around the grounds of the studio.

'She had read the book and loved it, but she did not tell her father about it because he did not like the books she read. So, she went to Massimo Ferrara. He was the General Manager of the studio, and he loved the book, but he knew that the government would question it and that it had to be filmed in such a way that it did not offend the Fascist regime. It's crazy, you know, that Mussolini's son, he was very involved in the film industry. I think he did not read the book because he approved the making of this film!'

The big problem for the studio was obtaining the rights to adapt the book. It was 1942, Italy was at war with the United States and there was no way of contacting Ayn Rand. Instead of dropping the project, they went ahead with filming without obtaining the rights, effectively breaking every copyright law in the book.

Scalera Studios pulled out all the stops where direction and casting were concerned. They brought in director Goffredo Alessandrini, who

was already one of the most successful directors at this time. He had spent the early part of the 1930s in Hollywood working for MGM but returned to Italy to make historical dramas and propaganda films.

Alessandrini brought in the best actors to play the three lead roles. Indeed, Fosco Giachetti, Alida Valli and Rossano Brazzi were all top box-office attractions at that time.

'Alessandrini was a good director, a gentleman, very cultured. A wonderful man.'

Rossano adored the part he was asked to play.

'The character of Leo, I loved it. I loved it because he was a nice, good son of a bitch! And he was really the aristocratic man that I think was, at that time, in Russia. They were all three wonderful roles.'

Things didn't get off to a good start, however. Two prominent Italian novelists were brought in to adapt the book, with disastrous results.

'Alessandrini, he came from shooting another film and read the script and hated it. The writers, they had decided that Kira should be a ballerina, not an engineer. That was crazy. He threw the whole thing out and wanted new writers to start from scratch.

'But me, Alida and Fosco, all the actors, we were contracted to play at that time, the sets were built, so we had to begin but we had no script! So, we follow the book. The new writer, Anton Giulio Majano, wrote the day before what we were going to do the day after. It was hard but, you know, it meant we were mostly true to the book.'

Filming began in early 1942 but in wartime no location work could take place. As a result, everything was built from scratch on the sound stage of the Scalera studios.

Inside the sound stage, the sets included a busy St Petersburg Square and marketplace, a deserted garden, a ship's deck, a train station, even a snow-covered street with a horse-drawn sleigh. Every set was painstakingly recreated by scenic artists, designers, and special-effects technicians. Authenticity was enhanced by the fact that the production designers were Russian born.

'You know, it was uncomfortable, being inside all day. With the lights and the equipment, it was a hundred degrees in there and you had to show the people that it was freezing cold, and we were perspiring so

much because of the heat. I had a fur hat on a lot of the time; I was so hot.'

The production team had the added responsibility of keeping the film running smoothly.

'Many of the extras in this film were White Russians living in exile, here in Rome. The posters you see in the film were done by them, so it was very authentic. We had countesses, counts, Russian nobility on the set. The first day they arrive to work, the production team would shout at them, you know, order them about, and these were people of nobility! Majano, he realised who these people were. He told the team that he would handle them and, you know, he was polite with them, gave them more respect. There is a scene in this film, at a market, and Alessandrini, he had these Russians holding objects up to sell and, I tell you, they are genuine. They brought in icons, gold, precious objects that belonged to them. Not props.

'And then, they were shooting more material than could fit into one film – good material. So much of that story could be told. So Majano went to the head of Scalera and told him, why not make two films? To release them as separate movies, *Noi Vivi* [We the Living] and *Addio Kira!* [Goodbye Kira!].

'The studio agreed but told him to keep it secret from us, the actors. They had made a contract with us for one film and the head of the studio said if the actors find out they're going to want to be paid double.'

He turned to me and threw his hands up in the air.

'We were not idiots! We said, "How long is this film?" And they told us, "Oh it's running a little long, don't worry about it." Someone in the cutting room told us it was going to be two films. We went to Scalera for more money, and he said no. Alida was so furious she walked out and started work on another film. They had to get her back because they had filmed so much with her. They finally made a settlement with us, but it was not the amount we should have received for two films.'

There is an interesting story about Rossano and his salary for this film. He was part of the Scalera's school of actors and, at the beginning of his career with them, he was earning 1,500 lire a film. It appears that, for *Noi Vivi*, the studio was going to try and reduce Rossano's fee.

Majano told Scalera's lawyers that if they did that, Rossano would sue, and he threatened to do so. They went to a labour mediator and Rossano won his case.

'Also, there was a time for me where I simply did not want to act. Lydia arrived one day with a telegram. She never visited me on set, so I knew something was wrong. That telegram said that my father had died.[62] I was so upset. This was my father, the man who had introduced me to so many things, who influenced so much of my life. It took me a long time to get over that.

'Alida Valli, she too went through some trauma. The man she loved, a fighter pilot, he was shot down and killed so this was not a good time for either of us.

'When I returned from my father's funeral, I learnt that Scalera had decided to premiere the films at the Venice Film Festival and that was just a few months away; so, the days become longer. Sometimes we get up at seven to start at eight-thirty in the morning and didn't finish till almost midnight. Then, when we finish, we have to learn lines for the next day. We were working fourteen, fifteen hours a day.

'One day, we left, Alida and myself, we ran away from the studio – they couldn't find us for several days. They kept calling my house. To work ten hours a day is enough. Not fourteen. After that, we establish regular hours.'

Throughout the making of the film, the Fascist authorities kept a very close eye on what was being filmed because of the content. Representatives from the government would come to the editing room on a daily basis to see what had been shot and to ensure there was no anti-Fascist content.

They also insisted that certain propaganda messages should be inserted in the movie, even though they clashed with the identities of the characters. Knowing that some scenes would be removed if seen, the editors hid the anti-Fascist scenes from the authorities during those visits.

'They would watch what had been filmed that day and sometimes they question how little we had done. The editors, they just shrug and the scenes they take out for the screening, they edit back in later.'

Despite the initial problems with the script and the dispute with the actors, *Noi Vivi* and *Addio Kira!* opened in 1942 and were critically acclaimed at the Venice Film Festival, both films winning the Biennale Award and being placed in the Best Italian Film category. It was shown at the Barberini, in Rome, for three months.

The movies were huge box-office successes and accepted as a masterpiece by the public and the critics. The two films together were the top grossing films that year. *Noi Vivi*, by itself, was the second. Audiences loved it, so much so that newborn babies were being given the names of Kira and Leo. It was Italy's *Gone with the Wind*, the film everyone had to go and see.

But it didn't take long for it to be viewed as a sly indictment of the Mussolini regime. People talked about it in the streets and there was a lot of joking going on because they knew the movie was making digs at the government.

'My country was suffering at this time. People were starving, literally starving, food supplies were not reaching us, and this is what Leo and Kira were putting up with so the public relate to the film.

'The government, you know, they thought, because this was anti-communist, it was anti-Russia and we were at war with Russia. It became known as the "the film of nudging in the dark". The public is not stupid, they knew. They knew they were under a similar regime and I heard, from some of the production team, there were comments on the street. Instead of "We the Living" – "We the Dead". Instead of "Goodbye Kira" – "Goodbye Lira". Italian currency, at that time, was worthless.'

In addition, the portrayal of an intelligent, sexually independent heroine, groundbreaking for its time, was viewed as controversial.

A copy of the film was sent to Goebbels, Hitler's chief of propaganda, in Germany. As soon as he saw it, he contacted Mussolini, demanding to know why the film had been made.

Once that conversation had taken place, Mussolini banned *We the Living*.

'I had no idea the film had been banned. As soon as I finished filming I went into the Resistance. I had been helping them, financially, to buy food on the black market but they asked me to lead a group and

I accepted. So, I cut ties with the industry, with everyone I knew in the industry. Alessandrini and Majano, they fought in the Resistance, too, but not in Rome.

'I learn later that Massimo, the General Manager, he had to appear before a court to explain why the film was made. They should have been asking that of Mussolini's son – he approved it! Vittorio Mussolini, he was the president of Ero films, and they help to finance *Noi Vivi*. But, Massimo, they told him he was no longer general manager. They considered him dangerous. That was a crazy decision but that's what we were living with.'

The police visited every theatre to seize the movie reels and all of those prints were burned. Any planned release in other countries was halted.

Those involved with *We the Living* knew they had something special and were loath to destroy it. So, they sent in the original negative of another film that had no significance and hoped the authorities would not check. Fortunately, they simply burned it, thinking it was *We the Living*.

'It was Franco Magli who hid the negative. He was the production manager on the film. I think he hid it in his basement.'

And there it lay until after the war.

How the film reappeared is also as remarkable as how the film was made.

'After the war, I returned to the stage and to filming and that's when I learnt that the film had been banned. To show the film now, we had to get agreement from Ayn Rand. About 1946 or '47, myself and Alida, we travelled to America with a copy of the film to screen it for Ayn Rand and to convince her to sign over the rights. Remember, she had not given permission for this film to be made and this was her life story. You know, she liked the film, she was pleased with it. And, even when we were filming it, we felt it was a good film, me, Alida and Fosco.'

However, Rand was considering a Hollywood version of the book. She was also suing the Italian film industry for unpaid royalties, and this was a process that went on for decades. She finally received her money in the 1960s. By that time, Scalera films had gone out of business. *Noi Vivi*

and *Addio Kira!*, along with the studio's stock of around ninety films, were put into an obscure storage facility and disappeared from sight.

Ayn Rand's lawyers, Henry Mark Holzer and Erika Holzer, had taken a keen interest in the movie and decided they wanted to find it. Rand had liked the film and told the Holzers that, if they could track the film down, she would like it restored and rereleased.

'The Holzers, they spent two or three years trying to trace that film. That would have been difficult then. It was the 1960s and they had to rely on letters, international telephone calls and the inevitable language problems. They were constantly networking, hoping that someone would be able to help them. Eventually, a friend of a friend of a friend made contact and they said, "Yes, we have this film."

'Henry and Erika, they came to Rome and talked to the people who had bought the Scalera catalogue and, of course, *Noi Vivi* and *Addio Kira!* were part of that catalogue. They had the original negative and they screen it for them. Not through a projector, they had to put it through a tabletop viewer, one reel at a time.'

The Holzers brokered a deal to purchase the film and had it shipped over to the United States. Plans were then put in place to restore and rerelease it.

We have reached the back of the Cinecittá studios and an area that would not have been here during Rossano's time. Here, there is a permanent set used for film and television productions – a replica of ancient Rome, complete with a building similar to the Roman Temple of Bacchus, a cobbled Roman road and various villas and merchants' stores. Further along is a replica of a Florentine village.

He grins. 'Go and tap on the walls.'

'What?'

'Tap, you know, tapping, with your knuckles – go hit the wall, hard.'

I ascend the steps to the mock-Bacchus structure. The building appears solid, as if it has lasted as long as the original. I tentatively tap on the wall and understand why he wanted me to do this. I tap harder. He chuckles. The walls are hollow and I'm sure you could easily punch a hole through if you wanted to.

'That is the magic of the cinema. It looks authentic but it is just an illusion. Everything here is illusion. You look behind here, it's all scaffolding.'

Lydia reappears. 'I have decided to go tonight.'

He lets out an exasperated sigh. 'You haven't anything to wear – are you going in your negligée?'

'Don't be crude.'

'You didn't have a thing to wear just now.'

'Don't you keep on at me.'

Lydia bids me goodbye. She is returning home with friends. She tells Rossano not to be late.

'She'll want to buy a new dress and then, you know what? She'll want new shoes and different jewellery to go with it. I could give her five million lire and she'd spend it in ten minutes.'[63]

How Lydia has heard this I don't know but we hear the echo of "cheap bastard" winging its way back to us.

He shakes his head with an incredulous expression. 'How did she hear that? You know it's me that earns the money and her that spends it.' He is trying to feign anger but not succeeding. 'Did you speak with Duncan Scott?'

'I did.'

Rossano with Duncan Scott (Courtesy of Duncan Scott Productions.)

Duncan Scott is the man who helped bring *We the Living* to a new audience in 1986, complete with English subtitles.

He is a quietly spoken, reserved American, who by a fortuitous turn of events ended up working on the first rerelease of *We the Living* during the mid-1980s.

At that time, he was living in New York. 'I was a student of Objectivism in New York city and I subscribed to *The Objectivist*. On the back of the magazine there was a calendar of events, and one mentioned this long-lost film version of *We the Living* that had been rediscovered and how they were going to re-edit the film and have it released in America. At the time, I was an assistant editor working on film. It was very early in my career, but I wanted to see if there was some role I could play in the project. I decided to write to the Holzers to offer my services.'

To Duncan's surprise, he was hired to work on the film and found himself working alongside Ayn Rand to view the entire film with the Holzers.

'Ayn Rand and I went through each scene, seeing how it could be changed and she decided to delete most of the subplot. The propaganda scenes that the government had put in, though, they stuck out like a sore thumb because they contradicted what the characters were saying.'

He gave an example. 'In the trial scene, Andrei is taken before this panel of party people. The Italian Fascist government had Andrei ranting against Capitalism. That needed to be changed. Also, taking the subplot out reduced the film's length to three hours so we thought we'd release it as one movie.'

In 1986, forty-four years after its original premiere, *We the Living* was rereleased internationally and once again declared a masterpiece by the public. The film received rave reviews. *New York Yesterday* said, '*We the Living* qualifies in every respect as film treasure… one of the best movies of the year.' The *Los Angeles Times* wrote that it was 'Hugely entertaining' and *Sneak Previews* called it 'An amazing piece of cinema.'

'And it was in 1986 that you met Rossano?'

'That's right. It was in Rome, and we chatted for a couple of hours. I found him very gregarious, very friendly, very open in his personality. He was welcoming and not at all wary. He was very pleased that we

were preparing this movie for release outside of Italy for the first time. It hadn't been seen anywhere since World War II. It was a very important film for him.'

'Did Ayn Rand comment on Rossano's portrayal of Leo?'

'We had a very special occasion where we ran the film for Ayn Rand when she was still alive. She was really pleased with all the actors. They did a great job. A lot of people in the room said how ridiculously handsome Rossano was. I ran this film a few times and so many people came up to me to say, "I didn't like Leo by the end of the movie." Well, that's the way it's supposed to be! He's come apart during the course of the movie, and they think they're supposed to like him all the way through.'

Rossano's nephew, Carlo, the author and Duncan Scott at the New York world premiere of We the Living. (Courtesy of Carrie-Ann Biondi.)

In June 2022, Duncan released the film for the second time, to commemorate its eightieth anniversary and numerous film festivals began showing it around the globe. After several festival screenings,

the world premiere of the film took place on 12 June 2023 in New York. Four days later, the European premiere took place in Belgrade, Serbia.

With the modern twenty-first-century technologies available, the film went through an amazing transformation. The clarity, contrast and condition of the movie is excellent but just as importantly, it remains atmospheric and of its time. To date, audiences have given generous applause at the end of each screening, and it continues to attract new fans.

I asked Duncan what Rossano would have thought of the eightieth-anniversary release.

'He would absolutely love it. This was a big, big film in his career. One that he thought was his best and I haven't seen all his movies but in terms of the power of his performance, I would think it's one of his best. He was dashing and wonderful in *South Pacific* and the other ones, *Summertime* and *Barefoot Contessa*. But this one made really big demands on his acting skills, and he came through.

'It was a part that allowed his talent to shine. It had a lot of range, a lot of depth. He had to transition from this heroic type of person to someone dispirited, losing all hope and giving up on everything. That's quite a big transition to make. Unlike so many other movies that he did, where he played a certain type and he played that well, here's a role that goes through quite an arc, as they call it in the industry. The transition from how he starts off in the movie to how he ends up is enormous. I don't think he was ever challenged like that in any other movie. He was proud of that film, that was really evident although, after it wrapped, he went straight into the Resistance.'

'Did he talk about his time underground?'

'He didn't go into detail, but I do know he wasn't in touch with people in the industry. The movie played its own role in the Resistance. It was received entirely differently from how the Fascist authorities expected. It sparked a spirit of resistance among the general population. It was hugely successful, the biggest grossing movie of that year and that was some achievement when you bear in mind it was banned halfway through its run.

'When I met him, he was extraordinarily generous with his time. I had no idea what to expect. I hadn't interviewed many celebrities, but he couldn't have been more welcoming. During the course of the conversation, I told him I hadn't had any success in reaching Alida Valli and he jumped up and said, "Oh, wait." He picked up the phone, dialled a number, handed me the receiver and said, "Here she is." So, I talked briefly with Alida.

'He had a certain level of bravado in him which is something you see a lot in actors. It was a positive trait, though. When he talked about things it was "this is the most" and "this is the best" and "this was the greatest" but his feelings about *We the Living* were certainly sincere.'

With the final take of *Noi Vivi* and *Addio Kira!* complete, Rossano, a fierce anti-Fascist, could no longer stand on the sidelines. His family and friends had suffered, and were suffering, under Mussolini's rule and he had witnessed many people, including those known to him, being victimised. He'd been approached before about leading a pocket of resistance in Rome. This time, he grabbed the offer and turned his back on the film industry.

Chapter Six

IN THE GRIPS OF NAZI OPPRESSION

Brazzi's role in the Resistance was significant and dangerous. He had played the dashing hero in many films, but here he would demonstrate the courage and bravery of a real one.

Before we speak to him and Lydia about it, it's important to understand Italy's position during World War II. To do so, I read through a number of books that covered the period to get an overview of how things were.

In the early 1940s, significant political changes took place. Up to this point, Italy had been fighting alongside the Germans. The country was led by Benito Mussolini; a Fascist, an authoritarian, dictator and narcissist who was happy to clamp down on anyone daring to oppose him.

In July 1943, Mussolini was removed from power and Marshal Pietro Badoglio was appointed in his place.

At the same time, on the southern tip of Italy, the British army had landed. Armies from the United States were close to landing further up the coast at Salerno.

Italy had now officially surrendered to the Allies.

In Rome and throughout Italy people waited for what they thought would be a transitional period between the German presence in the city and the Allies marching in.

However, the removal of Mussolini had enraged Hitler. Infuriated, he ordered two armies to take control of southern Italy and set up a line of defence at Cassino, approximately eighty-five miles south of Rome.

In Rome itself, on 11 September 1943, the German SS moved in to occupy the city, taking immediate control of the government. The police were put under German control, their head being Colonel Pietro Koch, a half-German, half-Italian who was fervid in his support of the SS and their methods. The Gestapo had a huge presence in the city, surveilling the population and its movements. This surveillance included raiding homes and businesses, using violence and threats without a second thought.

The newspapers, *Il Messaggero* and *Il Giornale d'Italia* along with Radio Roma were placed under Nazi control.

In a very short time, the third wing of Rome's civil prison, Regina Coeli, was full of political prisoners.[64]

Another "prison" was established on the Via Tasso. Number 155 was used as the headquarters for the SS, under the leadership of Colonel Herbert Kappler; number 145 was adapted as a prison and used solely for torture.

During this "transition", there were around 75,000 prisoners of war in Italy from various countries around the world. With Rome now under German control it was clear the anticipated liberation would not happen any time soon.

Fascists had been controlling Italy for years and numerous Resistance groups were already in operation. But, after this latest development, ordinary men and women began forming their own underground groups to fight the oppression, help escaped POWs and those being persecuted, and assist those of Jewish faith. In short, a blanket of compassion was thrown over the country by ordinary people living under extraordinary pressure.

Most Italians spoke only Italian, so communication with escapees was by a mixture of signs and expressions. (Although Rossano spoke several languages at this time, in 1943 he had not learnt English.)

Day-to-day life became impossible. The Nazis took the bulk of the nutritious food, leaving limited supplies for everyone else. People in the

city lived mainly on food not controlled by the state: vegetable soup, bread and potatoes. The nation's favourite drink, coffee, was now ersatz, made with ground acorns. People became so desperate they sought firewood and metal to sell so they could afford to buy the meagre scraps of food available.

Rossano, Italy's biggest film star at that time, was one of thousands who were more than happy to work against the Nazi regime. The government felt that entertainment was good for morale so, as an actor, he avoided the draft and, according to one report I'd read, he served a token thirty days in 1941. (I could find no evidence to substantiate that either way.)

His brother Oscar, in an interview after the war, confirmed that Rossano risked his life every day to save hundreds of POWs and people of Jewish faith.

At that time, he was still only twenty-six years old. He had married his student sweetheart, Lydia, three years previously. Here was a young couple with their whole lives ahead of them, about to risk everything, including the danger of paying the ultimate price.

Rossano meets me in a small trattoria. Lydia is with him, and we have ordered Verdicchio, their favourite white wine from the Bologna region, served with some bread and very high-quality balsamic and olive oil. Lydia is in a sleeveless summer dress and wears dazzling diamond earrings. Rossano is in trousers and an open-necked shirt, looking unusually casual but still managing to appear elegant.

'What did you think about Mussolini and his government?'

'Our family hated Fascism. My father was a socialist and I followed that view, too. I saw Mussolini speaking several times and, in a way, he intrigued me.[65]

'But, you know, this began, for my family, before the war. My parents would not allow the name of Mussolini to be said in the house. I remember that my sister, she was very intelligent at school, and they asked the class to write an essay about Mussolini. She only wrote three lines. She didn't know what to say! My father, he would speak out against him, publicly – he made no secret of his dislike. Because

of this, our family, and especially my father, was persecuted – it was relentless.'

This persecution was led by the Blackshirts, members of a paramilitary branch of government who thought nothing of intimidating or inflicting violence on anyone who spoke out against the regime.[66]

'Many of our neighbours in Florence, good, honest people, hard-working people, were taken away. I don't know what happened to them. My father, he was threatened many times. You remember, we spoke about the leather factories in Florence and, you know, because he spoke out, they burned one of those factories down.'[67]

'And remember, Rossano,' says Lydia, 'they visited your father.'

'Yes. This was before Mussolini was taken out of power. The Blackshirts visited our house once to "purge" my father. You know what that means?'

'My understanding is that they made people drink a bottle of castor oil, to give them diarrhoea.' Rossano confirms my understanding.

'That was something they did back then. My father was not intimidated by this. You know what he did? He invited them to have a glass of wine while he sat back and drank the whole bottle of castor oil they had brought.

'I remember my father was once beaten very badly. Then, they threatened me. I was making my name in Italian film, and they threatened me. They promised to destroy my face for the cinema.[68] At one point I thought the government would end the Brazzi family.'

Rossano had every motivation, therefore, to go underground and he was also in an ideal position as a wealthy film star and one of the few in the city who had money to buy food on the black market. Many of the escaped POWs initially had no ration cards or bread coupons. He provided funds so that they could at least eat.

'When I finished *Noi Vivi*, I stopped acting. The government, they wanted me to play in propaganda films. I did not want that.'

To get around this, Rossano (allegedly) faked some sort of illness but I could find nothing to substantiate that. Ultimately, however, he appears to have disappeared from the film industry.

'I was asked to lead a group of Resistance to operate around the Cinecittá film studios. That whole area had been turned into a prisoner-of-war camp. I was happy to do it and, financially, I could do a lot, although Lydia didn't realise that I was spending so much of our money.

'I was very wealthy at this point, but I was spending it all on feeding the hundreds of people hiding to escape the raids of the SS and the Fascists. One day, we were hiding out at a farm and Lydia said to me, "Rossano, even if you don't work anymore, we have so much money that we can be secure." She didn't know that I had spent everything.'[69]

Lydia, even if she was angry at the time, does not show it now.

He continues, 'And when you're young, you're brave. If we survive, we have our life ahead of us and if we're killed, well, it doesn't matter, does it? And being poor didn't matter. We were the same as everyone else at that time.'

'But Lydia supported your decision to be active in the Resistance?'

'*Certo!* Women across our country played a role, just as dangerous, you know, being a nurse and cook to these people, pretending to be a wife or sister of a prisoner. That takes courage. If you were stopped and something went wrong, you were shot. Many of these women had children and they were risking their lives, their family.'

'What did you do during this time?'

'You have to remember that my country was fighting *with* Germany. We went from being friends with them to being at war with them. That made it very difficult. We had a common enemy, but we had groups, underground, at war with each other. There were still many Fascist supporters. You could not trust anyone.'

It appeared there were numerous groups scattered around the city: anti-Fascist, anti-Communist, Party of Action, the CLN (Committee of National Liberation), to name but a few.

Hundreds of Italian soldiers had deserted. They were now avoiding the possibility of being recruited by the Germans or used as slave labour. Most still had their weapons when they dispersed into the underground factions.

'I was one of three leaders in our group, and we based ourselves around the film studio. I made many films there, so I knew the layout,

I knew the surrounding area. Every night, at dark, we got people out of the camp and we found a place in the city for them. We would cycle all over Rome with food, money, clothes. You could not forget anyone because everyone needed something, everyone was starving. Everything cost like gold, even things like flour and eggs.'[70]

Every day, every night, by car, truck and bicycle, Brazzi and his group brought food to the scattered hiding places. This was highly dangerous.

'Every day was a risk. For the prisoner, if they were caught, they went back to prison. For us, hiding them, we would face the firing squad, with no trial.'

Lydia adds, 'Yes, sometimes, we had twelve, fourteen, fifteen people in our house and we had to find ways to hide them.'

Those hiding places were not terribly imaginative and included simply hiding people in wardrobes, under the bed and in the basement.

Rossano continues. 'The Gestapo, they patrolled the street in plain clothes, you know, searching; sometimes one, two houses, sometimes a whole area. We had to be creative with how to hide people. With one or two, is not so hard but with fifteen!' He shrugs his shoulders. 'If they searched us with that many, we would not be sitting here.'

Those who shielded prisoners adapted their homes as best they could; false floors and walls; space within the eaves; a room hidden behind a wardrobe; a hiding place beneath the floorboards.

Rossano also had help from the Vatican.

'My uncle Marcello Mimmi was the Archbishop of Bari and later Cardinal of Naples at the Vatican. I was in the Guard and took part in duties protecting the Vatican City and his Holiness. I had access to the Vatican and that was helpful, you know, if we were running short of funds or places to put people. I knew which of the clergy were anti-Fascist and which of them to ask.'[71]

During the war, there were three units at the Vatican; the Swiss Guard, the Noble Guard and the Palatine Guard. The Swiss Guard have always been recruited from Switzerland. Unfortunately, I have been unable to establish which unit Rossano was in. It appears the Noble Guard had stricter entrance guidelines; however, being the nephew of a Cardinal

at the Vatican opened doors so he could have been in either. Both units were disbanded in the 1970s, leaving only the Swiss Guard.

The supply of funds came from wealthy donors around the city as well as being handed over by sympathisers at various events.

It is likely that Rossano attended one of those functions, a performance of Puccini's *Tosca*. A big fan of opera, Rossano had, you will recall, appeared in the film version in 1941. Interestingly, the parts he played in both *Tosca* (Mario Cavaradossi) and *Noi Vivi* (Leo Kovalenski), just prior to going underground, were of men fighting a dictatorship and wanted for crimes against the state. In some respects, it was a brave move to take on these roles, especially bearing in mind the persecution he and his family faced. These parts carried fierce anti-dictatorship messages and both roles showed him at his best as an actor.

He knew many of the cast in the theatre production. Indeed, one was the famous opera tenor, Benjamin Gigli, who had starred alongside Rossano in Monteverdi's opera, *Ritorno*.

It is well documented that this performance was attended in large numbers by Resistance fighters, many of whom had brought escaped POWs with them. Senior members of the Gestapo and SS took the exclusive boxes and sat alongside wealthy Italians who were contributing to the underground groups.

If Rossano was there, one can only imagine what was going through his mind on seeing such a diverse audience. One also wonders whether the Gestapo and SS knew they were sharing the auditorium with the very people they were attempting to hunt down.

Although they were officially neutral, many of the clergy at the Vatican were helping the various factions of the underground, in particular, an Irish priest, Monsignor O'Flaherty. Such was his influence within the Resistance movement, a film was made about him in 1983 called *The Scarlet and the Black*. Gregory Peck played O'Flaherty and Christopher Plummer played the SS officer, Colonel Kappler. It is a powerful film and one to watch as it does an effective job of showing what Italian Resistance fighters were going through.

Rossano, no doubt, would have come across this priest as, although

O'Flaherty was in the Vatican group of Resistance, he was well known for helping everyone fighting the regime.

At one point, Rossano's group had approximately two thousand escaped prisoners hidden across Rome, all needing food, clothes, ID cards and money.

Throughout the city, individuals were hard at work helping those in hiding. Tailors, in back rooms, made suits for literally hundreds of escapees. Men and women, employed in stores, would smuggle out rolls of cloth to keep the tailors supplied.

Government workers, in sympathy with the cause, "borrowed" official stamps and stole blank ID cards to issue so that every POW could move freely about the city. Those with the skills to do so taught basic Italian. Rossano and his group had a network of contacts like this helping them.

Working with them were doctors and dentists standing by to treat escaped prisoners, many of whom had dysentery, lice and scabies. It's a wonder they had the energy to escape.

Interestingly, members of the Resistance were mainly unaware of one another. Rossano says, 'The city was made up of small factions. At no point would any of us reveal if we were working underground; that way, if we were caught and tortured, we truly could not tell our interrogators anything because we would not know. Many of us were holding fake ID cards.

'In the countryside, in Velletri, where we later own a home, I had some farmers there baking bread for our escapees. They had an oven and had quite an industry going on. And I remember, clearly, one night, Lydia and I were at a hotel chatting and it got late. I said to Lydia that I had a bad dream, that they were bombing our house. I told her, "Let's sleep where we are," and we did.'[72]

'And,' says Lydia, 'we were saved because when we returned the next day, our house was in ruins, destroyed by bombing.'

'Was there ever a time when you thought you might give up?'

It is clear he can think of many occasions.

'Everyone lost people. I lost family, friends, neighbours. Things became very bad for us. The Germans began to clamp down on the city

and put a curfew in place. It was not unusual to see people hanging in the street, to deter those who defied the Occupation. They rounded up a lot of Jews and took them away. I would never see them again. Some prisoners of war were marched through the city, you know, paraded. That is against the convention. They should not have done that.

'If you did not have an ID card, then you were sent to a labour camp. We were drowning with escaped prisoners. They couldn't join their units because of the weather or the terrain. It was very frustrating for them, too. But the worst was Ardeatine.'

We have left the trattoria. Lydia has other things to do and Rossano has a specific place he wants to show me. He picks up the story.

'That was something that shook everyone. That was something that, for a short time, I felt it was hopeless to continue. But then, you know it made us more determined.'

We reach the corner of Via Rasella and Via Del Boccaccio.

The massacre at the Ardeatine caves was a crime of such brutality, it sent shock waves through the entire Italian community, not just amongst those fighting underground. Even those who had tolerated the German Occupation were affected by the inhumane nature of the crime.

Rossano knew people who were killed in this massacre. One in particular was screenwriter and cinematographer, Gerardo de Angelis, with who Rossano had worked at Cinecittá.

'It happened here, on this corner. On 23 March 1944, a Resistance fighter posed as a street cleaner and came here with his cart. He knew that a column of soldiers would be marching up this road to their barracks. His cart was stacked with explosives. As the soldiers came into view, he lit the fuse and walked away. The explosion, you could hear it across the city.'

Rossano points to the wall of one building nearby. It is pitted with holes.

'The soldiers that survived started firing their rifles at the windows, wanting to shoot anyone they could see. All of those holes you see, they are bullet holes.' He wears a pained expression. 'At first, we thought it was a victory for us, but it turned into something horrendous.'

Retaliation came immediately as orders arrived, direct from Adolf Hitler. He instructed that his head of security services of the SS in Rome, the notorious Herbert Kappler, to take charge of the reprisal. This entailed killing ten Italians for every single victim of the bombing. They rounded up 335 people – five more than the quota.

The majority of these were Resistance fighters taken from Regina Coeli and the notorious Via Tasso. Fifty-seven of them were Jews and some were simply snatched off the street. The youngest was fifteen years old.

On 24 March, those rounded up were taken to the Ardeatine caves just outside Rome. Kappler refused to allow the victims to speak with their priest. Dragged into the caves in small groups, each was shot in the back of the head.

Once the executions were finished (it took several hours), the Nazis set off explosives to seal the caves.

Massacres became the norm for the Nazi regime, and they routinely held the population responsible for any acts of opposition. As a result, the general population, including members of the Resistance, were on edge and more fearful regarding who they could or couldn't trust.

Had this bombing happened just a few weeks later, Rossano would likely have been one of those executed at Ardeatine alongside his friend Gerardo de Angelis. I'm sure that he reflected on this, too.

Why? Because Rossano was captured by the Gestapo just a few days prior to the liberation of Rome. He never knew, and would never know, who had given him away.

Please note: Because Rossano rarely spoke publicly about his role in the Resistance, it has been difficult to piece together what happened at this point. However, from the brief statements he did make, and through liaising with his family, I am certain of my facts where the following is concerned as his experience ties in with those I have researched via other Resistance fighters in Rome at the time, particularly those incarcerated in Regina Coeli prison just prior to the city's liberation. I am particularly grateful to Pen and Sword Publishing for allowing me to use material from William Simpson's book, *A Vatican Lifeline '44*.

Inside the Regina Coeli prison, Rome.
(Courtesy of the Historical Museum of Liberation, Rome.)

Of the two potential prisons available, Via Tasso was the one you prayed you wouldn't enter. Via Tasso was a prison few people emerged from. It was infamous for its brutal torture treatments.

The book *A Vatican Lifeline '44*, by William Simpson, describes life inside this prison. A colleague of his had the good fortune to walk out of Via Tasso and this is how he described it: 'Day and night, cries, moans and whimpers from these poor creatures being interrogated. I saw these poor fellows being dragged back to their cells, unconscious mostly, terribly beaten up.'[73]

Some of these prisoners were unrecognisable after the second or third day.

Rossano's friend, de Angelis, after being interrogated at Regina Coeli, was taken to Via Tasso and finally to Ardeatine. When his body was found it could only be identified by items found on his person, such was the brutality of the torture inflicted on him.

During my visit to Rome, I visited the Via Tasso prison, which is now the Museum of the Liberation of Rome. Much of the building has been left as it was during the Nazi Occupation. Cell windows are bricked

up and graffiti is carved into the walls, giving messages of hope and news of fellow prisoners. The names and photographs of those who died at Ardeatine are displayed here, including those of Rossano's friend, de Angelis.

I'm sure Rossano was relieved to be taken to Regina Coeli. But he also knew the Gestapo's likely reaction would be to torture him or simply execute him.

Regina Coeli lies on the bank of the River Tiber and remains a prison to this day. In the 1940s, although prisoners preferred this prison, it was still no bed of roses.

William Simpson was in this prison at the same time as Rossano. His description leaves nothing to the imagination. Resistance fighters and prisoners of war (men and women) were placed in the third wing, in which there were two hundred cells.

Each cell had a single lightbulb and, in most cases, four prisoners to a room on filthy straw mattresses. Cells were approximately fifteen-by-seven feet; a bucket served as the toilet, which was emptied twice a day. There was no soap.

'That wasn't the worst of it,' Rossano says. 'When the lights were on, we were uncomfortable but, when the lights went out, thousands of tiny bugs came through the vents and crawled all over us.'[74]

Simpson also tells us about an interrogation chamber in a room on the ground floor. This "interrogation" was carried out at night to unnerve prisoners. Not only did they have to contend with the conditions, but they also had to endure night after night of screams and wails of agony.

'If you were taken to that cell, I heard that you were tied, face down, on a metal bed and beaten. If you didn't talk after a few days, you went to Via Tasso.'[75]

Prisoners' lives in Regina Coeli involved trying to exercise and receiving four meals a day. Rossano gives a sarcastic laugh.

'You know what our four meals were? Coffee, two cups of ground acorns, one bowl of soup and a roll. The soup was just bits of vegetable stalks and rotten potatoes. If you were lucky, you might get some macaroni and a scrap of meat.'

Prisoners learnt to split their rolls to make them last through the day.

Food parcels from friends and family arrived occasionally and these were always shared amongst those in your cell. Even in prison, privacy was guarded and no one admitted why they were inside.[76]

It is pretty certain that Rossano would have had the same underlying dread as everyone else in that building. Would he be taken to the interrogation chamber? Would he be transferred to Via Tasso?

It was now 1944 and Italy was in a state of chaos and confusion; the bloody battle of Monte Cassino had been fought and won and the Allies were marching toward Rome. The German forces were on the back foot, many having already been captured.

German bombers were flying south over Rome in an attempt to head off the relentless march of the Allied forces. The Fascist-run Radio Roma claimed that the Allies were beaten and were in retreat.

Actually, the opposite was true.

Seeing defeat staring them in the face, German soldiers were leaving their posts en masse and, fortunately for Rossano, this included the German guards at the Regina Coeli prison. Instead of facing a firing squad, Brazzi found himself in the hands of Austrian and Italian guards. Here was an opportunity for him to plead for his life and he took advantage of it.

Remember, this was a man who was used to speaking in court as a lawyer and had award-winning acting skills. The Italian guards would have recognised him as a famous film star and he called on all of this experience to save his life.

He admits that, even in this precarious situation, he relied on his acting skills to convince his interrogator that he could have been helping anyone, Italian or German.

'We were at a point in this war where my country was in chaos. And we are all here Italians fighting one against the other.'[77]

Whatever he said made an impact. Whoever he spoke with was swayed by his argument; the threat of execution now a memory. Amazingly, just a few days later, he was to walk out of Regina Coeli a free man.

Even though they were in the confines of a prison cell, news filtered through to prisoners that the Allies were breaking through and were on the outskirts of Rome. The prisoners began to relax and were permitted to come out of their cells. In the distance, the sound of bombing and gunfire could be heard, and it was getting closer.

The Vatican Resistance group had already laid out plans to get its people out of Regina Coeli. This came to the attention of an Italian major who told them it would ruin the plans he had to free everyone. Rossano would have been aware of this, as a huge sense of anticipation was now permeating the entire prison wing.

Unfortunately, the Austrian in charge of the jail discovered these escape plans and ordered all of them back to their cells.

But the booming artillery was coming ever closer and discipline among the guards was almost non-existent. They were jittery and fearful for their own safety.

The Italian major confronted the Austrian commandant and, in no uncertain terms, told him it was pointless to try and block his plans. He was going to unlock every prison cell and free the prisoners. Realising his command was lost, the Austrian returned to his office. Before long, every partisan in the prison was ready to walk.

Out on the streets, dogged Germans continued to patrol, so the men and women were released in small groups so they could easily disperse into the city.

With the Germans now fleeing Rome, rumour spread that they were going to destroy the bridges crossing the Tiber. Many Resistance groups made efforts to try and stop that. Whether Rossano's group was part of that is not known but it is clear that these men and women would not stop until their city was liberated.

On 4 June 1944, the Allies arrived in Rome.

It was to be a day of celebration, for certain, but one of reflection for all of those men, women and children who had put their lives on the line. How many of them would be looking back on the horrors they had witnessed, the brutality and the killings of friends, family and neighbours and the hostility between countrymen? Atrocities carried out and witnessed during the previous months would not easily be

forgiven or forgotten. Indeed, brutal retaliation did take place against a number of men and women who were known to have supported the regime.

These short nine months of Nazi rule must have felt like a lifetime. Over those nine months, there were approximately 240,000 partisans in action.

Over 63,000 were killed in action.

Over 33,000 were wounded.

Over 20,000 were executed.

Even in 1960 Rossano appeared to sink into reflection about that period when reminded about it.

He was the subject of the popular series *This is Your Life*. For several decades *This is Your Life* was an extremely popular programme in the United States and globally. Each half-hour show featured a celebrity guest and during the programme the audience was treated to a potted version of their life story. Notable subjects were actors and actresses but prominent politicians, scientists, charity workers and military personnel also featured.

In the spring of 1960, Rossano Brazzi was the featured guest. One of the guests was Jack Fancourt, who had been captured by the Germans during the war. Jack was an escapee lodged with some friends of Rossano's in the city, where he became another mouth to feed. He was a big man with a big frame and a big smile.

This is what Jack said as he sat beside Rossano. 'While we were hiding in the house, you, Rossano, would come every few days with food, money and clothes for us and you risked your life doing this and helping other escaped prisoners of war, finding food for them and hiding places throughout all Rome. Of course, this whole time I didn't know you were a movie star; I just knew you were a very courageous person and I'll certainly always be grateful for you helping me through those months.'[78]

Rossano's response? 'I was very happy to do it, I can assure you.'

Observing Rossano's body language during this brief part of the programme is fascinating. Before Jack's introduction, Rossano had enjoyed greeting his brother, his childhood friend, Giovanni, Lydia and his mother. During these interactions, he was relaxed, laughing and

cheerful; I witnessed his genuine delight at having his family and friends alongside him. At all times, he made eye contact with everyone as each guest regaled the audience with an anecdote.

The moment the presenter began speaking about the Resistance, Rossano appeared pensive, broke eye contact and gazed at the floor, as if reliving certain memories. At one point he seemed to consciously force his shoulders to relax. His breathing was shallow and he looked lost in uneasy thoughts. Even Lydia looked concerned as she sat alongside him.

Rossano was gracious and welcoming when Jack came on but once the account began, he gazed at the floor. When Jack finished speaking, the presenter thanked him; but it took a second for Rossano to shake off his thoughts before taking Jack's hand.

Back on 24 May 1946, the Teatro Adriano, a huge theatre in Rome, was filled with Resistance fighters who had helped prisoners escape. The British High Commissioner in Rome, Sir Noel Charles, spoke to express gratitude to every single person. He highlighted the dangers they had faced of imprisonment, torture and death. The speech was broadcast across the country.

The American chargé d'affaires took to the stage and, along with other foreign dignitaries, presented certificates of merit to those ordinary men and women who had fought so bravely. Rossano, who was away filming, was among those who received this certificate, although it is rumoured that the majority of partisans were not so keen on receiving them and actually took exception to it.

They also repaid funds the people had paid out of their own pockets. Amazingly, there had been a system of receipts and bookkeeping throughout the period.

William Simpson's book is one that should be read by anyone wanting to learn about the Resistance in Italy. Simpson would have come across Rossano, as he was asked to help some escapees from the Cinecittá camp. Of course, he would have had no idea then that he was dealing with the biggest Italian film star of the day.

However, the book highlights the kinds of risks people like Rossano and Lydia took.

Rossano came close to paying the ultimate price. Twice. He initially escaped execution by being arrested just a few weeks after the Ardeatine massacre, then escaped it again by a few days, because the Allies were knocking on the door of Rome.

Later, Mitzi Gaynor, his co-star in *South Pacific* and a close friend, was to say that Rossano never took himself seriously, and that he and Lydia lived for fun, laughter and happiness. Having discovered his role in the Resistance, the persecution his family endured and his experiences during this time, I can understand why he and Lydia had to learn to have such an outlook, where nothing seemed to faze them.

Chapter Seven

LUNCH AT VIA SISTINA

I have located Via Sistina and have just climbed endless stairs to reach the apartment that Rossano and Lydia lived in during the early 1950s. The lift is in the process of being repaired.

The apartment is in an old building situated about one hundred yards from the top of the Spanish Steps. There are five floors to this building and the Brazzis live on the fifth.

Dressed in brown wool trousers and a cream shawl-neck sweater, Rossano greets me with a smile. He has a cigarette in one hand and, disconcertingly, a grey rabbit in the other. *'Ciao,'* he says.

Three white miniature poodles come racing toward me, immediately up on their hind legs, pawing me and wanting my undivided attention. They are adorable and I can't help but greet each one individually.

Rossano, pleased to see I love dogs, invites me into their small lounge, in which there is a two-seater sofa, a couple of armchairs and a dining table. I've come for lunch and the table is laid perfectly. The walls display fine art and on the various surfaces there are numerous family photographs and a number of acting awards, beside a very lifelike bronze bust of Rossano.

The couple collect antiques and several pieces are on show here along with some oil paintings. In the corner is a record player and a stack of LPs that, when I examine them, tell me this is a couple with a varied taste in music, from classical and opera through to jazz and

the crooners. The album playing at the moment is by Ella Fitzgerald, a particular favourite of the couple.[79]

The lounge is small and not something I would expect a big movie star like Rossano Brazzi to be living in, but I am to discover exactly who owns this apartment and why they are living there a little later.

The décor shows an unmistakable woman's touch. The fabrics and colour scheme radiate the invisible aura of "home".

Rossano hands me the rabbit. 'Could you hold Pedro for a moment?'

I do. Like the dogs, he is cute but, unlike the dogs, pays no attention to what is going on. Rossano calls out, 'Darling, our guest is here.' He hurriedly clears newspapers and magazines off the sofa and takes Pedro from me. 'I rescued him in Spain when I was filming. We went for a

Rossano with Pedro, the rabbit, and his dogs.
(Courtesy of Reporters Associati & Archivi/
Mondadori Portfolio/Bridgeman Images.)

picnic somewhere; I can't remember where, but I saw something go into the basket so I covered it with my jacket. When I looked, it was Pedro. He came back to Italy with us.' He chuckles. 'You know, we had a duck once. I had bought it to eat but it was too friendly, I couldn't kill it.'[80]

I scan the apartment. Off to the side of this room is a tiny kitchen where I spy Lydia by a stove. There is someone else there, too. This, apparently, is Irma, their maid. Carlo remembers her well. 'To the younger members of the family, she was Aunt Irma and very much part of the family. She managed all the houses owned by my uncle and aunt. I remember she was a very patient and classy lady.' They've had four servants in total over the years, including a chauffeur, all of them extremely loyal. Irma would be with them for decades.

To my left is an equally small bathroom, along with two bedrooms. The main room itself is light and airy and they are fortunate enough that theirs is the one apartment in the block that has a Juliet balcony. Lydia, who has scurried out of the kitchen to greet me, is quick to throw the doors open to show off the window box that hangs from the railing.

The plants provide a blaze of colour. Opposite me on this narrow street is the Intercontinental Hotel. To my right, the road leads past the Via Rasello where that awful bomb was detonated during the war, to Via Nazionale. To my left, I spot the tall obelisk that marks the top of the Spanish Steps. Just before that, on the right, is the exclusive Hotel de la Ville.

Rossano joins us by the balcony, absent-mindedly stroking Pedro. The poodles squeeze in where they can.

'We are big animal lovers but mainly we like dogs; the dogs travel with us. Lydia will join me wherever I am filming if she can, and we never leave them behind. They are with us when we go out here in Rome, to restaurants and cafés. They're our family, that's how we consider them.'

Knowing the background and the personal heartache the pair have had in terms of starting a family, I understand that.

There are only a few interviews where Rossano mentions starting a family and implies they wanted children but never got around to having them. Later in life, he and Lydia would try to adopt but, by that time, their age was against them. Dogs, therefore, have taken the place of a family.[81]

Early on in their marriage, Lydia was diagnosed with endometriosis, a condition that affects the ovaries and pelvic region. It is a painful condition and can affect a woman's ability to have children. Nowadays, of course, advances in medicine might have resulted in a different outcome for them.

Understandably, they never spoke of it publicly, but a comment made by a close friend of Rossano's to the *Saturday Evening Post* was, I felt, quite telling. 'There is only one time that I have ever seen Rossano sad, and that is when he remembers that he has no children – he dearly wanted an heir.'[82]

Rossano nudges me out of my thoughts and points to the Hotel de la Ville. 'You can see that the place here is very small. It belonged to Lydia's parents, and they stayed here during the winter months with Lydia's brother so it was very cramped. If I was meeting people to discuss films or contracts or whatever, I'd meet them over there. We will go over in a little while and have coffee. It's very exclusive – very old.' He turns to Lydia. '*Cicci*, let's have some wine. Is lunch ready?'

'Come to the kitchen.'

We follow her through to a kitchen which is just about big enough for the three of us. Irma gives us some room by taking plates to the table. Lydia, who has the reputation of being a fabulous cook, stirs the contents of two saucepans, one with tagliatelle and one with a sauce.

'This is *ragù*,' she explains, 'a dish from Bologna.'

I love this dish, a mixture of minced veal, beef and pork in a sauce made up with celery, carrot and onion.

A third saucepan comes to the boil and Rossano feeds in a portion of tagliatelle. I look on, a little confused. We have pasta boiling already. What is he doing? Lydia and Irma are already dishing up and transferring bowls to the table. Surely this won't cook in time.

Lydia tuts. 'Rossano has his own tagliatelle. Almost raw.'

I know I look a little aghast.

He looks almost offended. 'What! I like it like this.'

It boils for no more than a minute. By this time, we are ready to sit down. I cannot contain my concern. 'Who eats raw tagliatelle?'

'I do,' he responds. 'Oscar does, too.' My expression has not changed.

'Don't look at me like that.' He hands me a strand. 'Taste it, you'll like it.'

I do. I don't. He laughs.

'It is not normal,' Lydia retorts. 'Don't try to say it is.'

He grins. We go through to the lounge. When I said earlier that the table is laid perfectly, I mean it. Lydia, it transpires, collects exquisite tablecloths and napkins from her travels and, apparently, whenever she serves lunch and dinner, the table is prepared as if royalty is attending, with crystal glasses and fine crockery. Rossano pulls a chair out for me.[83]

'You know how many tablecloths we have in this apartment? Too many. We could open a shop.'

Lydia gives as good as she gets. 'You know how many suits he has in our wardrobe? I can hardly fit my dresses in. The pretty boy with the beautiful women chasing after him has a suit for every day of the month. He must be so bored here with no space and his big wife.'

A look of outrage crosses his face. 'What do you mean? I am not bored. I have what I need. Including you.'[84]

The bickering goes on for a while, but I am getting a glimpse of a very loving couple with typically Italian temperaments, enjoying brief bursts of argument over nothing, that quickly subside. Rossano is an attentive host, making sure our glasses are full, keeping the music playing, lighting Lydia's after-dinner cigarette. They are a relaxed couple, easy to get along with. The conversation flows. Their guests are normally family members and long-standing friends, away from the show business arena. It's rare, apparently, for them to sit down to eat on their own.

He tears off some bread, dips it in balsamic and oil and gives a piece to each of the dogs. 'Where are you now, with my story?'

'The war is over,' I tell him.

'Oh yes.' He tops our glasses up. 'Of course, I went back to acting and I have a little success during this time.'

'Little success,' Lydia repeats sarcastically. 'You won awards, don't you remember?'

There is a humble nod of the head. I find that when Rossano is talking about himself, he will tell me that he was successful in this show;

that another show was the best; that this was the most challenging role, etc. When others praise him, he appears a little more modest.

With the real-life heroics of his escapades in the Resistance behind him, Rossano returned to his first love, the stage. He began working in a theatre group with his good friend, the Italian actress Valentina Cortese. (She worked with him in numerous plays and films and played his sister in *The Barefoot Contessa*.)

His absence from the theatre had not dented his talent and he would go on to win the Italian equivalent of an Olivier or Tony award five years running.

One of his most celebrated performances was just after the war, in 1946. He appeared (with Valentina Cortese) in the play *Strange Interlude* by Eugene O'Neill. As in *Kean*, his role was complex and challenging. It required him to age fifty years over the course of the play.

'That play opened in Milan and I received the Italian Critics Award for that performance. You know, they considered that my best-ever performance. I remember that there was one scene where I always receive long applause from the audience.'[85]

He finishes his wine and declines a top-up, deciding instead to have a cigarette.

'I think, in my lifetime, I appeared in approximately two hundred plays, maybe more – not just in Italy but across the Continent and I received quite a few best foreign actor awards outside of Italy.'

Many of those plays were the classics, including *Faust* and *Othello*. One article I have seen claims that Dame Edith Evans invited him to appear opposite her in London; however, I have found it tricky to prove whether this actually happened. Despite his later international fame in the cinema, Rossano's first love was always the stage, and he would return to it throughout his life.[86]

We've moved to the sofa and Irma begins clearing the table. The dogs follow Lydia into the kitchen. No dog food for these poodles; Lydia makes a proper meal for them – steak with sauce and vitamins. Rossano retrieves Pedro and places him on his lap.[87]

'I am really an actor for the stage. When you gather to rehearse, you are working through the whole story. You get the feel of the story and

the characters. You project more. You have a real-life audience, and you feel the audience, the anticipation, when you are acting live. You do not get that on location.[88]

'When you are shooting a film, you can waste a whole day going over the same scene time and time again. A full day can sometimes amount to one or two minutes of film. There is a lot of waiting around. I get through a lot of books when I make a film. No, I prefer the stage, I tell you truthfully.'[89]

Interestingly, Rossano would state throughout his career that he was best suited for the stage and that he was only able to express himself well as an actor in a handful of films. Yet the movie industry was still enticing, and it paid well.

Pedro is put in a cage. 'Let's go to the de la Ville.' He calls out. '*Cicci*, are you coming with us, for coffee?'

'I will join you later. You go talk about yourself.'

I think this may kick-start a bout of bickering, but I just see an affectionate roll of the eyes.

'I'll take the children.'

Children? The poodles, I discover, are the children. He has red leads for each of them. He hands me one. 'Here, you take Bambi. I'll take these two.' Cliquot and Furia wait as he clips leads on to their collars.[90]

'Don't they need to eat?'

'That meal is for later.'

We walk just fifty yards, if that, up the road and into the foyer of the Hotel de la Ville.

'This building is eighteenth century; it used to be apartments for nobility to stay in during the Grand Tour. It only became a hotel in the 1920s.'

We enter one of several lounge areas. This first one has dark wood tables, aqua-green velvet chairs, a red sofa and patterned wallpaper. Roman busts are displayed on various shelves.

Just along from it is a slightly larger room with black-and-white tiled flooring, pale lemon walls, sofas and plush armchairs, along with a plethora of classical paintings on the wall.

Stay in this hotel today and you will be parting with serious money.

'Has it always been this nice?'

'Yes. There has also been a hotel opposite our apartment, but this one is nicer. I had to be professional with these things – if I was meeting a director or producer or someone like that, we would come here.'

He catches the waiter's eye and orders coffee. We sit in plush armchairs and the dogs turn in circles before settling down beside us. Coffee is delivered in a heavy silver pot. He pours and I remind him where we are with his story.

With the war over, Italy, along with its neighbouring countries began to rebuild but it would take several years for things to get back to normal.

'Cinecittá could not start filming straight away. They had bomb damage but the German soldiers, also, they had taken many props and had deliberately destroyed things. Not only that, but they also used the studio, for a couple of years, as a refugee camp.

'But it eventually got back to normal and they began filming again. They contracted me to play a number of roles. They were the swashbuckling roles again but, you know, if I wanted to, I could perform more seriously on the stage.

'And the movie business paid a better salary. Remember, I had spent most of my funds helping the Resistance. With my first films, with Scalera, I was not earning that much but, after *Tosca* and *Noi Vivi*, my salary went up. So, after the war, I could command the salary I wanted. And I began to get letters, you know, from women, some of them wanting to marry me.'

Again, because of his looks, the studio persisted in casting him as the hero; the romantic idol of the screen and, looking back, I would think he was frustrated that he couldn't secure more dramatic roles like the characters of Leo Kovelensky, Kean and Mario Cavaradossi.

'I would have liked more roles like that. I remember saying to Lydia that perhaps I go back to the stage. Perhaps film work is not for me if this all I am going to do. But then, I was young, I was having fun and being paid to have fun. I used to have dreams, you know, prophetic dreams – I will tell you about that side of my life later but, here, I had a dream, that I would be going to America. I don't know why, because I could not speak English.[91]

'Still, you know, that opportunity was given to me – from Hollywood –and I couldn't turn it down.'

He was approached by one of Hollywood's biggest movie moguls, David O. Selznick, who invited him to California. Rossano had been brought to his attention and he thought the actor was photogenic and could be a good leading man in America.[92]

'He offered me a contract for seven years, to play in Hollywood, and I took it. I couldn't speak English, so I had to study this language on the journey over. I hate flying so Lydia and me, we sailed out from Naples. I remember that like it was yesterday. We sailed on the ocean liner, the *Vulcania*, in the spring. It took a couple of weeks to get to New York and I studied all the time, the language.

'And then, we got to New York and I was so overcome with it and, I tell you, not in a good way. It was so busy, so built up, everyone rushing around so fast, I hated it. I got tired just watching people and I was already homesick. I said to Lydia, "That ship goes back in a couple of days, why don't we get on it and go home." She convinced me to stay, to give it a try. I would have gone home if it wasn't for her.[93]

'She said, "Rossano, you've had this opportunity, this dream, at least see if it comes to something." I was not so keen, but I do it, more for her than for me. I think Lydia was more concerned about my success than I was.[94]

'Selznick, he did not have a role for me at that time, but the studio provided a house in Beverly Hills, North Rodeo Drive, and I spent all my time learning English. I waited several months and Selznick still had nothing for me and I honestly wanted to go home. I was very homesick. Lydia was too but she was spending her time learning how to cook. My wife is the best cook in Italy, I tell you truthfully. Her fettucine and tortellini are the best.'[95]

He sits forward and makes a fuss of the dogs. They immediately jump up, vying for attention. Lydia has joined us.

'Darling,' he says. 'Do you want coffee?'

Yes, she does. He orders it.

'You know, there are two things that came out of that period. I had learnt the basics of English, to get by, and Lydia was turning into

a fantastic cook. We were known in Hollywood for our spaghetti parties.'[96]

'Spaghetti parties?'

'Yes,' Lydia says with enthusiasm. 'We made friends with people in Hollywood, many of them Italian, and our house was the house to come to for good, home-cooked Italian food. Greta Garbo, she celebrated her birthday the same day as Rossano, she visited a lot and Vincente Minnelli, he was over all the time. Also, Frank Sinatra – his family are from Sicily.'

Rossano's agents, Gene Lerner and Hank Kaufman, touched on the Brazzis' hospitality in their book, *Hollywood sul Tevere*. They praised Lydia's culinary skills in the kitchen and Rossano's impeccable selection of wines. Their individual qualities always combined to make an evening with them a special one. There would be fun, entertaining conversation, laughter; you would be made to feel part of their circle from the moment you arrived.[97]

Rossano's nephew, Carlo, recalls the same, commenting that the welcome friends and relatives received when visiting came from the bottom of their hearts.

Along with the fun came expense. The pair of them, I would discover, were famous for living beyond their means. Lydia was used to the good things in life – remember she came from a wealthy noble family – but the Brazzis lived day to day, and they always spent a little more than they should have done. The Hollywood lifestyle did not help matters.

'Hollywood, it was so different to Rome, very materialistic – everyone had yachts and big cars, swimming pools. We could only dream of things like this in Italy. We were only a few years from the war, and we were still suffering from that. I was earning a good salary and we tried to keep up with that standard of living. But, do you know, if you go to one of the famous restaurants in Hollywood, the cost of the meal is outrageous. I wasn't so keen on the food in America. I prefer Lydia's cooking, although I did like the hot dogs.[98]

'And I wasn't so happy with the tax rules. In Italy, you give the tax man a stack of lire, he is happy. In America, they scrutinise everything – you can't hide a cent from them.'[99]

Rossano was getting frustrated with the lack of work; it took a year for something to happen for him.

'Selznick eventually loaned me out to MGM to play a part with them.'

'And that part was in the film *Little Women*?'

Rossano with June Allyson in Little Women. (Courtesy of The Everett Collection Inc.)

'Yes. I was still young at the time, about thirty-two or thirty-three and I played Professor Bhaer in *Little Women* and I still don't know what I said in this picture because my English was very poor.[100] I got the script from them and someone to coach me but I was learning the words automatically, you know, not naturally, so I had no idea what was going on.

'And I was amazed the day I went to the studio, to the make-up people – I thought they had made a mistake and I reminded them who I was and they said, "That's right, we know who you are and this is the costume," and they tried all sorts of things with me; an artificial tummy, moustaches, a beard, glasses and everything. I thought it was a romantic part and I looked like an old man. And, you know, I was appalled that

I had to clock in at the studio like a factory worker. We didn't have anything like this here in Italy. The discipline in Hollywood was very strict.'[101]

'It wasn't a good part for him,' added Lydia.

Did he really think it was that bad? I saw the film and, given he hardly knew any English, I thought he did a good job, and the acting was on a par with that of his co-stars and it did turn out to be a romantic part. Although the costume people had originally transformed him, in the film, the glasses are barely worn, the moustache is discarded and, if there was an artificial tummy, it was not that prominent.

'No, it was terrible and I think the critics, they were not so complimentary about my performance. My accent was very strong and the timing, sometimes, of my delivery was not right. No, it was a disaster for me.

'What is important about acting is that you understand what people are saying to you and you are not just reacting to their words, you are reacting to the nuances, you know, the way something is said, the meaning behind what is said. My English was not good enough to do this. I didn't always understand what was being said to me and, when you don't know the language that well, it's a problem because everyone seemed to be talking so fast.[102]

'But the cast were nice. It was my birthday when we were filming, and they celebrated with me. They got me a cake. I enjoyed working with them; I just wish that my English was more fluent at that time.

'June Allyson was my love interest in this film and, of course, we worked together later in *Interlude*. And Elizabeth Taylor played one of the sisters in *Little Women*. I think she was only sixteen or seventeen and already quite stunning to look at. She made excuses to come to my dressing room, for advice, for rehearsal and always in a revealing top. I had to force myself to be a gentleman at that particular time. But her mother! *Mamma mia.* She escorted her everywhere; she didn't have a moment to herself. Her mother was…' he waves a hand in the air, 'what is the word in English?'

'Controlling?'

'That's it. That's exactly what she was.'

I had seen this documented in many articles about Taylor during her early roles.

'You know what I remember most about Elizabeth? She ate a lot of chocolate. She remained a good friend. We saw each other often.'

Janet Leigh, who played Meg in the film, remembered Rossano being quite shy on set because his English wasn't very good. He was, apparently, very popular with the crew because of his charm and grace. She would get to know him much better when his language skills improved. They would later star together in the 1969 movie, *Honeymoon with a Stranger.*[103]

'When we finished that film, I said to Lydia, "I want to go back to Italy. I don't feel this is right for me." We were missing home and our friends and family.

'I had quite an argument with Selznick. He was giving me no roles and told me my accent was too strong. I told him to release me from my contract. He made some derogatory comments about Italians, and I remember I punched him so hard he went through the window. The police came and I spent a night in jail because of that. He will tell you something different, that we had no argument, but we did. I tell you truthfully, I wanted nothing to do with America. Lydia and I, we went back to Italy.'[104][105][106]

Unfortunately, I was unable to substantiate Rossano's version of events; however, Selznick did deny any argument or fight, but he did release Rossano from his contract.

(Also, that year, Rossano was taken to the police station for punching a police officer. He had popped out very early one morning to buy a newspaper and was stopped for speeding. The policeman, allegedly, grabbed Rossano's collar while he was still in the car and became threatening. Rossano got out of the car and punched him! The officer in question was later found to have been drinking and suspended.)[107]

Rossano described his first visit to Hollywood as the worst year of his professional life. He and Lydia had enjoyed the social side of the trip but, work wise, it was not a success for him and one wonders if these fights he had with Selznick and the police officer were borne out of

frustration and homesickness, although the family believe his reactions match the circumstances.

As we heard earlier, Rossano and Lydia had tried to keep up with the lifestyle in Hollywood and, although he had been earning a good salary, they returned with very little money. Lydia was keen on expensive jewellery, and she had spent a considerable sum on various gems while in California. Their expensive lifestyle would, in a very short time, become a problem. Arriving in Italy, the public were critical of him. He had, prior to leaving for America, bragged about his contract with Selznick and returning to Italy without success did not endear him to his public.

In Italy, journalists reported that he had lost weight although Rossano was not a man who had extra pounds on him – he played sports constantly and kept himself in shape.[108]

Lydia is quick to jump in at this point. 'I have never seen so many thin people as in Beverly Hills. All of the big stars, the women, they are tiny. Hardly any waist. Always on a diet.'[109]

Lydia is a big woman, unashamed of her size, so she doesn't understand why being thin was such a necessity. Rossano nods his agreement, and I am reminded of an answer he gave when a reporter commented on Lydia's size. 'My love for her,' he told the reporter brusquely, 'does not depend on the size of her hips.' He turns to Lydia. 'You remember what you said to a reporter once, at a party?'[110]

She laughs. 'Oh yes. The reporter, he remarked that I was plump, and he nodded to an actress and said, "She's very thin." And then he nodded to another and told me she was thin, too. Before he could say anything, I told him, "Yes, they're thin but who has Rossano?"'[111]

Rossano absent-mindedly strokes one dog's ears. 'For Hollywood, you have to look good. The film actors, they are all on rigid diets. If you don't look good, you don't get the part. Hollywood is all about looks. Well, it was in those days. Not so much now.'[112]

'Did you have work to come back to in Italy?'

'I didn't care if there was no work. I was just happy to be home. The first thing we did was to go to Florence. My mother was there and Lydia's family, too, so we took a holiday and spent time with them. But, yes, I had a film to do, with Anna Magnani. She was huge star in Italy

and becoming known internationally. She was not beautiful, you know, but she had a wonderfully expressive face so she could play all sorts of roles.'[113]

'Had you made your mind up never to return to America?'

'During the journey back, I had calmed down from my fight with Selznick, but I was not going to return unless it was something I wanted to do. I didn't want to be bullied. The star system in Hollywood, you know, the studio bosses control you, they own you. It was difficult for foreign actors to break into Hollywood.

'Only a few, in my day, had managed this; Louis Jourdan, Charles Boyer and, of course, Rudolph Valentino. Isa Miranda, who starred with me in *Summertime*, she stayed more in Europe than in Hollywood. So did Alida Valli.

'But, you know, Hollywood was beginning to take notice of Europe at that time. Some of the big directors were thinking of coming over here to film because it was cheaper so I thought it would be good to stay in Rome and see what happened.

'After we spent time with our families, I went to the island of Salina to film *Vulcano* with Anna. There was going to be another, *Quo Vadis*, but that didn't happen for me.'

Lydia adds that they had been due to return to America. 'Remember, Rossano, you were contracted to play opposite Paulette Goddard.'[114]

Rossano shrugged. 'That went to someone else. I was not in favour with Hollywood. If I was going to make something of myself there, I had to improve my English and my accent. Hollywood likes the idea of the Italian actor, the French actor, the Spanish actor – but, you know, they wanted an American version of that. I could not fulfil that role – not at that time. I was offered several parts in America, but I declined them all. I don't like being away from home and long and constant trips to Hollywood was something I thought I would hate.'

Remaining in Italy, he made the journey to Salina, to begin shooting *Vulcano*.

Chapter Eight

ERUPTION OFF-SET

Some critics described *Vulcano* as bordering on neorealism but it received mixed reviews. It was reported that had Rossellini not been directing *Stromboli* on the neighbouring island at the same time, *Vulcano* may have been more successful.

I viewed the film; it's atmospheric and I enjoyed it. Anna Magnani is fantastic, Gabrielle Brook, who plays her sister, is excellent and Rossano plays his role naturally and without effort. There is a fantastic scene where the villagers go to sea to catch tuna; some of it is stock footage, but the film-makers have incorporated that into the movie well.

Anna Magnani plays Maddalena, a prostitute from Vulcano, plying her trade on the streets of Naples. After a brush with the law, the police order her to return to Vulcano where she moves in with Maria, her younger sister, and kid brother, Nino. The islanders ostracise her and refuse to work alongside her.

Rossano plays a visiting deep-sea diver, Donato, who has come to recover shells from the seabed but also to search for treasure from a wreck off the coast. However, the bulk of his living is made as a white slave trader. When he arrives on Vulcano, he spots Maria and knows that he will get a good price for her in North Africa. He courts her and she falls in love with him. Both Maddalena and Maria work for Donato on his boat, pumping air to him while he is diving.

Maddalena is suspicious of him. As the story progresses, Maria accepts Donato's proposal of marriage. She boasts to Maddalena that Donato has promised to take her travelling with one of those places to be visited being Morocco. This confirms Maddalena's suspicions. To persuade her sister to call off the marriage, Maddalena sleeps with Donato, but this does not dissuade Maria from wanting to be with him.

Her attempts having failed, Maddalena kills Donato while he is diving by cutting off his air supply.

There are no winners in the story, however. The island is volcanic, and its volcano begins to erupt as the film ends.

We exit the Hotel de la Ville. Lydia has a couple of things to do but asks where we'll be.

'Caffè Greco,' he responds as she dashes off.

I head in the other direction with Rossano and the dogs.

'Here – here is a good view of the city.'

Just a few yards from the hotel, we arrive at the obelisk. Beneath us are the sweeping white Spanish Steps. At the foot of the steps, the Fontana della Barcaccia (Fountain of the Ugly Boat) and, beyond this, Rome. We lean on the balustrade to survey the various domes, spires and statues that rise on Rome's famous skyline.

'It was nice to get back to Italy to film. I had a good role, as a bad man who had no respect for anyone – only interested in his own personal gain. I liked that. I tell you, though, the drama here, it was more off-screen than on it.

'Anna had been having an affair with the film director, Roberto Rossellini, and he was the one filming *Stromboli* on the next island from us with Ingrid Bergman. He was a big director here in Italy and it was well-known that these two, him and Anna, were together. But it was also known that Roberto had eyes for Ingrid Bergman.

'Anna was angry because he had cast Ingrid in a series of films he was making. She thought she was going to get these parts and, like me, has the Italian temperament. She went crazy with him.

'Roberto, he was filming literally twenty kilometres from where we were. With Ingrid. The newspapers, they had got hold of this story. They

were trading one actress against the other, you know, asking the question about him and Anna – would they stay together, that sort of thing.

'I had played a part in that romance, not intentionally, but I could see there was something between them. The three of us had coffee one time and Roberto didn't speak Swedish and Ingrid's Italian wasn't so good but she spoke English so I was translating, and I could see a spark there. I knew this would be a romance before it started – even with the language problems.[115]

'Because of this, filming with Anna was troublesome. She had a temper, you know? She would stand on the shoreline shouting insults to Ingrid and we came to blows during one scene because of it. You know she almost killed me? I played a diver, in one of those old diving suits with the iron helmets; very heavy, very bulky. I had a professional diver with me, guiding me for the underwater scenes which was just as well when I tell you what happened.[116]

'On this day, Anna was furious. Roberto told her that he was finished with her, that he was now with Ingrid. Naturally, she went crazy and was arguing with our director, with everyone. The diver told Anna that she had to operate a piece of equipment to keep the air coming to me. We got into the sea and began filming the underwater shots. Anna was so distracted with her love life, arguing with everyone, that she forgot about the equipment. I could have died down there!

'When I got back to the boat, I grabbed hold of her and forced her head under the water – for a long time. We fell out straight away. Then, later that night she came to me and said that now we'd introduced ourselves, we could get on with things.' He laughs. 'We became good friends after that.'[117]

He would continue to film in Italy and the Continent, making fifteen films in total over the next four years.

'There are a lot of films that I do and only a handful that I really like and one of those during that period was about the composer, Enrico Toselli, and his affair with the Crown Princess Luisa of Saxony (*Romanzo d'Amore*). Her husband commits her to an asylum but she manages to free herself and Enrico instigates an affair with Luisa, in Florence. He eventually marries her, but it does not go so well for them and they are

destined to die alone. I enjoyed that movie and I studied Toselli to get an idea of what sort of man he was.'[118]

But things were about to take a turn for the worse and Rossano would, for the first time ever, come up against failure – an experience he had never had before in his entire life.

Chapter Nine

COFFEE AT CAFFÈ GRECO

'There is a very old café here, just off the piazza, which is one of the oldest in Rome.'

With the dogs happily trotting beside us, we descend the Spanish Steps, pass the Fontana della Barcaccia and proceed a short way down the cobbled Via Dei Condotti to the Antico Caffè Greco. Inside, the café shows off its history. Old sepia photos of famous customers and ancient documents relating to the café cover the walls. There are nooks and crannies, the furniture is dark and the café itself is long and narrow.

We sit at a circular table. Rossano orders us both a white grappa, a fairly strong grape-based brandy but not unpleasant. Sitting down, he lifts one of the poodles onto his lap. The other two look a little put out by this so I lean forward and make a fuss of them.

As a new decade, the fifties, began, Rossano continued filming in Italy, France, Spain and Germany, and (he would frequently say with pride) with no dubbing as he was fluent in all of these languages.

But, again, he was being cast in heroic films and, no matter how much the studios wanted to churn these out, audiences were tiring of them.

Neorealism had taken a grip on the film industry; films were tales of despair, of people facing adversity in a tortured world. Many of them starred non-professionals, the ordinary man on the street. Rossano's roles were out of favour and were not hits at the box office. Despite his

obvious acting ability, directors still pigeonholed him as a handsome and heroic protagonist. His popularity began to decline.

Lydia joins us. Another grappa is delivered. He lights cigarettes for them both.

'This was bad for me; honestly, very bad. I had only ever known success in my life. I had success in sport, in education, my stage career and I become the highest paid actor in Italy. Now, I am out of favour with my audience. I had been at the top my whole life and suddenly I was at the bottom, the very bottom. It got to a point where the only fan I had was Lydia.'[119]

'And what did you do to get over that?'

Lydia shifts, gives me a knowing look and offers to speak. Rossano holds up a finger to quieten her. 'I started to produce films and I invested all of our funds. That, in itself, became a problem.'[120]

'And you borrowed money, too,' adds Lydia.

Another gesture to quieten her. 'Yes, I borrowed, too. And the films I invested in were not successful.'

'How much debt were you in?' He gazes at the ceiling, then at Lydia and then at me.

'I lost in a very short time, in American money, I would say about $500,000.' He gives a careless shrug. 'We were broke; we started all over again.'

Lydia chuckles. 'I don't want to talk about it.'

He laughs. 'She's still upset.'[121]

The pair of them are joking about this and, as is normal for them, they don't dwell on the situation as it really was. For me to get to the bottom of this, I have to dig deeper, but not with the Brazzis.

It was the men who would become Rossano's agents who enlightened me. Hank Kaufman and Gene Lerner in their book, *Hollywood sul Tevere*, divulged the complete truth; that things were far worse than Rossano and Lydia were willing to say.

It was early 1953 when Rossano's career hit rock bottom.

Rossano and Lydia had moved to the Via Sistina apartment, owned by Lydia's parents, because they couldn't afford anywhere to live. The apartment was relatively small and Lydia's brother, Roberto, would often stay there so, if all five were in residence, there was very little room.

Conducting professional business meetings there was impossible and that's why Rossano met producers, directors and so on across the road at the Hotel de la Ville. He was embarrassed by the situation and simply didn't want anyone to know the dire position he was in. Only those exceptionally close to the couple knew how bad things were.[122]

The couple later nicknamed it the House of Resistance due to having to seek shelter there during those years.[123]

All of the jewellery that Lydia had accumulated was delivered to the pawn shop which, for her, was devastating. Rossano was a proud man and, although he would never admit it, his pride and self-respect were severely dented. His confidence disappeared and he sunk into depression.

In some respects, he only had himself to blame.

Aside from living beyond their means, Rossano never kept an agent for long and was relying more and more on Lydia to read through his contracts. Gene and Hank likened him to a slippery eel and, within the small circle of Italian agents, it was felt he could not be trusted.

Hank and Gene made their own observations, detailed in their book, *Hollywood sul Tevere*. According to them, Rossano had more or less burned his bridges where agents in Rome were concerned. Most of those who had represented him had stories to tell about being paid their percentage late if, indeed, they were paid at all. He relied so heavily on Lydia to oversee his contracts but was blind to the fact that she was no businesswoman.[124]

'I took roles just to earn some money and they were not good roles so my popularity went down some more. Then, when my popularity went down, my salary went down. I was almost working for free.'

'Then he started taking out l—' Lydia shoots a look at Rossano. 'Stop kicking me.'

Rossano shoots a look back at her.

'He always kicks me when he wants me to stop talking.'[125]

'That will never happen – you never stop talking.'

They grin at each other. Lydia finishes what she was going to say. 'He started taking out loans to pay off other loans. I didn't know anything about this – this investing in films.'

'You know why? Because if I told you I was investing, you would not have let me do it.'[126]

'That's right. And we would not have been in the mess you got us in.'

A slight raise of an eyebrow acknowledges this. He draws on his cigarette.

Hank and Gene confirmed in *Hollywood sul Tevere* that this was a period of immense worry for the couple. In debt, and with several loan sharks on their back, they robbed Peter to pay Paul, gave promises they had no hope of fulfilling and did everything they could to keep their heads above water. Had it gone on for much longer, they might well have ended up in court. One man who had loaned Rossano money and was always being given excuses and false promises when he wanted repayment questioned the actor's ability to understand the concept of honesty.[127]

This was a horrendous experience. Rossano loathed the stigma of debt he had dragged them into. He felt a failure, had lost hope for the future and he lived with that anguish every day.

'If Rossano was a woman,' Lydia says, 'he would always be pregnant. He doesn't know how to say no and he is too trusting of people who have less business sense than he has.'[128]

An Italian puff of the cheeks. 'I was doing what I thought was best.'

Lydia concedes that he was. 'I was angry when I discovered what he had done but I could not be angry for long. I know he was doing it for us, for his career. But, Rossano, you are too trusting and, with you, it is never the truth.'

Rossano's smile is wry. It is clear he was not a businessman, but neither was Lydia a businesswoman. However, for a little while, she continued to oversee his contracts because agents were so wary about whether they'd be paid.

He would never go into detail about the state of his affairs because of his pride but one thing remained certain, and Hank and Gene confirmed this several times. The Brazzis were eternal optimists.

'I am a believer in fate. Something always comes up for me and it did this time. I was at the lowest point of my career and, suddenly, Jean calls me. Jean Negulesco. He calls me from out of nowhere.'

The phone call took him by surprise, and it came from the very place that he'd turned his back on in 1948 – Hollywood.

A STROLL THROUGH THE BORGHESE GARDENS

Rossano and his brother, Oscar.
(Courtesy of Carlo Fiorentini.)

Before we venture into the glamorous world of Hollywood in the 1950s, I wanted to explain a little about the Hays censorship rules (sometimes known as the Breen Office) that Hollywood was bound by during that time; rules that irritated Rossano considerably.

I'm in the beautiful gardens of the Villa Borghese. This is a huge park, extremely popular with the residents of Rome, especially on sunny weekends. Around the old Borghese family home, there are museums, statues, open-air cafés and gelato stands dotted along the wide avenues that weave their way through landscaped lawns, cypress trees and shrubs.

Rossano is with his brother, Oscar. They're messing around playing football while waiting for me. I watch for a couple of minutes. It's good

to see this side of him – the human being, not the film star. He would be recognised often in Rome and was always courteous and mindful of his image. Those who did approach him were treated to the charming and sophisticated film star, happy to oblige them with an autograph.

His nephew, Carlo, recalls a time in Buenos Aires, where his uncle was filming on location. One evening there was a party for the cast and crew, and they descended on a nightclub. Wine flowed and music played. Across the room, Carlo spotted his ex-neighbours who now lived a considerable distance away. When he spoke with them, they said they'd heard that Rossano Brazzi would be there, and they just wanted to see him. Carlo offered to introduce them to his uncle, and they said, 'No, please don't disturb him.' They were happy being there, watching.

Rossano was having a grand time at his table but, when Carlo told him about his neighbours, he made the excuse that his table was too noisy and went to join the couple. He spent some time chatting with them and later, when called away, he had wine sent to their table and paid for their meal. Carlo, throughout his time with his uncle, never saw him being anything but courteous to his fans, even when he would have preferred no interruptions.

Now Rossano sees me, and I find myself on the receiving end of that courtesy. 'I'm so sorry, I didn't realise you were here. Are you early?' He checks his watch. 'Oh! I am late.' He apologises again. He reaches into a pocket, brings out a handkerchief and dusts his shoes off. 'You know Lydia gets frustrated with me about two things. I'm untidy and I'm always late.' He winks. 'According to her, anyway.'[129]

'Is it an inconvenient time? I can always come back later.'

'No, don't go away. Let's talk.'

'What's on the menu today?' Oscar asks.

'Censorship.'

Oscar gives me a "good luck with that" look. He slaps his brother on the back. 'Rossano, he will tell you what he thinks of that. I will leave you to it.'

We find a shady place by a row of statues. The sun is shining, creating dappled shade under the trees. Children are having fun at a small play area ahead of us.

'We lived just along from here, from around 1955 I think it was. We had a penthouse apartment that overlooked these gardens. It was very lovely. Very beautiful.' He turns to me. 'I'm sorry, you wanted to speak about censorship. I have to tell you, that used to send me crazy.'

I can't say I blame him. I imagine a large proportion of Hollywood films suffered as a result of the insane guidelines imposed on directors. I can certainly see how some of Rossano's films could have been much better without them.

Rossano, being European, struggled to comprehend the system, as did many European directors.

'I thought it was crazy. Really. Most of the films we made on the Continent were not shown in America and, if they were, some scenes had to be cut or they were banned altogether.'

This is true. Many Continental films were branded immoral, blasphemous, outrageous and shocking. Umbrage was taken against words of a sexual nature and, all in all, directors had to be very careful about how things were filmed, what people wore, how they behaved and what was being said, along with the message behind what was being said.

In Thomas Wiseman's book, *The Seven Deadly Sins of Hollywood*, he informs readers that three versions of the film *Folies Bergère* were made: the original, one to satisfy the Vatican and one to satisfy the Hollywood Hays code. Most of the changes, apparently, related to what was being worn.[130]

Unfortunately, Rossano's reintroduction to Hollywood would fall foul of this censorship, which will become clear as we explore his Hollywood career.

Once his fame took off, he was seen as a replacement for Rudolph Valentino and Charles Boyer. Although Louis Jourdan was seen as handsome and sexy, Rossano had something more that fans could not put into words, although one woman did explain that when watching Rossano in *Summertime* she felt that sex seeped out of every pore of his body.

During the 1950s, the censorship affected him more because of the roles he would be cast in as a "Latin lover". The serious arts of wooing

and making love are, in some respects, comical when watching films of this era now. There were strict regulations concerning sex, language and what you wore – and, more importantly, what you didn't wear.

'The problem with this censorship was that, in America, the marriage is sacred, nothing can interfere with it. If there is any hint of an affair, it has to be so subtle that you could almost miss it. I think, in the rules, it says something about it having to be presented attractively. I don't know what that means exactly. Because, of course, for the American, you could not have sex outside of marriage, or before marriage. They say that any scenes of passion must not stimulate. That's crazy. How can you make love without passion? How can you kiss someone and not be stimulating?'

It seems that any overzealous behaviour in respect of kissing, hugging or adopting suggestive body language was unacceptable. Any sort of perversion, sex-slave trade, interracial relationships was an absolute no.

Rossano chuckles. 'You know, *Vulcano* would not have been allowed in America – that whole film was about me trying to get the sister, Maria, to Morocco to sell her. He tries to have sex with Maria and then has sex with the other sister. Hays would have been, how do you say in English…' he waves his hand around, 'apoplectic. That's the word.'

In Hollywood, everything had to be in good taste, with no vulgarity, obscenity or profanity. Clean-cut, morally correct America was the order of the day.

Nakedness was strictly off-limits and there were to be no scenes of undressing. Heaven forbid if you were to dance in a suggestive manner. Again, Rossano is bemused by the whole thing.

'When we were making *We the Living*, there is a scene there where Leo and Kira board a boat to try to escape Russia, to freedom. They kiss and, in the morning, you see them in bed together – a single bed. Leo has his shirt open to the waist. It's clear what has happened: they have had sex. That was 1942 and we were permitted to do this. In the 1950s in Hollywood, that scene would have been cut. I think the people who made up those rules must think the public are stupid. I will give you an example of this.'

He goes on to tell me an interesting story that I discovered on the DVD extra about the making of the film, *South Pacific*.

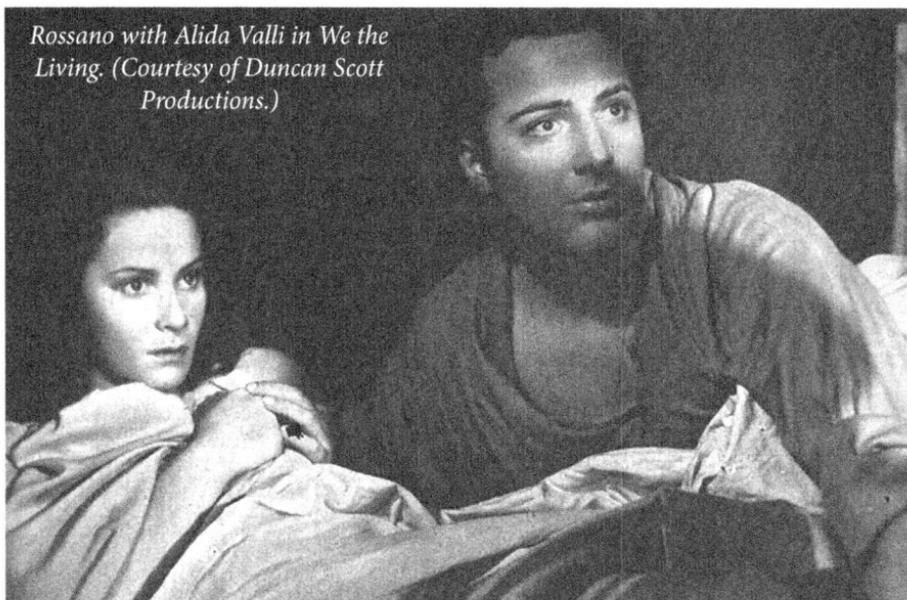

Rossano with Alida Valli in We the Living. (Courtesy of Duncan Scott Productions.)

'When we were filming *South Pacific*, there is a scene where Lieutenant Cable sails to the island of Bali to meet Liat, the daughter of Bloody Mary. It is obvious during that first meeting that the two will have sex. Bloody Mary is trying to marry her daughter to the American GI, for a better life. When they originally filmed that scene, Cable has his shirt on during the trip across to the island. Then, a few hours later, he is shown with his shirt off. That is supposed to tell us that he's had sex with this girl.'[131]

He fixes me with a look of astonishment.

'You know, the Hays committee, they said that was unacceptable. Just taking his shirt off! You don't even see them in bed together! To get around this, the director told John Kerr, who played Cable, to keep his shirt off for the whole scene. So, when we see Cable sailing across to the island, he has his shirt off and tucked through the belt and it stays like this.'[132]

Rossano wears a bemused grin. 'I don't know what they were so frightened of in America. You know, if the man and woman were married, and there was a bedroom scene, they would show two single beds with a cabinet or something between them. I don't know any married couples that sleep in single beds, do you? It's crazy. What sort of marriage is that? I didn't understand it. I still don't understand it.

'And affairs happen all the time in America – all the time. Lydia and I saw it in Hollywood – we didn't know who was with who the first time we arrived!'

He sits up and faces me, his brow knitted.

'Do you know that everyone over there had a psychiatrist? Always calling them for help.'

'Presumably, you didn't do that.'

He gives me a look of disbelief.

'I had Lydia, Oscar, Franca, my mother. What do I need a psychiatrist for?' He gives an Italian shrug and shakes his head.

Even though most of his English-speaking films were financed by Hollywood, those directed by Europeans such as Jean Negulesco, Roberto Rossellini and David Lean, and filmed in Europe, appeared to stretch the rules a little more. Having viewed a number of his early Italian films, I am of the opinion that they were happy to be less restrictive where passion was concerned, and the films were all the better for it.

Rossano will refer to the censorship later as we look at his Hollywood career. For now, you will remember that he has received a call from Jean Negulesco, who will be responsible for launching that career.

Chapter Eleven

MAKING A WISH AT THE TREVI FOUNTAIN

I can hear the cascading water before I arrive at one of Rome's most iconic monuments. We are only about half a mile from Rossano's apartment on the Via Sistina and, here I am, staring at the beautiful Trevi Fountain. I am fortunate to have arrived just a few months after the monument has been cleaned and, really, the beauty of this fountain could reduce you to tears. It is wonderful to stand so close to the mythological figures, the falling waters, the chariots, sea horses and quirky carvings.

We have the "children" with us, and they are up on their hind legs wanting to leap into the water, their tails wagging excitedly. Rossano squats down and chats to them in Italian, then he pushes himself back up and hands me a coin.

'The rule is that you should turn your back on the fountain and throw a coin over your shoulder into the water. If you do that, you will return to Rome.'

I dutifully go through this ritual along with many others but already I know I will return.

'I consider this fountain lucky for me because, in a way, it relaunched my career. Lydia and I, we often walk around this city at night and, back then, there were not so many cars, not so many people and, very often, we had this fountain to ourselves. We should do that one evening. You can't leave this city without seeing it at night.'

He leads me a short distance to the piazza at the bottom of the Spanish Steps where we find an open-air café. It's humid so we each order a cool beer. The dogs settle down under the table.

Five years after his self-proclaimed disastrous Hollywood debut in *Little Women*, the famous Romanian director, Jean Negulesco, handed him an opportunity. The two had met in Hollywood back in 1948 and Jean promised Rossano that if a part came up for him, he would be in touch.[133]

'I thought he had forgotten about me. It was five years since we met, and I had resigned myself to not playing in Hollywood. The films they were offering didn't attract me, so…' He says this with resigned indifference.

Rossano's reputation hadn't helped. Remember, he was out of favour at this time and many directors assumed he was no longer the actor he used to be and would not hire him.

'I was not popular in Italian cinema, but Jean took a chance on me, a big chance, and I will always be grateful to him for that.'

Jean did, indeed, take a chance. He was directing and casting the film *Three Coins in a Fountain*. The producers had wanted Rossano's rival in the Italian "romantic lead" stakes, Vittorio Gassman, to be given the part. Jean took it upon himself to say that Gassman wasn't free and wouldn't be for some time, which wasn't strictly true. On that basis, the studio reluctantly accepted Jean's decision. The studio bosses were wary as they remembered Rossano's appearance in *Little Women* and thus were expecting a man with a very strong accent.[134]

'Here is Jean. I asked him to meet us here.'

Jean Negulesco walks with a bit of a stoop. He has thinning grey hair smoothed back and a world-weary expression. By 1953, he had already made his mark on Hollywood with more than seventy films under his belt and had worked with some of the top names in Hollywood.

Jean picks up the story. He says in a strong accent, 'I was in Paris and I phoned Rossano in Rome and I told him that I would come down there in a couple of days and I wanted to talk to him about doing a picture. And one thing I wanted to make sure of was that Rossano had not put on too much weight… from spaghetti.' This amuses Rossano. 'Well, the

next day, the next morning, I came downstairs to have my breakfast in my Paris hotel, and there he was. He had driven all night up from Rome. Tired but as young and handsome as ever.'[135]

Rossano turns to me. 'And, you know, I took the role.'

'I told Rossano that there were six roles and not to expect anything important. He was the third male lead behind Clifton Webb and Louis Jourdan, two big stars at that time.'[136]

'I was overjoyed,' says Rossano. 'I think I had about fifteen minutes of screen time, if that, but it felt right. I liked Jean and he put his trust in me. I didn't want to let him down. The filming was mainly here, in Rome, at Cinecittá, which meant that I could go home every night. That was important for me. I didn't have to spend much time at all in Hollywood.'[137]

'And you played the role beautifully,' says Jean, turning to me to explain. 'You see, Italians all over the world are known to be dramatic, bombastic, but, in this film, Rossano played that part of the young Italian, with whom the American girl falls in love, so gentle, so humble and so kind that all the women, all over the world, fell in love with him.'

Rossano offers him a grateful smile. 'Thank you, Jean, you helped me a lot.'

The part might have been a minor one but *Three Coins in a Fountain* broke revenue records that season. Journalists around the world were commenting on the love scenes between Rossano and Jean Peters as being the most beautiful in years. Many hinted that there was something going on because the pair of them were so natural and realistic.[138]

'I did fall in love with her just a little and I think she did with me. I liked her and we got on well. A love scene is always more realistic if you are fond of each other.[139]

'So, did something happen?'

All I receive are raised eyebrows. He is infuriating when asked questions about his love life. When journalists in the 1950s asked if readers should presume that he never cheated on his wife, he frequently answered, 'Presume what you like.' But he would spill the beans to me later about his marriage and would be surprisingly open about it.[140]

In 1953, where the American public was concerned, Rossano Brazzi was now the new romantic screen personality, someone with charm and charisma. Women were tired of boy-next-door types and the macho men played by some of the top American actors. They were ready for some old-fashioned Continental charm and Rossano had picked the right moment to enter the spotlight once more.[141]

Once the film was released, he began getting fan mail by the sackful.

'I was getting thousands of letters every week and hundreds of marriage proposals. Some were from mothers asking me to come and meet their daughters and some were threatening suicide if I did not reply.[142]

'I responded to them all. Not me, personally. Lydia, she organised our families to help reply. She is good at organising things like this. I was surprised at how mothers were happy to throw their daughters at me, even though I was already married.' He seems bemused. 'I told you before – I didn't see it. It wasn't until I got to around sixty years old, maybe a little less, when I see that I was not bad looking when I was younger.'[143]

Three Coins in a Fountain was just one of what were collectively called "Hollywood on the Tiber" films. The studios saw the lure of the exotic Italian Riviera. Discounting *Little Women*, Rossano's first three films for Hollywood, starting with this one, were filmed in Rome and Venice.

'You know, my friend Frank Sinatra opened this film with the title song.'

It was an unusual way to open a film – the audience are treated to a visual tour of Rome while Sinatra sings *Three Coins in a Fountain*. (It was Sinatra's first number one single in the UK.) It resembles a travel advert for the city. We then hear an Italian song while the credits come up. It is here we see that Rossano is definitely the "third" male lead. The two main actors and three actresses take top billing on one screen. Rossano's name is listed on the second screen along with several other performers.

'There are three love stories going on here. Mine is the shortest story. I play a translator, Georgio, and I am in love with Anita, a secretary,

who is played by Jean Peters. One day, before Anita is due to go back to America, we spend the day together at Georgio's family farm. Then word gets out and work colleagues are not supposed to see each other outside of work so I lose my job. That is the basis of the first story. Anita is heartbroken and I have to go back to the family farm and give up my dream of being a lawyer.

'The second story is of the Clifton Webb character, Mr Shadwell; he plays a well-known writer who is a recluse. His secretary, Frances, is in love with him but he is oblivious to that, so she is unhappy. Of course, that eventually works out well for her, although it's a little bittersweet.

'The main love story is about the prince, played by Louis Jourdan, who falls for the third American girl, Maria. She plays every trick in the book to lure him in. She pretends to like all the things he likes – art, food, wine, opera. When he discovers this is all a ruse, he breaks off the romance. Of course, it is a happy ending, and all the couples get together by the Trevi Fountain. It's a nice film and I enjoyed it.'

My first thought when watching this film was how vital it was that Rossano made a good impression as he was $500,000 in debt at the time and his reputation had sunk. It is a lovely film – very much of its day but good, nonetheless. Although he was only on screen for a short while, Rossano did manage to make an impression; his acting was very natural, his accent was not as strong as before and he was confident in front of the camera, so much so that directors began to sit up and take notice.

This film won Oscars for best song and best cinematography. Jean Negulesco would go on to work with Rossano in further films but, for now, one director at the top of his game had taken notice of Rossano Brazzi. That man was Joseph L. Mankiewicz.

Chapter Twelve

A LAZY AFTERNOON
AT VIA SISTINA

Rossano, with Ava Gardner, in The Barefoot Contessa. Humphrey Bogart and Valentina Cortese in the background. (Courtesy of The Everett Collection Inc.)

Back at the Via Sistina apartment, the balcony doors are open and a warm breeze is flowing in. I am in the lounge with Lydia. She's

taken one end of the sofa and I've opted for an armchair. Rossano is in the kitchen, singing, or, more accurately, he is joking around with his singing. He actually has a good voice but is deliberately messing up. Lydia pleads for him to stop before we all "go crazy". He shouts across to us while raiding the fridge for a bottle of wine.[144]

'Joseph Mankiewicz, you know he was just twenty years old when he produced *The Philadelphia Story* with Cary Grant and Katharine Hepburn. He is like me, had success early on.'

That was in 1940. Mankiewicz went on to direct some of Hollywood's most classic films: *The Ghost and Mrs Muir, All About Eve, Guys and Dolls* and the film we're about to talk about, *The Barefoot Contessa.* Although he co-wrote many screenplays, *The Barefoot Contessa* was all his own work.

Rossano wanders in, distributes glasses of wine, collects Pedro and plonks himself down on the sofa next to Lydia, who is writing letters. The dogs settle on the sofa between them.

'A lot of American directors were coming to Rome in the fifties to film at Cinecittá. The American audience had fallen in love with Italy and many films were being made in this location: *Quo Vadis, Three Coins in a Fountain, Roman Holiday, Ben Hur* and, of course, *The Barefoot Contessa.* It was cheaper to film here, too.'

'You were happy to take on another Hollywood picture?'

'My confidence returned after *Three Coins in a Fountain* and I knew that I could play the part offered to me, although not as Joseph had wanted, but we'll talk about that later. For me, this was another career opportunity, and the salary was important, too. Hollywood paid a higher salary than Italy and that meant I could pay off some of my debts.

'And I was working with some of the biggest names in Hollywood – Humphrey Bogart, Ava Gardner, Edmond O'Brien and, with Humphrey, I learnt a lot from him.'

'Mankiewicz described this as a Cinderella story.'

'Yes, that's what it was. The poor little girl who finds love with a prince type of thing. But, where Cinderella ends happily, things do not end so well for this girl.

'There are three stories within the film, like *Three Coins*, but there was much more depth to the plot and to the characters, more to do as an actor.'

The first story follows Maria, played by Ava Gardner. She is poor and works as a dancer in a Spanish nightclub. She hates wearing shoes. Here, we meet Kirk, a film producer (allegedly based on Howard Hughes) who wants to sign her to his company. His motives are solely money and power.

Humphrey Bogart plays Harry. He works for Kirk and strikes up a friendship with Maria and is there for her throughout the film. Maria becomes a big movie star but tires of Kirk's domineering attitude and, at a party, she is introduced to a Latin American playboy, Alberto. This leads us into the second strand where Maria cuts ties with Kirk and runs off with Alberto.

Alberto, played by Marius Goring, is a shallow man, similar to Kirk in that he is super-rich and conceited. Their time together is brief, and we see her coming to blows with Alberto at a casino in Monte Carlo.

During this altercation Rossano, as Count Vincenzo Torlato-Favrini, appears. He intervenes and escorts Maria from the casino. This takes us to the third story and the most interesting one. Count Vincenzo is an Italian nobleman.

'Maria falls deeply in love with Vincenzo, but he holds a dark secret and this is where the film, although good, could have been better. You know why? Because of the censorship.' He tuts with frustration.

Joseph Mankiewicz originally wanted Vincenzo's secret to be far darker than what is shown in the film.

Rossano feeds Pedro some lettuce.

'Vincenzo was a selfish son of a bitch; very charming and debonair but only interested in himself and the family line. It's not easy to like him. His secret, in the film was that he was so badly injured during the war he could not have sex and he does not tell this to Maria.

'And, you know, the secret in the film did not go down well with my Italian fans. Many Italians, at that time, believed you were the person that you play, and to portray a man who cannot physically make love, well, a percentage of them would believe this was a problem I had!'[145]

Lydia chuckles. He glances at her with a grin.

However, in that era, they would have been more concerned by what Joseph had originally written. Mankiewicz had conceived of the Count as being a homosexual and was planning to show him in bed with a male servant. Mankiewicz was European and happy to be bold with his storylines but, of course, he came up against the Hays code. He admitted himself that he wrote and filmed *The Barefoot Contessa* at a time when he couldn't make it as he'd wished.[146]

'He spoke about this and explained his original idea about the Count being homosexual, but he had to change the condition to suit the censors. I think that was a shame because this would have made the Count more believable.

'He had to rewrite it so that Vincenzo now suffered from a war wound. I am a man, and you can do some damage to that area of your body and, believe me, it does not prevent you from having sex.' Rossano throws up his hands and smiles. 'We had to comply with those rules although Joseph hints at something darker during the film.'

Knowing this, I watched the film again. When Vincenzo first brings Maria to his villa in Rapallo, the chauffeur has his eyes on the couple the whole time and you have every reason to believe that he is looking at Maria. Later, on their luxury yacht, the chauffeur is at the controls and again staring intently at the couple. Had Joseph's original script been permitted, I think it is obvious that the chauffeur would have been Vincenzo's love interest, not Maria. In the scene where Vincenzo chats to his sister about marrying Maria, we are given a hint of the secret but it seems very odd to be so furtive about a war wound.

'And, toward the end of the film, where I come to Maria's bedroom on our wedding night. This is where we learn what a son of a bitch the Count is. He tells Maria, on the night of their wedding, that he cannot consummate the marriage because of the war wound. Joseph filmed this with lighting that was, I think, very menacing. I am telling Maria I cannot make love with her but the way it's filmed suggests there is something more. I would have loved to have played Vincenzo as he was originally conceived.[147] But, you know, like *Vulcano*, there was just as much going on behind the scenes than in the film.'

He lights a cigarette and explains a scenario that I had sourced from the DVD extra that accompanied the film.

'I found it challenging, working with Ava. Humphrey Bogart and I had to intervene a few times when she flew into a rage. Bogart didn't help matters. He didn't like Ava – he didn't think she could act, so this caused problems. Their characters are supposed to be the best of friends. If Bogart didn't like the way Ava was playing a scene, he would mess up so they had to film it again. And Ava, I saw in an interview once, she said that I was difficult to work with and thinking about other things.' He looks incredulous. 'I don't think I was difficult. I try to get on with everyone I work with. The only thing I had on my mind was paying off my debts and I wouldn't let that interfere with my work. I'm not unprofessional in that way.'[148] [149]

'Did they argue?'

'No. I tell you truthfully, I felt sorry for her. She was still getting over Frank Sinatra, and she also struggled in this film because Joseph didn't work with her the way she wanted. Even Joseph, in later years, admitted that he didn't direct her as well as he could have. That didn't help Ava.'[150]

From reports I've read, it appears this was not a happy set to work on. Humphrey didn't like Ava; Ava didn't like Humphrey; Mankiewicz didn't get on with Ava; Ava wasn't keen on Rossano; Mankiewicz grumbled that Rossano had not been his first choice and had a simmering annoyance that he couldn't get James Mason to play the role. Humphrey was ill (and looked it), Ava's tempestuous marriage to Frank Sinatra was ending. (Frank was in Rome at the time and trying to resolve things.)

'Me and Ava, we were not compatible with each other, and we could not get over that. The scenes between us, where we were supposed to be so in love with each other, they were hard to do, and we relied on our best acting because we did not have that rapport. It was not Ava's fault, but it wasn't mine, either. We were just different people. Sometimes it happens that way.'[151]

'But the Sinatra relationship was dominant?'

'Yes, very much. It was one of those stormy marriages, where they

couldn't live with each other, but they couldn't live without each other. Frank was crazy about her but livid with her at the same time.[152]

'You know, Ava had an abortion about eighteen months prior to us filming and Frank found out later. He was furious. That's the sort of relationship they had – tempestuous. I tell you, Lydia and I, we argue all of the time, we both have the Italian temperament, but we're never nasty. We never hurt each other. With Frank and Ava, it was brutal the way they argued.'[153] [154]

He nudges Lydia. '*Cicci*, you always knew which couples would stay together.'

Lydia nods. 'When we first spent time in Hollywood, we were in a villa in Beverly Hills and we could not believe the number of marriages that fell apart or the affairs going on and being reported about in the newspapers. I could always predict who would stay together.'[155]

'And she was right about these two – Frank and Ava. They would flare up at the least little thing. By the time Ava was filming with me on *Contessa*, their marriage was finished. Frank tried to make it work, sent gifts to her but she didn't want them. You know, Frank attempted suicide at one point.'

Even though the marriage between Frank and Ava was all but over at that time (the divorce didn't go through until 1957), Frank requested that a prop from the film be saved for him.

'There is a statue in this film, of Maria. Very lifelike. Frank had it packaged up and shipped across to America after the film had wrapped. He was still married to Ava, but I think he was already in another relationship.'[156]

Lydia lets out a *pah*. 'I wonder what the new woman thought of that!'

Ava's mood swings were, as we have heard, hard to predict but Bogart was having his own battle. The years of heavy smoking were taking their toll, and he would die of cancer just a couple of years later.

'I remember he was coughing a lot, and we would have to reshoot some scenes because of this. I didn't realise that he was so ill at that point. I got on well with him and he said, when I came to Hollywood, to call him and he would organise something for us. When we came,

he invited us to his house for dinner with a few friends. He had a nice house, all marble floors and some good paintings. That was just a year before he died.'[157]

Rumour had it that Rossano's three white poodles appeared in the film, although I cannot substantiate this. They have been in a couple of films so it could be true.

The poodles appear at the end of a scene in the ladies' powder room. It's an amusing take on society at that time; the scene starts by showing beautiful women retouching their make-up; we then see an elderly lady who has lost the art of applying rouge and looks rather clownish. Finally, the camera reaches one black and three white poodles, immaculately turned out, awaiting their owners.

Edmond O'Brien went on to win an Oscar for his supporting role and Mankiewicz was nominated for his screenplay. There were a handful of negative reviews about the film but, overall, it was a huge success with cinema audiences and garnered glowing reviews from both François Truffaut and Fellini.

In addition, Rossano's popularity began to increase as women fell for the Continental look. Hollywood magazines were taking note of him.

Rossano remained on the Continent to fulfil contracts for movies, including dubbing Hollywood films into Italian, but a significant role was just around the corner. *Three Coins in a Fountain* and *The Barefoot Contessa* had placed him on the ladder, but his next Hollywood film would catapult him to international stardom.

Chapter Thirteen

A DAY BY THE SEA AT FREGENE

A few days later, Rossano opens the door of his apartment to me. He's in pale blue trousers, turned up a little at the ankles, a short-sleeved open-necked shirt and plimsolls with no socks. This is the first time I've seen him this casual.

It is a beautiful day and I discover that on nice days, if they are both free, they go to the beach. Fregene is their favoured spot as it's only a half-hour drive from Rome and they own a beach hut there. In the winter, he tells me, their weekends are spent at the ski resort of Terminillo, an hour's drive from Rome.

Rossano calls the dogs to heel and attaches their leads. 'We're meeting some friends there but you will join us, yes? You can come in our car. Gene Lerner is coming, too.'

It would be remiss of me not to go on this outing and I'm happy to get more insight into him as the man rather than the actor. I know, also, that Gene has stories to tell about Rossano at this point in his career.

But first, the journey. This proves to be an entertaining one. The family later confirms this is typical of a normal drive with the Brazzis.

Rossano opens the passenger door for Lydia, who has offered to drive.

'If you drive, I'll have to get out and walk,' he says with a grin, winking at me.[158]

A drawing of Rossano and Lydia in their car by Rossano's nephew, Carlo. (Courtesy of Carlo Fiorentini.)

Rossano usually preferred to be at the wheel. He owned a number of beautiful cars over the years and, in front of me today, I see a sleek, black sports car. He loved speed, although he often had a chauffeur because of the number of speeding tickets he received. He admitted, that when he drove fast it made him nervous. Not an ideal combination.[159]

His nephew remembers one time when he was driving with his uncle beside him in the passenger seat. 'My parents were in the back and Uncle Rossano said to me, "I like the way you drive, Carlo, but can't you go a little faster?" Then he turned to my parents in the back seat and said, "I'm sorry, but I can't stand seeing cars in front of me."'

I'm settled in the car. The roof is down, and the dogs enjoy the breeze. Sitting in the back seat with the "children", I am already getting an idea of what is in store.

Lydia, who doesn't stay quiet for long, begins her vocal observations. 'Mind the pavement… read that sign… don't go so fast… watch out for that bump… don't overtake.'

Rossano remains calm. A gesture with the hand that says all is fine, the odd "I see it" and "stop worrying". Eventually, though, things get too much. The voice is raised. 'Lydia, I know what I am doing. Stop with the directions – you want me to have an accident?'

She quietens down but not for long. A pedestrian is close to the edge of the pavement with no intention of crossing; it's too close for Lydia and she yells, 'Mind the lady!'

Rossano swerves a little, drives past the lady and pulls over. He turns to her. 'Lydia, listen to me. Will you stop trying to guess what I am going to do. I could have an accident with you yelling. I know how to drive. Just shut up.' He puts the car in gear and pulls away, mumbling, 'Any more and I will drop you at the train station and you can get the train,

and you will have to walk from there – you know how far that is, from the station to the beach? Too far for you.'

'I can get a bus.'

'You hate the bus.'

I wonder if there will now be an awkward atmosphere in the car but there isn't. Lydia goes straight on to discuss the friends they will be meeting at the beach.[160]

Mitzi Gaynor, Rossano's co-star in *South Pacific*, likened Rossano and Lydia to characters in an Italian *I Love Lucy*. I understand the comparison. This couple cannot exist without these bouts of argument and Rossano is right, they don't seem to argue about anything significant. Once the present bickering is over, it's history and they're on to something else straight away.

At Fregene, he parks by the beach. There is an impressive row of Art-Deco houses running along the road, facing the ocean. The beach stretches for several miles, linking up with other resorts, but we are pretty central. There is a variety of open-air bars and restaurants and the beach is busy with day-trippers.

Here, Rossano Brazzi is simply Rossano enjoying a day at the seaside with his wife and friends. The beach hut serves as a dumping ground and changing room. The dogs run free though they constantly check that Rossano and Lydia are nearby. There is a volleyball court marked out on the sand and Rossano is quick to change into his Speedos and join his friends for a game. Lydia, herself in a revealing swimming costume, settles in a chair and chats with the less energetic members of their party.

We enjoy a picnic of sandwiches, prosciutto, cheeses, wine and fruit. Everyone goes in and out of the water at intervals. The sun is warm and the smell of suntan lotion mixes with the sea air.

If anyone recognises the famous movie star messing around with his friends and the dogs, they do not disturb him. If they do, he is happy to stop and chat. Ultimately, he can be himself here, with no paparazzi or adoring female fans trying to get a piece of him.

Taking a break from the volleyball, he sits down on the sand next to me and lights a cigarette. He looks tanned and fit.

Rossano at his beach hut in Fregene. (Courtesy of Reporters Associati & Archivi/ Mondadori Portfolio/Bridgeman Images.)

'Are you having a good time?' he asks.

'Yes, I am having a wonderful time and it's nice to see this side of you.'

'We like it here. We come whenever we have time and the weather is good. We call a few people because it's nice to share the day with friends. Where are you with my story?'

'We are at the film that launched you internationally.'

'Ah, yes. *Summertime*.' (Or *Summer Madness* as it was called in England.)

Based on the play *The Time of the Cuckoo* by Arthur Laurents, *Summertime* began filming in Venice in 1954 and would be the third "Hollywood on the Tiber" film for Rossano. (Rossano, according to some

sources, appeared in the play later in life. Bette Davis wanted to play opposite him but decided against it as she didn't want to be compared to Rossano's co-star in the movie, Katharine Hepburn. Unfortunately, I couldn't substantiate the theatrical role.)[161]

Summertime was adapted for the screen by the writer H. E. Bates and film director, David Lean, but Arthur Laurents was not impressed. I read the play and felt the screenplay had enhanced the story but also that Laurents was right to be disgruntled as there are some interactions in the play that would have slotted nicely into the film.

David Lean directed some classic movies for the cinema: *Lawrence of Arabia, Doctor Zhivago, Ryan's Daughter* and *The Bridge Over the River Kwai,* to name a few. However, he cited *Summertime* as his favourite, the one into which he put more of himself than any other. He adored Venice and would, after this film wrapped, own a home in that city for several years. He also had a lifelong ambition to work with one of Hollywood's greats, Katharine Hepburn, and was finally able to do so with this film.[162]

Katharine Hepburn plays Jane Hudson, a lonely, middle-aged spinster on a European holiday, who has booked into the Pensione Fiorini in Venice for this part of her trip. In the famous Piazza San Marco, she is flustered by the attention of Renato de Rossi (played by Rossano), an antique shop owner who is intrigued and amused by her.

After meeting him by chance, she falls in love with Renato but discovers he is married, albeit separated, with children. Frustration and anger surface from her past as her idea of love is lodged firmly in the realms of fantasy. Renato brings her into the real world and they embark on a brief affair. Because of her upbringing and morals, she knows the affair is wrong and she cuts her holiday short to return to America.

Hepburn plays this role brilliantly. In 1954, she was approaching fifty and her youthful beauty was beginning to fade. In a period where glamour was everything, Hepburn goes against form and shows us a vulnerable older woman who craves love. David Lean was drawn to the theme of loneliness. Without any need for words, her expressions show us how lonely and in need of affection she is. She is real in every sense

of the word and even now, in the twenty-first century, many people can identify with Jane – the older woman whose beauty is waning.

It is interesting to read various comments about the ending of this film, and how they are affected, by when those comments were written. Remember, this film was made in the 1950s, when the censorship rules were strict, especially in America. David Lean must have had a battle with the American financiers over what could or could not be said and he featured a lead character who was having an affair with a married man. That, immediately, went against the censorship rules.

In the 1950s, comments on Jane's conduct questioned what she was doing even embarking on this affair. How could she be so immoral? Comments made by women today are critical of her leaving Venice. Why would you leave a man as hot as Renato? Who cares if he's married?

Rossano in Summertime (Courtesy of Daniel Boutieller, TCD, Paris.)

Although this film was a vehicle for Katharine Hepburn (she was nominated for an Oscar for best actress) and many believe this to be

one of her best performances, Rossano also made an impact on the audience.

'When this film was released, Ilya Lopert, who produced the film, he called me on the telephone and told me I was now the number one screen lover.'[163]

Interestingly, the tourist trade in Venice increased tenfold after the film was released, with many women scouring the shops, hoping to encounter Renato de Rossi. When the world premiere took place in the city on 29 May 1955, around five hundred women descended on him. His shirt was almost ripped off in the process.

Rossano's fan mail increased tenfold, too. He received several thousand letters each week from around the world. But the role had nearly not come about at all; indeed, Rossano had not been considered for the part when they were casting.

Gene Lerner has joined us and Rossano decides he wants to play with the dogs. Gene helps me up.

'He's gone,' says Gene, 'because he knows I'm going to tell you what happened when he went for this role.'

What Gene is about to tell me is astounding and he and Hank Kaufman had written about it in *Hollywood sul Tevere*. I knew Rossano had a poor reputation with agents and was a man who could manipulate a person with his charm but what happened with Gene and Hank stuns me.

Gene suggests we relax in one of the beach bars. We head over to the closest one and order cocktails before making ourselves comfortable.

Gene explains that director, David Lean, and producer, Ilya Lopert, were in Rome searching for an Italian actor to play the part of Renato de Rossi, Katharine Hepburn's love interest in the film *Summertime*.

'They hadn't approached us,' Gene tells me, 'which was odd because we had a number of English-speaking Italians on our books so I tried contacting them, which took an age. After God knows how many phone calls, I decided to visit the places where I thought they might be and finally tracked Ilya Lopert down to the foyer of The Excelsior, where they were staying.

'When I went through the list of actors we had on our books, Lopert was pretty damned rude about all of them and insisted none of them

had what it took to play the role or to play opposite Hepburn. One name kept buzzing around my head and that was Rossano's. Hank and I knew him. We saw him socially, but the problem was we didn't represent him.'

'And you put his name forward?'

He winces.

'Lopert almost spat the name back at me, told me he didn't have what it took and that his reputation was shot. I told him he was basing that decision on Rossano's current reputation. I said to him, what about *Tosca, Noi Vivi, Toselli, Kean*? I really pushed to defend him and I also told Lopert that Hepburn's reputation had been shot not so long ago.'

Lopert, apparently, remained unmoving in his opinion of Rossano.

'I was getting nowhere so I tried a different angle. I said to him, "What if David Lean finds out he missed an opportunity because you refused to at least meet Rossano?" Well, that drilled a chink in the armour. He agreed to see Rossano but he told me that Rossano had to come to the hotel that evening, on his own, and that he'd only give him a few minutes. It sounded to me like he was going to dismiss him the moment he arrived, but I agreed.'

The first step was complete. 'How did Rossano react?'

'I met Rossano pretty much straight after and he was thrilled. He confirmed he didn't have an agent and that he wanted this role more than anything; that he'd pay whatever percentage we wanted if we could get him the part. He swore on his mother's life.'

(Rossano often swore "on his mother's life" and generally made horns – a gesture to ward off a curse or bad luck – under the table or behind his back when he did it.)

'I told him that he had his work cut out because Lopert had such a poor perception of him as an actor. I listed Renato's character traits and Rossano was confident he could fulfil what was being asked of him. And he was right. Compared to his roles in *Noi Vivi* and *Tosca*, this was an easy part for him. He was really excited about it and me and Hank were, too. The film would be big for us if we pulled it off. I told him to let us know the moment he heard anything. That man, Lopert, didn't tend to hang about so I knew Rossano would have an answer within an hour of meeting him, maybe less.'

I have a suspicion of where this is going.

'Rossano met Lopert at ten o'clock that night and, from then on, we waited. And waited. And waited. In the morning, I phoned his apartment. He wasn't answering. Lopert and Lean couldn't be contacted. We had no idea what was going on.'

Gene and Hank spent the following day trying to find either Rossano, Lopert or Lean. Finally, almost twenty-four hours later, they took a chance and went to The Excelsior, only to see the three men chatting amiably at the bar. Rossano, they discovered, had signed the contract, keeping Gene and Hank out of the negotiations.

Gene shakes his head. 'I was very fond of Rossano, and Lydia; but at that moment, I could have easily throttled him.'[164]

Gene, promising to finish the story later, leaves to rejoin the group.

Rossano is coming toward me in his Speedos, tanned, handsome and wet from swimming, rubbing his hair dry with a towel. I am immediately reminded of something Mitzi Gaynor said during an interview in the 1990s. Due to copyright, I can't quote it verbatim but it, effectively, suggested that Rossano was rather well endowed beneath his snug costume. I suppress a smile.[165]

He orders a cocktail and takes the seat Gene vacated. We sit for a while. I can't bring up what Gene has said because Rossano never speaks about it. I do know that something happened that would have appealed to his ego.

Even when Lopert told David Lean that Rossano might be suitable, Lean was not convinced. When he eventually met Rossano, he was planning to tell him he wouldn't get the role. The outcome was very different. Lean's biography by Kevin Brownlow confirms that he was so impressed with Rossano he didn't bother auditioning him; he knew he was right for the role. Rossano is also happy to confirm that.[166]

'I was looking forward to working with Katharine – she was a true Hollywood great and I was to be her co-star. I was the big star in Europe, but she would know only a handful of my films, if that. She was the international celebrity, known all over the world. This was a big opportunity for me.'

'Reports I've read say that you didn't get on, initially.'

Rossano on the set of Summertime with Katharine Hepburn and Gaetano Autiero.
(Courtesy of The Everett Collection Inc.)

He lets out a laugh.

'We fell out during the first scene! I was ready to pack my bags and go back to Rome. I'd booked into Venice's Gritti Palace hotel with Lydia. It's one of the most expensive in the city.'

They were still in debt at this time. As if reading my mind, he continues.

'I don't like hotels and I wanted some comfort. You're right, though, we didn't get off to a good start.[167] Katharine knew her mind. I admired her so much, more than any other actress. She was intelligent; she knew about film and direction, but she was trying to direct me. And, David, you know, for some reason he didn't like me, and I never really knew why. I found out after that initial meeting that he disliked me on sight. I hadn't even said anything at that point!'[168] [169]

This is widely reported, although, to be fair to Rossano, David Lean was, apparently, notoriously difficult to get on with.

'Tell me about the argument.'

'Katharine and I, one of the first scenes we had to do was a love scene and she started to direct me. She wanted me to act in a way that suited her. She almost lectured me and, really, compared to her I was no one – so I listened. But when we did the scene, I knew how I wanted to play my part, so I ignored what she said and did it my own way. That annoyed her.[170]

'I was getting direction from her and from David but mainly from her – what *she* wanted, how *she* wanted me to act. I knew my part, I knew her part, I knew what was needed in this scene. I flew into a rage. I turned to David and said that I can't act with her. She flew into a rage too and said she couldn't act with me.[171]

'I got back to my hotel room and was thinking about packing my bag. Perhaps, again, I would turn my back on Hollywood. I wasn't feeling that good, either. I had a touch of flu.'

'Presumably, the falling out resolved itself?'

He smiles. 'Yes. You know, Katharine rang me that night and told me that I was the most frustrating man she'd worked with but that she liked me. I told her, "Katharine, you are the big star here, I know that. You have made many wonderful films and I have made just a handful in comparison, but I have to make my own way; I have to prove myself and I can't do that if you are going to interfere by directing me and making me act the way you want me to in your scenes." She understood – we talked for quite a while and, at the end, she said, "I think we can enjoy working together." And, you know, we did.'[172]

Katharine later admitted that she was bossy and that Rossano acted the scenes the way he thought he should act them. She didn't like it but, she said, he was too charming for her to oppose him![173]

She was so impressed with Rossano that she told David Lean to put Rossano's name alongside hers in the credits, sharing the top billing.[174]

'I appreciated that. Very much. And it was a beautiful film.'

'Some critics said that it was a little slow.'

'That's because Venice is slow. It was another personality in the film and David showed it like that. It had to be like that. I don't watch many of my films, maybe four or five, but *Summertime* I can easily watch. It is Lydia's favourite film of mine.'[175] [176]

Rossano and Katharine Hepburn in Summertime.
(Courtesy of Daniel Boutieller, TCD, Paris.)

'And were there any problems on this set?'

'A couple.' He rolls his eyes. 'One to do with the censors, of course, and one that affected Katharine personally. There is a scene where, as Jane, she is trying to film on her cine camera and she is walking backward – she ends up falling into the canal.

'You know, the canals in Venice are filthy, you really do not want to go swimming in them. They spent some time putting a tarpaulin under the water to keep the silt from coming up. I told her not to do it, to get a stunt person in but she insisted on doing it herself. Katharine did the shot and they had to do a couple of retakes and a little while later, she got an infection in her eye. You know, she suffered with that for the rest of her life – it never really went away.'[177]

'And the censorship problem?' Not for the first time, Rossano throws his hands up in despair at the Hays rulings.

'I don't understand it – I never understood it. They complained about all sorts of things but, you know, David stood by his decisions.

There were a couple of things here, mainly when I had my big speech. Jane discovers that Renato is married and confronts him about that. I talk about Americans getting uptight about sex. Jane suggests that Americans take sex seriously. Then I suggest that instead of taking it so seriously, that she simply do it.

'I will be honest with you, when I was learning those lines, I thought they would be cut. Just saying the word sex was, I think, pushing the rules, especially in the context that I was talking about – physical sex. David managed to keep that in.

'There is another part, later in the speech, where I talk about eating ravioli and that she wants beef steak. All of that is a metaphor for sex and the studio didn't like that either. I think they told David to cut that, but he didn't. I don't know how he got around that but I'm glad they kept it in.'

Rumour was that one of the American producers, Robert Dowling, demanded that the "ravioli" speech be cut from the American version. Whether it was or not is unclear. The show also went over budget and producer Ilya Lopert, thinking that filming was taking too long, told the police to deport David Lean if he didn't finish the film on time!

'And there are reports that no one took Katharine to dinner – is that correct?'

(In her biography, *Katharine Hepburn: A Remarkable Woman* by Anne Edwards, she bemoaned the fact that no one asked her to dinner and admitted that her acidic personality put people off. She was, apparently, in a particularly ungracious mood because of problems with her relationship with Spencer Tracy.)[178]

He rolls his eyes again. 'After that initial argument, we got on fine. She can be a little prickly, you know, but we went for drinks. I don't know, actually, that we went for dinner but I remember going for drinks with her and she called on me and Lydia at the hotel. I was suffering a little with flu and I didn't want to go out much – I was going back to the hotel to bed.

'She turned a lot of heads in Venice. It is a very stylish city and I remember Katharine was happier in old trousers and an oversized shirt. I like that sort of independence in her. She was good company, and she knew the business; always so many ideas where the film was concerned,

suggesting things and trying different ways of acting something. I learnt so much from watching her. We had a few people to the hotel for drinks and dinner, including little Gaetano.'

Gaetano Autiero played the street urchin, Mauro, who takes a shine to Jane Hudson during her stay in Venice.

Rossano laughs. 'He took a shine to her in real life, too. He came to ours one day to have lunch and Lydia and I, we joked about him playing a street urchin and teased him about his crush on Katharine.'

One of the technicians on the film would later brief a reporter that he had observed that Lean could be incredibly offhand and irritable, Hepburn would often simply dismiss people, but apparently Rossano was always happy to talk to everyone, regardless of who they were.[179]

Rossano and Katharine between scenes on Summertime
(Courtesy of The Everett Collection/Bridgeman Images)

'I have situations in my life where I have to be courteous.'
'Even when fans are almost ripping your shirt off?'
He gives a wry smile. 'That didn't annoy me – that was frightening.'

When the film was released, Rossano flew to New York to help with promotion and attend the US premiere at Radio City. Mobbed by a crowd of female fans, he was in danger of having his shirt torn to shreds. With him were Margaret Truman (President Truman's daughter) and Bob Hope. Bob alerted the police who rescued Rossano from the fans' clutches. As explained earlier, this also happened in Venice and the scene would later be parodied in the successful Italian documentary *Mondo Cane*, where Rossano is shown being besieged by fans.[180]

Lydia has joined us. 'She didn't accompany you on this trip?'

'No,' says Lydia, lips pursed.

Rossano grins. 'We had quite an argument about that. Not me and Lydia, but me and the studio. Lopert, he had given strict instructions that Lydia was not to accompany me to New York. She went crazy and, I have to confess, that I was annoyed about this, too. I like Lydia with me. I like to talk things through with her at night when we are alone, and I missed that.'[181]

It was imperative for the studios to show Rossano as the stereotypical Latin lover – that he should embody that persona for the fans. If Lydia were to go, she would have to be invisible, so she was told that it was best for her to stay in Italy. The couple, for the sake of his career, reluctantly accepted the decision.

Lydia explains. 'Rossano was building his image and they said it didn't look right to have a "wife" by his side. Especially a fat one.' She roars with laughter. Grinning, he leans across to hug her and kiss her on the cheek.

'And the studios, you know, they didn't even like me talking about Lydia. They cultivate a brand for you and, if you are seen as some sort of love interest, they don't want you to even say that you are married! I argued about that many times with studios because I like to have Lydia with me. Most of the time, during my career, Lydia did come with me.'[182]

'I tell you, when I went to New York for this promotion, I thought, secretly, that I would enjoy that time to myself, be a bachelor for a while. After three days, I missed Lydia so much and I missed being home. I spent hundreds of dollars on phone calls to her – every day.'

Hundreds of dollars! Lydia laughs. He reaches for her hand.

'Lydia likes to talk. She drives me mad sometimes, especially first thing in the morning – she always wants to talk. I wake up slowly, you know, and I don't want that, but, when you are far from home, well, you want to hear the voice of the person you love.'[183]

Summertime was a huge success with both critics and the public. Fans around the world were suddenly in love with Rossano Brazzi. Up to 40,000 letters a month arrived, and he received extravagant gifts from wealthy fans.

'A woman had a brand-new Cadillac delivered to my hotel in New York, with a letter asking me to visit her. I think she lived in Pittsburgh or Chicago – I cannot remember where – can you believe that? Someone else sent me a gold watch. And there was a group of fans who had put their funds together and they offered to fly me over to Japan to spend time with them. Lydia, too.'[184]

Two young admirers wrote to Rossano asking if they could spend a few weeks with him to learn Italian. He sent them each a dictionary! And, often, women would ask to be kissed on the lips instead of receiving an autograph.[185]

Within two years, Rossano had gone from being out of favour, at rock bottom professionally and financially, to being one of the most recognisable film stars in the world. For many, that adulation would continue for decades. Even in the late 1960s, there is a report of Rossano and Oscar visiting a nightclub in New York and having to be escorted out of the back door because female fans overwhelmed them.

He finishes his drink. The couple decide it's time to pack up and go home. I go to join them, but Gene is back and quick to jump in.

'Don't you want to know how everything turned out?'

I sit back down. 'Yes, I was wondering how on earth this business over the negotiations had been resolved.'

In *Hollywood sul Tevere*, Gene and Hank explained how they mended their fractured relationship with Rossano. I was interested to learn about this and asked Gene to explain.

'*Summertime* was critically acclaimed around the world and Rossano was front and centre in the international film community and reporters all over the world wanted to interview him.'

I could testify to that. I had several hundred magazines piled up in my office to prove it.

'The press couldn't get enough of him and neither could the public. Women wanted to sleep with him; men wanted to be him.'

'And how did you feel about this?'

'The fact that the film was such a success and that Rossano had turned into a global phenomenon was maddening for us. I mean, if it wasn't for us, he wouldn't have even got the part!'

'So, what changed?'

'Before Rossano travelled to New York for the Radio City screening, Lydia came to our office. She strolled in full of smiles and hugs and the poodles were leaping around being equally loving toward us, but we were wondering why she was there. I'll be honest, I was a little wary after the way Rossano had treated us. Then it all came out. Rossano, she said, was downstairs in the car but she'd decided to come up first. She basically offloaded on us, telling us that she didn't want to handle Rossano's contracts, that she was getting stressed out with everything and she wasn't cut out to deal with the legalities. She wanted to hand everything over to us. I could see how uptight she was.'

He sits forward, quite animated.

'She wasn't a stupid woman. She knew *Summertime* was his big break; she knew this was his chance to make something of himself and she wanted professionals to look after him. She'd told him to get an agent and that she wanted to be free of anything to do with contracts and salaries and everything that went with it.'

'And how did you and Hank feel about this?'

'Oh, we were happy to do all of this, but we were worried about Rossano and his reputation with agents. We'd had first-hand experience of his behaviour, and we didn't want to go through that again. Hank told her how long the contract would be for, what the percentages were, that we would have exclusivity, all the stuff that goes with being an agent. She became almost matriarchal, telling us that Rossano would do what he was told, and he'd sign what she told him to sign. Then she went to the window and yelled down to him to come up.'

I was interested to know how Rossano behaved when he appeared,

bearing in mind what had happened. Surely he would be embarrassed, at least?

'He put on the charm, as if nothing at all had happened. He smiled, he embraced us, told us how lovely it was to see us. It was as if the deceit had never happened; I tell you, it was difficult to be immune to his charm and we pretty much made up there and then.'

'No arguments at all?'

'Not from us, we didn't get a chance to say anything. Rossano and Lydia had pretty explosive tempers and me and Hank just stood by and watched as they kicked off.'

I had wanted to get some sort of insight into the Brazzis' rages at each other and I was about to get it. Gene rolls his eyes.

'Rossano started, blaming Lydia for messing things up, for not being able to sort his contracts out. He said that she didn't know what she was doing, that he couldn't stand her dealing with anything anymore. He called her a stupid idiot.'

'And Lydia?'

'Lydia gave as good as she got, calling him a few choice names and telling us we had to keep tabs on him the whole time, even when he went to the bathroom. Every few seconds they were yelling at each other to be quiet, to shut up.

'Rossano raised his voice even more; shouting, gesticulating, tutting, telling her she was useless, that she took all his money. She accused him of lying and gossiping when things are supposed to be secret. She said he should try keeping his mouth shut. When he yelled, she yelled louder.'

'It sounded as if, in this overheated Latin scenario, you had had no opportunity to intervene.'

'None. If we'd have tried to negotiate with them at that point, we wouldn't even have been heard. I tell you, he was incandescent and he looked like he wanted to hit her. Anyway, this ranting and raging went on for several minutes, then she began to act as if the whole thing was a joke and that just made Rossano angrier.

'We were pretty used to the fights between Rossano and Lydia. They loved each other a whole bunch but, if you didn't know them, you'd have thought these two hated each other. The dogs were barking and yapping.

Rossano flung an arm up, yelling at them to shut up, then stabbed a finger at Lydia, yelling at her to shut up.'

'Did you manage to get a word in?'

'In the end, it was Lydia who gave us the chance. She turned her back on him, lifted her skirt and thrust her backside at him. We'd seen her do that a couple of times before; Rossano just closed his eyes in resignation.'

I can't help but laugh, wishing I'd been there.

'Well, that was our opening and we took it,' Gene continues. 'We didn't refer to their argument, just went straight into what our terms were, take it or leave it. I think he was all done after rowing with Lydia and pretty much told us to do what we wanted. We told him the percentages and how the money would come to him. Lydia told us the money would come to her. That started off another shouting match but not for so long. The following day, Rossano came in and signed the contract with Lydia as a witness. I'll be honest with you, that signature not only sorted out the problems we'd had with *Summertime* but it sealed a lifelong friendship between the four of us.'[186]

In Fregene, Gene and I rejoin the others who are now getting into their cars. I tell Rossano that I will get a lift with Gene. He has more to tell me, and I am keen to get that information.

He nods his understanding. 'I will see you at the church; telephone me later and I will give you directions.'

Church? Ah yes. We'll get on to that in a while. I take his telephone number.

I get into Gene's car and we follow the Brazzis but not for long. Rossano zooms ahead and I can imagine Lydia already starting to have her say about that!

Gene's driving technique is more sedate, and the next instalment is also detailed in *Hollywood sul Tevere*.

'*Summertime* was a big payday for Rossano,' said Gene, 'but he and Lydia were still over $400,000 in debt so it was vital they stayed on track to clear that. The pair of them loved to spend so we kept tabs on them. The first thing I did was make sure that we controlled their finances

and that we made the decisions concerning what films he made. It was difficult, though. If you could win a gold medal at the Olympics for talking, Rossano would win it, hands down. He'd talk to anyone and everyone, promising to be in this movie and that movie. I put a stop to that straight away. I also pitched for a higher salary than normal. Rossano was big news, and this was the time to take advantage of that, financially, to clear their debts.

'I stopped him promising to be in movies without our permission, but I couldn't be with him twenty-four-seven. Apart from him making promises he couldn't keep, the public wanted in on the action. Women wanted to get to know him, spend the night with him. Even husbands were okay about it if their wives slept with him! That's how popular he was.

'And no matter how much he loved Lydia, he played away on a few occasions during this trip.' (We will be talking with Rossano about his marriage and love life in the next chapter.)

'Did you stay on longer in New York?'

'Yes. When Rossano returned to Rome, I stayed on to negotiate the best contract I could. The company keen to sign him was Universal-International and although it wouldn't be made until later, the first film we agreed on was *Interlude* with June Allyson.

'I asked for $100,000 for that film and then pushed for more for each subsequent film. We also put in a stipulation that Rossano could make films for other companies if he wanted to and that he would receive a percentage of the takings.'

'That was unusual.'

'It was unusual but not unheard of. If the name is big enough, the studio will grant some leeway because they know they're going to make money.'

One clause that Gene insisted on having in every contract was that if the role of Emile de Becque came up in *South Pacific*, Rossano would be allowed to play it regardless of what else he was filming. Rumours were circulating that a film version of the musical was in the pipeline and both Gene and Hank felt this would be a huge opportunity for Rossano. It is clear, from some of the films they chose for him, that the roles he

was given reflected aspects of Emile de Becque's personality, getting the industry primed to see him as being right for the part.

Gene also wanted to take an advance payment back to Rome for Rossano.

'I can tell you that is something Hollywood never did. An actor never got paid a cent until they began filming.'

'And how did the studio react?'

'I put a figure on the table: $50,000. I wanted that in cash and a signed contract drawn up straight away. I thought I'd pushed it too far because no one said anything. It would have been easy to take that request back, but I was ready to walk. I knew I would find another studio. A woman in the room, I can't remember who it was, she said that she didn't understand why anyone was dithering about it. Rossano was worth millions to the company – give him the cash and sign the contract.

'A few days before Christmas, I had everything I'd asked for: a signed contract and $50,000 in cash. I went out and got some wrapping paper and wrapped the cash up in twenty-five separate parcels of $2,000, packed my suitcase and flew to Rome.'

Gene has quite a smug look on his face. What was he so happy about?

'The day after I got there, Hank and I were invited to a Christmas party. I knew Rossano and Lydia were going, and they didn't know I was back or that I'd secured a deal so I planned a surprise. I took the contract and the parcels of cash with me in a bag. When I got to the party, I brought out the contract and there were huge cheers all round. Rossano was so excited. After a while, I went into a side room with Hank and got the parcels out. Hank looked a little confused when I told him to get Rossano and Lydia. When he brought them in, he closed the door and I told them I'd got a present for them. Well, they looked as confused as Hank did, but Lydia went over and opened one of the parcels. She saw the green dollar bills. She opened another, then another. Rossano just stood there, watching. Then he began opening them up. Then, chaos! They were yelling and whooping so much – they couldn't believe it.'

It must have been a huge relief bearing in mind the debt they were in.

'Rossano just kept staring at all this money. I leaned towards him

and told him how much was there. He couldn't take it in. I had to repeat it a few times. Lydia burst into tears. Even Rossano couldn't keep the tears back. I think he'd held them in for so long he had to let it out. They just sat on the bed holding each other, sobbing.'[187]

For Rossano, the worry of debt was now subsiding and, although the money would start to roll in, he and Lydia remained in the small apartment on the Via Sistina until they were financially secure and certain they could move. They had their eye on a luxurious residence in another part of Rome that was in the middle of construction. For now, Rossano had something else on his mind which had nothing to do with movies.

He was organising a beautiful ceremony to celebrate their fifteenth wedding anniversary. That their family boycotted their wedding in 1940 had rankled and, although relations didn't suffer, he and Lydia decided to renew their wedding vows at a church close to the family homes in Florence. This time, everyone would be attending.

BEHIND EVERY
SUCCESSFUL MAN

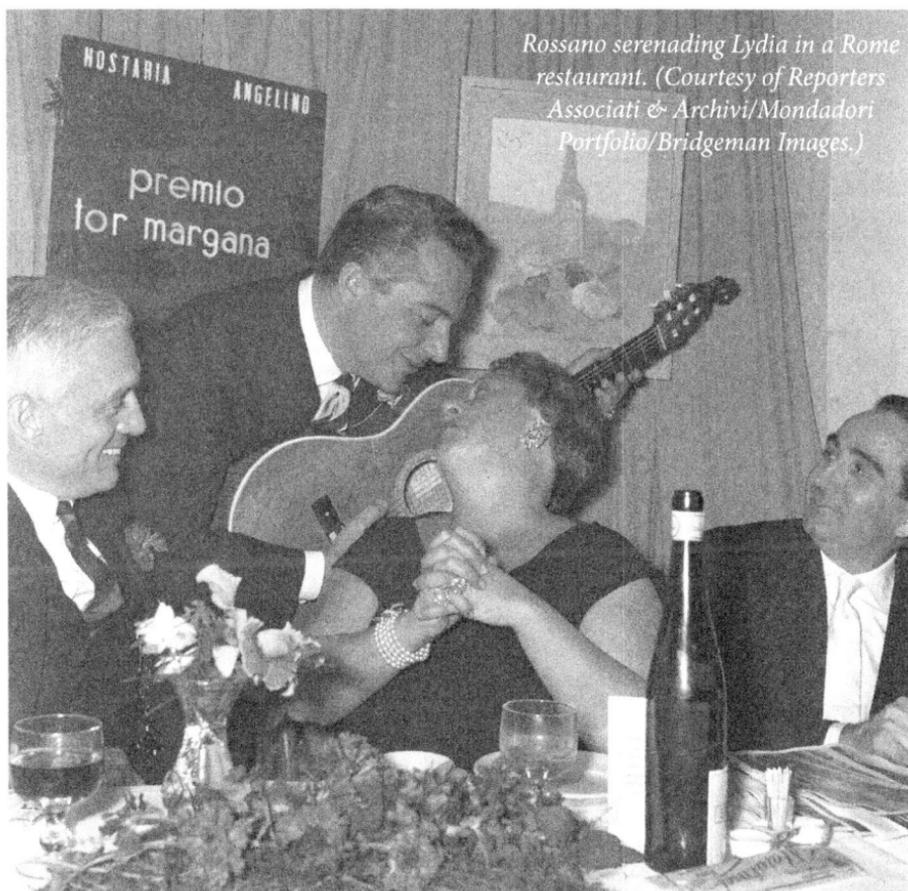

Rossano serenading Lydia in a Rome restaurant. (Courtesy of Reporters Associati & Archivi/Mondadori Portfolio/Bridgeman Images.)

W e are standing in what was the San Iocapini church in Florence. It is now Greek Orthodox but in 1955 it was a Catholic church just a short distance from the home of Rossano's widowed mother. The back of the church faces on to the River Arno and, like most churches here, it is ornate and beautiful.

It's not much to look at from the outside; railings separate it from a narrow road that leads between the Ponte Vecchio and Ponte Trinita. Three feet behind the railings is a wooden door. The church is relatively small compared to many in this area but spectacular, nonetheless. Ahead is the apse and chancel with ornate carvings and religious paintings in gilded frames. Above, we are treated to a vista of biblical scenes. The colour scheme throughout is white and cream which helps to highlight the gold paintwork, statues and frames.

Rossano, dressed in a dark suit, wanders down the nave, no doubt remembering the day he and Lydia knelt at the altar on their fifteenth wedding anniversary, renewing their wedding vows here in front of family and friends.

I, on the other hand, am thinking about the work I put in that resulted in me being here.

Rossano and Lydia at the beach in Fregene
(Courtesy of Reporters Associati & Archivi/Mondadori Portfolio/Bridgeman Images.)

The fact finding for this biography, especially where Rossano's marriage is concerned, was carried out in dribs and drabs but, after several months of work, I had sourced more than three hundred articles and interviews, spanning four decades. A handful were written by Rossano and these were some of the most telling because he did not touch on the clichéd romantic image.

Of one thing there was no doubt: he adored Lydia.

She is mentioned in the majority of publications and always with great affection. He relied on her in so many ways and, although he hinted at moments of indiscretion, it is obvious that no woman could drag him away from Lydia even though a few determined ladies did try!

As with the chapter on *We the Living*, I make no apologies for the time taken over this part of his story. This anniversary seems a good time to delve into the Brazzi marriage – not just the first fifteen years but the full forty-one; his feelings toward Lydia, his moments of indiscretion and, as importantly, what Lydia might have thought of them.

Rossano takes a seat next to me on the front pew.

'You know, my wife is wonderful. She's intelligent, funny, attentive and very feminine. And she greets me, every time I walk through the door, she welcomes me as if she has not seen me for months. That's why I like to go home. I love being at home – Lydia encompasses everything I want in a wife. We have gone through many trying times, including war and poverty. When my career collapsed around me, she supported me. When I spent all of our money on feeding prisoners of war, she supported me. A lot of women would not do that. Without her, I would not have been a success. She is the best thing that ever happened to me and every year, I loved her more.'[188]

He quickly turns. 'Don't misunderstand me, we argue – all the time, always we are bickering about something; but we love to argue, it is stimulating for us. Occasionally, we rage at each other. We both have fierce tempers but, you know, we never hurt each other – our arguing is never nasty or vindictive. Of course, I am no saint but Lydia, she does not have a jealous thought. Not one.

'This was a special day for us: the organ played, we had a choir, candles, the bells rang. It was special because our families were there

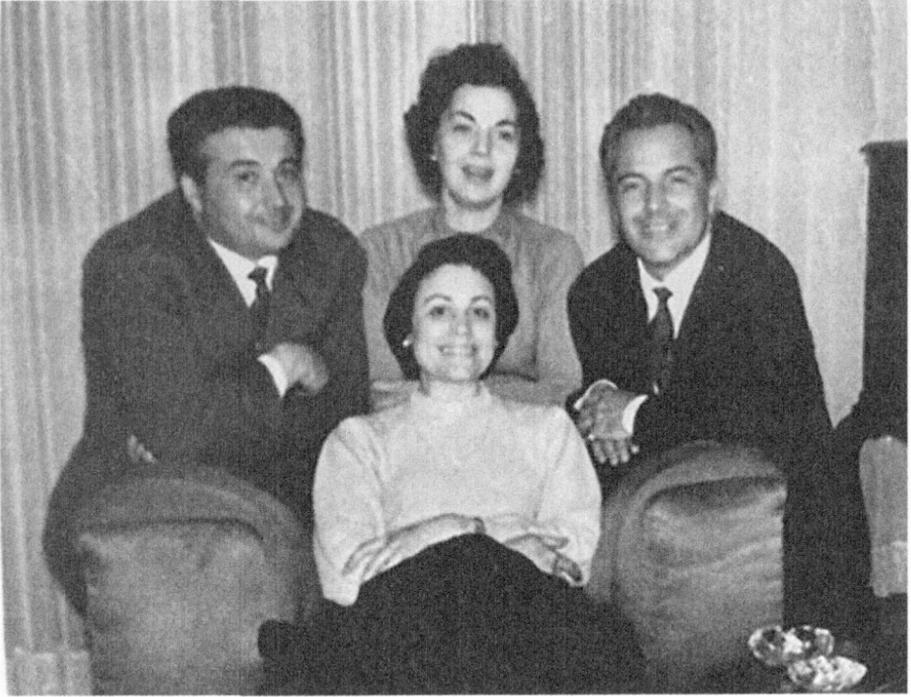

Siblings, Oscar, Franca and Rossano. Seated is Maria, Oscar's wife.
(Courtesy of Carlo Fiorentini.)

– all of them, aunts, uncles, nephews, nieces. You know, we are a tight family unit. I love them all and we were together as much as we could be. So, to have them here witnessing this service, well, I only wish that my father had been alive. My friend, he sang "Ave Maria", I won't lie to you, I cried.'

Rossano had asked a famous opera star to sing "Ave Maria" but, unfortunately, the singer's name is not listed, and the family cannot remember who it was.

Rossano's nephew Carlo attended the service and admits that, being a typical nine-year-old boy, he was bored stiff and the service seemed to go on forever! 'I remember the church was very cold and very dark and I couldn't wait to get outside into the sunshine. I do remember, when the opera singer sang, that my uncle was very emotional. I just wanted to get out of there!'

They did eventually "get out of there" and were greeted outside by fans shouting out their best wishes. The family then made their way to

Family photos taken at a local trattoria after the renewal of the wedding vows. (Courtesy of Carlo Fiorentini.)

Rossano's mother's house to continue with the celebrations and, later still, to a trattoria.

Having family and friends attend was clearly joyous for them but Rossano and Lydia also received a benediction from Pope Pius XII.

'How did that happen?'

'I told you that my uncle was the Archbishop of Bari and later Cardinal of Naples and he was based at the Vatican and I was in the Guard, so I went to the Vatican often to help with ceremonial occasions. Of course, during my time with the Resistance I was in and out of that place when we ran short of funds or hiding places for escaped prisoners.'

'And this led to being acquainted with the Pope?'

'Not exactly. There was an incident that happened, outside of the Vatican and his Holiness had reason to speak to me about that.'

Rossano had pledged to stay silent on the matter and he did. The subject arose just once in the form of a letter and an obscure newspaper clipping. When this came to light, he confirmed what had happened but never spoke about it publicly and the information was never leaked. The brief news article and letter disappeared into a storage facility.

'What happened that had to be so secret?'

(Please note, wherever possible and to be transparent, I have attempted to substantiate everything in this biography by checking and double-checking information. The story below was verified by two sources, including Rossano. I would have preferred some verification from The Vatican but was unable to obtain this.)

Early in his incumbency, Pope Pius XII visited the Sisters of the Poor, a short distance from the Vatican, and this became a routine part

of his schedule. About the same time every week, he and a small party made their way out of the Vatican to visit them, stay for a little while, then make their way back. There was no pomp and circumstance – no ceremony.

On the day in question, Rossano had volunteered to escort the Pope.

Also on that day, a man from a dysfunctional family was planning to assassinate the Pope. This man had been arrested several times for sexual offences, including rape, and had been abused as a child. The inner turmoil he was suffering had turned him against religion and, in particular, the Catholic faith. As a result of this, he had decided the Pope must die. He planned his attack meticulously and had, for several weeks, studied the Pope's schedule. The excursion to visit the Sisters of the Poor would be, he deemed, his best opportunity as the Pope had limited protection and never deviated from his route. It was Holy Saturday, the day before Easter Sunday. Armed with a large kitchen knife, the man entered Rome and waited. Hungry from his journey, he stabbed a man to death for some fruit.

The Pope and his small entourage made their way out of the Vatican in a carriage and proceeded toward their destination. A short while later, they began their return journey. As they approached, the would-be assassin, brandishing his knife, leapt into the carriage and attempted to murder the Head of the Catholic Church.[189]

There are no reports of this anywhere online. I approached the Vatican; initially, they did not answer my emails. When eventually they did reply, they claimed not to have any information about it. Having discovered how this information was leaked, I believe they themselves may not have known or may not have documented it, officially.

When writing this biography, I followed the trail of investigation behind the US edition of the *This is Your Life* programme, aired in 1960, that featured Rossano as the subject. I managed to secure the paperwork which consisted of telegrams back and forth to Italy to confirm who would be travelling to the United States to appear on the show, who needed passports and what flights they were on, etc. Most of it was irrelevant.

But, in amongst the trivia was a letter from a viewer (written after the programme had aired) enclosing a small newspaper clipping, asking

why no mention had been made of the news within that article, saying that surely it warranted a mention on the programme.

The clipping described, in a very flowery old-fashioned style of writing, how an assassin had attempted to kill Pope Pius XII. It goes into great detail about what happened, how the man had planned the attack and how he was later judged, by those who knew him, to have had mental health issues.

It further describes how a papal guard foiled that attempt and fought with the would-be assassin who was eventually killed by the guard.

Apparently, before returning to the Vatican, the Pope insisted that everyone present should promise him that no mention of this incident would be made to anyone. This was to remain private between them and never to be spoken of again. Those promises were given.

The following day, Pope Pius XII delivered his Easter Sunday prayers to the masses. Later that afternoon, in a private meeting, he bestowed thanks and blessings on the papal guard who had saved his life – Rossano Brazzi.

The article is American and is not a prominent piece. Rossano was not a "name" at that time. He couldn't have been, otherwise the journalist would have pounced on that. His name appears in the last sentence of a thousand-word report and the journalist simply describes him as a papal guard, "a young man called Rossano Brazzi".

'I don't know how they [the newspaper] found out about that. When this happened, the few of us that were there swore to his Holiness that we would not speak of it and I stayed true to my word. An attempt on the Pope's life would have had consequences so he wanted nothing to be said and, you know, we all made that promise. Obviously, someone in that group couldn't keep their mouth shut.

'The people from *This is Your Life*, they rang me a few weeks after the programme was aired and asked if it was true and I said yes, it was true, but that we had sworn to say nothing.'

'On the renewal of your wedding vows, the delivery of a benediction from this Pope was, therefore, personal.'

'Very personal. I felt very honoured to have this. It was a wonderful

day and it was particularly special to have my sister there. She had flown from Buenos Aires with her family to be with us.'

He was clearly very close to his sister.

'I used to get mad when I thought of them in Buenos Aires – it's too far away. You know, one time I was down there – I was doing some filming, in Brazil, I think, and of course I went to stay with them. I sat down with Franco, my brother-in-law, and I said to him, "Nice house, Franco. If I were you, I would redo the bathroom and kitchen, repaint it all, and then set it on fire. Why the hell aren't you coming back to Italy?"

'I never really got over Franca being so far away. The rest of our family were here and she was thousands of miles away with the children. I did not like that.'

Getting back to Lydia. 'At this point, after fifteen years of marriage and as you were now a big movie star, loved and adored by women all around the world, what was your secret to a happy marriage?'

'Simple. I chose the right woman.' He grins, lighting a cigarette. 'But there is more than that – it is about compromise, tolerance. When you are first together, there is an intensity in love and, of course, sex is a part of that passion, but that can't stay with you – that passes and that's when some marriages fall apart. You have to see the differences, not just the similarities; the same as our parents and grandparents had done.[190][191]

'I can tell you, if any other woman did some of the things that Lydia did, I would resent them but, with Lydia, I know what she is thinking, I know her reasons for doing this and she is the same with me. I know I annoy her at times, but we understand that. It's a different sort of love and a much more powerful one because it comes with time, it comes with the experiences that you have gone through as a couple; the interests that bind you, even small things like cooking, playing cards, listening to music.[192]

'I make the decisions but, you know, Lydia governs the home; she is the one who keeps my life running perfectly. I would not cope without her. She manages me, helps me, she praises me…' he dips his head to me, 'when I deserve it. When I walk through my front door I always feel she is waiting for me and that is a wonderful feeling to have. I have never asked myself why I got married. I can't imagine life without Lydia.'[193] He leans forward. 'If I had my time over, I'd marry her again.'[194]

A family friend once told the *Saturday Evening Post*, 'They really are the happiest of couples with a true joy in being alive and having one another.'[195]

Another observation was made by a man who ran the newsstand just along the street from where Rossano and Lydia lived. He remembers them walking out often and, even after years of marriage, he recalled them strolling hand in hand as if they were still newlyweds.[196]

But, despite the great love Rossano had for Lydia, there had been many moments of indiscretion. His nephew, Carlo, said he had two lives. This is what he had to say:

'He loved my Aunt Lydia more than anything else and he loved being at home with her. But he had two things going on – sexual adventures and home were two different worlds for him. The family knew it, he knew it and he didn't hide it, she [Lydia] understood it. My grandmother [Rossano's mother] was not happy with the womanising and she got mad with him a couple of times.

'I remember he had affairs in Argentina. I know one time when he was filming in Argentina, and he was living in a big place just outside of Buenos Aires with a swimming pool and a lot of bedrooms. There was a lot of people living there – Ann-Margret and her husband and part of his crew and my mother stayed there for a few days with my sister. I used to go occasionally.

'But these ladies would show up at the house and there was a stewardess; she was very good-looking and she used to come over when she flew into Buenos Aires. She was obviously one of my uncle's girlfriends. It figured because she was very good-looking. And when my parents cleaned out the last apartment that he was living in they found evidence of that.

'This affair with the stewardess went on for months. Lydia was in Italy taking care of her brother because he was sick. He had others, too, some of them were just a one-time fling, others went on for months. He liked it, it was a sport for him. With his brother, Oscar, it was the same thing, and, like Lydia, his wife accepted it. As my Aunt Lydia grew older, she was more attracted by other aspects of the partnership's intimacy, and he always went back home.

'All of their friends in Italy were like this and they talked about it as a natural thing, a peripheral thing, like going to the stadium to watch football; for them, it was a cultural aspect of a man's life. My grandfather, Adelmo, from what I heard, was also like that.

'For women that worked in the movie industry, the environment invited that behaviour, they were chasing the guys for physical reasons and, possibly, for prestige. I don't know but it happened. It was not unusual.'

Having read a number of autobiographies and biographies of the various stars of the golden age of Hollywood, I am of the opinion that they were all at it like rabbits!

This marriage was, therefore, littered with Rossano's "sexual adventures" and, interestingly, in the hundreds of articles and interviews I've read, he seemed to manage this with relatively little scandal. Indeed, most magazines reported that he was devoted, dedicated, true and loyal to Lydia – a model husband with no hint of indiscretion.

Early on in his career, however, one particular actress propositioned him and this became quite a piece for the gossip columnists.

The Mexican actress, Maria Felix, who had starred in two films with Rossano, was so obsessed with him that she offered to buy him from Lydia for $2 million plus her jewellery. She would not settle for being the lover and Rossano admits that he loved her very much. Such was her determination, she telephoned the Brazzi home and managed to get through to Lydia. On connecting with her, Maria demanded that Lydia file for divorce.

Rossano remembers the incident well. 'It's impossible to forget it. I didn't know she was going to call but, you know, Lydia… she dealt with that.' He smiles. 'You know what she said to Maria? She said, "Go ask Rossano if he wants a divorce. See what answer you get." I went to her dressing room and there were scenes, you know? She threw stuff at me and she smashed a mirror over my head. I slapped her to calm her down.'[197]

'Did you often slap women?'

'No! But I tell you, if a woman slapped me, I'd slap her right back but, on this occasion, it was the only thing that stopped her. She was hysterical and, you know, that slap broke one of her teeth. Of course, I paid to have that fixed and, I tell you, I did love Maria very much but I would never have left Lydia.[198]

'I don't believe in divorce [divorce was illegal in Italy at that time] but I do like to flirt and Lydia is fine with that. And a man flirting with a beautiful woman shouldn't send his wife to the lawyers. That's preposterous. Lydia does not think that way and neither do I. If I take a woman out to dinner, where is harm in that? Many American women will say, "but you are married" and I say to them, "I'm not asking you to marry me, just to have dinner."'[199]

'It's clearly more than dinner. Lydia doesn't mind?'

He grins. 'Lydia is wise, she never asks. If I have said that I am coming home for dinner, I'll call her hours before to say that I won't make it. I don't want her making dinner for me if I won't be there. I always confirm the time I will get home, and I am always home when I say I will be.'[200]

'But, with Maria Felix, surely what happened was more than just flirting.'

His expression suggests that he knows this. 'We rarely argued about these things, but I know that Lydia was not so happy about being telephoned like that. I would never intentionally hurt Lydia and I have always tried to make sure she knows she is the most important person in my life. These indiscretions, they are not serious for me and I have never behaved in a way to make Lydia resent me. Jealousy and resentment, they are a sure way to break a marriage down and we never had that. Ever. For Italians, love is a game, it's fun. You Anglo Saxons, you take love so seriously.'[201]

'These first fifteen years of marriage had seen you both conquer many things – marrying under the cloud of parental disapproval, the risks and dangers during the war, losing everything and having to start over again.'

'And these are also things that can break a marriage but, you know, we were stronger for it. I was tempted once in my life, seriously, but

when I thought about what I would lose, I quickly came to my senses. I know I have the best wife a man could possibly want.[202]

'The trouble is, I fall in love easily and I am like a teenager when that happens but the thought that I may lose Lydia...' He smiles. 'And, you know, she is clever. When we go out together, my focus is on Lydia and Lydia only. I see beautiful women but it's not right to look when you are with your wife. Then *she* points out the lady and *she* say to *me*, "Look at that beautiful lady."' He throws his hands up in the air. 'What am I supposed to do?'[203]

His expression is suddenly serious.

'My mother, she rarely interfered with our marriage, but I remember once, another relationship got into the headlines. I was starring in a film with Agnès Spaak. It was, I think, in 1965, we were filming *Un Amore* and my friendship with her became public. My mother was round to our apartment straight away and, you know, she slapped me. I was fifty years old, and she hit me – hard. She was furious at me for allowing this to get out but, I tell you, I took it. I understood.'

While Rossano and Lydia were kneeling at the altar in January 1955, one of those "adventures" had resulted in a woman getting pregnant. She would, in July of that year, go on to have a child.

Because Rossano never spoke about this, I had absolutely no idea whether the child existed or whether the story was made up by an obsessed fan. If it was true, did he know he was a father and, if he did, was he in contact with the child? There were rumours that the woman claiming to have had an affair with Rossano was mentally unstable and had made everything up. I was certainly inclined to believe that as I couldn't uncover any information to collaborate her claim.

It is only when I eventually established contact with the family that this other life of Rossano's was confirmed. Yes, he was a multi-relationship man – he adored women. No, Lydia didn't mind. Yes, the family knew about it, and so on. It was kept within the family and stayed there.

The mother of Rossano's child was, apparently, quite forward in her desire to have a baby and she wanted the father to be a celebrity. She was in Italy at the time and befriended Rossano who was happy to oblige!

The mother returned to her home country where she brought the baby up. The Brazzi family were of the opinion that Rossano played no part in the child's upbringing.

Most of Rossano's interviews with the press were during the 1950s and early 1960s. In the many hundreds of articles and interviews published in magazines and newspapers around the world, Rossano does not speak of "affairs", "sexual adventures" or the fact that he had a child. He often states that he is not a saint but, of course, that could mean anything.

Very often, it is clear to the reader that he is "toying" with journalists. He gave them what he thought they wanted, even though it might not have been true. He loved bending the truth, exaggerating and telling lies – it amused him.

Glynis Johns, who starred with him in *Loser Takes All* had this to say when watching Rossano with journalists. 'He says things which make his publicity man shudder, and the reporters jump with glee. He says it all with his tongue in his cheek – but it's not always printed that way.'[204]

Indeed, both Rossano and Lydia liked to tease reporters because they took the couple so seriously. One journalist reported that Rossano had returned to his Beverly Hills home in a foul mood one evening. Lydia was serving dinner for a number of guests. When Rossano arrived home, he upended the dining table into the nearby swimming pool. Lydia calmly ignored the outburst and took the group to a nearby restaurant, telling Rossano to remain at home to cool off.

The story is not true, they simply enjoyed toying with the press.

One big surprise, especially in that era, is that he never appeared in the Hollywood gossip columns.

He grins. 'Some of those columnists were manipulated by the owners of the studios to help publicise their films. I got over that quite easily. I met several of the top columnists in Hollywood at one time or another and they were always after some sordid detail but, I tell them, I am Italian. I am a part of the mafia. You spread rumours about me, and you will be sorry.'[205]

He was joking, of course, but not one gossip columnist wrote about him in anything other than glowing terms.

Those in Rossano's circle knew of his philandering, including his agents, Gene and Hank. Gene Lerner discussed the topic in *Hollywood sul Tevere*.

Some women avoided a potential affair or one-night stand. A large proportion of women, however, were happy to spend time with him in the biblical sense. Some, unfortunately, fell in love with the man and Gene and Hank had to step in on occasion to convince a besotted woman to back off.

It appears that Rossano wasn't the only one making the first move. A number of women were quite brazen and simply knocked on his dressing room door and invited themselves in.

Lydia, they explained, was aware of Rossano's extramarital activities and, as we have heard from Carlo, she tolerated it; as did many wives in Italy at that time. In public, she refuted all allegations and stood by Rossano, insisting that he was a loyal husband.

No matter how many affairs and one-night stands he had, Gene and Hank confirmed that Rossano always went home. Home is where he loved to be and, as Carlo mentioned to me one time, home is where he shut the door on that "other" life to be with Lydia.[206]

Actress Shirley Jones, who starred with him in *Dark Purpose* in 1964, is one of the few who actually mention being propositioned. (Remember, in those days, if a woman was to admit to sleeping around, her career would have been over.) In her autobiography, *Shirley Jones: A Memoir*, she describes how the pair of them got on well and how, after filming had finished one day, Rossano asked if she would like to have dinner and get a hotel room.

Shirley had traditional values and told him she was married. Rossano said that he was also married but that Lydia wouldn't mind. Shirley did mind. Rossano cast the rejection off and didn't pursue it.[207]

His co-star in *La Contessa di Castiglione*, Yvonne de Carlo, recalls an amorous advance in her autobiography, *Yvonne*. Rossano made his move early on in filming and convinced Yvonne to have dinner with him. They had a wonderful time, and he walked her back to her hotel room where he promptly got her in an embrace with a flow of romantic

dialogue. Like Shirley, she declined the invitation to take the fling further and, again, did not pursue it.[208]

In her book, *A–Z of Men*, Diana Dors expressed great admiration for Lydia. She understood that when her husband did go off on one of his adventures, she wouldn't let him into the bedroom until he'd presented her with some expensive jewellery![209]

This confirms his nephew's observations about his uncle's technique. 'He never went against any woman's will, nor did he insist much if rejected – his sense of respect for others would not allow that to happen – but he didn't have any remorse after successful opportunities.'

As he renewed his wedding vows here in 1955, Rossano must have counted himself very fortunate to have such an understanding wife who loved him unconditionally. When I asked the family what he loved most in life, the answer was unanimous: Lydia and his home. His most frequent observations about his wife, spread over four decades, were:

In spite of all the beautiful women he was surrounded with, he found Lydia the most interesting; without her he felt incomplete; he never once fell out of love with her and she was not only his wife but his lover, his best friend and soulmate.

'You know, when we were older, we didn't argue so much, we were more complete, because of the years we had spent together.'[210]

'And what did Lydia think about your "indiscretions"?'

Rossano looks up to the ceiling of the church and studies the angels above him. 'I think you need to speak with her about that.'

A few days later, I arrive at the Via Sistina apartment and the bubbly bundle of energy that is Lydia ushers me in. The dogs are quick to fight for attention and Pedro is on the sideboard, whiskers twitching. The doors by the Juliet balcony are wide open.

'No Rossano?'

'He is in bed with a cold.'

She invites me to sit beside her. Irma brings in coffee and enticing pastries. The dogs sit patiently examining the edible items closely.

Asking Lydia about her husband's "sexual adventures" seems very

wrong but, if I am to write a truthful biography, I need her input. She speaks clearly and her responses are considered.

'There would be something wrong with Rossano if he did not look at a beautiful woman.' She laughs. 'And if women don't look at Rossano, we would go out of business! When you marry, you don't suddenly become blind to the opposite sex. Rossano does not stop looking – that would not be natural. When we are together, I know that he sees pretty women but he pretends not to notice them. You know what I do?' She beams and repeats the story Rossano told me earlier. 'I know he wants to look; I point them out to him. I say, "Rossano, look at that lady over there, she is beautiful." He looks and agrees, but he does not linger on her.'

'And when he's on his own?' She looks at me.

'How would he compare if he had only experience with me? I am not jealous – I have no need to be jealous because there is nothing to be jealous of. If I was not the woman for him, do you think he would come home to me? If I was not the woman for him, do you think he would spend hundreds of dollars every day calling me from far-off places and writing long letters? Why would he do these things if I was not in his heart and in his mind? He comes home an hour late here, an hour late there.' She blows out her cheeks. 'It is of no matter.'[211]

This woman knows her mind and exudes extreme confidence in herself and their relationship. She knows Rossano; she knows what he likes, what he loves and why he will never leave her.

'Can you expand on this?'

'One thing Rossano will tell you is that I am always cheerful, that I am intelligent, I am interesting, I keep a good home, I look after him and my cooking will always keep him here.' She chuckles. 'Always. His favourite dish at the moment is minestrone. I cook it very slowly. He loves it. We have good conversations. We laugh together, we live for today, we don't take life seriously. And we have gone through many situations together, sometimes very bad situations. He is a good man and would never hurt me.[212 213] But it is my personality that brings Rossano to me.'

The *San Bernardino Sun* interviewed Lydia at the height of Rossano's fame and she made some telling observations about husbands and wives.

'When a husband comes home, he does not want to come home to a complaining wife. In America, I saw many wives complaining about their husbands – in front of other people! Some of them would vow to do something to their husband in retaliation for something they had done. I would never criticise Rossano like that, not in public. That, I think, is not good. Men are more sensitive about these things than we realise. Rossano would be shocked if I did that to him. It would be humiliating for him.[214]

'And our love is different to these passions that he has in his heart. These sudden passions are not lasting.'

She goes on to tell me that anniversaries and birthdays are always special in the apartment and that those celebrations last for several days, involving meals out, evenings with friends at the opera and intimate dinners at home.[215]

'I never interfere with his work. I don't go to the studios; I don't ask him about his work – if he wants to tell me then I will listen. It is easy being Rossano's wife. He is a good boy. We fight, of course, but I cannot stay angry with him.

'Although, I did worry him one time when we had one of our big rows. We have them now and then and I was furious with him, so I didn't talk to him. For two days. I went about the house singing and talking to the dogs, but I didn't talk to him. Even when we had visitors – we are always having family call in – I talk to them, but I didn't talk to him. After two days, he looked so sad. He hated it. He said, "Lydia, please, talk to me!" He looked like a little boy who had lost his mother. I couldn't stay mad any longer.'[216]

'And you honestly did not get jealous?'

'No. After years of marriage, any woman is more alluring than the wife because she is always a thrill, an excitement, an adventure. Rossano likes excitement but then it quickly wears thin. I realised when we first were together that I had to trust him. He works with beautiful women so he will be among beautiful women. And I do trust him. I have said to him sometimes, "You poor man, don't you wish you were free of me?" And he gets in such a temper and he says, "Don't say such things. I'm happy. I have everything I want."[217][218][219] I travel to most locations with

him because he wants me to. We take the dogs and we have fun. If a man has permission to flirt, you know it takes away a little bit of the fun for them.'[220]

The door opens and, for the first time, I see a Rossano far removed from the charming and elegant man that the public normally sees. He's in pyjamas and a dressing gown. His hair is ruffled, he looks very sorry for himself, and he's clearly congested with cold. Through glazed eyes, he acknowledges me.

'The pretty one has risen,' says Lydia to me with a smile but is immediately attentive to him.

'*Cosa stai facendo alzandoti?*' (What are you doing getting up?)

'*Volevo del succo d'arancia.*' (I wanted some orange juice.)

'*Te lo porto io. Torna a letto.*' (I'll bring it to you. Go back to bed.)

'*Grazie.*' He frowns at the open windows and gesticulates. '*Chiudi la finestra. Vuoi che si trasformi in polmonite?*' (Close the window. You want this to turn into pneumonia?)

He shuffles back to the bedroom. Lydia ignores the request to close the window.

'Poor boy.' She heads to the kitchen and prepares a drink which is, of course, prepared with love. She places a jug of orange juice with a crystal glass on a tray, along with a napkin and some ice and water. Before going into the bedroom, she stops and turns.

'When a man is happy at home, he stays at home. And Rossano, he is happy at home.'

This marriage does amaze me, and I am in awe of the couple in some respects. They are totally at ease with each other, they tease each other, they argue; they understand and respect each other. They pretty much grew up together and their bond is almost tangible. It is obvious when one of them enters the room how deeply they care about each other simply by the way they react.

This "other" life that Rossano had was something that Lydia shut out publicly. When journalists became intrusive, she would deny any untoward behaviour by her husband and express horror that they would

suggest such a thing. Indeed, in the conversations I have had with these two, much of what they say hints at affairs rather than confirms them.

All of Rossano's "sexual adventures" were either daytime flings or lasted a few months at the most. However, one woman was in his life for thirty years and was kept out of the public eye all of that time. It wasn't until after Lydia's death that news of this woman emerged; Rossano will go into more detail about that later.

For now, we are firmly ensconced in the mid-1950s. A trend has hit Rome, sending ripples out to the rest of the world.

Chapter Fifteen

THE SWEET LIFE

Rossano is wearing tailored trousers and a loose, rust-coloured casual shirt worn outside of his waistband.

We are in the dressing room of his penthouse apartment overlooking the Villa Borghese gardens. The doors to a long wardrobe are open and I am looking at row upon row of suits, perfectly hung, from lightweight summer ones to the darker wool ones for winter.

Rossano had over three hundred suits and rotated them frequently. If he purchased more, he would give some away; one lucky recipient being Piero, Rossano's chauffeur.[221]

To go with all of these suits, he needed plenty of shirts (more than four hundred), ties, cufflinks and shoes – the latter, of course, he knew plenty about – many handmade, of the finest leather.

'You know, my sister, Franca, she always complained to me about shoes.'

I give him a quizzical look.

'She loved the fashion, but she often said to me, "Rossano, I hate wearing high-heeled shoes. By the end of the day, my feet are aching. I want to wear flat shoes, like you." I said to her, "Well, wear flat shoes." And she glared at me. "Who will look at my legs if I wear flat shoes?"' He chuckles. 'She loved shoes, and handbags. She was very stylish.'

He locks eyes with me.

'Did you know it was me who helped to launch Angelo Litrico?'

'Yes, I did. What a rags-to-riches story that was!'

It is likely that most readers will never have heard of the wonderful Angelo but, to introduce him, Rossano insists we walk the streets of Rome. He escorts me into the beautiful Villa Borghese gardens, just across the road from his apartment, where we stop for an ice cream. The dogs accompany us. Let off the lead, they scamper off to seek out trees and chase pigeons.

'You have heard of *La Dolce Vita*?'

'The Fellini film? Of course. Who hasn't?'

'You know the lifestyle?'

The lifestyle. Yes. *La Dolce Vita*, the film, was released by Fellini in 1960. It's a three-hour explosion of film that caused quite a stir with the population, many of whom likened the director to the devil incarnate. All sorts of insults were thrown at him. It was the content (sex, prostitution, adultery) that shocked those people.

However, to another part of the population this highlighted a revolution, one that had been brewing in Rome for several years. Fellini was a part of that. He took it, added his own unique touch and the world was treated to *La Dolce Vita*: The Sweet Life.

In the 1950s, the young people of Rome were bursting out of the terrible war years and creating something special. Hollywood on the Tiber was established, and A-list celebrities arrived by the dozen. Most descended on the fashionable Via Veneto area of the city, visiting Harry's Bar, the Café de Paris and Georgio's Restaurant, along with the many other clubs and establishments in between.

You could not walk down Via Veneto without bumping into celebrities or seeing them eating and drinking in the various restaurants. Richard Burton, Elizabeth Taylor, Kirk Douglas, Sophia Loren, Gina Lollobrigida, Anna Magnani – the list was endless and Rossano and Lydia were part of that crowd. Rome was "cool" and many functions along this avenue would still be in full swing well into the early hours.

'I tell you, Via Veneto was not a place to be during the Occupation. The Excelsior and Flora hotels along here, they were places where the SS visited often, like a second headquarters. But Rome was the place to be in the 1950s. Not the whole city. People think that the whole of Rome

was living *la dolce vita* but that wasn't true. It was its own area. Like in your country. In the 1960s, London was the place to be, wasn't it with… what did you call it?

'The Swinging Sixties.'

'That's it. Everyone wanted to be in London but not the whole of London, I think?'

He was right. The atmosphere of the Swinging Sixties was limited to areas such as Carnaby Street and the King's Road and just a few hundred people could lay claim to actually being a part of it. The bands that had conquered the world at that stage were mainly from England.

'And later in the decade, everyone wanted to be in San Francisco, with the flower power and the peace. And the music, too, it had shifted to America. Again, just a few streets.' He runs a hand through his hair. 'Everything changes. For us in the fifties, the place to be was Rome.' He calls the dogs to heel and attaches their leads. 'Let's go to Via Veneto.'

It doesn't take long to arrive at the heart of what was *la dolce vita*. Via Veneto is one of the most modern avenues in Rome. Built in the 1880s, it is lined with huge, elegant buildings and one of the most expensive areas in which to buy property. Some of Fellini's film was shot in this area. Just around the corner are Rossano's old flat in Via Sistina, the Spanish Steps and the Trevi Fountain.

'Of course, this is different to how I remember it. The Café de Paris has closed down, Harry's Bar is not the same and Georgio's, which had my recipe on its menu, they have gone too.'

It's a shame that I cannot see this place as part of the living breathing "sweet life" that Rossano knew. It really is just another street now, albeit an impressive one. Georgio's, now renamed Orlando's, takes up a corner at Via Sicilia and is, unfortunately, closed. Rossano, a keen cook, had developed a chicken recipe that was quickly snapped up by the head chef there. He promises me a copy.

'It's nothing special except that I use a more unusual wine,' he says. 'That's what makes it different.'

Harry's Bar remains open at the end of Via Veneto, directly opposite the Villa Borghese gardens. A faded photo of an older Rossano is outside.

It retains the old-fashioned charm of yesteryear but, of course, *la dolce vita* has long since disappeared.

Regardless of that, we head inside and find two velvet wingback chairs to sit on. The floor is marble and there are ornate lamps and wall-lights. It's intimate and in the background, Frank Sinatra is singing about how nice it is to go travelling.

Angelo Litrico, Rossano's tailor in Rome (Courtesy of the Sartoria Litrico Archive All Rights Reserved by Sartoria Litrico Società Benefit S.r.l. © www.sartorialitrico.it)*

'Are you going to tell me about Angelo Litrico?'

'*Certo!* One moment.' He needs a cigarette. Our coffee arrives. 'Would you like a pastry?' Without waiting for an answer, he requests a selection. 'You know, I have always liked the Italian cut for a suit but Angelo, he took it further. His suits were like putting on another skin. Every bit of a suit I bought from him fell just right.'[222]

'Is it true that you insisted the suits you wore in films were Italian?'

'As much as I could. I didn't like the suits in America – they were not cut so well. In Italy, there is an elegance, a sophistication with the design, the cut. When I chose my costumes for *South Pacific*, I got the artist's impressions and had them made here, in Rome. Not with Angelo.

The studios had a specific tailor here who made suits. But, my personal wardrobe, there were many from Angelo.'[223]

'Where did you meet him?'

The pastries arrive. He offers me one and peels away a chunk for himself. The dogs also get a portion each.

'At an opera, here in Rome. You know, Angelo, he was a very humble man from a poor background, the oldest of twelve children. From Sicily. Did you know his father was a fisherman?'

'I have discovered that.'

'Angelo did not want that life. He wanted to be a tailor so he learnt that skill. He could have been a tailor on the island but he had high ambition and he would not earn that much staying on Sicily. So, he came here to Rome at the end of the war and was an apprentice. Then, I think, in 1951, he opened his own shop, not far from here on Via Sicilia, close to Harry's Bar and Georgio's. He worked hard and he was very focussed, you know, of what he wanted.'

'And what was that?'

'Rich and famous clients. To do that, he knew he had to move in the same circles as them. By the early fifties he was very skilled, although I did not know him then. And, of course, this was when Rome was entering the time of *la dolce vita*. Hollywood on the Tiber. These things were beginning to happen here.'

'How did you meet?'

He leans forward and takes a bite of his pastry. Flakes filter down. He licks his lips and brushes crumbs off. The dogs are quick to locate those crumbs. 'Well, Angelo, he had saved some of his wages to buy a seat for the opera – at the Teatro Dell'Opera di Roma here in Rome. Those seats are not cheap, I can tell you. For him to meet the people he wanted to make suits for, he had to sit with them – among them – you understand?'

'I do.'

'He bought a seat in the front row.' He grins. 'And he wore something that made him stand out. I was at that opera, and I sat just along from him but I noticed him straight away, because of what he was wearing. He had a green tuxedo on. We were all wearing black and I admit, I was a

little envious. I thought it was stylish, original. When the interval came, I went to find out who his tailor was.

'I found him in the bar and I asked, "Who is your tailor?" He told me the address. He didn't tell me it was him! The next day, Vittorio Gassman and I [Rossano's rival in the Italian heart-throb stakes], we went to the that address. When we arrived there, we saw him working in the corner and I said to him, "You made that jacket?" And he said "Yes." He was very shy about it and, you know, that impressed me. I ordered several suits from him on the spot, including a replica of the evening jacket he had worn.

'I am very fortunate – I never changed size at all during my adult life. For these first suits, Angelo took measurements from me in, I think, 1954 or '55, and he never had to take them again. I had that dinner jacket all of my life. I never got rid of it.'

After Rossano's death in 1994, that green tuxedo was given back to the Litricos by the Brazzi family. The Italian Ministry for Culture Museum in 2008 declared this, and all the Litrico Tailor's shop historical archives, to be a "cultural asset of national importance". It is a beautiful green jacket and one that would not look out of place in the twenty-first century.

*First jacket ordered by Rossano, made by Angelo Litrico in 1955 (Courtesy of the Sartoria Litrico Archive * All Rights Reserved by Sartoria Litrico Società Benefit S.r.l. © www.sartorialitrico.it)*

'Have you spoken to Luca?'

Luca is Angelo's nephew and, yes, I did eventually speak with him.

He was easy to get hold of and more than happy to talk about his uncle. Luca is a quietly spoken man with short greying hair and, like Rossano, has an air of elegance about him. His English was better than my Italian and he spoke with a heavy accent as he confirmed everything that Rossano had told me.

'My uncle moved to Via Sicilia because there was *la dolce vita*. The first actors from Hollywood came to Rome. Hollywood on the Tiber. Buying the ticket for the opera was the best thing he did. He knew he had to make something interesting, so he made that green dinner jacket. When Rossano asked him about the suit, my uncle was very scared and just told him the address. But this was the beginning for him. Rossano was already a big star and my uncle remarked that he was one of the most elegant men. It was Rossano who introduced my uncle to *La Dolce Vita* crowd.'

Rossano's nephew Carlo remembers his uncle wearing a tuxedo when he was in Buenos Aires filming. 'It was just a regular one: black suit, tie with a white shirt, but he radiated perfection.'

Male celebrities and statesmen began flocking to Angelo. Very soon, this unassuming son of a fisherman would go on to tailor for some of the biggest names in Italy and across the world, including for John F. Kennedy, Mikhail Gorbachev, Christian Bernard, Yuri Gagarin and King Hussain of Jordan.

Litrico still operates as a family-run bespoke tailoring business, headed by Luca Litrico, nephew of Angelo and oldest son of Franco, Angelo's younger brother, who carried on the company after Angelo's death in 1986. Luca has recently moved back into Rome from the family country villa outside Rome, with the entire historical archives and all this atelier of men's fashion.

Rossano orders more coffee and pastries. Hank and Gene have joined us and I express my interest in the *dolce vita* lifestyle. 'Rossano, could you give me an example of a typical night out?'

I receive a slow nod; he ponders, sifting through his memories. 'You know one person who was with us quite a bit during this time? Margaret Truman. Do you know who she is?'

Yes, she was the daughter of President Harry S. Truman. She was a socialite but also an actress, opera singer and journalist.

'She was over here a lot during this time with her fiancé, Clifton. He was a journalist, too. The evenings I remember fondly are those spent beginning with a meal and a drink. For me, I liked Georgio's and the Café de Paris, but I think the evening I am remembering was in a restaurant at the Monte Mario.'

This is a hill on the outskirts of Rome that overlooks the city.

'My friend, Walter Chiari, he was an actor and singer here in Italy and very much part of our crowd.' He turns to Hank and Gene. 'You were there, too. We went to the Trevi.'

Gene takes up the story, from *Hollywood sul Tevere*.

'We'd finished dinner and Rossano and Walter were joking about, doing imitations of various film stars, experimenting with how they'd act if a different director were in charge. It was one of those you-had-to-be-there moments but it was really entertaining and fun. Walter grabbed a guitar and the whole group started singing Italian songs.'

Hank shifts forward. 'We wanted Margaret Truman to sing. She had a fantastic voice, but she was reluctant to get up because she hadn't

Rossano, Margaret Truman and Walter Chiari goofing around in a Rome restaurant. (Courtesy of Reporters Associati & Archivi/ Mondadori Portfolio/Bridgeman Images)

performed for some time. But eventually we convinced her. She sang an aria and it was so beautiful.'

Rossano grins. 'At that point someone suggested to go to the Appian Way. We piled into the cars and raced down to Il Palatino.'

The Palatine is one of the seven hills of Rome where the ancient ruins of the heyday of the Roman Empire are situated, including the huge arena where the chariot races took place.

Hank continues. 'I'd never been to Il Palatino in the middle of the night. The moon shone down on those ancient temples, and it all looked magical. When we got there, we just ran wild, leaping and running around the statues and the tombs. Margaret sang again and a few others joined in. We had a few trained singers in our group, and I can hear them now. It was so joyful, so enchanting.'

'Eventually,' Rossano says, 'we made our way to the Trevi fountain and, you know, this was just a year or two after I had made *Three Coins*, so I sang that title song.'[224]

Rossano lights a cigarette. 'Was Lydia with you?'

'Of course. She loved to socialise – more than me. I prefer to stay at home but, once I am out, I enjoy myself. I remember that evening, when Margaret sang. She had been quite shy about it but we encouraged her and, you know, she sang beautifully.'

Most Romans could not afford the *dolce vita* lifestyle. However, many youngsters bought Lambrettas or Vespas and it didn't cost much to order a cappuccino and wear sunglasses day and night. Young women were quick to recreate the designs of the film stars of the day. Rome was chic, fashionable, romantic, stylish and *the* place to be.

British and American stars were lining up to be seen on the Via Veneto and, of course, the avenue was swimming with top Italian actors and singers.

Rossano settles back with a wistful smile. 'This was a good time. We had a lot of fun.'

Although very much in love with her fiancé, Margaret Truman had a soft spot for Rossano Brazzi. There was one event, highlighted by Gene and Hank in *Hollywood sul Tevere*, a dinner, that she and Clifton had been invited to. The seating plan showed that Clifton would be sitting

next to the Swedish actress, Anita Ekberg, who would go on to star in the film, *La Dolce Vita*. Margaret bristled at this. She thought Anita was a bad influence and she requested that Clifton be seated elsewhere.

The organisers sat down with her to explain this would be tough because once you alter one person's location, you have to figure out where to put the next. Margaret remained concerned about things as they stood so some time was spent trying to rearrange all the seating. Her next question changed everything.

'Who am I sitting next to?'

When told that Rossano would be her companion, Margaret suddenly lost interest in where her husband was sitting.[225]

Chapter Sixteen

ONE NIGHT IN ROME

It is a somewhat chilly spring evening in Rome, and we are sitting in a trattoria just along from the Villa Borghese gardens.

Rossano, as always, is the picture of elegance in a stylish dark blue suit, a light blue tie and gold cufflinks. Blue, apparently, is his favourite colour – any shade of it.[226]

Our table for two is in the corner but we cannot escape the laughter coming from Lydia and her friends at the table alongside us. The woman is positively bubbly, a live wire.

'I do wonder if she was ever depressed or sad.'

'Very rarely and, when she is, most people, they do not see it. But I tell you once, when we were in America, in Hollywood. It was that first disastrous visit in 1948. We were invited to a dinner party and Greta Garbo was one of the guests. I was looking forward to meeting her – she was a true Hollywood great, you know? But, when Lydia and I got out of our car, one of our dogs ran out and was killed as a truck drove by. I had not seen Lydia so upset – she couldn't even talk.

'The dogs are our family and to witness this was unbearable, for both of us. When we got in the house, I took her to a quiet place because she just wanted to cry. Greta came over and asked what had happened. She spent a long time that evening with Lydia. She became a good friend and I will never forget her kindness toward my wife.[227] But it's unusual to see Lydia like that. She is a magnet for people because she is so exuberant – so joyful.'

A plate of lamb cutlets garnished with rosemary and a drizzle of oil is placed before me. Alongside, a mixed salad. Rossano has opted for steak and all the trimmings. The poodles have shifted their focus from Lydia's table to ours. He pours me a glass of Chianti.

We're here to chat about the years between *Summertime* and *South Pacific*. This was "his" decade, the period when he was on top of the world. His image gazed out from countless magazines across the globe; fans wore badges bearing his photo and gathered outside the hotels he stayed in when on location; women threw themselves at him, sometimes literally, and reporters couldn't get enough of him.

To keep up with the fan worship, members of the Brazzi family continued to help behind the scenes. Each had a role to play: one (often his father-in-law) replied to letters; one answered the phone; one set up appointments –it was a family business. All the while, Rossano continued filming on the Continent as well as in Hollywood. He made the odd television appearance and took part in a couple of documentaries.

Gene Lerner and Hank Kaufman were managing Rossano's finances, getting the couple back on track financially and negotiating the best deal where contracts were concerned. No one could doubt their ruthless business sense.

They secured agreements that were rare in the early fifties. Lerner had stipulated that he wanted Rossano to be a free agent. Although signed with Universal-International, he could go where he wanted if the film appealed to him, and he would receive a percentage of the gross takings.

In addition, there was the clause that Gene had written into every contract: should the role of Emile de Becque come up in *South Pacific*, Rossano was free to drop everything and take that part. Emile de Becque was a man's man, a French plantation owner, strong, yet sensitive. Because they were intent on Rossano getting this *South Pacific* role, even though nothing had been finalised, Lerner and Kaufman chose roles for him that they felt would highlight characteristics common to the role of Emile.

The Hollywood establishment was happy with this. It had found its replacement for Valentino and was not about to let him be anything else.

Rossano, eager to conquer Hollywood at the time, was happy to go along with his romantic image although this would later frustrate him.

The first English-speaking film to be released after *Summertime* was *Loser Takes All* with Glynis Johns. It was 1956.

Rossano with Glynis Johns in Loser Takes All (Courtesy of STUDIOCANAL)

Rossano, sipping his wine, smiles.

'I have good memories of that film. We shot mainly on location in Monte Carlo but some of the interiors were at Shepperton Studios in England. Once I got to know Glynis Johns, I liked her. She was a little standoffish when we first met but that may have been shyness. We got on well together.[228] I remember we had a scene in a hotel room and one of the lights caught fire, those bedside lights you get. The bulb had got too hot and the fabric went up in flames. The only thing to hand was a bottle of wine.'[229]

'Didn't that make it worse?'

'No, it wasn't real. It was cold tea, I think, something like that. Whatever it was, it was disgusting. Lydia was there, too, with the dogs. She spent time shopping and sunbathing. I was looking for her at one point because the director, Ken Annakin, he wanted a dog for one of the scenes. I couldn't find her and Ken had problems finding a dog because everyone made excuses.'[230]

I had read about this and I am certain this would never happen now,

where so many seek fame; but when residents of Monte Carlo were asked if they would lend their dog for a scene in the film, they all made an excuse.

He chuckles. 'One of them told Ken that her dog didn't like acting! Then I was embarrassed because I couldn't tie my bow tie. I am hopeless with those things, and it was one of the crew who came to my rescue. He joked with me, you know, the suave Continental romantic who couldn't tie a bow tie.'[231]

The film is a good example of a 1950s romantic comedy and reminded me of those starring Rock Hudson and Doris Day. It was based on the short story *Loser Takes All* by Graham Greene (*Brighton Rock* and *The Third Man*). He also wrote the screenplay for this film and, unlike in many of his books, there were no political or religious angles: he wrote it purely as a light-hearted comedy. It moves along nicely, against the stunning backdrop of Monte Carlo. Like *Summertime*, the film had an excellent cast and it is great to see Rossano play a more light-hearted role.

Rossano with Joyce Carey in Loser Takes All (Courtesy of STUDIOCANAL.)

'I enjoy comedy. It gets tiresome telling a woman that you love her. I get scripts where I have to say, "I love you". Then the woman, she says back to me, "I love you, too."' There is an exaggerated roll of the eyes. 'I can't play a love scene like that. That's not real.'[232]

Glynis Johns, probably most famous for her portrayal of Mrs Banks in Mary Poppins, wrote a piece for the film's press release. This is how she describes working with him: 'He moves like a hurricane, argues in a

storm of violent Italian, Spanish and English, and when he kisses you on the set it feels as if you've been hit on the head with an anchor. It's all put on of course, you know it, he knows it, but it doesn't seem to make any difference. It's a wonderful experience acting with this man – though one should not, I feel, be hit on the head with an anchor too often.

'He's a professional actor and a natural man. He has that ability to make you believe every word he says – even when you know it isn't true. This is probably because he always says what *you* want to believe. His manner off the set always keeps you guessing. One moment he is quietly charming, smooth, suave – the perfect example of sophistication and grooming. In another moment one feels that he would not have the slightest compunction in dragging you off by your hair to the nearest cave. And the interesting thing is that one feels one wouldn't mind being dragged off to the nearest cave!'[233]

Did Glynis succumb to Rossano's charms? One cameraman recalls a scene where Rossano and Glynis kiss passionately. When the director yelled cut and the cameras stopped rolling, the pair of them continued in their embrace for some time.

After this film wrapped, Rossano and Lydia found themselves living the dream and, more importantly, earning money. He had paid off all of his debts from earlier in the decade and they had money in the bank. In their book, *Hollywood sul Tevere*, Gene Lerner recollects a pivotal moment when he and Hank were invited to the couple's Via Sistina apartment.

'Rossano and Lydia had asked us round to their apartment on the Via Sistina for drinks. When we got there, Lydia was in the bedroom getting ready and Rossano mixed some cocktails for us. He looked particularly happy with himself and told us that he and Lydia wanted us to be the first to hear their news.

'Well, we wondered what it was. It couldn't be anything to do with film-making because we'd made it clear that we were in charge of that side of things. Anyway, we waited for a while and Lydia suddenly shouted from the bedroom, telling us to close our eyes. Rossano grinned and repeated Lydia's request so we closed our eyes. We heard Lydia come out; we were instructed to look.

'Jeez, I couldn't believe what we were seeing! It turned out that the couple had got all of Lydia's jewellery back from the pawn store and I swear to God she was wearing everything: a glittering tiara, sparkling earrings, necklace, rings, brooches, bracelets. She was festooned like a princess, dazzling in the light.'[234]

Success had arrived. Abundance began to bloom. They moved into the newly built three-bedroom penthouse near Via Paisiello, overlooking the Villa Borghese park, with an expanse of living space and a terrace large enough to land a helicopter. Carlo remembers getting lost on his first visit because the place was so big.

*Rossano on the terrace of his Rome penthouse (Courtesy of Reporters Associati &
Archivi/Mondadori Portfolio/Bridgeman Images.)*

Guests, dinners, receptions, expensive cars and travel became the norm. Three new servants (Dorina, Piero and Maria) joined Irma in the Brazzi household, and they would remain in the couple's employ for many years.[235]

Life, for the Brazzis, was life again but Rossano didn't get a chance to enjoy his new penthouse for long as he had to fly to Africa to film *Legend of the Lost* with John Wayne and Sophia Loren.

He swallows a piece of steak and takes a swig of Chianti. 'That was filmed in Libya. We were in the desert for a few weeks and, I tell you, that was hard work. We were very remote for some of the scenes. Some days, the director had us travelling for twenty, twenty-five miles in a jeep to find a location. By the time we arrived, we felt as if we'd been pummelled. In the daytime, it was over a hundred degrees and at night we froze.[236]

'We were staying in a very cheap motel in Ghadames and it had no heating – we had to wear several layers at night just to keep warm. And you had to check your shoes in the morning to make sure no scorpions were hiding there. Snakes too.

'One area that we filmed in was very interesting: a lost city that had been excavated just a few years before. It was called Leptis Magna, a huge Roman city. The Emperor Septimius Severus was born there. Very impressive. What you see on the screen is that city – it wasn't a film set.

'In the evening, there was nothing to do. We played table tennis, cards or read and we waited an eternity for the Land Rover to come with the mail. Lydia, she wrote me often telling me her news and what the family were doing.[237] It is not Monte Carlo, eh?'

One thing that Rossano had with him on arrival in Libya was the excitement of being contracted to 20th Century Fox. It was 1956 and Rodgers and Hammerstein had announced they would be making a film version of *South Pacific* and they had signed Rossano Brazzi to play Emile de Becque. Sophia Loren, in her autobiography *Yesterday, Today, Tomorrow* remembers her friend was always chirping away, singing on set. The main song in his repertoire at that time was "Some Enchanted Evening". (We will be exploring that particular film in the next chapter.)[238]

Rossano turns to me. 'You know, Sophia had a bad experience there. Because there was no heating at night, we were given gas heaters. She was on the ground floor and because she is wary about intruders, she locked all the doors and windows so, every night, there was no air in that room. If I hadn't been there, she would have died.'

Sophia confirms, in her autobiography, that she woke up with a raging headache, feeling confused and disoriented. Her instinct was that she needed help and had great difficulty even getting to the door. Summoning her last ounce of energy, she managed to open the door and then lost consciousness. Fortunately, Rossano was returning from a walk and found her.

Immediate first aid, including mouth-to-mouth resuscitation was needed. The attending doctor was convinced that she may had died if Rossano had not found her.[239]

Rossano shakes his head at the memory. Then, with a grin, he remembers something. The following anecdote was detailed in Lerner and Kaufman's book, *Hollywood sul Tevere*.

'She did me some damage. She plays Dita. My role as Paul has a good arc in the story. He begins as a good man but, by the end of the film, he is overcome by greed and lust. When Paul tries to force himself on Dita, she has to fight him off. Sophia, she kicked out very hard during this scene and that kick went to where a man does not want to be kicked. I tell you, I fell to the floor. She couldn't have aimed that better if she tried. I thought I was going to be sick. I had to go back to my trailer to lie down. You know, it took some time before I could even straighten up.'[240]

I can't help but laugh and he smiles at my amusement. Fortunately, Rossano's jewels suffered no permanent damage and filming continued.

'I remember I had a scene where I had to drink some water in the desert – at a waterhole. I scoop up the water and drink it and, you know, there were things swimming around in my mouth, newts, I think, but they do a couple more takes because of the light or a plane flying over so we keep going. I don't know how many of those things I swallowed.'[241]

Sophia Loren would later comment on her memories of filming with Rossano. The two were good friends and she and her husband were frequent visitors to the Brazzi homes in Italy and Beverly Hills.

She described him as the ultimate professional and told a number of reporters that he deserved his good fortune.[242]

Rossano with Sophia Loren after completion of Legend of the Lost. (Courtesy of Reporters Associati & Archivi/Mondadori Portfolio/ Bridgeman Images.)

Sophia also remarked on something else. Rossano said in many interviews that he didn't see how good-looking he was when he was younger. Well, Sophia tells a different story and was often teasing her friend on the set because he was so focussed on his looks![243]

John Wayne shuddered at the conditions when filming in Libya and remarked that he never wanted to go back there. He was also absolutely certain that Sophia and Rossano were having an affair even though she was engaged to be married at that time. The pair spent most of their time together off-set. Wayne had the outlook that many men had back

then. He could excuse Rossano but for a woman to behave like that was unforgiveable.

Loren's biographer, Warren G Harris (*Sophia Loren: A Biography*), felt that Wayne had misinterpreted the signs. The Brazzis were long-time friends and socialised often with Sophia and Carlo Ponti, the man who would become her husband. He did go on to say he could understand why it might have happened. Rossano was incredibly handsome and romantic, they were miles away from home and both had that Italian mentality in respect of love.[244]

Aside from these observations, I could find no confirmation of an affair.

One thing that was highlighted during the shooting of this film was Rossano's sense of fun. Although boredom had set in for the majority of the crew, Sophia recalls the presence of her friend as being a welcome relief; he was always joking, mimicking, messing around and hamming-up his image.[245]

Indeed, the three of them apparently got on well and Sophia (in her autobiography, *Yesterday, Today, Tomorrow*) recalls a night when the wife of the Mayor of Ghadames was unwell and had to be flown to the nearest hospital. With no lights on the runway, she, Rossano, Wayne and a few of the crew assembled the set lights to illuminate the area so that the plane could land.[246]

One thing that Rossano was immensely proud of was a comment made by renowned film director, John Ford. This was reported in the Italian newspaper *La Settimana*. The director had apparently said that, if given the right part, Rossano had the skills to win an Oscar.[247]

That same year, although released in 1957, he played a famous conductor in the film *Interlude* with June Allyson, his co-star in *Little Women*. Rossano takes another swig of Chianti. 'June is a very natural actress. Off camera, she is a lively person who I think would have liked to play different roles. That was a problem in Hollywood in those days. With June, they would cast her as the dutiful wife, the mother, the devoted sister, that sort of thing. It's a shame she wasn't allowed to show all of her talents.'[248]

It's a disappointing film in that the story takes some time to get started and the script, for those actors in the peripheral roles, was poor. It received mediocre reviews.

'I don't watch many of my films because when I see myself I always see something I don't like. This film, you know, it needed improvements before its release.' He sits forward with a grin. 'I think I must have looked very tired during the first morning of shooting. I remember I didn't get any sleep the previous night because I couldn't see how to turn off the light.'[249]

I can't help but chuckle.

'I'm serious. I looked everywhere and I couldn't find the switch. When I tried to take the bulb out, it wouldn't turn so the light was on all night. In the morning, I found it. You know where it was?'

'I haven't a clue.'

'In the bathroom! Who puts the light for the bedroom in the bathroom?'[250]

All the same, he did enjoy conducting the orchestra. His face lights up. 'Oh yes. The Austrian conductor, Herbert von Karajan, he helped me with the moves, you know, for conducting. I didn't realise it was so involved. He helped with that and with the scenes where I play the piano. I can play a few chords, but he showed me how to be more natural with it.'[251]

We take a break and tuck into our dinner. He refills our glasses, turns to Lydia and says something to her in Italian. She roars with laughter, then suddenly kicks off her shoe and brings her leg up.

'Rossano, kiss my foot!'

Exasperated, but with a wink, Rossano obeys.

The family, along with Kaufman and Lerner, claim that this was something Lydia did often: whether at home, in Hollywood or as here, at a small trattoria, she would order him to kiss her foot. It was one of their ways of showing affection for each other.

Rossano turns back to me. 'I tell you truthfully, by this time, by the time of *Interlude*, I could see I was getting typecast, and I wanted to do something different. On the Continent, I play a variety of roles: detectives, spies, murderers, sadists… but, in Hollywood, always the

romantic. I know my agents' goal was Emile de Becque but I wanted something different.'

He took that chance in early 1957 when he filmed *The Story of Esther Costello*, based on a book by Nicholas Monsarrat. That, most definitely, was not a love story.

He catches the eye of the waiter and orders two limoncellos.

'I wanted to do that film exactly because it was different. My character was an evil son of a bitch, really, from the very start of that picture. It was easy to hate him.'

His co-star in this was star of the golden age of Hollywood, Joan Crawford. She had a reputation for being difficult on the set, but, apparently, the pair of them got along well. According to some interviews I saw, it was Joan who insisted Rossano be cast as her leading man, and she was delighted to be playing opposite him. In her biography, *Joan Crawford*, by Lawrence Quirk and William Schoell, when he arrived on set, she thought he was absolutely gorgeous and immediately wanted to strip him naked! Did they have an affair? She did not let on but, knowing what we know about Rossano (and Hollywood in general at that time) it wouldn't be surprising.[252]

Joan plays a woman who adopts a deaf, dumb and blind girl (played by Heather Sears) who grows up to be a beautiful young woman. Together, they start a charity and tour the world giving inspirational speeches to raise money for those with disabilities.

Rossano plays the ex-husband, Carlo, who comes back on the scene to cosy up to his ex-wife and exploit the charity work being done by the two women. Toward the end of the film, Carlo rapes the daughter.

Heather Sears was celebrating her twenty-first birthday on the day of the rape scene. Apparently, Rossano sent her a bouquet of flowers that morning with a note apologising for having to attack her on her birthday.[253]

'Of course, with the censorship, you see nothing, but it is clear what has happened,' he says.

'And the critics hated it?'

'The critics were all right with it. It had a good reception at the Venice Film Festival. It was my fans who hated it. I received thousands

of letters, from all around the world, telling me I should not have made the film; how could I behave like that with this girl.' He shakes his head in frustration. 'It's not me, it's the character! I'm an actor, why shouldn't I play a part like that? I realise that, in Hollywood, I am stuck with the image they create for me.'

He consigns this quickly into the history books and, with a mischievous smile, tells me a story that I remember reading in Gregory Speck's book, *Hollywood Royalty*, although it also featured in a couple of magazines.

'I have to tell you, some of that film was shot in London and we went there to do some promotional work. Lydia came over, too, and Joan's husband, Alfred, or soon-to-be husband, I don't know, but he was there. We had planned to go out for the evening after a press conference. This was at the Savoy Hotel and the press were downstairs waiting for us. Lydia was running late, so I told her I'd see her downstairs. I met up with Joan and Alfred and we speak with the press.

'Then Lydia arrives and, of course, she is so exuberant that the journalists, they all go to her – they forget about me and Joan. I went to get a drink and when I got back, Joan is gone. I said to Alfred, "Where is Joan?" He says, "Oh, she doesn't feel well, she gone to bed." Well, she was fine two minutes before. I knew what had happened. She didn't like that Lydia was getting the attention.

'I was wondering what would happen, you know, with Joan. The following morning, there was a knock on our door and a man stood there with flowers, for Lydia.

'They were from Joan. She'd written a note to say that she was sorry. A part of her, the actress, hated to be upstaged. We became great friends after that and, like Greta Garbo, she was a big fan of Lydia's cooking.'[254]

He nods his head at Lydia. 'You know, once, when we were in London, she insulted your Queen.'

'How on earth did she do that?'

'I was once presented to Queen Elizabeth during a function and the press, they wanted to speak with me. When we first arrived in London I had a fever and went straight to bed. I was supposed to be interviewed on television later that day and Lydia, she went to speak with them instead. They asked her what she thought of London and you know what

she said? She wasn't so keen because of the Queen. *Mamma mia!* The interview was live so they could not edit this. She just carried on, like she does, telling the viewers that if the Queen loved animals so much why did she have a law that meant we have to leave the children at home.'[255]

They apparently had encountered problems travelling with the poodles to the UK and had to leave them in Italy.

'Lydia was upset to leave them behind. They travel everywhere with us. I told her to be careful about what she says but…' he shakes his head, 'she never listens to me. You know, we went to Kennedy's inauguration in 1961 and I told her, "You have to be respectful of him now." I made her swear to behave. You know what she did? At the reception, she kept telling him jokes and teasing him.'[256]

All this is said with feigned annoyance. He obviously found both events highly amusing.

He smiles. 'I like that about her. She is very real.'

The sun has gone down and it's a clear night. The shot of limoncello is an excellent liqueur on which to finish dinner.

'Let's go. I want you to see Rome at night.' He leans across to peck Lydia on the cheek. 'We're going for a walk. We'll see you later.'

Rossano and Lydia often strolled around the city in the evening and Rossano admitted that Rome was the one place he loved to walk after dark. I must confess, the city undergoes a transformation at night.[257]

'It is beautiful, yes?'

'Yes, it is beautiful.' We view the same buildings and monuments and walk down the same streets, but there is a romance about the place that you don't get during the daytime. I can understand why the pair of them enjoyed this pastime.

Getting back to the matter in hand, as mentioned earlier, just prior to Rossano travelling to Libya, he had signed with 20th Century Fox for the role of Emile de Becque. Rumours about casting had quickly circulated as it was felt that whoever landed the role of de Becque would be in the running for an Academy Award.

Nothing is ever simple with Rossano, however, and I am to learn of his frustrations leading up to filming *South Pacific* and his simmering anger when on location in Hawaii.

AN INVITATION TO THE PENTHOUSE

Left, Rossano's penthouse apartment. Right, church of S. Teresa di Gesù (Author photo)

The penthouse apartment overlooking the Villa Borghese is so big you could get lost in it. As we enter the hall, I am reminded of a plush hotel reception area; I step onto a polished marble floor

with two statues of golden angels standing to the left. In an alcove is an antique Chinese vase. A floor-to-ceiling mirror takes up the wall at the far end. I expect to see a concierge in a frock coat and a top hat asking if he can help me. This is a far cry from the Via Sistina residence.

The lounge is spacious, with a dark wood Venetian dresser displaying a number of Capodimonte figures and eighteenth-century porcelain dogs. There is a circular Chinese coffee table and, beyond this, a library housing the works of the great classic writers.

In a second, more spacious lounge, there is an eighteenth-century French fireplace and, opposite the lounge is a large dining room with Louis XV furniture and Persian rugs.[258]

One eye-catching piece of furniture is the seventeenth-century Sicilian altar that now serves as a bar. In front of this, a couple of comfy sofas. On the shelving behind, a selection of ancient crystal bottles.[259]

Rossano, dressed casually in trousers and a jumper, is giving me the tour, clearly proud of their home and the collectables in it.

'We're always looking for antiques. You know how much we have of value in here, in antiques? Nearly 1,000 million lire worth. See that statue there? Fifteen million. That painting? Twenty million. Everything authenticated.'[260]

The kitchen is a whole lot bigger than the poky one in their previous apartment and comes with all mod cons. This is a priority for the couple as they spend a great deal of time cooking their favourite Tuscan dishes and concocting new ones. He also had a small cinema installed and adapted one of the rooms as an office.

If this hadn't impressed me, the next thing will.

At the Via Sistina apartment, they looked out on a narrow street with no view except for the hotel opposite. Here, from a wide, circular terrace, the city of Rome stretches out before them. Immediately below are the Borghese Gardens and the zoo. Surrounding them are residences as luxurious as this one, many with penthouses offering the same vista. This is luxury living.

There are a number of small statues on the terrace along with containers of colourful flowers and a selection of comfortable chairs

dotted around. Inside the telephone rings. Irma, their maid, calls for Rossano to come.

'Oh, I have to take that. Make yourself comfortable.' He disappears.

Before I chat with Rossano about *South Pacific*, let's have a recap.

Kaufman and Lerner were aware, back in 1953, that a film version of *South Pacific* might eventually be made. With Rossano's success in *Summertime*, the pair of them paved the way for him to take the lead role if it came up.

On Broadway, *South Pacific* was one of the most successful stage musicals at that time, winning ten Tony awards. During the early 1950s, it ran for nearly two thousand performances. When Richard Rodgers hinted that a film might be made, rumours began circulating. Who would play Emile de Becque? Potential names, at that early stage, included Louis Jourdan, James Mason, Errol Flynn and Yul Brynner.

Because Lerner and Kaufman had put a clause in every film contract stating that Rossano could be released should the role come up, they didn't have to worry about that side of things. What they did need to do was convince Rodgers and Hammerstein. This particular wheel was put in motion just prior to the trip to New York to promote *Summertime*.

Gene Lerner wrote to Rodgers and Hammerstein, putting Rossano's name forward for the role. He suggested they watch *Summertime*, told them he would be in New York promoting the film and requested a meeting.

He received a response from Richard Rodgers confirming that the film version was only a thought at the time. He did, promisingly, invite Gene to meet with him in New York.

Gene met both Richard Rodgers and Oscar Hammerstein. They said they would watch *Summertime* and, if they were interested, they would get in touch.

Amazingly, Richard Rodgers, Oscar Hammerstein and director, Josh Logan, viewed *Summertime* on separate occasions and, without contacting one another, each had decided that Rossano was the man to play Emile de Becque, providing he could sing. According to Logan in his book, *Movie Stars, Real People and Me*, both Rodgers and

Hammerstein had heard him sing and were happy with his voice. This is also confirmed in Mark Eden Horowitz's book, *The Letters of Oscar Hammerstein II*.[261]

However, Rossano made a record in Italy and allowed his ego to take over. The record found its way to Rodgers and Hammerstein. They decided that, although Rossano had a good voice, he didn't have sufficient depth and strength to interpret the songs in the right way. The songs were operatic and written specifically for the man who starred as Emile on Broadway – renowned Italian opera singer Ezio Pinza. Pinza was already out of the running, unsuitable for the film role. He was to die in 1957.[262]

Rossano, who had studied opera as a teenager, was confident he could do the songs justice.

Rodgers was not convinced, and Gene spent a considerable amount of time talking him round. Eventually, the composer agreed to give Rossano a chance. He wanted some recordings of his singing and they would decide based on that.

A singing teacher from the Rome Opera House was hired to develop Rossano's voice to its full potential and to do it as quickly as possible. Rossano promised that he would dedicate his days to rehearsal, work hard and shut himself away to concentrate solely on developing his voice. His singing coach, Marion Magneti, described Rossano's voice as a beautiful baritone and she was confident that he would do well.[263]

Eventually, several recordings were made and sent over to Rodgers and Hammerstein, who listened to the recordings but were not impressed. Oscar Hammerstein sent a personal letter to Rossano confirming that, yes, he had a good voice but he didn't have the power in that voice to interpret the songs the way they wanted him to. He could have the part, but he would be dubbed.

Receiving this news, Hank and Gene spoke to the voice coach. They discovered that Rossano had not dedicated those last few months to practising, after all – he had attended only a few lessons. They told Rossano of the decision to dub his voice and he became very depressed.

Why he didn't take the lessons seriously is a mystery. Whatever the reason was, he would not be singing.

Gene encouraged Rodgers to give Rossano another chance in a recording studio in California. He felt the studio would be better equipped and that Rossano could sing direct to Richard Rodgers. Rodgers was happy to go along with that.

Over the two weeks preceding his departure for Hollywood, Rossano spent every available moment with Marion. It had been at least twenty years since his operatic training, so he had a lot to catch up on to strengthen his vocal chords.

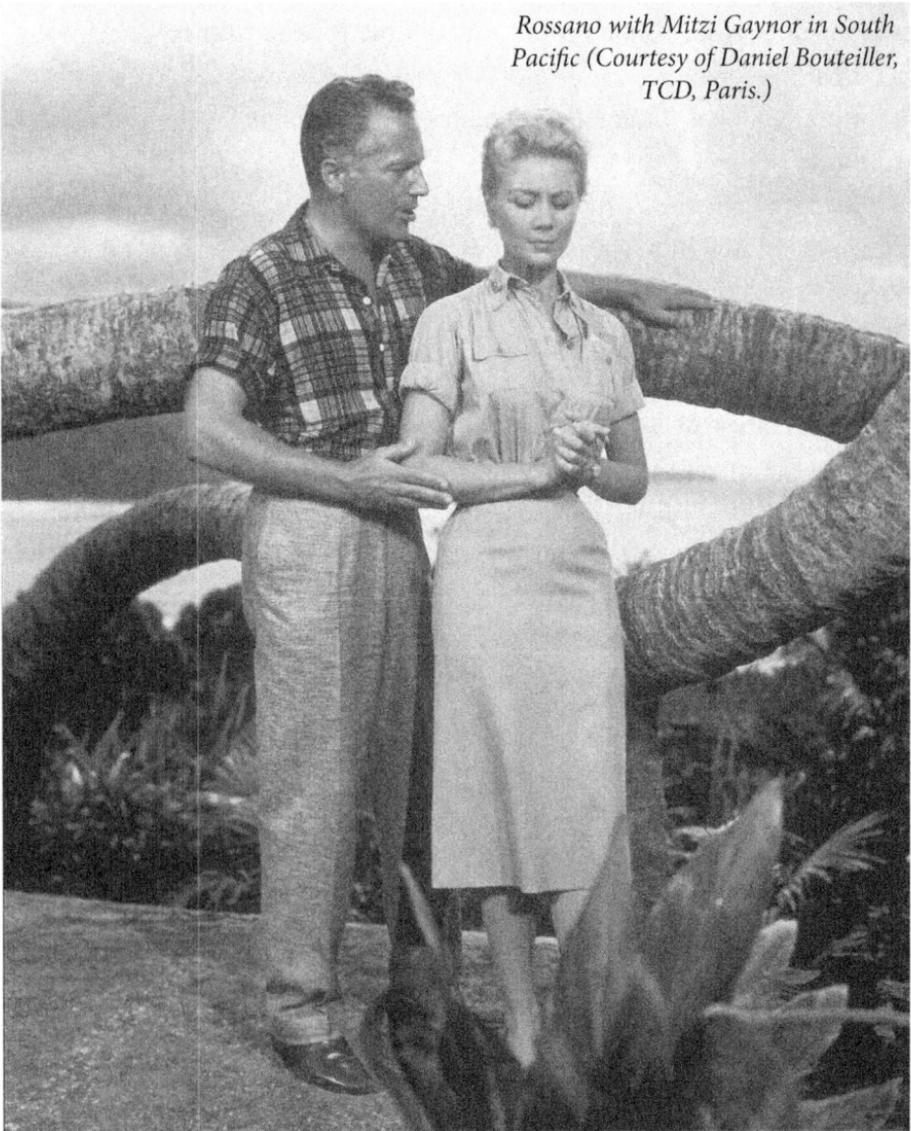

Rossano with Mitzi Gaynor in South Pacific (Courtesy of Daniel Bouteiller, TCD, Paris.)

Rossano reappears. 'You want a cocktail or something?'

We settle on Campari and soda and make ourselves comfortable on the terrace. He is keen to tell me about the farewell party they had prior to leaving Rome.

'It was late summer in 1957 and we had around two hundred guests. Lydia and I were due to leave the next day. I had some pre-recording in America to do and then on to Hawaii to film. The airline, Pan Am, they had laid on some Hawaiian food and everyone was given a lei, you know, the Hawaiian garland.'

Family and close friends attended but the place was also a who's who of Italian film and music stars. International celebrities filming in the area also attended, including Rock Hudson, Alain Delon and Rossano's director from *The Barefoot Contessa*, Joseph Mankiewicz.[264]

One highlight for Rossano that evening was going to be that he would sing his songs from the show ("Some Enchanted Evening" and "This Nearly Was Mine"). His singing tutor, Marion, was there to watch him perform. Rossano goes on to tell me about something I read in *Hollywood sul Tevere*.

'I was just about to sing and she fainted. Completely unconscious. Lydia called for a doctor because she was not really responding. It was very worrying because, when she did come around, she looked very confused. The doctor, he said that she was suffering with exhaustion, and it took some time before she felt better. But she finally recovered and I got to sing for her and my friends.

'I had friends telling me how envious they were, of me spending a few months in Hawaii.' He gave me a cheeky grin. 'I told them I would keep in touch, maybe send some photos.'[265]

The following day, Rossano and Lydia, along with their family of dogs, left Rome for California. When they arrived, the first item on the agenda was to get Rossano into the studio to record "Some Enchanted Evening".

The recording was sent over to Rodgers and Hammerstein. In Mark Eden Horowitz's book, *The Letters of Oscar Hammerstein II*, there is a transcript of the letter sent to Rossano. It was in the form of the proverbial "sh**" sandwich, assuring Rossano they felt he was a great

actor, then advised that he'd be dubbed then, for a second time, assured him that he would bring many qualities to the role.

I discovered one article that was published after the film was released, stating that Rossano did sing a few phrases on "Some Enchanted Evening" and that professional opera singer Giorgio Tozzi took over for the crescendo. This was the family's understanding, too. The Rodgers and Hammerstein Organisation, however, were adamant that Rossano's voice was not used.

Rossano never spoke publicly about his feelings over the dubbing decision, but we will get a taste of his anger about it later.

For the part of Emile's love interest, Nellie Forbush, there was a long list of candidates including Doris Day, Audrey Hepburn and Elizabeth Taylor. It was the young musical-theatre star, Mitzi Gaynor, who wowed Rodgers and Hammerstein with her audition, and she got the part.

Rossano and Mitzi Gaynor in South Pacific (Courtesy of Daniel Bouteiller, TCD, Paris.)

'You know the first thing she said to me when we met? She put on the strongest Italian accent she could, like Anna Magnani, and she said

I was the greatest living Latin lover.' She would repeat that observation several times in interviews.[266]

The pair of them with their respective partners, would form a lifelong friendship. Indeed, Mitzi thought one of the best things about being on location was socialising with Rossano and Lydia.[267]

The musical is based on the Pulitzer prize-winning novel *Tales of the South Pacific* by James Michener. Michener served in the South Pacific during World War II and this book contained a collection of stories featuring a number of people in various situations, all of which drew on his experiences during his time there.

The story featuring Emile De Becque and Nellie Forbush represents just a small percentage of the novel, but Rodgers and Hammerstein felt they were the couple to concentrate on for the main love story.

In the book, Emile flees France as a young man because he has stabbed a man to death. He jumps on a boat and lands on an island in the South Pacific. He has affairs with Polynesian women, resulting in several children. After a few years, he establishes himself as a wealthy plantation owner on the island. The US Navy has units on the island during the war and Emile meets the young nurse, Nellie Forbush. They fall in love.

To make Emile more acceptable for the American audience, the man Emile kills was not stabbed, he simply hit his head on a rock during a fight. Also, to satisfy the Hays code, they had Emile marry one Polynesian lady and have two children by her before she died.

The theme running through *South Pacific* is racism. When Nellie learns that Emile was married to a Polynesian, and the children he introduces to her are his, she calls the romance off. Emile, feeling he has nothing to live for, decides to work with the Navy to help them win a battle against the Japanese being fought on another island. Nellie, realising she may lose Emile, regrets how prejudiced she has been and prays that he will return alive. He does and the romance restarts.

'I like Emile very much. He is a strong, honest man. He has a history, a past, with problems, two kids and a wife that died. He has gone through much adversity, you know? He's very rich but very much alone. When Nellie comes along, he comes alive.' He turns to me. 'I would have liked to play in that film without music.'[268]

He said this in several interviews, but I wonder if this is to do with the fact that he was dubbed. It rankled with him throughout filming. To be fair to Rossano, everyone, with the exception of Mitzi Gaynor and Ray Walston (who played Billis), had their singing voices dubbed. Mitzi Gaynor was a musical-theatre performer. Ray Walston provided the comedy aspect and didn't need a "voice" as such. Everyone else was dubbed, even Juanita Hall who played Bloody Mary – and she had played that particular part on Broadway!

One thing that would have infuriated Rossano, and which he would have found emasculating, was that the man dubbing him, Giorgio Tozzi, was listed in the credits. That was very unusual at the time, but Tozzi was a known opera singer so it was decided he should be credited.

Before flying to Hawaii to film, the actors and actresses had some pre-recording to do. Those being dubbed learnt to synchronise with their respective singers. They were given recordings of the songs to learn. Rossano spent hours with Tozzi going through the timing, the breathing techniques and how to act the songs as they were sung. According to Josh Logan, in his book, *Movie Stars, Real People and Me*, he remained furious and every time Tozzi recorded a take, Josh Logan could see Rossano (when Tozzi wasn't looking) react unfavourably, although he was always gracious and courteous toward the singer.[269]

While the actors were working on the pre-recording, over 150 set designers descended on the island of Kauai, Hawaii, which would serve as the location for Bali. It was 1957, and the location was mainly jungle with no proper roads. In addition, over two hundred locals were hired to help with construction. Their remit – to transform the jungle and beaches into a film set. It was, at that point, the largest ever movie location with a budget forecast of $10 to $12 million.[270]

'We had months of filming, split between Hawaii and Hollywood – a few months on the island and a few in Hollywood and it was hard work. I know that it sounds very lovely being in Hawaii, but it rained nearly every day and, because of that, they had to keep rebuilding the sets and we had to keep repeating scenes because the weather would change so quickly.'

Many of the palm trees that you see in *South Pacific* are fake. During a storm, they were blown over or damaged and had to be repaired and

repositioned.[271] 'There was a lot of waiting around, you know, and I think we all got a little crazy at times.'

Rossano's temper did rear up. During one break in rehearsals, he became very frustrated about being dubbed. Mitzi, who got on well enough with him to be honest, told him that he didn't have a strong enough voice. Unfortunately, it still infuriated him.

At one point, as they were filming the scene where he sings "Some Enchanted Evening", he deliberately messed up saying that he couldn't get in sync with the recording and that Tozzi had a terrible voice.

In Josh Logan's autobiography, *Movie Stars, Real People and Me*, he explains that he took Rossano to one side. The conversation was direct and to the point. In no uncertain terms, Josh reminded him that they were in the middle of the Pacific; that every break in filming costs money; that Rodgers and Hammerstein would not allow him to sing no matter how many tantrums he threw. Josh gave an ultimatum. Would he play the part or not? If not, he needed to get on a plane and go home.

Rossano responded immediately, promising to do as he was told.[272]

His pride was sorely tested but Josh Logan later said, 'He was resisting it. It was a struggle with his own ego. Brazzi acted the songs brilliantly. He can convince you by his emotions, his eyes, the attitude of his body, that he believes the words. I think he is a far better actor than he has been allowed to show.'[273]

'I enjoyed working with Mitzi,' Rossano says. 'She's wonderful and we had a good time on this set. I said to her, you know, "We are having too much fun, we are enjoying this too much." Later that day, during a scene, we found something very funny. I don't know what we were laughing at, but we couldn't stop and Josh, he had his moods and he was not happy. He came over and told us he never chose us for the film. Mitzi, she was devastated and she kept telling him how sorry she was. I don't know why! We hadn't done anything wrong. Then he said he didn't mean it – that he was glad we were there.'[274]

He gives a nonchalant puff.

'We didn't always get on that well,' he says, referring to Josh Logan.

Despite his frustration over the dubbing, he made the best of things. Lydia was with him and Mitzi's husband, Jack Bean, had also joined the

party. Indeed, he was actually having a lot of fun which is, of course, what he and Lydia loved the most. They stayed at the Coco Palms resort which, in the 1950s, was frequented by many Hollywood stars, including Frank Sinatra and Elvis Presley. The hotel was a Hawaiian masterpiece that captured the culture and spirit of the islands.

Rossano, Mitzi Gaynor, Lydia and Mitzi's husband, Jack Bean, at Mitzi's house. (Mitzi Gaynor Archive courtesy of Polly O Entertainment.)

Unfortunately, after a hurricane in the 1990s, the hotel was forced to close. Photographs of it today paint a sad picture of a once exotic jewel on the Pacific island.

'In the evening, after filming, I liked to go rowing and on days off, the four of us would take one of the Jeeps and tour the island, have a picnic, go swimming. Lydia and I, we organised a *luau*. That is a traditional

feast with music and dancing, and I got to do the hula in a grass skirt – not well, you understand, but Lydia cheered when I eventually got it right. The food there was beautiful, I liked it very much.[275]

'And Lydia, you know how much she loves animals? Well, she found two kittens without a mother so, guess what?' He laughs. 'They came home with us. The crew gave Lydia a name, Saint Francis, because she was always saving animals. You know, she cannot stand by and watch anything suffer. I spent a Sunday morning, once, visiting friends in Rome and trying to convince them to take in a stray cat that she had found.[276] [277]

'I remember years ago, when I worked more on the stage, I was at a final dress rehearsal at the theatre. There were some flowers on the dresser and she just walked on with some water. I told her, get off the stage, this is the dress rehearsal! She told me to shut up, that the flowers needed water.' He shakes his head but not without a fond smile.[278]

'And, getting back to the film, Mitzi Gaynor said in an interview that the cameras were noisy?'

He rolls his eyes. 'You know, the sound had to be recorded, after filming, in the studio. All the speaking parts, footsteps, doors opening and closing, even the sound of the waves crashing on the shore. Every single thing you hear had to be recorded later. They were using a Todd-A-O camera, and it was effective for the panoramic screen but, *mamma mia*, it sounded like the drilling of roadworks hammering through your living room. Whatever we were filming, Josh was having to shout his instructions to us and then, back in Hollywood, we had to dub everything in.[279]

'Post-recording is quite a challenge, but I was used to this at Cinecittá. We did this quite often in Italy, having to study the film and making sure that your speech was synchronising with the action.' He pulls his shoulders back and appears very proud. 'But, you know, that film was the third top-grossing film in the whole of the 1950s.'

It was the biggest grossing musical of that year. In London, the film ran for four-and-a-half years and the profit from that city alone paid for the production of the movie.

The public loved it and the critics, too. Ted Chapin, a producer, performer, presenter and former president of the Rodgers and

Hammerstein Organisation had this to say about Rossano: 'He's very effective in this role. He's a good actor. The voice is a good match for Brazzi and the best job of dubbing an actor in a movie. In Colonel Bracket's office, we see Rossano at his best. He plays this scene very effectively, very realistically even by today's standards.'

Paulo Szot, who played Emile on Broadway in 2008, kindly gave me his thoughts on Rossano. 'He's the Emile de Becque the world remembers from the movie; an extraordinary actor who knew how to show on the screen how sensitive and human Emile is.[280]

Rossano should have been on top of the world and, to those outside of his circle, he was, but his underlying feeling was that *South Pacific* was a disaster for him. (He often cited specific films of his that he is proud of, and *South Pacific* was never mentioned.) Rumours that the role might lead to an Academy Award died down, the likely reason being that he didn't sing.

The film received one Oscar for Best Sound. The producers were disappointed that it didn't win more but realised it might have been because the musical itself had already been a resounding success on Broadway, scooping up ten Tony Awards.

A few months after its release, Gene commented on his own disappointment in *Hollywood sul Tevere*. The film had been a massive hit in the public's eyes and Rossano was still as popular as ever. However, the scripts being sent and the roles being offered were not of the calibre they were expecting. He worked alongside the best in the business, but the films were just not up to standard. [281]

Also, the concept of the perfect leading man in Hollywood was beginning to change. The charming gentleman, whether Latin or American, whether Rossano Brazzi or Cary Grant, was going out of fashion. In his place, new male lead roles were going to the likes of James Dean, Marlon Brando, Clint Eastwood and Paul Newman.[282]

Rossano, in many of his interviews, was philosophical about his image and the question of how long he could go on playing the romantic lead. He understood it couldn't go on forever. Two years after *South Pacific* he was thinking of retiring.

He mixes another Campari and soda for us. 'I got restless, you know, and sometimes I thought I wanted to do something different. I'm like everyone else, I have interests but don't always have time to pursue them. I'm lucky to visit many wonderful places when I am filming but I don't get to see them: the art galleries, museums, monuments, historic sites, that sort of thing.'[283]

He was certainly a very rich man at this time. Each film paid well and, don't forget, he received a percentage of the gross takings. He also invested in property so, providing the Brazzis didn't live way beyond their means again, retiring was an easy option for him.

He leans forward. 'You know, sometimes I prefer to do nothing. Just to stay at home. Then I get bored. I am a paradox: I doubt myself and hesitate and become dissatisfied. But then I think perhaps I don't retire. I am getting older, perhaps I'll get parts more suited for my age.'[284] He sits back with a sigh. 'I used to love going to our place in the country, to sit and read poetry, like I did when I was a boy.'

This is a side to him I haven't been expecting– someone reflecting on life and possible regrets. All the same, he never dwelled on those regrets for long.

And he didn't retire.

Indeed, he had several films lined up after *South Pacific* and the next one would take him back to the Continent – to France.

LUNCH AT THE PIAZZALE MICHELANGELO

People-watching is something one normally does from the comfort of a café or restaurant. I am at Fiorentina football club in Florence, watching the team play their rivals, Juventus, and it proves to be just as entertaining.

The stadium is packed and noisy and I am surrounded by fans gesticulating, cheering, jeering and swearing. Every tackle, foul and near miss is felt by the crowd and a whole heap of insults is being thrown at the opposition, some of them not repeatable.

Alongside me are Rossano and Oscar. Each is dressed casually in trousers, a sweater and a jacket. Rossano has a cigarette in his mouth and is completely engrossed in the game. In his mind he is kicking every ball and taking every header and, like everyone else, he and Oscar have plenty to shout about if the game is not going their way, although they are restrained. I later learn from the family that the pair were usually mindful they would be watched so kept the tendency to swear and curse to a minimum.[285]

After the game, we spill out onto the streets. Oscar bids me good day and Rossano and I jump in his car and head up to the Piazzale Michelangelo which provides the most spectacular views of Florence and the many bridges that span the Arno River.

There are a number of open-air cafés and restaurants here. To take

advantage of the view, we find ourselves a good spot. The young waiter delivers our order of pastries and coffee.

'Did you often go to the football?'

'When I could, yes. Fiorentina, the team I played goalkeeper for, is the family football team; we all support them. We took Carlo and Fabrizio a few times, but I go to whatever sporting event is on. Of course, even though I gave it up, if there is boxing going on somewhere, I will go. By nature, I am a lazy person, but I have always loved to play sports.'

He sips his coffee and turns. 'Where are you, with my story?'

'*A Certain Smile.*'

He acknowledges it. 'Ah, yes, we filmed that in France, around Paris and on the coast. It was based on a book, a very good one.'

A Certain Smile is based on the book of the same name by the French writer, Françoise Sagan, an existentialist. I can certainly imagine the role came naturally to him. He plays Luc, a happily married man, in love with his wife, who cannot help but have adventures with attractive women.

He holds up a finger as if to admonish me but the gesture is accompanied by a cheeky grin.

The main protagonist is a teenager, Dominique, who is influenced by existentialism, wanting the freedom to do what she wants in life and be in charge of her thoughts and actions.

She is a student at the Sorbonne in Paris. Like many at that age, she is bored and wants

Drawing of Rossano.
(Courtesy of Sarah Bairstow.)

to grab life by the horns. When Bertrand, her boyfriend, introduces her to his uncle, Luc, she breaks off her romance and pursues Luc, whom she sees as worldlier and more exciting.

Luc is happily married to Françoise but regularly strays for the sake of a fling. For him, these affairs are simply fun and nothing else.

When Françoise visits her mother for a few weeks, Luc invites

Dominique to join him on his own holiday to the South of France.

'The book caused some controversy when it was first published because she [Sagan] talks about Dominique wanting "adult" fun and how her obsession with Luc is to have sex with him and have him fall in love with her. Like Jane in *Summertime*, Dominique has this notion of true love, a fairy tale, and that Luc will leave his wife for her. She is so wrapped up in her thoughts that she doesn't realise the consequences of what she is planning.'

On their return, Luc learns that Françoise has been told that he had a woman with him while he was away. As a result, he calls off his romance with Dominique.

For him, that's the end of it and he is not that upset. Dominique, however, is distraught. She's in love with Luc, but much of her distress is because of the effect she had on Françoise who she valued as a true friend.

'Of course, once Françoise finds out, that bond between the two women is broken beyond repair.'

When all of this comes to light, Dominique can see the pain she has caused and, by the end of the story, has grown up. There is a great deal of psychological exploration going on in the book. Françoise, who lost a child, treats Dominique as a daughter. Dominique welcomes this. Her own mother is stricken with grief over the loss of Dominique's brother, who was killed in an accident. Because her father fusses over her mother, Luc becomes a father figure to Dominique as well as a lover, a man with experience and maturity.

Hollywood, as was its wont in the 1950s, had its say. Due to the Hays censorship, strict rules were in place concerning what they could or couldn't show. Jean Negulesco, the man who had relaunched Rossano's career in *Three Coins in a Fountain*, was the director.

Rossano read the book and was personally frustrated by how he was being asked to play Luc.

'I had a word with Jean about this. The book is explicit for its time; it's clear that Luc and Dominique are at this hotel to have a passionate affair. We weren't showing any of that. All we see is two people sitting on a beach or having lunch together. That's not even an affair. That

censorship, you know, was maddening. You couldn't get any depth into the characters. I said to Jean that we have to *show* something, this is a sexually active man who has brought this woman on holiday to have an affair.'[286]

But Jean's hands were tied. Initially, he was not allowed to film at the Sorbonne because of the book's content. Interestingly, money talked. When he offered to contribute to the university's fund for poorer students, the Sorbonne immediately lost its sense of moral outrage and allowed filming to take place.

'He had the same problem in the South of France. The location people had found a few hotels for our scenes down there and the owners, they all refused. One man told Jean that he thought the book was outrageous and wanted nothing to do with it. We found one, eventually, but it took some time.'[287]

The film was brilliantly cast but, because of the censorship, the quality of the script was mediocre. Christine Carère, who played Dominique, played her role to perfection. Joan Fontaine and Rossano did their best, but their characters lacked the richness highlighted by Sagan. Had censorship allowed, this could have been a masterpiece because the novel is so compelling and well-written.

On a side note, in her biography *No Bed of Roses*, Joan Fontaine was amused by Lydia's sense of humour. News had reached Joan that Rossano was becoming quite romantic with Christine Carère on location in the French Riviera. When Joan brought this to the attention of Lydia, she was quite nonchalant about the whole thing, questioning why he had waited weeks to make a move on Christine.[288]

Joan also got annoyed with Rossano at one point because he kept singing "Some Enchanted Evening" on the set!

He orders two glasses of Verdicchio then sits back and admires a lady walking by, paying particular attention to her legs. If this man wasn't admiring women from a distance, he was waxing lyrical about them – and I mean lyrical in the poetic sense.

Gene Lerner (in *Hollywood sul Tevere*) described being at the Villa Borghese apartment with Rossano and Roger Vadim, a French screenwriter. It was a men-only gathering.

'It'd be very difficult to forget the conversation between the two of them. It was as if someone had announced that a serious debate would be taking place about man's love for women. We were on the terrace of Rossano's penthouse drinking Scotch and Rossano and Roger were discussing the female form, exchanging stories of their encounters, their methods and how they felt when they were around women. They weren't just sitting there either, they were pacing up and down, gesturing, being very animated and passionate about the subject.

'They discussed the experiences they'd had with various women and how much they adored their grace, their charm, their appeal. There was admiration and warmth for the affection women provided and the sacrifices they made. It was almost poetic, divine even, with no hint of anything sordid or pornographic. They were like two Michelangelos discussing their models, genuinely overwhelmed by the beauty of the female form.

'Rossano poured more drinks and they dissected every little thing. How to caress, to stroke, to hold a woman. If they spoke about hair, it wasn't just about her hairstyle. It was eyebrows, eye lashes, the fine hair on the arms, the pubic hair. They considered the curves of the whole body; the shape of the eyes, the nose, the cheekbones, breasts, nipples, hips, feet, legs, the texture of the skin and how different it was depending on where you were looking or touching. Every part of the body was explored including the vagina and that whole area between the legs.

'Then, when I thought they'd finished, and I have to tell you this was not a half-hour debate, it went on for an hour or two, they got on to a woman's character, her sense of humour and the beauty within her soul: women's maternal aspect, their courage, their strength, their empathy. Every single thing you can think about, they discussed with poise, with elegance, with respect, tenderness and love.

'I have never witnessed anything like this and I never did again. It was a true homage to the female, young and old, from all cultures, all creeds. Those two men were almost kneeling in gratitude to have the privilege to love women.'[289]

Realising I am watching his subtle observations of the various women in the vicinity, Rossano quickly adjusts and gives me his full attention.

'I'm so sorry. Forgive me. My next film, *Count Your Blessings,* was based on another excellent book by Nancy Mitford - one of your famous authors in England, yes?'

Yes, Nancy Mitford wrote some excellent novels including *The Pursuit of Love* and *Love in a Cold Climate.* In some respects, she was ahead of her time and explored morality and sexuality in detail.

She considered this book, *The Blessing,* a more personal story. It challenges the question of love and whether people from different cultures can come together in love.

This film was once more directed by Jean Negulesco. Rossano's co-stars were Deborah Kerr and Maurice Chevalier.

The story deals with a well-to-do English woman, Grace (played by Kerr), who meets and marries French aristocrat, Charles-Edouard (Rossano). This relationship produces a boy, Sigismund, aka "The Blessing". They move to France where they divide their time between several properties located around the country but stay, mainly, in Paris. Grace struggles with the culture and the immoral behaviour of the men and women in respect of extramarital affairs.

When she discovers that Charles-Edouard has set up numerous women around the city, Grace returns to London with Sigismund who is around ten years old. (Sigismund was played by child actor, Martin Stephens, most famously known for his role in the 1960s classic sci-fi film, *Village of the Damned.*)

Rossano tilts his head toward the sun and closes his eyes. 'Sigismund, he is an intelligent boy. He likes that his parents are separated because he sees that he can be spoiled. Each parent dotes on him and buys him presents, bigger and better than what the other has bought. This is an ideal scenario for him so he keeps them apart however he can.'

Nancy Mitford did spend time in Paris and had a relationship with a Frenchman, so she had good experience to draw on. The book is a marvellous comedy exploring the differences between cultures.

It's a good film but is a very tame version of the book and vital components were left out. I thought everyone played their parts well

and Rossano has some wonderfully comic moments pretty much in line with the character as Mitford wrote it but lacking complexity. Again, the censors clamped down on certain aspects and, surprisingly, not sex.

Rossano sits up and puts his sunglasses on. 'I read this book and enjoyed it – it has comedy and is an intelligent piece of writing. But, in the novel, there are Americans who play a prominent part in the story, and they do not appear in the film. Their story weaves in with what is happening between mine and Deborah's roles. That whole thing was discarded. Do you know why?'

'I have no idea.'

'Because it showed the American in a bad light, as a couple mixed up with communism. Of course, in those days, the Americans were calling out communists and blacklisting actors and directors, many of them Italian, who they thought were inclined toward that movement. Ingrid Bergman, she was talked about as being a dangerous woman because of her relationship with Rosselini.' He shakes his head in disbelief. 'And this story, well, I was annoyed they didn't lean more toward what the author had written.'[290]

In her biography *Deborah Kerr* by Eric Braun, Kerr agreed. Both she and Rossano had looked forward to making this film because, on paper, it bore the hallmark of a great success.[291]

Martin Stephens, who played Sigismund, read *The Blessing* later in life and concurred with his fictional parents – the film did not do the book justice.

On a brighter note, the public liked the movie; Rossano was still popular with his fans and he had two appearances lined up on American television in 1960 that would further endear him to the public.

THIS IS YOUR LIFE

A woman calls his name. It's Lydia with the dogs. He greets her with a kiss and pulls a chair out for her then squats down to greet the children as they compete for attention. The waiter takes an order for olives and wine and he and Lydia chat in Italian for a while.

'We should speak English,' Lydia says, sticking her chin out at me and then at Rossano. 'How will I improve if I don't speak it?'

'If I speak English with you, my English gets worse.'[292]

'Selfish bastard,' she mutters. Before he has a chance to respond, she asks, 'You enjoy the football?'

'We lost.'

'Always you lose.'

'Not always, Lydia.'

Rossano lifts one of the dogs onto his lap. Knowing the banter will not last long, I wait for a gap and, sure enough, just a minute later, I am able to bring up the television programme *This is Your Life*.

A genuine smile lights up his face. Lydia too seems chuffed at the mention of this programme.

'You did not want to go out,' she reminds him.

Was he surprised? He groans.

'I had an argument with Lydia. She had helped to organise this with Oscar and I knew nothing about it. There was a match on the television that I wanted to see, and I was looking forward to watching

that and she kept on about someone at the studio wanting to speak with me.'

'I told him,' said Lydia, 'there was a producer that wanted to see him urgently and he had arranged for us to meet for dinner.'[293]

'And she said that, before the dinner, we had to go and watch a show being recorded. I told her, "I don't want to watch a show, I want to watch the game. Leave me in peace. You go."' He repositions the dog and makes a fuss of it. 'Well, she wouldn't stop so I said, "Okay, I go, but it had better be a good reason for me to miss the game." Then I find we are in the audience for *This is Your Life* and Ralph Edwards, who presents the show, he starts describing me!'

In the programme, Ralph Edwards begins by telling the audience that the film world has known many screen lovers. He then puts together a four-piece jigsaw: a Roman brow, eyes that women say look right into their heart, etc. Once the pieces have come together, the image of Rossano's face is complete. The camera cuts to him and Lydia. He appears visibly shocked. He is dressed in a dark suit and Lydia is in a black dress, sparkling diamond earrings and a fur stole.

'I couldn't believe it. I think I was a bit nervous, you know. But it was a wonderful evening. Oscar, my mother, Jean Negulesco, Giovanni, they had all come over from Rome. Mitzi was there and even an American that I had helped during the war [Jack Fancourt]. The best surprise was Franca. She, Franco and my niece, little Maria-Lidia, had been flown over from Buenos Aires. I couldn't believe it. But I never understood why Carlo and Fabrizio were not permitted to appear.'

The nephews were also a little put out that Maria-Lidia was allowed to go and not them. Carlo, although disappointed at the time, told me he had benefited from missing out. His grandmother, Rossano's mother, invited him to stay with her for six months and bought him a brand-new electric guitar which he has to this day. He also remembers being given a pair of jeans from Saks Fifth Avenue that had cost a fortune. His schoolmates, he recalls, were very envious.

Franca and Maria-Lidia didn't miss out even though they were on the show. Lydia gifted her sister-in-law a very beautiful gold bracelet and Maria-Lidia, who was about six at the time, received a large doll

that she named after the couple's (and Maria-Lidia's) favourite poodle at the time, Titti.

'Lydia and the family had kept that surprise secret from me. They had been planning it for months between them. The television company, they give me a copy of the tape, the recording you know, and later in life, if I felt nostalgic, I would put it on. Sometimes it made me upset, especially later in life when I had lost some of those people.'[294]

That same year, Rossano appeared on *The Dinah Shore Show*. Dinah was a huge star at that time and regularly pulled in twenty million viewers for her hour-long variety show. He appeared for around twenty minutes, alongside Jimmy Durante, and the audience loved it.

'I enjoyed that show because I could be myself. I did a sketch with Dinah and sang with her. Me and Jimmy Durante, we did a duet together and had some fun with that.'

'He called you Rossana,' says Lydia, chuckling.

The banter before the duet was obviously scripted but he and Durante seemed to be having the best of times. And Jimmy's mispronunciation? It appeared to be a genuine mistake and Rossano had roared with laughter at the gaffe.

His singing on the show prompted RCA to offer him a recording contract and he did release a couple of records although, as we heard earlier, he would have preferred to recite poetry.[295]

In 1962, he had no misgivings over his third English-speaking film after *South Pacific. Light in the Piazza*. This beautiful film stayed completely true to the book that inspired it. Indeed, the scriptwriter added an element that only served to enhance the story.

'That was filmed mainly here, in Florence. Where we are sitting, here on the Piazzale Michelangelo, we did a scene here, Olivia de Havilland and I. I enjoyed this film very much because I am not cast as the lover. I am put into a role more suited for my age – the role of the father.'

The producer was Arthur Freed, one of the most well-known people in the business whose films included *Singing in the Rain*, *An American in Paris* and *Gigi*. When he cast the film and announced that Rossano would play the father, this was felt to be a good choice. Freed thought he was an excellent actor.

Rossano, Olivia de Havilland, George Hamilton and Yvette Mimieux relaxing in Florence during the filming of Light in the Piazza. (Courtesy of The Everett Collection Inc.)

'At this time, I had my own studio with Oscar, in Rome, and Arthur Freed made use of that for this film.'[296]

The film is based on a novella of the same name by American writer, Elizabeth Spencer. She published a paperback of short stories, each one involving Americans who visit or live in Italy. *Light in the Piazza* stood out as the go-to story in this collection when it was published in *The New Yorker* magazine.

And what a delightful story it is, although it's one of the few where I feel the film is actually far better than the written word. Rossano's Signor Nacarelli is pure comedy and he plays the part well. Here, he is the father of a grown-up son, Fabrizio, played by a very young George Hamilton.

Olivia de Havilland plays Mrs Johnson, who is sightseeing in Florence with her twenty-six-year-old daughter, Clara. Clara (played by Yvette Mimieux) is a beautiful woman but with a tragic background. Due to a horse-riding accident when she was a girl, her mind has never fully

developed as an adult. She is an eternal teenager. Clara meets Fabrizio, who falls head over heels in love with her and finds ways to continually bump into the mother and daughter. Clara then falls in love with him.

Signor Nacarelli plays Cupid and there is a wonderful scene where he "happens" upon Mrs Johnson, Clara and Fabrizio having dinner. This has clearly been set up by the father and son in an attempt to get the two young lovers together.

After initially considering him a nuisance, Mrs Johnson realises that Fabrizio is good for Clara. Her daughter is learning Italian, and we see her developing, mentally, as the story progresses. After some setbacks and adversity, the couple get married.

It's refreshing to see Rossano in a different role. The director, Englishman Guy Green, has freed Rossano from the serious seducer and he is all the better for it. Much of the comedy is conveyed through expression and body language. I find this film an absolute delight. The backdrop of Florence is, like Venice in *Summertime*, an additional character.

'In the book Mrs Johnson's husband, Noel, he makes no actual appearance in Italy. The screenwriters, they have him coming to Rome and that introduces some extra drama over this potential love interest of Clara because he is against the union.

'It was nice for me to film in Florence, and I took Olivia to some of the museums and galleries, you know, to show off my city. I remember that George Hamilton kept on at me about getting his accent right. He didn't have that part initially and was keen to secure it so I coached him with some pronunciation. He did a good job, I think.'[297]

The film was a big success for Rossano and some critics bemoaned the fact that more wasn't made of the relationship between Signor Nacarelli and Mrs Johnson – the scenes between them had many comical nuances and the actors had a clear chemistry on screen.

'We had a good dynamic, you know. We socialise and get on well and, for me, I was happy to play something other than the clichéd lover.' He rests a hand on my arm. 'Shall we take a walk?'

Lydia has seen someone. She asks that we keep the dogs with us while she goes to chat with them.

We share the dogs between us, climb the steps to the top of the Piazzale and gaze at the rooftops of Florence, the dome of Il Duomo and the countless bridges across the Arno. The sun reflects off the water.

Rossano's career was full of highs and lows, and, after the success of *Light in the Piazza*, I am sure he hoped that he would be on an upward trajectory. Unfortunately, the next English-speaking role he accepted sent him spiralling downwards.

He closes his eyes. '*Rome Adventure*. You know, by then I was sick to death of these characters. I could play these roles backwards, in my sleep. I was bored with them and then there was my age! I was not the age to be seducing a younger woman in the way I was asked to.

'And I prove, in *Light in the Piazza*, that I am better in the roles suited to my age, with some comedy; but Hollywood always want me as the lover. Even, later in life, in my sixties, if they want that, they turn to me. This film, *Rome Adventure*, it's a typical love story, a love triangle; it's no different to others. But they pay me well and it was filmed in Rome, so I didn't have to travel anywhere.'

The reviews for this film were poor. Some viewed it as an Italian travelogue with a ridiculous plot. Rossano's character was not part of the love triangle, but he was called upon to dish out the charm and, at this time, such grace and courtesy was out of fashion.

'My Hollywood career has always had a predictable structure: there must be a woman, of course, I have to be very charming, there has to be an affair of some sort and I must put on my best Continental image.'[298]

His most memorable English-speaking films followed this formula although he might have wanted to subtract *Rome Adventure* from this list of movies.

Following this and other commitments around the world he returned to Italy in 1964 to film *Dark Purpose* (*L'Intrigo* in Italy). We resume our walk. Rossano lights a cigarette.

'This film I enjoy because I had control over it. It is based on a novel by Doris Hume Kilburn and I bought the rights to it. It's a thriller, a suspense, you know, and I felt it would transfer to film well. We filmed it in Italy, and this was produced at my studio in Rome, the one I ran with Oscar.[299]

'And we have a good cast for this – Shirley Jones, she plays an American lady who works for an art historian [played by George Sanders]. Shirley gets involved, romantically, with my character but she doesn't know that I have some very dark secrets. I have told her that I am a widower, but my wife is in a room in the house and, after a bad accident, she has sort of been brainwashed into thinking she is my daughter. I am very devious and seeking to benefit from this. That secret is gradually brought out as the film develops. I found this a satisfying role to play and I enjoyed playing the villain.'

Like many of Rossano's films, copies are hard to come by but I managed to find this on DVD although the quality was terrible. This was a good movie for its time, although the first ten minutes are incredibly slow and tedious. It's cast well and it keeps you wondering about the "secret" and what will happen to Shirley Jones when she finally discovers it.

Immediately after this, Rossano headed down to South America to film *Pão de Açúcar* with Rhonda Fleming. It was 1963.

'I was delayed by two or three days getting to that country. The whole of Europe was covered in snow for months, and I couldn't get a flight out because of it. Rhonda was a little angry with me, I think.'

It was the same across the whole of Europe. Snow began falling late December 1962 and didn't let up until around Easter time.

'Rhonda had been invited to an event with the Kennedys at the White House and she declined it because we were supposed to be filming. She arrived okay but there were no flights from Italy so she could have gone to that function.' He shakes his head. 'I couldn't help it. I don't control the weather.

'In this film, I play a coffee plantation owner, who is a rich man and a chauvinist. He has a brief romance with an American woman [Fleming] and they get married. Of course, she quickly realises that, although he loves her, he expects her to just be the wife. She gets bored. She can't even do housework because the servants do it.

'One thing I loved about this was spending some time with plantation owners to see how they live and work. It's very hard work – long hours, you know.'[300]

Filming took place in some remote areas of Brazil, but some shots were needed at the annual Carnival in Rio de Janeiro.[301]

'The carnival was good fun. And, of course, while I was in South America, I couldn't go home without visiting Franca and the family.'

Rossano continued to perform on the stage and make films on the Continent in his native language, including the film *Un Amore* with Agnès Spaak where the gossip columnists seized on the romance between the pair of them. You will recall that Rossano's mother was none too pleased with him for allowing this to get into the press.

Entering 1965, the charming image that was so popular in the 1950s was obsolete. Female fans who had adored Rossano back then now thought he was out of date and old fashioned. He understood this and often joked with reporters that many women wouldn't have a clue who he was anymore. It didn't seem to bother him. On one Italian television programme he sent himself up as a clichéd lover and enjoyed making fun of the image.

He stops at a vendor and buys us each a gelato. 'What do you want to talk about next?'

'*The Battle of the Villa Fiorita* with Maureen O'Hara.'

'Oh yes, we filmed that around Lake Garda. That is a nice area of Italy. Have you been?'

'I have.' It is an incredibly beautiful part of Italy, close to the Dolomites. 'And I saw the film. Were you pleased with this one?'

'Yes, I like this film, although I was tired when I arrived. We had finished filming *Un Amore* in Rome in the evening. Once that wrapped, I drove through the night to reach Lake Garda to start work on this film the next day. The first thing I am faced with is a damned journalist wanting quotes for the press pack. I told him what I thought he wanted to know but, you know, in my head I think I wanted to tell him something else – I was so tired. But the atmosphere among the crew was good. I remember we took part in a football match; it was for charity and I was goalkeeper for the British team. That was a lot of fun.[302]

'In this film, I play a father again but, of course, I had to play the lover as well, although a more mature lover. The romance in this film was secondary to what was going on. Did you read the book?'

'Yes, I did.' It was written by renowned German author Rumer Godden and is recognised as a classic "coming-of-age" novel. Her descriptions of the Italian countryside, the villa and Lake Garda take the reader straight to the shoreline and the tiny village close to the Villa Fiorita.

Rossano with his dogs on the set of The Battle of the Villa Fiorita. (Courtesy of Martin Stephens.)

Rossano plays Lorenzo, father to Donna, his sulky teenage daughter and soon-to-be stepfather to Michael and Debbie, his fiancée's children. It's mainly written from the point of view of Debbie, who is aged around twelve. Debbie blames Lorenzo for splitting her parents up and, when Lorenzo takes her mother from England to live with him in Italy, she vows to go over there and bring her back home. Michael, her older brother, is wary of this course of action but agrees to go with her.

Rossano, an avid reader, researched all his roles and he did the same here. He grasped his character well but I'm sure he must have been disappointed not to have seen more of his motivations brought out.

The film spends an inordinate amount of time showing the children's journey from England to Italy. This, unfortunately, cuts down on the time the director has left in which to explore the relationship between the stepchildren and Lorenzo. Both Debbie and Michael fiercely resent Lorenzo but, in the book, they develop a bond with him and this isn't explored in any great detail in the film. Although Debbie's plans to bring her mother home are successful, she has regrets over the outcome of her scheme.

Rossano chatting with Martin Stephens on the set of The Battle of the Villa Fiorita
(Courtesy of Martin Stephens.)

I managed to track down Martin Stephens who played Michael. This was Martin's second film with Rossano. You will remember he played Sigismund in *Count Your Blessings*. He was nine years old in the earlier film and had now reached the age of fourteen and was working on his fourteenth production.

Because he was still at school, as soon as a scene was shot, Martin was whisked off to study, so was unable to mix socially with the cast. However, he had this to say about Rossano: 'He gave me a warm welcome when we started *Battle* [1965]. Of course, he recognised and knew me from five years earlier. I think he was relieved that I was someone he knew he could work with. Rossano was a professional on set. As you know, he came from a legal background, and he brought this professionalism to his film work. Even by the time I made *Count Your Blessings* [1959], I had acted in about five films and some TV plays, so I was familiar with the discipline needed. I think he appreciated a child actor who took the job seriously and responded well to direction. I was fourteen when we shot *Battle of the Villa Fiorita* and I was getting ready to retire. Rossano relished filming on home territory and we spent several very pleasant weeks on Lake Garda. [The location for the Villa Fiorita is now an exclusive hotel and was once the residence of Claretta Petacci, Benito Mussolini's mistress.][303]

Olivia Hussey, who played his daughter, told me: 'I absolutely loved working with Mr Brazzi, he was wonderful. I always called him Mr Brazzi because I was so young. He was a very sweet, kind gentleman. I remember getting very, very bad food poisoning and was in bed for a week with nuns watching me around the clock as my fever was so high. Mr Brazzi spent some time with me, telling me how I was missed on set and hoping I would be better soon. He was very respectful and lovely, and treated me really well even though I was only thirteen. He was such a joy to work with and a pleasure to be around on the set. Lydia was also there – she was sweet and always smiling and they adored their dogs. They were a really lovely couple.'[304]

Rossano nods slowly. 'I remember her being very sick after eating fish sandwiches. I enjoyed working in Italy. It is my home and it was good to have Lydia there with the children.' He digs into his pocket and brings out some biscuits for the dogs.

In Maureen O'Hara's autobiography, *'Tis Herself,* she remembers Rossano spending time telling her of his sexual conquests and making a fuss of his dogs. He was also attempting to woo the script girl with a variety of techniques. Whether he was successful or not, we do not know.[305]

In an attempt to release the shackles of the romantic figure once and for all, Rossano leapt enthusiastically into his next project, a children's film called *The Christmas That Almost Wasn't.* Paul Tripp wrote the story and the screenplay and Rossano directed it. (This was his debut as a director.) Both he and Paul also starred in the film.

This is a mad, crazy, goonish and thoroughly enjoyable film, featuring cartoonish personalities. The story is excellent. Rossano plays the evil Phineas T. Prune, a man who looks and behaves like Dick Dastardly, the baddy from the children's cartoon *Wacky Races,* complete with moustache, shifty eyes and a top hat. It has laugh out loud moments and I can imagine young children loving it.

Rossano with Lydia in The Christmas That Almost Wasn't
(Courtesy of The Everett Collection Inc.)

Lydia also had a prominent part to play. (That same year she starred alongside Peter Sellers in *After the Fox*, filmed in Italy and directed by De Sica.)

'She played Mrs Claus. Lydia is a good actress, very natural.'[306]

Of course he would say that, but she did play the part well – a mother hen fussing around Santa Claus and the busy elves at the North Pole. I was unable to trace any interviews with Rossano about this film but, watching it, he looks as if he was having an absolute blast. He even gets to sing his own songs!

His role in this film is as far removed from any of his previous roles as it could be and I would imagine he relished it. Prune is intent on spoiling Christmas, trying every devious trick in the book to foil Santa Claus and stop him delivering his presents. We later discover that an event in Prune's childhood had turned him against Christmas. Of course, it all ends very happily; Prune embraces the festivities and Christmas goes ahead as planned.

The film was a huge success with children although the reviewers were not that enthusiastic about it. However, it pulled in several million dollars in revenue and was staple viewing at Christmas for American children during the seventies.

Lydia has rejoined us and picks up one of the dogs.

'We made this at Cinecittá studios so, again, Lydia and I could simply go home every night after filming.' He looks at me and gestures towards her. 'But you know what she did? She called the police – to arrest me.'

I stare at Lydia, who laughs. 'I didn't like the way they were treating the reindeer.'

'I don't know what you were so annoyed about, they were fine, they had the zookeeper with them. He would not have allowed us to mistreat them. What were you thinking?'

'I was thinking of the reindeer, of course.'

As they launch into one of their typical altercations, I ponder on what happened. Rossano had brought in four reindeer from the local zoo. They were on screen for three seconds, if that. Accompanying the animals was a zookeeper who remained with them at all times. Apparently, the reindeer needed something fitted to their feet and Lydia

was not happy about that. Paul Tripp, who had a major part in the film, was also in the firing line. She told them both to leave the reindeer alone or she would have them arrested.[307]

Regardless of assurances from the zookeeper, Lydia became infuriated and called the police, who arrived a little while later. 'I told them to arrest Rossano and Paul for cruelty to animals,' she says now, almost with pride.

'I couldn't believe it – I love animals, why would you think I would hurt them? I could have slapped you.'

'You world-class son of a bitch.'

He grins and moves in to cuddle her. 'Oh, Lydia, I love it when you come on to me like that.'

They were off again! How I would have loved to witness the conversation between them during the drive home after *that* incident.

Although it was a success for Rossano, the films that followed it were mediocre. *The Bobo*, with Peter Sellers and Britt Ekland, had Rossano showing as the third lead. He was on screen for six or seven minutes in a film that was almost two hours long. Some 1960s films remain classic viewing but, unfortunately, this one was of its time and now appears very dated.

'When I filmed *The Bobo*, I was a little uncertain because I had heard that Peter Sellers was a difficult man to get on with. He was fine with me but not with his wife [Britt Ekland]. Their relationship was not so good at that time. You know he fired her because she hadn't learnt the script properly! He got her back because she had the main part but, *mamma mia*, that makes things awkward for everyone else.'

He followed this up with *Woman Times Seven* with Shirley MacLaine. Shirley received a Golden Globe award for this movie.

I was keen to see *Woman Times Seven*. Alongside Rossano were Peter Sellers, Alan Arkin, Michael Caine, Robert Morley and Vittorio Gassman. The film was directed by the legendary Vittorio de Sica.

It was a vehicle for Shirley MacLaine, who portrayed a different woman in each of seven separate stories. The idea was a good one. The first story, featuring Peter Sellers, was superb; it was a short, funny,

observational scene. The second, featuring Rossano, was excellent and comedic and I was looking forward to viewing the remaining stories. It was an unusual format for a film, and I enjoyed the concept and, of course, Shirley MacLaine was excellent.

Rossano filmed in Italy over the next couple of years. Some of those movies were made by him and Oscar at their studio, Chiara Film, in Rome. A number were also written by the siblings and directed by Edward Ross, a pseudonym Rossano used for certain projects. However, nothing of any real artistic value was emerging.

While international projects were not going so well, Rossano chalked up a huge success in Italy in 1966 when he took the lead role in the TV thriller, *Melissa*. Written by the master of thriller writers, Francis Durbridge, this particular series had audiences glued to their seats and received excellent reviews. (The British version, starring Peter Barkworth, achieved the same reaction in the early 70s.) Indeed, Rossano would achieve iconic status in Italy with two further Italian crime dramas which we'll come on to later.

One aspect of this that made it an interesting watch is that much of it is filmed using sets. Francis Durbridge wrote for the stage, and we see Rossano in an environment that is almost identical to a stage setting. His acting in this series is compelling and audiences get a glimpse of his talent within a theatrical environment. The series is available to view on YouTube.

Toward the end of the 1960s, Rossano filmed *Krakatoa, East of Java*, but at the time he was distracted by Lydia's health.

'Most of that was filmed at Cinecittá but we had some scenes in Mallorca. Lydia was not well at this time and I was worried about her. I didn't like being away.'

Lydia explains that she had developed cancer but that it had been caught early. 'Rossano, he came home every weekend and I was staying at our place in the country because it was more restful for me.'[308]

Fortunately, the treatment Lydia received was successful, although the disease would return a few years later. Satisfied that Lydia was fully recovered, Rossano committed to filming in Argentina for several months.

'Lydia was going to come with me but her brother, Roberto, was not well and she wanted to stay home to take care of him.'

This trip to Argentina would see him embark on his lengthy affair with the stewardess. Not wanting to embarrass Lydia, I decide not to remind him of that flirtation right now.

Rossano's nephew Carlo remembers his uncle visiting during this time and offers the following as a memory which gives us an insight into what it was like to work and socialise with him: 'My uncle arrived at Ezeiza International Airport sometime between the end of 1967 and the beginning of 1968 along with a crew of technicians, crates of filming equipment, his brother Oscar and a few international movie stars arrived. They were coming to shoot Seven Men and One Brain.

'From my perspective and that of my family, the event was an opportunity for a lengthy, memorable get-together and, of course, for sticking our noses into the "beau monde". Uncle Rossano settled in a large villa near San Miguel, west of Buenos Aires and my mum, dad, Maria-Lidia and I would go over and hang around for days at a time.

'Short stays at the villa offered opportunities to be with personalities of varying charm or interest, but above all, I enjoyed the luck of sharing the pool, meals, my uncle's wine [he and Lydia owned a vineyard in Italy], conversations and some guitar playing and singing with Ann-Margret and her husband Roger Smith: a remarkable couple because of their mutual affection, their human qualities and artistic skills.

'We also had entry rights to studios, offices and filming locations and I got to meet, sometimes shake hands or even sit at the table with, personalities like Gina Maria Hidalgo, an Argentinean soprano popular at the time; Lando Buzzanca, Italian comedian; and my idols, Argentinean comedians Javier Portales and Alberto Olmedo.

'It was not just meeting jet-set people that I enjoyed; I had the privilege of exploring landmarks that are normally off-limits to ordinary mortals, such as the Teatro Colón, Buenos Aires' opera house. I walked unaccompanied, several times, all the way from the president's balcony to the backstage and basements.

'At this time, I was twenty-two, studying at the Buenos Aires University School of Architecture and playing in a rock band that had

survived from high school days. We called ourselves The Allens. My uncle was kind enough to let us participate in a couple of scenes at the shooting sites but little to nothing was included in the final version of the movie. However, it was lots of fun.

'The first shooting site was a then-renowned disco, Sunset, located in Olivos, a lively area north of the city. The place was crowded with hundreds of extras, technicians, actors, journalists and snoopers. We'd been dressed up and provided with top-notch sound equipment for the occasion. Our arrival time had been early in the afternoon but we had to wait until about 3am for our turn; a little tiring but not too boring. During most of the waiting time, we were asked by the managing guys to keep on playing.

'The bulk of our repertoire came from The Beatles and other rock stars of the era, plus a few songs of our own. People watched, danced and chatted with us. Naturally, a few girls tried close encounters, but the atmosphere created by my uncle was serious, mostly work, work, work, so that part had to wait. The actions at shootings were amazingly spectacular in their arrangement and coordination. I can still feel some excitement from that memory. However, a more intimate thing happened during a second shooting.

'This time we were at the rooftop garden-restaurant-pool of the Plaza Hotel, downtown Buenos Aires. Another city landmark. Early arrival, dress up, etcetera mirrored the requirements of the previous filming site. This time the night turned rather cool.

'We were offered coffee and snacks as we kept playing. At one point, Petretto, one of my uncle's close assistants, came over and, addressing me in Italian, politely but showing a bit of displeasure at our repertoire, said something like, "Hey, come on *ragazzi* [boys], can't you play anything in *Italiano*?"

'We dug into our secret romantic song list and started to improvise from the main theme of the musical *Rugantino*: "*Roma nun fa la stupida stasera…*" Our orchestration was improvised and far from good, but it took just a few seconds for a small crowd, including Rossano, Oscar and the Italian technicians, to gather around the stage and sing along. The atmosphere got warmer; very enjoyable.

'A few scenes of the movie were filmed in Mar del Plata, the urban beach resort of Argentina. During that time, some excuse for celebration, maybe it was a birthday, led to a party in a good local restaurant.

'Besides my uncle, who was the host, the crowd involved the whole filming crew, plus Ann-Margret, Roger Smith, Lando Buzzanca, of course my mother, and a few others including myself. My uncle had asked me to bring over the guitar. I wasn't happy about that but agreed.

'I was seated next to Lando Buzzanca. He was one of the most popular Italian comedians of that decade, so I was excited about the prospective jokes and laughter. However, I was soon taught a lesson to control my expectations better. His conversation remained fixed on his sister and later switched to his mother. Lots of tragedy, zero comedy.

'Then Uncle Rossano decided it was time to sing and was looking to me. Someone suggested, "In Italian", so I picked up the guitar and tried some unrehearsed suggestion from the crowd, hoping for somebody else to take on the singing. Still no luck. So, I made a short, unconvincing performance to justify the presence of my instrument.

'Then suddenly, events took a positive turn. Roger Smith waved at me for the guitar. He grabbed it with professional confidence and hoorah, he and Ann-Margret immediately took off in a fantastic, lively show. I really don't know how to put it into words: a jewel of a performance. The spirit of the party rose again to its rightful heights. Thank you, angels, I thought.'

In 1969, he travelled to Spain to play a detective in *Honeymoon with a Stranger*, alongside Janet Leigh. Janet, you will remember, appeared with Rossano in *Little Women* in 1948. Her fond memories of him had not diminished and she later described this to a journalist.

They, apparently, got along much better during this film because his English had improved. The crew were a great crowd, and they had a lot of fun throughout the shoot. Both of her daughters were with her in Spain and one, Kelly, celebrated her birthday during that time. Rossano went to her party and spent some time chatting to the children and making a fuss of them.

To Janet, he was very generous with his time, especially during interviews. She realised that he didn't just speak Italian and English but Spanish, French and German too and he sat alongside her during press interviews to translate for her. She described him as a talented and wonderful actor who created a good chemistry on set.[309]

Rossano's next film has now become a 1960s cult classic: *The Italian Job.*

Rossano in The Italian Job (Courtesy of The Everett Collection Inc.)

The producer, eager to appeal to the Italian audience, hired two of the country's most iconic actors – Raf Vallone and Rossano.

He turns to me. 'Did you know Raf was in *We the Living*?'

'I did not.'

'That was his very first film. He didn't get credited because he had no speaking part.

'We had only minor roles in *The Italian Job*. I play a mafia boss in the opening scene, driving the Lamborghini around the Italian alps. Later, I have just a few minutes telling Michael Caine how to go about robbing some gold bullion. Raf, he plays a rival mafia boss, again, with just a few minutes of screen time.'

Everyone remembers the opening to this film where Matt Monro croons *On Days Like These*. The iconic Italian alps, an iconic Italian car and an iconic Italian actor at the wheel. Rossano couldn't have looked cooler, wearing stylish sunglasses and with a cigarette in his mouth.

'You know, they named those sunglasses after me.'

Here was something I had to check out and, sure enough, he was right. They are made by Renauld Mustang, a well-known label in the 1960s but still a high-end brand today. During a relaunch, the gold-wrapped glasses were rebranded as the "Rossano" and are still available to purchase.

Sadly, the producer's tactic for wooing the Italian audience did not work. While the film was a massive hit around the world and would later become one of *the* iconic films of the 1960s, the Italian audience was not so keen – the likely reason being that their police and authorities were made to look like idiots.

'Rumour had it that you were unable to return to the United States to work because the IRS (Inland Revenue Service) were chasing you for unpaid taxes.'[310]

He gives me an indignant glare. 'Where did you hear that?'

'I have the documentation.'

'Oh.'

Lydia laughs. 'Good for you. You catch him out.'

He grins. 'That's true. I never liked the tax system in America. They take every cent and more if they can.'

(This wasn't the first time. His nephew recalls a couple of occasions

where the FBI pounced on his uncle when he entered the United States. 'He liked to be a little subversive,' was Carlo's observation.)

To explain, after *South Pacific* had wrapped in 1958, Rossano returned to Rome and made the occasional trip to America to be a TV-show guest or film the odd interior scene for films. By 1973, he had run up a tax bill of over $1 million.

Broadway producer Gen Genson had booked Rossano to star as Svengali in a musical, *Her Master's Voice*, based on a play by George du Maurier. But the government would not allow Rossano to enter the States until he paid his taxes.

'I told Genson to sort it out – I signed a Power of Attorney to authorise him to manage it. You know, he negotiated a discount from that sum and I was able to pay it easily. I decided not to take that part on Broadway, and I think the project was abandoned.'[311]

Although Rossano kept busy making films around the world during this time, little stood out as memorable. Had he not been pigeonholed by Hollywood, things might have turned out differently. I decide to broach this subject when we next meet.

Chapter Twenty

DRINKS ON THE TERRACE

I follow Lydia into the larger lounge of the Villa Borghese apartment where I find Rossano napping on a sofa, a newspaper on the floor.

'He loves to take a nap – that is a hobby for him.'

'Why doesn't he go to bed to nap?' Rossano, although his eyes are closed, is quick to respond.

Drawing of Rossano
(Courtesy of Sarah Bairstow.)

'She won't let me. But she lets the dogs sleep on the bed!'

I look to Lydia for an explanation. It's succinct. 'The dogs are innocent; he is not.'

She leaves and I spot a grin on Rossano's face. One thing I have learnt from these sparring bouts is that Lydia inevitably has the last word.

Getting up, he suggests we move to the terrace, where we find two loungers. The dogs follow him. He is in casual trousers; his shirt is open and he's barefoot. The sun is warm and there is a gentle breeze.

He has the look of a contented man; but I do wonder if, privately, he had regrets about some decisions he made, especially after *South Pacific*.

Where his film career is concerned, I cannot help but think he – or his agents – made some bad decisions and I believe Hollywood, and the way the studios were set up in those days, missed a huge opportunity with this man.

My feeling is that he probably only discussed such matters with Lydia. She was the only person he would truly listen to. The family confirmed that he could be incredibly stubborn over certain matters and, if Lydia couldn't make him see sense, no one would.

During interviews, he rarely admitted to regrets; the only subject he actively expressed disappointment over was the role Hollywood asked him to play time and time again. He accepted, however, that he had helped to cultivate this image because he had wanted to conquer Hollywood quickly.

Unfortunately, he fell foul of the "star system". Hollywood wouldn't cast him in any other kind of role.

He glances at me. 'You have a question?'

'The brand, the image – when did you really get tired of it?'

He lights a cigarette and goes over to a mobile trolley to pour drinks. The dogs look up to see where he's going. I hear ice fall into the glasses. The dogs settle back down.

'Very quickly. Definitely by the time of *Rome Adventure* but tiring of it a little before. When I became older, I was grateful to have an older face, but they still come to me for a romantic part. In Europe, I was playing different roles, but all Hollywood wanted from me was the Continental lover.'

He hands me a glass and sits down.

'When you are fifty, sixty years old, that is not appropriate – my looks were not so good then – not for what they wanted. They paid me good money – so I played them. That is the way things were. You know, John Wayne, he only made about ten films less than me. How many of his films do you remember? Only those that really stand out as excellent films. I made over two hundred films, and most are no good whatsoever. Only half a dozen were excellent. The same with Tyrone Power. He said, like me, that he made numerous films but only a handful were good.[312][313]

'And I said this before, June Allyson, who starred with me in *Interlude* – she was always being cast as the girl-next-door – the typical American wife. She was capable of so much more than that but the studios, they never allowed it.

'That is why I admire Katharine Hepburn so much. She stood up to these movie giants and she got the roles she wanted. Bette Davis, Greta Garbo, Joan Crawford, they all went against the stereotype.'

Brazzi's decline, during the 1960s, came after a decade of being at the top. He earned several million dollars over this period and, even today, the world is still waiting for another global Latin lover. Some have tried but, realistically, only two people have taken the crown for any length of time – Rudolph Valentino and Rossano Brazzi.

We heard earlier that Rossano had considered retiring completely from acting to pursue other interests. He was a scholar, an intelligent man who was interested in culture and history. Did he regret not feeding that intellect?

He was a critically acclaimed stage actor. Had he remained on the stage, he could have been the Continent's Laurence Olivier or John Gielgud. Did he regret not staying with his first love?

He was also a critically acclaimed film actor in Europe and played a variety of roles. Did he wish that he'd been more prudent with the roles he accepted from Hollywood?

We will never truly know. If a new project came up, he was always enthusiastic about it, but he never regained the heights he'd reached with his stage and early screen roles and, where Hollywood was concerned, the characters he played had little depth.

I sought out Dorothea Marciak who is based in France. She is an editor, translator, writer, scholar of the Italian Renaissance and well-respected authority on historical art and culture. Several email exchanges took place, and I was provided with a very constructive and comprehensive analysis of Rossano's career, especially where Hollywood was concerned. She also gave me permission to use the information she provided to the *Rossano Brazzi International Network* website. Here are some of those comments. I will leave you to make up your own mind:

'He should have never gone to America! I said once that he has made some mistakes in his life and one mistake would be when he went to America where they made him act the role of the Latin lover.

'He had something of that already in his first Italian roles and he himself said that Scalera had cast him to be some sort of a "diva". But acting in Italy required so much more feeling and expression than in America in the '50s. Even as a lover, which he was in *Tosca* and *Noi Vivi*, those parts were richer, complex and more interesting to play in Italy than in Hollywood. *Tosca* and *Noi Vivi* show Rossano at his best.

'He was capable of such psychological complexity in his acting that I'm always surprised of the poorness of the roles he had to play in Hollywood. Is that a question of culture, of society? I guess there were two different cultures, two different conceptions of acting, of feelings and of virility.

'Brazzi in Hollywood should have been a woman at that time. He could have made more extreme choices, taken more risks, just as Katharine Hepburn did. She was not only a beautiful woman but would break that image whenever and as soon as possible. I know a few examples of actresses behaving that way and succeeding, but I know no actor who would break the image and go on acting, not at that time.

'Italian movies just after the war began to play on the double sense, and put their great actors in embarrassing, comic situations, knowing that their virility or sex-appeal wouldn't be lost in the laughter. Not in America where, it seems to me, acting is so serious.

'What remains in my mind after all these years is a sort of "pity" for his wasted talent. He was handsome but not only that, he could have made a great actor in Italy but let himself be "caricatured" by the American movie industry. It worked and it paid, and he was successful, but what I felt, watching the young talented man playing in *Tosca* and *Noi Vivi*, was something quite different which was never fulfilled in his later life.

'It reminds me of a book by Malaparte, *La Pelle* [The Skin]. It is about American "liberators" bringing "liberty and democracy" in Napoli at the end of World War II. The whole story consists of a series of dramatic and very cinematographic pictures and scenes taking place in Napoli.

'The main question is repeated through conversations between the narrator [Malaparte himself] and an American officer. That question is: How can a beautiful civilisation like the European one be able to give birth to such horrible things as Nazi camps, [the] Holocaust and all the horrors of World War II?

'The American in the book doesn't understand how pure beauty and pure horror can coexist in the same civilisation. He thinks in binary terms; bad vs good, like in Hollywood films. He doesn't understand either why the Neapolitan people cheat and rob American soldiers, instead of being grateful to them. The answer for Malaparte is one of an old and complex civilisation where good and bad [are] bound, where things are not so clear, a civilisation which gave birth to Dante and Shakespeare know[s] that things and people are never one colour, one way.

'It takes place exactly at the moment when *Noi Vivi* is filmed (1942) and, for me, it shows perfectly the way Brazzi must have felt, being chosen for his acting skills but cast again and again in the caricatural part of the "Latin Lover" – as seen by American people, for an American audience, which allows no complexity, no humour and no spirit. These were the tasty and joyful qualities that were embraced in Italy by actors like Toto, de Sica, Vitorio Gassmann, and, of course, Mastroianni and Fellini.

'It is interesting to compare Rossano Brazzi's career to Alida Valli's, his co-star in *Noi Vivi*. They were both promised a great career but followed completely opposite paths from this movie together; Alida Valli stayed in Europe and Italy and worked with great directors in the theatre and movie industry, while Brazzi, despite his obvious "glorious Hollywood era", has had his career, in my opinion, completely destroyed on an artistic level by the cliché of the handsome and seductive Italian man that Hollywood insisted on constructing around him.

'I think the most interesting point is that the American movie industry of post-World War II was completely unable to feel the subtleties of the European situation in that time, the subtleties of characters and personalities, and, consequently, unable to write and offer actors such as Rossano Brazzi interesting and complex parts. Unable to or didn't want to.

'Directors such as Rossellini, Fellini or Vittorio de Sica could help themselves thanks to a good sense of humour and irony in their movies, but Brazzi [in Hollywood] played in movies with very little humour.

'Even Sophia Loren who came to the US as a star with her husband-producer didn't find a great movie where she could express the whole range of her talent as an actress.'[314]

Rossano looks at me. 'All those who went to Hollywood suffered a little. Sophia Loren is a good example of this. Have you seen her Italian films?'

'I have.'

I was bowled over by her acting. Hollywood pigeonholed her, as it had done with Rossano, and her English-speaking roles are shallow compared to what she was asked to play in Italy. A good example of her acting is in the Italian film *Two Women*. She would be the first to win the Best Actress Oscar for a foreign-language film with that role.

'Me, Sophia, and Anna [Magnani] we all suffered in Hollywood. I came to hate what I was asked to do but, if I wanted to work in Hollywood, I had to accept the role or not work at all.'[315]

The other side of this coin is, of course, Rossano's personality. I agree with Dorothea, that he wasn't given the right opportunities in Hollywood – that Hollywood failed to use his talent.

But did he lose sleep over it? We have seen that he simply wanted to enjoy life and he lived for today. If he had regrets, he didn't carry them for long.

Because of the roles he was given in Hollywood, some viewed him as a lightweight actor. But, the likes of David Lean, Jean Negulesco, De Sica and Alessandrini can't all have been wrong. Actresses of the caliber of Bette Davis, Katharine Hepburn and Joan Crawford saw what he was capable of. Those who have not seen *Tosca* and *We the Living (Noi Vivi)* will be unaware of the depth of his acting. Later Italian TV roles like *Melissa*, too, highlight his acting credentials. Other directors who later worked with him all commented that they didn't realise he was such a great actor. Had they also been fooled by the Hollywood image?

'I am not the best actor in the world, but neither am I the worst. I learn my trade and I am a professional. My English would never be the

best, but I was good at expressing myself with my eyes, my hands. A look, a touch or a gesture from me would show more than a hundred words in a script and that is the basis of good acting.' [316]

I wonder if he regretted not working with Fellini.

'Would you have liked to work with Fellini?'

I receive a curt nod. 'I would have worked for him for free but...' He shrugs, reaches for my glass and gets up. 'You want another?' [317]

LIVING THE DREAM

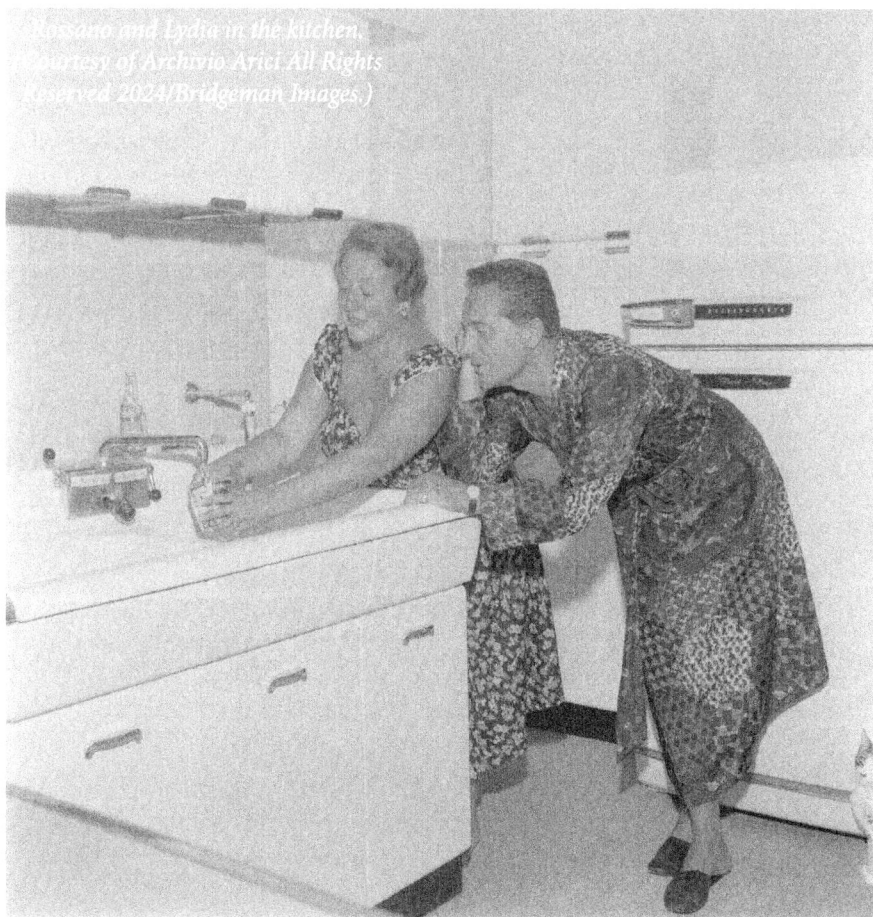

I look on as Rossano and Lydia concoct something in the kitchen. Neither one seems to be in charge – this is a joint effort and, for once, there is no bickering or sparring. They're enjoying the process of preparing and cooking food. The family confirmed that Rossano became his most charming and animated when the subject of food came up.[318]

We are in the immense kitchen of their home in Beverly Hills, California; relatively small compared to their neighbours. The cream-and-yellow two-storey house sits way back from the main road. It has five bedrooms, a large terrace, a swimming pool, a boules pitch and a tennis court. They chose this particular house because of the number of trees and shrubs surrounding the property which, they said, reminded them of Tuscany. A constant visitor to this kitchen was Judy Garland's husband, Vincente Minnelli, who enjoyed the couple's hospitality. Other frequent guests included Rossana Podestà, Marco Vicario, Joan Crawford, Sophia Loren, Robert and Flora Alda (Alan Alda's parents), Mitzi Gaynor and Mario Lanza. (Rossano and Robert Alda were two of the six pallbearers at Lanza's funeral in Rome.)[319] [320]

A large number of friends, both in the US and in Italy came from outside the movie business. Rossano, dicing carrots, is quick to tell me why. 'If you have actors to your home, all they talk about is acting and films. I don't want to talk about work when I get home. A lot of our friends are authors, scholars, painters and people from everyday life. The conversation is more interesting away from the movies.'[321]

Lydia adds garlic to sizzling olive oil. Rossano adds the onions and carrots. He reaches for some celery and slices that into the pan, leaving a little to eat himself.

They are giving me a taste of traditional Bologna. Lydia wears an apron over her floral summer dress. Rossano is dressed in shorts and a short-sleeved shirt.

'Are you trying some different herbs?' he asks her.

'Yes, I think so.'

He reaches for a bottle of red wine and locates a corkscrew. 'And don't forget the wine this time.'

'Are you doing the Caprese?'

'*Certo.*' Rossano steps behind her as she is stirring the pan. He hugs her tight and kisses her on the cheek, then retrieves large tomatoes and some mozzarella from the fridge. 'Did you remember the basil?'

'I didn't get it, you said you would get it.'

'Don't we have any on the patio?'

'The plant died. Use something else.'

'On Caprese!' He checks the herbs they do have and brightens. 'Oh. We have some here.' He tears some leaves off and turns to me. 'You want some wine?'

I do. Back at the fridge, he selects a bottle.

Watching them prepare lunch confirms what everyone has said: these two are seasoned cooks – excuse the pun. They don't follow a recipe; they simply taste how the dish is coming along and add what they feel it needs.

Lydia adds some salt and tips in a dash of wine. He nudges her elbow so a little extra alcohol escapes into the pan. They grin at each other.

The dogs, who have returned from their walk with Irma, immediately race into the kitchen. You can almost see the thought bubbles above their heads – are they cooking for us?

Rossano orders them out. 'You'll get yours later.'

The table, as always, is laid perfectly. The wine and salad are brought from the kitchen to the table and, a little while later, the meal is served. Lydia and Irma strike up a conversation.

Rossano takes a slab of Parmesan and grates a portion for each of us. 'Where are you, with my story?'

I remind him. In 1970, the film adaptation of Harold Robbins' novel, *The Adventurers*, was released. Filmed all around the world but, predominantly in South America, this saw him paired up again with Olivia de Havilland, his co-star in *Light in the Piazza* and another detour to visit his sister. Again, this film, although lavish, was not a great success with film critics.

But, just when you think that Rossano has left his success behind, something comes up that catapults him back into the public eye. You will remember he scored a big success with the Francis Durbridge thriller, *Melissa*, in 1966.

Well, in 1970 in Italy, photographers and journalists were again clamouring for a piece of Rossano Brazzi after he starred in a series there called *Coralba*. Though he was now in his mid-fifties, women had rediscovered him and even teenagers wanted to know who this man was, learning that he had been a screen icon during the forties and fifties.

This five-part thriller gave him tremendous personal success. Not only was he back in the public eye but the programme was produced by Chiara Film, the studio he owned with Oscar.

'I was so pleased about this series. I was in my fifties; I wasn't so handsome and I could play someone more fitting for my age. You know I had to sign a stack of autographs for a friend of mine to give to his children. They said their friends all wanted them at school. Can you believe that?[322]

'This series was set in Hamburg, in Germany, and I played a doctor from Venice, Marc Danon. He heads up a pharmaceutical company and is being blackmailed and suspected of murder because of something that had happened in the past with his company. It is a good thriller and it was very popular in Italy.'

I managed to view this series and, although my Italian is limited, I understood the gist of it. What made it stand out was the quality of the plot and the acting by all members of the cast.

It was reminiscent of thrillers written by Francis Durbridge or some Hitchcock films. Timeless. If *Coralba* were restored and rereleased today, it would likely be just as popular. Rossano's brother, Oscar, appeared in one episode as a taxi driver and, I have to say, he is also an excellent and natural actor.

It must have made him very happy.

'You know, I work hard. I get up at six or six-thirty in the morning and keep myself in shape. Every project I take, I try to do my best and sometimes it is good and sometimes it doesn't work out so well. I was very proud, especially as it came out of our studio.'

In one interview, Rossano was a little scathing of Italian directors, sarcastically commenting that it was as if they had figured out, after all these years, that he could actually act![323]

But, even with this success, he and Lydia made plans to return to America.

'I had more opportunity in America. There, it doesn't matter how old you are. In Italy, the roles tend to go to a specific actor. If your face does not fit or you are too old, the door is closed. Metaphorically, I died in Italy three or four times because the Italian public is critical of me. That happened to Gina Lollobrigida and Vittorio [De Sica]. Vittorio, he told me once he had died seven times in Italy and recovered. In America, they will always offer work no matter how old you get. But I had a family matter to sort out before I left.'[324]

His sister Franca had been speaking with Rossano quite often during the early seventies. Her daughter, Maria-Lidia, was in love. She was a teenager and the man she loved, Raul, was two or three years older. Raul was moving to Canada and he wanted Maria-Lidia to go with him. Franca was set against the whole idea – Maria-Lidia was too young. Eventually, she allowed her daughter to go for a holiday, on the proviso she returned home via Italy and spent time with Rossano and Lydia.

'When Maria-Lidia arrived to us from Canada, Franca called me and said that this Raul had followed her from Canada to Italy. She was furious and asked me to intervene. I was very fond of Maria-Lidia and I couldn't see that this man had any prospects; and she was still only seventeen or eighteen. This was, I think, a first crush so it was particularly special for her.'

Franca idolised her older brother, but she also valued his advice, so she asked him to mediate and sort things out.

'My sister and Franco had done what they could. And, you know, sometimes it needs to come from someone else. Children, at that age, do not always listen to their parents. I told Franca to leave this with me and I would try to talk some sense into them. I invited Raul out to dinner and I asked him, you know, "What are you planning? What do you want to do?" He had a job as a waiter in a top hotel, a qualified server but he had no money, no plans, so I understood why Franca was worried about this union. Raul told me he wanted to settle permanently in Canada.'

Raul takes up the story.

'Rossano was very kind and courteous. I remember I was a waiter at an event and Rossano was there. He came up to me and said, "On Saturday next, we meet at the Taverna Flavia. You, me and Maria-Lidia." He was very much the protective uncle and was steering me away from his niece. This restaurant, at that time, was a well-known haunt for artists. He drove me there and asked me about my intentions. I said I wanted to settle in Canada and the following week he arranged for me to meet the Canadian Ambassador! He was determined to offer me anything in order to keep his niece away from an uncertain destiny.'

Raul and Maria-Lidia, however, continued with their romance in Rome. Rossano tuts.

'Maria-Lidia was staying with us and, you know, the pair of them ran away. They went to Florence but then returned to Rome. We called the police one time because we could not find them. Eventually, things worked out. Raul went to Canada and Maria-Lidia returned to Argentina. She eventually married and settled down with a family.'

Raul had this to say about Rossano: 'I found Rossano was ultra-cordial and friendly and did his best to see both sides of things. He was a man of the world and, although he was "my enemy", he was a pleasure to deal with. I will always remember him and regret that I could not get to know him more but, with the situation I was in, he would not have allowed that.'

After mediating this family crisis, Rossano spent much of his time in America with the occasional trip home to visit family and carry out filming commitments on the Continent, South America, Africa and England.

In Africa, he appeared in *Mr Kingstreet's War*, set at the beginning of World War II. Rossano took on the role of a Fascist Italian officer.

In England, he was cast alongside Sam Neill in the horror film, *Omen III – The Final Conflict*. Neill played Damien, the Antichrist and Rossano was the priest, Father DeCarlo, whose mission in life was to destroy Damien.

Sam Neill told me an anecdote that I found amusing, especially so many years after Rossano had played Emile de Becque: 'When we were

shooting *The Final Conflict,* we were delighted to hear that Rossano was in the cast. Of course, in our Anglophone world, Rossano was most famous for *South Pacific* and in particular "Some Enchanted Evening". On the days he was expected to work I would sing this song, badly, in the car on the way to the studio.

'Lisa Harrow [a co-star] and I would ask each other if we were brave enough to ask him to sing it for us one day.

'But then lo and behold, she was walking past his dressing room and a familiar song could be heard. She rushed into my dressing room, steaming with excitement. "He's singing it now!" I dashed back to his door and we stood there, our jaws dropping, listening to the great man singing the great song. We couldn't believe our luck.

'We never heard him sing any other songs – maybe that was his entire repertoire.'[325]

In America, he, along with a number of older film stars, accepted parts in the popular series of the day, *Hawaii 5-O, Charlie's Angels, The Love Boat, Hart to Hart,* etc. In the UK, he took part in a Ruth Rendell mystery and a Somerset Maugham play. All this was a far cry from the roles of his heyday but, in his own words, it paid well and he and Lydia could live the lifestyle they wanted. These roles are not memorable, the scripts were poor and they are all dated. However, at least they more suited to his age.

'In Hollywood, we all lived together. Kirk Douglas, Cary Grant and Maureen O'Hara, they all lived nearby. We were great friends with Mitzi [Gaynor] and Jack. I got our house there when I first started making money in America, back in the fifties and it was paid off in around ten years. Lydia, she just roamed around barefoot, never got dressed – just stayed in her negligée. I liked the lifestyle. Every morning, I threw myself in the pool, then have breakfast on the terrace and, if I have something to do like a script to read, then I start work.'[326]

'What did you think of the star system in Hollywood.'

'I didn't think anything of it. A star does not mean you can act – it means you are popular. I know many "stars" and they cannot act to save themselves.'[327]

In the mid-1970s, they returned to Italy and to his first love, the stage. One of his popular appearances on home soil was in a play by Ibsen at the Teatro Erba Chieti to the east of Rome.

During my own travels in Italy, I happened upon a beautiful theatre in the tiny community of Volterra, about seventy miles from Florence. The door was open and I was invited in to take a look around. Displayed in the foyer were photographs of actors and actresses, including one of Rossano. I learnt that he had appeared in a play at the theatre in 1975.

'I still loved the stage, even though it didn't pay so well. I tell you, Richard Burton, when he was at the height of his career, he would occasionally go back to the stage in England. The Hollywood producers couldn't understand it. Why go to the London stage for a few pounds a week when we can give you thousands? He was not persuaded by that and I liked that about him.'[328]

Remaining in Italy, he took on the lead role in a TV drama called *La Promessa* (The Promise), based on a book by Friedrich Dürrenmatt. Rossano played a detective obsessed with catching the killer of young girls. He has quite an arc in this, turning to drink and eventually going insane. This was the third immensely successful Italian TV drama for him (following *Melissa* and *Coralba*). Again, his popularity in Italy rose and, again, journalists wanted a piece of him.

Gene Lerner remembered being in Rome at that time and picking up a newspaper, *Il Messaggero*, in which there was a review of *The Promise*. The review praised Rossano's portrayal of Inspector Mattei who finally drives himself mad over the investigation of a killer of young girls. Rossano, in their words, was a revelation.

I watched *La Promessa* and was bowled over by Rossano's character arc. Over a two-hour drama he transforms from a well-respected police inspector to a man who has lost his mind over the murders and his belief that they had charged the wrong man. By the time the police have discovered they did have the wrong man, Rossano's character is beyond understanding.

Gene watched the series and was moved by his friend's extraordinary performance. At sixty-three years old, Rossano was triumphant again.

He hadn't seen the Brazzis for some time and wondered how they were doing. Wanting to congratulate him, he telephoned them.

Rossano smiles at the memory. 'I remember this telephone call. It was so nice to hear from him. I shouted to Lydia, "It's Gene on the telephone." She snatched the receiver from me and starts to chat. I couldn't get a word in.

'She told Gene she was so happy to hear from him and that we had missed seeing him and Hank. You know, we talked about all of the wonderful years we had spent together and why did we lose touch. We spoke about getting together again.'

Unfortunately, this would be the last time Gene spoke to Lydia.

Chapter Twenty-Two

S. TERESA DEL BAMBINO GESÙ

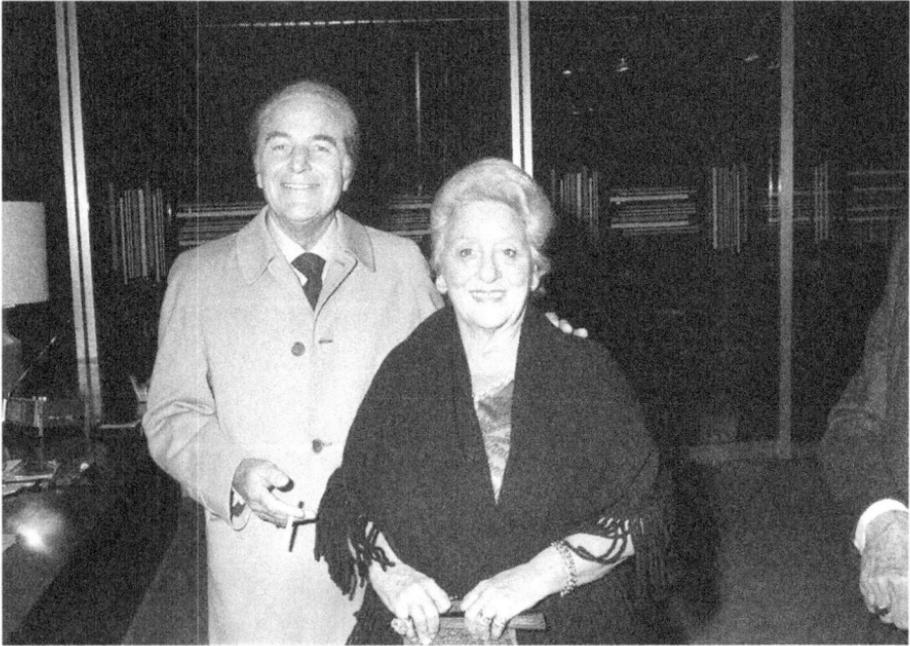

Rossano with Lydia just a year or two before she died. (Courtesy of Reporters Associati & Archivi/Mondadori Portfolio/Bridgeman Images.)

On 21 April 1981, the funeral of Lydia Bertolini Brazzi took place in S. Teresa di Gesù, the church that she and Rossano had admired so many times from the splendid terrace of their apartment on Via Giovanni.

Gene tells us that he was at the church.

'Throughout the service, I could see Rossano struggling. He focussed on Lydia's coffin with such intensity I could almost see his thoughts and what he was wishing for. He was willing Lydia to return to him, to get out of that little box just in front of him and laugh in that joyful way that she had. But, of course, Lydia would not be coming back.

'We'd no longer hear the back and forth of their entertaining arguments, her insistence that he be quiet, that he kiss her foot, his equally mischievous and flirtatious responses. He looked a broken man at that point, and I wondered whether he'd ever recover from this.

'Me? I was thinking about the good times we'd had; that day when they opened those parcels of money; when Lydia had got all her jewellery out of the pawn shop and leaping around La Palatine in the middle of the night.'[329]

This was, understandably, a devasting time for Rossano and, by his own admission, he fell apart and made decisions that I am pretty sure he regretted as, after this period, he adopted a quieter lifestyle. Although he rarely gave interviews after his heyday, those interviews became fewer after the following incidents.

It's important to note that not only had Rossano lost his beloved Lydia, he had also lost his kid sister, Franca, the previous year.

By now, readers will know that, apart from his mother, these were the most important women in his life. He adored his sister from the moment she was born. Her death devastated him, especially as she was still relatively young – only in her fifties.

Throughout his grief for Franca, he had the worry of Lydia who had redeveloped cancer. Tests proved it was at an advanced stage so there was very little help that could be offered except to ensure she was as comfortable as possible.

I am sitting with Rossano and Oscar in the church of S. Teresa. Unlike many of the churches that I have seen in Rome, this one is not grand or magnificent. It is compact, pretty and intimate. Small icons are displayed on the pale lemon walls and, although the ceiling is high, it is plain. Neither Lydia or Rossano wanted any fuss with their funerals and

this little church, just next door to their home, fitted the bill where those wishes were concerned.

'Lydia, you remember, she had her first cancer scare in 1968 when I was filming *Krakatoa, East of Java* in Mallorca and I went home every weekend to be with her. Fortunately, she got over that and I had her with me for a few years more. When it returned, she had to go into a nursing home. She was being helped there but it was only a few months after being diagnosed that she left me forever.'

The loss of his sister was upsetting enough but to have this compounded by the loss of the woman he considered his soulmate would have hit hard.

'I had depended on Lydia throughout my whole life with her; she looked out for me, shielded me from people she felt were trying to use me. I am not the best judge of people because I see the good in everyone. After she went, I turned to her as if she was still here. I went to the cemetery, to her tomb, often, to talk to her.'

Rossano was rich, famous, in his mid-sixties and still a handsome man and there were endless numbers of people wanting to be around him, wanting to be a part of his circle. Lydia had a shrewd head on her shoulders, a great deal of common sense and was happy to cut people out of their lives if she felt they would hurt or manipulate Rossano. In some respects, she was a matriarchal figure within the marriage. She knew that he was vulnerable to being taken advantage of.[330]

His nephew Carlo confirmed this. He was also quick to remind me that his uncle was not naïve; he was educated, well-read and a scholar, but he was terrible at understanding people's intentions. This was Lydia's area of expertise.

Now, he was alone. Lydia, his wife of forty-one years, was gone. His beloved sister was gone. There is no doubt that Oscar would have rallied around but no amount of sympathy and words would fill the void left by two significant deaths. Unfortunately, his dependence on Lydia in respect of filtering the good people from the bad left him floundering. She pulled him back from his occasional childish whims, encouraged him when he was depressed and kept his feet on the ground when fame threatened to heighten his ego. Within two years of her death, he was to

make decisions that could have had far greater consequences than they actually did.

I think it's true to say that there was a side to Rossano, an ego, that would prove to be damaging for him. There was a bravado about the man – not necessarily a negative trait –but he had no qualms in bragging about who he knew. This left him open to the very people that Lydia used to shield him from.

His true friends continued to do their best to support him. But to those who wanted to take advantage, he was rich and vulnerable with friends in high places – the ideal man to take advantage of. The few interviews he gave around this time show him proudly boasting of his ties with people like Ronald Reagan, the US President of the day, and those in his circle. This made him a prime target for manipulation.

Lydia often said that Rossano could not say no to anyone. If someone wanted to meet him, he would meet them. If a charity wanted money, he was happy to give funds and although these were normally pleasant interactions and all above board, he took everyone at face value and rarely thought ill of people until events proved otherwise. Ultimately, he was too trusting.

In 1981, two men who were able to get to him were the former colonel of the secret services, Massimo Pugliese, and the former head of SISMI, Giuseppe Santovito. Italian newspapers were full of articles about this at the time, most notably *L'Unità* and the *Corriere della Sella*. I have attempted to dissect what happened during this time from those publications:

SISMI was a military intelligence agency in Italy. Santovito was already under investigation in connection with two other cases dating from the time he headed the military intelligence service. Indeed, a number of arrests of high-ranking government officials were made and most of them belonged to a masonic lodge known as P2.

P2 (Propaganda Due) had quite a list of prominent politicians, secret service personnel and other government and military officials as members. Santovito claims in many reports that he was unaware of the P2 lodge and its activities. Pugliese was, apparently, a member. The two were, allegedly, very close although Santovito would often claim otherwise.

The lodge was founded in the nineteenth century but, due to its nefarious activities, its charter was taken away in the 1970s. However, it continued as a clandestine operation with some questionable political ideals leaning to the radical right. The lodge was implicated in a number of crimes and unexplained events, including murdered journalists, the bombing of the Bologna train station, and the collapse of prominent banks, along with various corruption and bribery cases.

Opinions about P2 differed. Some saw it as a shadow government trying to influence those who ran the country. Others deemed it a society of egos seeking career options by networking with high-ranking members.

A parliamentary commission dedicated to investigating the activities of P2 members compiled over thirty volumes of documents, many relating to trafficking oil, drugs and arms to Third-World countries. Much of this seemed to be under the guise of charitable work or helping to rebuild infrastructure in war-torn countries.

The case that Rossano was linked to involved arms smuggling.

Hundreds of police raids took place in Italy during this time. One of those raids uncovered a list of nearly a thousand people linked to P2. They included state officials, politicians, military officers, heads of state, members of the secret service, mafia families, bankers, police chiefs, relatives of the last Italian monarch and a future prime minister. Having seen a list of the prominent members, I can understand why some believed P2 was putting people in place to overthrow the government.

In early 1983, after lengthy investigations, police arrested Santovito and Pugliese at their apartments in Rome's smart Parioli area. Included in their raids was Rossano's luxury penthouse apartment, also in the Parioli district in Rome. His acquaintance with Pugliese and Santovito was under scrutiny.

'I was in the United States at the time and Oscar telephoned and told me what was happening. My first reaction was frustration, anger, you know, this is the last thing I needed. However, I trained as a lawyer; I know about these things and I had nothing to hide, but it was upsetting to have this happen.'

Oscar added, 'My brother knew many people. He met people all of the time and was always being asked for favours and to lend his name to something. Pugliese talked to me in the 1970s; he wanted to make a documentary about the Holy Shroud. Rossano was interested in that but the project fell through.'

Rossano did not count Pugliese as a friend, but Pugliese had kept Rossano's contact details and the former colonel would draw him into another scandal at the same time as this one. (We'll explore that in the next chapter.)

But, for now, Santovito was the man being interrogated. He was accused of a long list of crimes, all of which he denied or pleaded ignorance of. He claimed that the huge loans he was accused of securing from American banks were simply to help Somalia rebuild its infrastructure. He argued that agreements were in place to help build a dam and restore that country's agriculture as well as repair power lines. Santovito was alleged to have spoken about profits to be shared with Pugliese and Rossano.

Santovito later claimed that he didn't know anything about US loans or the needs of Somalia and distanced himself from any friendship with Pugliese. He claims he was unaware of any Freemasonry links.

Some reports state that Rossano was a Freemason; however, when I checked with his family, they confirmed that he was not. It is not hard, however, to be associated with a Freemason. Ninety-nine per cent of lodges around the world are legitimate and well run and renowned for their charitable works.

Rossano was mentioned in one document seized at the house owned by Pugliese. This document related to the purchase of commercial aircraft. Santovito explained that these planes were being used for rescue and aid after a severe earthquake in Iran. Rossano, allegedly, did travel to Somalia for what he thought were infrastructure talks and he was spoken about as a PR man for this operation.

Even at this stage, one has to wonder why a country would look for help from such people. This sort of work is normally overseen by governments. Also, the judge in charge of interrogating Santovito had little evidence on which to question Rossano, although clearly something, or someone, caused him to request his presence.

The early 1980s was a dark time for Italian politics. Reading the reports and watching political documentaries about this case, it is clear that many officials, across all government and military agencies, could have been linked to some of these crimes.

Reports I have seen make no mention of Rossano. Just one hints that he was asked to front the organisation as a PR man. Because of his connections to the White House and with various celebrities, he was a person of interest for Santovito and Pugliese.

Rossano's first defence when facing the press upon arriving to speak with the judge was to highlight his philanthropic work –and there was a lot of it. He and Lydia gave to numerous charities, not just in Italy but worldwide. One can't help but think that he had been duped into thinking this was, given that the Freemasons are famous for it, charitable work.

There was, allegedly, a letter, speaking of a meeting between Rossano and Reagan to negotiate "funding". It didn't go into detail but, again, one has to ask why Rossano would be doing this if it was about arms trafficking. It makes little sense and I'm sure that Reagan's advisors also would have questioned this.

Aside from this, there really was no evidence linking Rossano to these crimes.

Learning that his home had been searched, Rossano offered to return to Italy and speak with the judge. The press turned out en masse. Here was an iconic Italian film star mixed up with some dodgy people and they were hungry for a story.

'I told them I really had nothing to say. I meet people all the time, every day, good and bad. I can't vet everyone I meet. I got asked about my political views – this was all to do with politics and I got caught up in it. I wasn't the only one, either.'

He spent little time with the judge and testified at two trials. The highlight of his court appearance was not Rossano himself but his lawyer who apparently was highly entertaining in the courtroom, reducing many of those present to raucous laughter and giving the more serious-minded subdued amusement.

Journalists pressed Rossano over whether he knew Pugliese and Santovito and the actor, unusually for him, became impatient, curtly reminding them that he would not have come all this way if he didn't know them.

'I didn't want to tell them anything because my words were private, between me and the judge and, you know, after that, I was free to leave and go back to America. There were no charges against me. I really found it very irritating and frustrating.'

Rossano was one of a multitude of people questioned by the authorities. Interestingly, in spite of the many people named as being involved in these activities and the P2 lodge, the hundreds of raids on homes and the volumes of paperwork produced, only a handful were found guilty of arms trafficking.

Perhaps I am biased because I have come to know Rossano Brazzi and the few members of his family that are left. This man was a humanitarian, who risked everything during the war trying to save POWs and people being persecuted. He spent his life giving to causes helping those less fortunate than him. My feeling is that he was sold a story of good deeds, of rebuilding, restructuring, of restoring power and water to war-torn countries. I am certain he would have been proud to put his name to that.

Would Lydia have seen through Pugliese and Santovito? There is no way of knowing but she had a sixth sense about people. It's likely she would have sent them packing.

Unfortunately, in her absence, Rossano became involved in another incident, again as a PR man for what he thought was a charitable organisation.

A STORM IN THE CARIBBEAN

At the same time as the arms trafficking incident, Pugliese involved Rossano in a project that, in hindsight, seems idiotic. This scam also had alleged ties to the P2 lodge although there is little in the reports that I found that show they were heavily involved, and Pugliese is hardly mentioned.

Rossano's involvement only came to my attention in a book called *Caribbean Time Bomb* by Robert Coram. I'd like to thank Robert in this main text of the book for giving me permission to make use of his investigation and to freely quote from the chapter featuring Rossano.

The major player in this incident was Robert Vesco. Vesco began his career as an investment banker but didn't stay legal for long. He was wanted by several US agencies for financial misconduct, underhanded credit issues, embezzlement, setting up dummy corporations, illegal investments, drug smuggling and security fraud. One organisation labelled him the king of financial fugitives.

By 1981, he was on the run from US officials and doing everything he could to avoid extradition from the various countries he relocated to. He had accumulated millions of dollars over the years and had influence. As such, he was able to woo a very corrupt government in Antigua at the time with a scam worthy of a Hollywood film.

Vesco was living in Costa Rica and the country had happily hosted him in exchange for payments to specific people in power. Once those people were out of power, however, Vesco was thrown out.

He made his way to Antigua where he implemented a plan to buy its sister island, Barbuda, with the intention of setting it up as a sovereign state. Vesco's friend, Pugliese, contacted Rossano about the project, telling him that this was being set up with the co-operation of Prince Joseph Gregorio of Italy, who was calling himself the Grand Master of the Order of Aragon.

Rossano's understanding was that the island of Barbuda would be turned into a community to support those with disabilities and help with medical research and charitable works.

Lydia, I am sure, would have been asking questions at this point, especially where the mythical Order of Aragon was concerned. For Rossano, the idea that he might be part of setting up a residency or foundation dedicated to charity appealed. His interest was aroused.

Pugliese and Vesco worked on Rossano. His links to high profile personalities, including Reagan and major Hollywood celebrities and minor royals were useful to them. They wanted him as their poster boy, a spokesman for the Order of Aragon: the project required a "name" with the right connections. Rossano, they decided, was that man.

As far as Vesco was concerned, this island was a place where he could live out his life without fear of extradition.

It is unlikely that those outside of Vesco's circle knew who he was or what his background was. Unless you mixed solely with the criminal fraternity, there was no reason why anyone would question him. He was rich, charming and knew the right people. There was no internet and no way of getting quick information. Obtaining information on people took time and, as we know, Rossano (without Lydia) was too trusting.

What Vesco was looking for was an island with its own sovereignty and laws. He had the ear of the Bird government on the neighbouring island of Antigua, a government that had been mixed with decades of corruption and upheaval.

Those behind the Sovereign Order of New Aragon (SONA), whether Robert Vesco, or an obscure collection of European royalty, settled on Barbuda as the location where the government would be most receptive to their ideas. A proposal submitted to the Bird government said the primary aims were to "maintain peace in the

modern world, propagate the tradition of chivalry and charity and engage in charitable works".

A palace was to be erected for Prince Joseph Gregorio, the leader of New Aragon. Port facilities, banks and commercial areas, as well as "residential areas for the knights" would also be built. The knights would come from all over the world, drawn from people of high finance and excellent education.

Rossano was advised that he would be a "knight" and Shirley Temple's name appears to have been put forward, although there is no evidence to suggest she did involve herself.

Vesco and "New Aragon" planned an international airport, the runway of which would serve as a boundary between the Vesco/New Aragon property and the remainder of Barbuda. Knights and princes would land at the airport and go through Aragon's customs and immigration facilities – not Barbuda's. The sovereign principality would, amongst other things, issue its own passports.

Alarm bells sounded at the American embassy. If Vesco set up a principality and issued himself a diplomatic passport, it was conceivable that he would be beyond the reach of American law enforcement. And if he had the authority to operate banks, casinos and other institutions, it could become a financial nightmare, not only for Americans, but for people around the world.

What if they began issuing diplomatic passports to fugitives? Barbuda could become a sanctuary for the felons and con artists of the world. Although the New Aragon plan was easy to dismiss as a comedic or bizarre scheme, there was panic at the idea of a sovereign territory being so close to America's back door, especially if the Bird government granted everything Aragon was asking. The charitable reasons for this order were also fading into the background.

To quell the growing number of questions, Prince Gregorio of Italy met with the Antiguan Cabinet and told the group that the SONA was founded in 718 AD and that his title could be traced back to the time of the Visigoths. He called on the US embassy and left a thick, leather-bound book covered with red ribbons and wax seals. Prince Gregorio said the book would answer whatever questions the US might have about New Aragon.

A US embassy investigation discovered that along with the unknown minor royal, Prince Gregorio, the front man for New Aragon was Rossano Brazzi.

A government investigator by the name of Paul Byrnes wondered what the Birds were up to and began making inquiries.

A few days later, Lester Bird telephoned Byrnes and asked why he was asking questions about New Aragon. Byrnes explained that he represented the interests of the US and he wanted to know what was going on. Who were New Aragon? What was their purpose? He told Bird to answer the questions and Bird simply said he would call back.

Byrnes then received a telephone call from Rossano who, apparently, side-stepped the outlandish accusations being made about New Aragon and terminated the call.

Byrnes took the leather-bound book to some lawyers; they translated it as gibberish. He copied information to the CIA, the FBI and various State departments and received nothing back. For some still unknown reason, no replies were ever received. It was as if the queries had disappeared into a black hole. This was an official inquiry by the US Embassy, and it was ignored.

John Tipton, the former Vice President of Tiffany's Atlanta store, was keen to be a knight of Aragon. He received an embossed document emblazoned with the seal of His Serene Highness, Prince Joseph Gregorio, which said:

Following the review of your past humanitarian and charitable activities and your belief in the betterment of the human race, HSH Prince Joseph Gregorio has accepted and approved your candidacy, and will graciously bestow upon you the Commandery Cross of the Sovereign Order of New Aragon. HSH Prince Joseph Gregorio is pleased to bestow this high honour to you, and in His name, we send you greetings and compliments.

The document was signed by Count Augusto Giuseppe M. Agazzi, Grand Chancellor of New Aragon.

Tipton was tracked down and asked how he came to receive the

Commandery Cross. He explained that he had paid $5,000 for an exclusive beer and wine franchise on New Aragon and he produced a letter confirming it. The letter was signed by Grand Chancellor Agazzi. In return, he was to give forty per cent of his profits to New Aragon.

Even though it had the full support of the Bird government, New Aragon fell apart. Vesco was on the run and Pugliese and Rossano were in Italy, being questioned about the arms trafficking. After his telephone call with Byrnes, Rossano distanced himself from the whole operation. There is certainly very little in the reports, videos and literature I've seen that mentions him.

Even today, it is not clear if Vesco and the Sovereign Order of New Aragon were allied, or if it was simply coincidence they arrived at the same time with the same idea. It seems too coincidental, given Vesco's background and his need for a base.

Count Augusto Agazzi claimed that Vesco had no part of New Aragon and reputedly said: 'Our mistake was Rossano Brazzi. We were going to have Pavarotti as our front man. We decided on Brazzi because he was friends with Reagan and because Pavarotti was,' he waved his hand over his head, 'too much up there.' He shook his head in despair. 'It was a mistake.'

Rossano never spoke about this. The only comments he made were to the press when returning to Italy to speak to the judge about the alleged arms smuggling.

In both incidents, Rossano was set up as a front man and PR spokesman, and both were linked to charitable projects. Rossano, it would appear, was lured into these projects because of his connection to Reagan and the president's circle. Both projects would have boosted his ego. There was a small part of him that took pride in defying authority and this is where Lydia would have reeled him in, I'm sure.

Thankfully, for Rossano, nothing came of either of these incidents. Where the arms smuggling was concerned, any notion of his involvement was thrown out of court. As for this odd concept of the Order of Aragon, he had distanced himself from the main players long before it imploded.

By the time these investigations had come to an end, the rawness of

his grief was subsiding and he was now spending time with a woman who had been in his life since 1953.

He turns to me. 'Before we speak about that, we should talk about my beliefs. I don't want to forget about this because it is important to me. Do you mind?'

'Not in the least.'

Chapter Twenty-Four

LUNCH AT FREGENE

A few days later and we're back on the beach at Fregene, just the two of us. He has booked a table for lunch at a bar and we're here to chat about his religious and spiritual beliefs. He was affiliated to the Catholic Church, a believer; however, his beliefs extended beyond conventional religion.

There is a gentle breeze coming off the ocean. A short distance away, children are running in and out of the shower on the beach, screaming and laughing. He's in cotton trousers and a linen jacket, happily watching them play.

One thing that may surprise readers is that, aside from conventional religion, Rossano and Lydia were both very spiritual. They believed in past lives and reincarnation; they were certain that those "in spirit" were able to contact them and vice versa and the family related some interesting stories to me to confirm that belief system, one of which made my jaw drop.

The waiter delivers a selection of hams, cheeses, olives and salad and we each settle on a glass of chilled wine. He seems thoughtful as he picks out a selection for his plate.

'You remember our family friend, Nello, my first drama teacher in Florence? Well, if we were free on a Saturday night, we would go over to visit him and his girlfriend, Nina, to play poker. He lived in the next building to my mother's place. She was on the second floor and he was

on the fifth; it was on a narrow street and they exchanged salt and oil and onions. They had a little basket tied to a string, from his balcony to hers – to her kitchen window.

'There was me, Lydia, Nello and Nina and, if my sister was in the country, she would come, too. Nello, you know, he was interested in spiritualism, that sort of thing.

'They had a big clock, like a grandfather clock – they'd had it for years and it never went wrong, always on time. It was very noisy. Every fifteen minutes it would chime. It had this big tick-tock and one evening, Lydia, she couldn't concentrate on the cards because of the noise, she says, "Can somebody shut off that damn clock, it's bothering me."

'Well, I tell you, that clock stopped straight away and they were never able to make it work again. They couldn't fix it and they couldn't find what the problem was. You may say this is a coincidence, but I tell you other things, too.

'This was another poker night, at Nello's, and my sister was there with my nephew, Carlo. He was messing around in another room and suddenly there is a shout. Carlo, he was about nine years old at this time and he was very frightened.'

Carlo, who had provided a few of the experiences from this chapter, relayed this story to me.

'I had been looking at Nello's theatre memorabilia but decided to go back to the room where they were playing cards. I started to walk and I felt something really strange. And then, suddenly, my legs stopped working, it was like somebody was holding me by the ankles. I fell and I started crying and shouting. And they all came over and said, "What's going on?"

'I said, "I don't know, somebody made me trip." This was a little bit of an unbelievable thing to have happened, but it did happen and it was very real. I still remember that clearly, even now.'

Rossano nods at the recollection and alerts me to another example that has just sprung to mind.

'Another time, again, we were playing cards – Lydia, she went into a trance, and we all saw what happened. She was like a statue and she asked for a pen and paper so we got those for her. Then she started to

write in German. She never spoke a word of German and she wrote, I think, two sheets of paper and I forget now, but I think it was a famous musician or a writer or somebody, I don't remember, but I do remember that she went through this experience. When she woke up, she didn't recognise what she had done. She had a lot of these things happen to her.'

'And you? Did you have experiences?'

'Yes, but mine were mainly dreams, you know, prophetic dreams. I told you before, about staying away from our house when it was bombed, during the war and about going to America that first time. That's how I normally experienced these things.

'But there was a time, when Lydia and I were travelling and a fly appeared and she said to me, when I die, I'll come back to you as a fly. And, you know, when

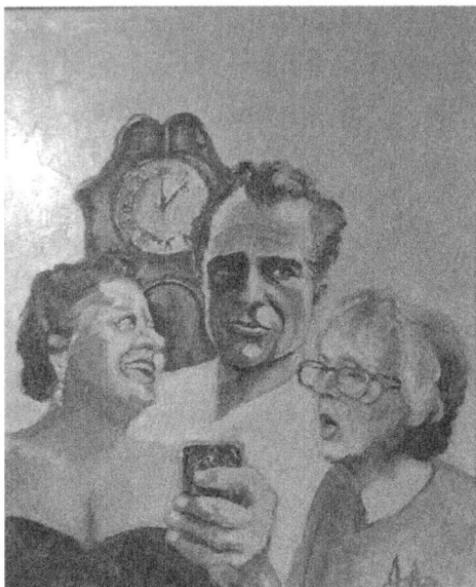

The author's reaction to Rossano's spiritual anecdotes, captured and painted by Rossano's nephew, Carlo. (Courtesy of Carlo Fiorentini.)

Lydia passed away, I had a fly hover around me for ages and I said to it, "If that's you, Lydia, stop here on the palm of my hand, fly here, fly there, land on my nose, land on my knee, land on my foot." It did exactly what I asked it to do.[331]

'This all began for me when I was around fifteen. I had a friend, Maria. She was sixteen and we dated for a while. Then I went to university and then to Rome and I lost contact with her. But, one night, I had a dream, that Maria was running to me and shouting out to me. She was very happy, joyful and kept telling me that there were fantastic things in store for me.

'The following day when I came to the office, at the law firm, nothing was unusual. But, because of the dream, I tried to contact Maria. I got

through to her sister and she came to see me in Rome. She told me that Maria had died of leukaemia a few months before.

'I had goosebumps, I tell you. I asked her, "When did this happen?" I learnt that Maria had left us a few days before she appeared in my dream. Then her sister said that she had something for me, from Maria. She gave me a small package and inside of this was a ring.'

You can't help but notice it. It is a large ring placed on the little finger of his left hand and it shows the three masks of the Greek theatre: comedy, tragedy and anger.

'Maria has come into my dreams only occasionally but, when she does, I take notice of her. I was in America to finish a film one time. Lydia was in Rome. One night, Maria came into my dream, and I felt uneasy about it, it really upset me. I called Lydia straight away, but she told me that she was fine, that I wasn't to worry.

'But when I returned to Italy, I found Lydia was not well. We went to a doctor, a consultant, and she had to go through several tests. They diagnosed pancreatic cancer and, because it was advanced, they could do nothing for her. A few months later, she left me forever.

'Another time, Maria came to me in a dream. She was very beautifully dressed in a wedding dress. When I woke up, the sadness that I'd had since Lydia died had gone. At that time, it was 1984, I was in a relationship with Ilse and that dream prompted me to propose to her. I think that Maria was telling me it was time to move on, to make Ilse my wife.'[332]

He wore the ring that Maria had given him from the day he received it until the day he died. It's clearly visible in many of his films and he only removed it if instructed to do so by a director.

'I am like many actors; I have things I do before I perform. I always pray in my dressing room and put my hand on my heart. If I have a difficult thing to confront, I do the same thing. And, you know that I don't like flying so I have a routine when I sit down. I tap the window and the seat a few times as if I am putting a shield up to keep me safe.'[333]

Knowing there was a serious spiritual side to him and that he took an interest in astrology, I examined the star sign that Rossano was born under – Virgo. The general perception of Virgos is that they are people of

intellect, possess rich personalities and are intelligent and adventurous. That does describe him, but it also describes half the people on the planet! As this was so generalised I obtained some in-depth analysis based on Rossano's date, year and time of birth. From this, I combined the common factors that came out in respect of his career, personality, relationships and spirituality.

Whether you believe in this sort of thing or not is of no consequence; but, given what you have already learnt about this man, it is quite revealing. When I showed the results to the family, they felt it was uncannily accurate: *unbelievable* was the word they used.

The results can be found on the website that accompanies this biography: www.rbrazzi.com.

For now, let's return to one of those prophetic dreams, where Maria suggested to Rossano that it was time to remarry.

Chapter Twenty-Five

SUMMER IN THE TUSCAN COUNTRYSIDE

I am sitting in a trattoria overlooking the Tuscan countryside. There are grape vines on the trellises surrounding us. Rossano, bronzed by the sun, is in his seventies, but still cuts a dashing figure. His hair is a little thinner and there are a few wrinkles, but the blue eyes still sparkle and the charm and wit have not disappeared. He is in tailored trousers and a cotton sweater. The sun is warm and bright in a cloudless sky. On his lap is a black miniature poodle, Blackie.

We are talking about the loss of Lydia.

'I found that part of my life very harrowing. I couldn't believe that she wasn't by my side anymore. I felt truly alone, and I tell you truthfully, I did not want to be alive. She was everything to me, my anchor in life. In the years after she died, I went to the cemetery often, every day, sometimes twice a day, to take flowers for her and to chat with her about things. If I didn't have time to visit, I would say a prayer to let her know I was thinking of her. Depression weighed heavy with me, and I began to drink a little more than I should have. I was in America filming one time and returned as soon as I could because I couldn't bear to be far from her grave.[334]

'I would have self-destructed had I not found something. I was going through Lydia's paperwork and I found a letter that she had written to me. Of course, we both knew that she would not survive her illness and she left this note for me.

'In that letter, she told me that I had been the best husband she could ever have wished for, that she had loved our life together. That was a turning point for me. I wanted to make her proud and she would not have wanted to see me like this.'[335]

He turns to me.

'You know what she said to me, just before she died? She said that she was glad that I wouldn't be alone, that I had someone to be with. She had that ability, even at that stage in her life, to be thinking of my happiness. That's what made her such a remarkable woman. She only ever wanted me to be happy – and she did everything she could to make sure of that. She was intelligent, she knew there was someone who would make me happy after she had gone.'

From those comments, it sounds as if she knew about the particular "other" woman in his life, Ilse Fischer. He would not commit to answering this directly. In interviews, the name of Ilse Fischer was never mentioned until the late 1970s when he and Lydia were seen out and about in Rome in an attempt to quash rumours about an alleged twenty-year affair between him and Ilse.[336]

When questioned by journalists at various restaurants, both flatly denied their marriage was in trouble and Lydia dismissed the reports as rubbish. Rossano bemoaned the fact that he was always being linked with one woman or another in invented stories.

We know, of course, that the man couldn't help himself where affairs were concerned but we also know that the family kept quiet about them. Any hint of problems and the Brazzis would unite as one.

This time, though, the reporters were spot on.

In 1953, seventeen-year-old Ilse Fischer had gone to her local cinema in Munich, Germany to see *Three Coins in a Fountain* and had promptly fallen in love with Rossano Brazzi.

Every waking hour, she thought about him and how she could manage to meet him. She watched *Three Coins in a Fountain* as often as she could while it was on release. Even at that young age, she was contemplating marrying him. She never considered the possibility that he was already married.

The Fischer family often visited Italy for their holidays, and she

would try to persuade them to visit Rome instead of their normal haunts. Many arguments about this infatuation with a film star took place in the household, but nothing deterred Ilse.

'Her parents and older brothers came to Italy on holiday, to places like Capri. She had started work as a secretary in Germany and kept on at her father about wanting to meet me. You can imagine what he thought of that!

'But, you know, she didn't leave it at that. She was a very beautiful young woman and it was *la dolce vita*, here in Rome, and there were opportunities for beautiful women. She moved to Italy and became a model for Biki, in Milan, but that's quite far from where I was. Because of this, she decided to move to Rome, and she managed to get some work, as an extra, in some films. That way she could be close to me. She was an extra in one of my films at one time. I would see her, occasionally, at Cinecittá but I didn't really know her, not at the beginning. But you should ask her about this.'

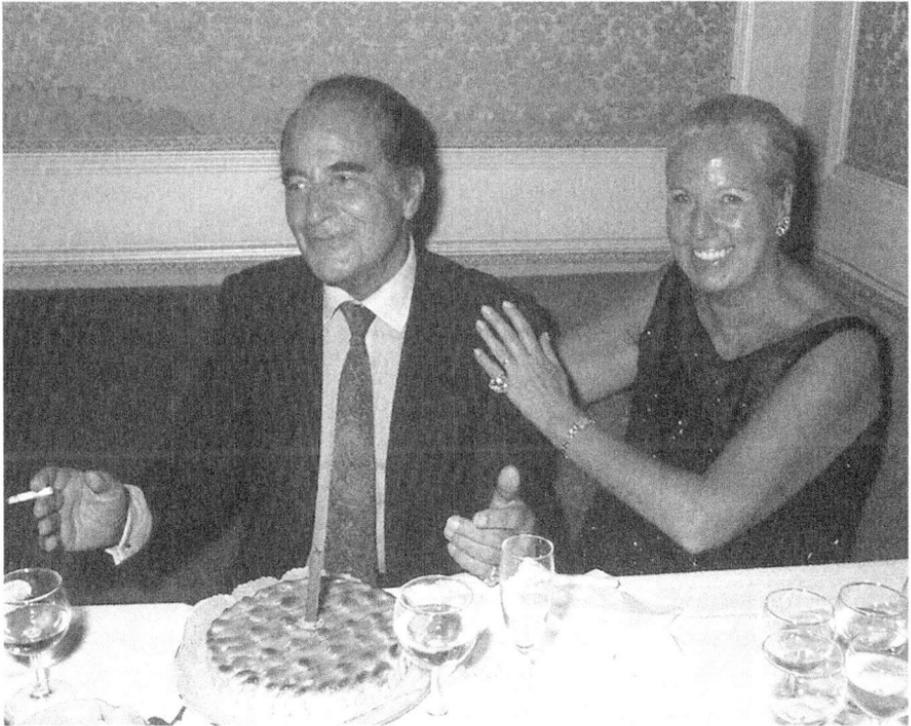

Rossano and his second wife, Ilse. (Courtesy of Umberto and Sabraina Pizzi.)

Ilse Fischer is a similar build to Lydia and is twenty years younger than Rossano. She wears a cotton summer dress and is tanned with long, blonde hair and a ready smile. It is clear that she loves Rossano very much – she is almost glowing with pride as she takes a seat beside him and holds his hand.

'It is true,' she says, 'that I fell in love the moment I saw him on the screen. I told all of my friends and my brothers how much I loved him, and they teased me incessantly. When I was still in Germany, I would pretend that he was having lunch with me or chatting to me in a café. Any boyfriends I had did not last long because I knew they would not live up to Rossano. All I talked about was Rossano. I didn't want them to touch me even. Understandably, they did not want a relationship, but I didn't care.'[337]

Rossano squeezes her hand. 'I could see – when I first met Ilse – that she was in love with me, and I knew she wanted more than I could give her because of what she had said to others. My brother, Oscar, he told her that I would never leave Lydia. One day, when I saw Ilse at the studio, I told her to forget about me, that I was happily married and that this wouldn't change. I told her to find a man and have a family, not to ruin her life for me.'[338]

'This was not a crush,' Ilse said. 'I was in love with him and, even though I knew he was married, I thought that one day I would marry him. And I never loved any other man. My friends said this was ridiculous because he was always with his wife, but I was happy to stay in the background and love him from a distance. There would be times when we would bump into each other, and he would chat with me or peck me on the cheek and those meetings would fill me with a joy beyond belief. I would hold on to that memory until we met again. Sometimes, if he and Lydia went to Fregene for the day, I would go and sit some distance away. I just wanted to see him.[339] I sent him letters but he received thousands of letters so they would not have meant anything to him.'

'And, you know,' said Rossano, 'I would come out of the studio every so often and find flowers in my car, violets across the dashboard or on the seat. On a couple of occasions, I found records – Beethoven, Chopin,

that sort of thing. One day, I saw her sneaking away from the car and realised who it was that was leaving these tokens.

'Most women, at that time – remember, I was at the height of my fame then – they almost threw themselves at me, they had no qualms about it. With Ilse, she remained quiet, in the background.' He grinned. 'That intrigued me. She made me curious. And, you know, whenever I went to my car, if there was nothing left for me I felt a little sad about it.[340]

'We began to see each other. We took some walks in the country or down by the ocean and I would visit her apartment and we would sometimes have lunch or breakfast together. That's all. Ilse was a respectable girl; a pure woman and I did not want to spoil that.'

Ilse adds, 'He would often remind me that this could be nothing more than it was because he loved Lydia and I was fine with that. Even when he went to America for a few years, I was happy to wait and be content with the occasional telephone call.'[341]

'Oscar gave her a job at our studio,' Rossano says, 'as a translator, so we saw each other often.'[342]

And did Ilse meet Lydia? One magazine article suggests she did; however, most magazines contradict that. In several interviews, Ilse stressed that she only saw Lydia from a distance and she had no animosity toward her. As far as Ilse was concerned, anyone who loved Rossano was a good person. She never hassled or bothered the couple or did anything that would intentionally threaten the marriage.

Rossano is quick to stress that, 'I would never hurt Lydia. Ever. If I thought, for one minute, that we were hurting her, that I was hurting her, I would have put a stop to it, believe me.'

Ilse says, 'I was upset when Lydia died because I could see how distraught Rossano was, and I had grown fond of her myself. He was very, very depressed and I worried about him. I knew that Lydia was, and would always be, the most important woman in his life but I wanted to be there for him, to support him, so I would drop by to spend time with him. I thought, even with Lydia's passing, I would remain in the background.'[343]

'I went through a terrible time,' Rossano says, 'and it was Ilse who, over the months and years, brought a smile to my face. She cried with

me, supported me and gradually gave me a purpose for living. I am not a man who can be on his own – I need a woman in my life, someone to love and someone who loves me. I realised that this was the woman I wanted, and I said to Blackie, "I think it's time for me to get married again." And I know Lydia would have approved of this union.'[344]

'When Rossano asked me to come and live with him, I couldn't believe it. And then when he asked me to marry him, I couldn't believe that either!' She laughs. 'All of those years waiting.'

Rossano would continue to visit Lydia's grave until the day he died, and Ilse was well aware of what Lydia meant to him. However, Rossano loved Ilse very much and this was confirmed by his family. You will remember that when I asked the family what Rossano loved the most in life, the answer was unanimous: Lydia and his home. After Lydia died, his loves were Ilse and his home.

'Lydia and Ilse both had a desire to ensure that I was happy. I could not ask for anything more than that. I have been very lucky, and I loved them both very much.'

The marriage took place three-and-a-half years after Lydia's death and the couple moved to the small community of Morlupo, just north of Rome. Rossano was sixty-eight years old. He and Ilse ventured out occasionally but they preferred the quiet life. Ilse was the woman who ensured he had the tranquil existence that he enjoyed in his autumn years. Now, his pleasures were a walk in the countryside, a swim at the beach or dinner with friends.

'I appreciated things that I didn't when I was younger. I think you do as you get older, you see the beauty of nature, the joy of simple things like flowers and woodland. Ilse is very laid back and uncomplicated. I didn't work so much because I felt that I should be spending time with her. She loved me for so long from a distance. I wanted to reciprocate that love as much as I could. And, like I did with Lydia, we applied to adopt children.'[345]

Once more, the question of age meant that the application was refused. This only reconfirmed to me that his one regret was that he did not have children present in his everyday life.

Just a couple of years after their marriage, Ilse was almost taken away from him. Rossano puts his head back and closes his eyes as if reliving the moment. Ilse goes inside to order more drinks. (This event was, surprisingly, documented in *Gente* magazine in August 1986. The reporter had just finished interviewing the couple and was on her way out of the bay when she heard shouts.)

'We were on holiday at Salerno. On this day, I was on the terrace, reading. Ilse was in the sea swimming. I suddenly heard her shouting and, you know, I thought she was joking because she was always joking with me. Then, Blackie, he started barking and, you know, dogs have a sixth sense. I could tell from him that something was wrong. I ran into the ocean and could see she was struggling. She kept going under the water. I swam out to her and I had to dive down to get her.

'This whole time I kept sending up prayers, you know, "*God, please don't take her from me.*" The owners of the hotel, they ran down to help and someone called an ambulance. When we got her to the shore, she was not breathing, and I performed mouth-to-mouth resuscitation on her and she came back to me. The medical team, they gave her oxygen and take her to the hospital.

'She had developed bad cramps and could not get the strength to swim. When we got to the hospital, I realised that I had cut my legs on the rocks, but I didn't feel it at the time – I was so worried that I had lost her.

'But this is how Ilse is like Lydia – thinking only of me. She wakes up in the hospital and she asks me how *I* am! I stayed strong for her at the hospital but, I tell you, when I got back to my hotel room I was so emotional and I felt sick to my stomach.

'Luckily she made a full recovery and we had ten years of happiness together.'[346]

Rossano stayed true to his desire to spend time with Ilse and took a step back from filming. He gave very few interviews during this time, preferring instead to remain at home in the countryside with her and Blackie. He did complete a handful of films on the Continent; none of these films would catapult him to the fame he had experienced in the past but, as he said on numerous occasions, they paid well. He smiles at a memory.

'I had a part in a successful television series, *The Far Pavilions*. I had to ride an elephant. Did you see that?'

I have seen it and, initially, didn't recognise him. The make-up disguised the good looks and the costume was regal and extravagant.

'I sat on that animal for so long. I tell you, when I got off that thing, I could hardly walk.'[347]

Charitable work was now more important to him. He and Lydia had been philanthropists throughout their lives, donating to specific causes close to their hearts, especially charities helping animals and children. In one interview, Rossano admitted that he would happily break someone's neck if he saw them mistreating an animal or a child.[348]

In the countryside, the couple owned a farm for stray dogs. They had number of employees, including vets to take care of the animals. (He once cancelled an important appointment with a producer because he found an injured dog on the street. No one claimed it so he took it home and it became a part of the family.)[349] [350]

He made contributions to an orphanage, a rest home for the elderly in Canada and the actor's retirement home in Bologna.

Childhood leukaemia in Italy was a charity close to his heart throughout his life. (You will remember that his school friend, Maria, died of leukaemia.) He also contributed to an organ donation transplant facility. In those later years, he mainly worked in order to ensure he could continue with his charitable work.

Lydia, in her extrovert way, amused many people over the course of several years when she drove around Rome at Christmas Eve, distributing five thousand lire notes to traffic police.

Like many celebrities, he was happy to get involved in advertising. He became the face of Prince spaghetti and was always happy to promote the ocean liner SS *United States*, a ship that he and Lydia sailed on often. Rossano's mother also featured in a magazine advertising a slow cooker. (Carlo found this quite amusing as he said she wouldn't have had a clue how to use it. All she needed were pots and pans.)

In later years, Rossano actively took part in events, such as telethons, to help raise funds, once again for children and animals.

Rossano on SS United States with Bill Krudener (Bell Captain) and Henry Moreno (Asst. Chief Purser.) (Courtesy of SS United States Conservancy.)

Apart from these charities, he did what he could for those that needed a helping hand within the film industry and used his influence to give Italian actors and actresses a start in their career.

However, there was one thing I want to know that he really hasn't answered with any great clarity throughout my time with him.

'Come on, it is time to spill the beans.'

He gives me a stern look and wags his finger at me; but he cannot hide the glint in his eye as a wide grin appears.

'I cheated on Lydia a thousand times – more. She knew, she always knew. Most of them were at the studio, during working hours and, you know, it was often the women who came to me, not the other way around. I would come back to my dressing room and find a girl there. I was a hot-blooded Italian... how can I say no to Marilyn Monroe – in my dressing room – proposing to me? What I am supposed to do, turn her out? I confess, I lost my mind over her.'[351]

Marilyn Monroe often said that her perfect man would be someone who loved poetry, who had sensitivity, masculinity and was physically attractive. It seemed that Rossano couldn't have been more suitable.[352]

'Even Lydia understood that one. She was so beautiful. And very intelligent, too.' His smile is warm and genuine. 'Oh, my Lydia, who else could be so forgiving. But, I tell you, with all these women, it was just fun, nothing serious. I loved Lydia more than anything and no one, not one of these women that I went with, these beautiful divas, not one was good enough to take me away from her. But I have to tell you, after Lydia died, I had tremendous guilt over the infidelity and I worried that I had hurt her. That letter she left for me confirmed that I had no need to worry.'[353][354]

'And Ilse?'

He leans in. 'I didn't become intimate with her until we married. She was so pure; it wasn't right to take advantage. I have been truly faithful to her. I still look at women, of course, and they look at me. I had someone give me her phone number just a few weeks ago; but if a woman wants to make love to me now, I would have to go to a gym or something for a few days.'[355]

We laugh.

'I'm serious. I'm getting old now, I don't have the energy; I prefer a glass of wine, I tell you truthfully.'

I have to wonder – is he playing with me or telling the truth? His family did provide me with some information that leads me to believe him. Because Ilse was employed by Rossano and Oscar, and because she lived nearby, there would have been restraint on his part. He had a particular regard for Ilse and they feel he controlled himself because of the respect he had for her. The fact that he married Ilse suggests to them that this relationship had been platonic. His behaviour with her was not at odds with his personality.

He suddenly sits up. 'Oh, I nearly forgot. I never gave you my chicken recipe.'

He hands me Blackie and, with the agility of a twenty-year-old, he leaps up, goes over to where his jacket is hanging and feels in a pocket. Blackie strains to follow and only relaxes when he returns.

'I have been carrying this around to give to you. I told you before, it's nothing special – it's the wine that makes it a little unusual.'

This recipe was introduced at Georgio's during the *dolce vita* years

at a birthday party for Hank Kaufman and it remained on the menu for decades.

He'd written the recipe for *Polletto à la Brazzi* with a fountain pen: *Chicken open in half and cooked on the stove with salt, pepper, olive oil and Cannellino white wine; fresh tomatoes, black Greek olives and champignon mushrooms.*[356]

'No measurements?'

He takes Blackie back. 'I don't bother with measurements. Taste it as you go, you'll know if you need more of something. Just make sure the chicken is cooked.' He fixes those blue eyes on me. 'You know, I have enjoyed this – going through my life with you. I don't know who is going to be interested. I shouldn't think anyone remembers me, but I love talking about myself, I can never shut up. That's the Florentine in me… but, you and me, it's been fun, yes? And that is the most important thing.'[357]

'Yes. It has been fun.'

It's been good to discover the man behind the actor. Ilse returns with a tray of soft drinks. Rossano excuses himself, hands Blackie to Ilse and goes to chat with the owner.

ARRIVEDERCI, MIO AMICO

Rossano's tombstone in Cimitero Flaminio, Rome. (Author photo.)

Ilse watches Rossano with a wistful smile.

'Rossano was always healthy. Always fit and in good spirits. He would get colds and flu, the same as the rest of us, but never anything to worry about. His friend, Fulco Scarpelloni, said just a few weeks before

Rossano died, that Rossano was always optimistic and full of life. And Rossano, he had plans – he was working on a film when he became ill and he'd just had some routine medical tests and everything was fine.

'But he developed a slight fever and a bit of a cough, and I told him to go to the doctor and, eventually, he did. The doctor, he told him to stay in the hospital so they could do some tests. I went home to get some overnight things for him and, when I got there, the hospital rang and told me to return straight away.'

Sadly for Ilse, by the time she returned, Rossano had passed away. Doctors diagnosed his illness as a rare viral disease that affected the nerve centres. He was also suffering with pulmonary difficulties.

Ilse makes a fuss of Blackie. 'When I left the hospital to get Rossano's pyjamas, Blackie refused to leave. It was very unusual because he would go with either of us but, this time, he wanted to stay with Rossano. I went to pull him away, but he kept tugging and then escaped and leapt on to the bed. It was as if he knew he would not see him again.'[358]

It was Christmas Eve 1994. Rossano was seventy-eight years old.

He stipulated that, when he died, he wanted no fuss or paparazzi. The family abided by those wishes. They did not divulge the location of the funeral and only immediate family and close friends attended the service.

He is buried in the Cimitero Flaminio, a huge and picturesque cemetery about thirty minutes north of Rome. Lydia and Oscar are also laid to rest there. The stone plaque on the wall is simple and plain – just as he'd requested.

Chapter Twenty-Seven

A LIFE WELL LIVED

Readers will remember (in my introduction) that on Boxing Day 2020, I was inclined to watch *South Pacific*. At that point, I knew little about Rossano Brazzi.

As I was writing the previous chapter, I felt incredibly sad, as if I was grieving for the death of a long-standing friend. For around three years, I had spent just about every waking hour reading about him, understanding him and getting under his

Rossano with Mitzi Gaynor on the left. (Mitzi Gaynor Archive courtesy of Polly O Entertainment.)

skin. With input from his family, I began to anticipate how he would react and behave in certain situations. In short, he and Lydia became a part of my life, as if they were close friends.

Through him, I discovered opera; I read Dante and Carducci; I learnt of the bravery of the Italian Resistance. He introduced me to Italy, a country I have fallen in love with, so much so that I am learning Italian and spending holidays there. And, of course, I became involved in the restoration of the film he was most proud of.

What a shame that journalists in the 1950s focused only on the romantic leading man. If only they had delved deeper.

Here was a man who loved nothing more than to laugh and have

fun; whose family and home were more important to him than anything else; a humanitarian; a man who put his life on the line, literally, to assist those being persecuted; a charming, kind, yet mischievous man who occasionally crossed the line with his behaviour and storytelling; a man with a childlike naivety and temper where some matters were concerned; a scholar, a student of the classics, an educated man and a spiritual man with a passion for life.

As far as his stage career is concerned, not many actors can boast of having received for five years running the best actor award from the Italian critics. Very few had the talent to impress Renato Simoni and Emma Gramatica the way he did.

Where his film career is concerned, Hollywood critics and reviewers either praised him as a brilliant actor or slated him as a poor one. He was the first to admit (and Lydia agreed) that only a handful of his films were worth remembering.

However, there are very few foreign actors who can lay claim to being in four high-grossing award-winning movies that continue to be shown to this day: *Three Coins in a Fountain*, *The Barefoot Contessa*, *Summertime* and *South Pacific*.

There are very few foreign actors who can add a now cult film to that list: *The Italian Job*.

And very few actors can include being in a film that has been restored, released and reintroduced, with critical acclaim, to an international audience – twice: *We the Living*.

Other projects could have been outstanding successes had the Hays censorship been less demanding: *A Certain Smile* and *Count Your Blessings* are two that immediately spring to mind. Fantastic novels with rich characters and plotlines, excellent directors, amazing locations and a first class cast in each – completely ruined by censorship. And, of course, Hollywood selected him only for roles that required him to be a Continental lover.

He took his acting seriously. In *Toselli*, he actively sought out information on his character and researched documents on the composer to prepare for his role. In *Pão de Açúcar* he spent time with the owner of a coffee plantation to understand what the job entailed. He

spent time with Herbert von Karajan to choreograph his conducting in *Interlude*.

I must also ask if *We the Living*, released in 1942, was the first neorealism film in Italy. *Rome, Open City*, released in 1945, is generally regarded as one of the first but it doesn't come much more real than Ayn Rand's life story in Soviet Russia. Yes, it had named actors but I feel it slots nicely into that genre.

He is likely not to have thought about it much, but he should be proud of those achievements.

A handful of people summed him up perfectly.

Actress Valentina Cortese who worked with him in the early days, both on the stage and in films, and was part of his circle of friends from the late 1930s. She remembers his ability to be able to see the humour in something during even the darkest times. The pair of them had to grow up quickly during the war and she described him as a good man. She had fond recollections of filming with him and remembered he was always sneaking a smile at her during a serious scene or romantic embrace. She knew about his philandering, but she also knew how much he loved Lydia and described them as a beautiful couple. She only saw him become sad over one issue and that was when he dwelled on not having children with Lydia.[359]

Actress Mitzi Gaynor, his co-star in *South Pacific* and friend during those later years, said, 'Rossano had a very healthy attitude in respect of his cinema image. He never took himself seriously and he had a wonderfully warm and gentle sense of humour and that's why everyone who knew him, loved him because he was sweet and gentle and kind. All of us that worked with him, and knew him socially, just loved to be around him.[360]

Glynis Johns, his co-star in *Loser Takes All*, said, 'Rossano the man is quite something. Completely uninhibited, he stands tall, tanned and handsome, with greying hair at the temples and a complete repertoire of wooing dialogue, polished to perfection. When I posed for stills with him – of us embracing in some romantic spot in Monte Carlo – I know that for the single instant as the shutter clicks, *he is in love with me*. Two seconds later he will be talking about a football match he saw in Madrid.

He is a fine sensitive actor with whom any actress worth her salt would like to act. I know people are not very interested in acting as such – and I suppose Rossano knows this too, hence the act – but to me his two finest points are his acting ability and his wonderful sense of humour.[361]

Carlo, with his uncle as a baby, and now. (Courtesy of Carlo Fiorentini.)

There are very few immediate family members left who remember Rossano. His nephew Carlo recalls advice his uncle gave him that remains with him to this day. 'About life, study or work, he told me not to be shy, to be and do my best or at least try; and, if you want to enjoy and succeed in what you like to do, you must not be afraid of being unconventional. Where girls were concerned: "If you like a girl, go for her!"'

Ben, one of his great-nephews (Franca's grandchild), said this: 'We wish we had been old enough to spend more time with him. I was the only one from the three of us who met him. When visiting Italy with my parents, I know my Great Aunt Lydia cooked excellent pasta dishes and they would take everyone to the best restaurants in town. Everybody knew them wherever they went.

'Our mother [Maria-Lidia] was really proud of her uncle and, as a result, we were too. We admire him greatly, so much so that we named our catering company Brazzi, instead of using our family name [Kenny].'

Rossano's niece, Maria-Lidia and her sons, Eamon, Ben and Sean. (Courtesy of Ben Kenny.)

Fans today, of all ages, express a sense of loss. There are a number of websites that feature his most popular films and they come with generic observations. Some ask whether it is stupid to miss someone they haven't met. Many watch his films and realise they miss him. Others go straight to the heart of the matter – he was sexy and no other actor alive today has what he had!

He would be the first to say there was nothing exceptional about him. If you mentioned his acts of heroism, he would have emphasised that many had done the same. If you mentioned his extreme lows, he would state that everyone faced adversity. That's true. In some respects, he is no different from any other man who lived through the era he did.

But not everyone had Lydia, the girl he met as a teenager and spent the best years of his life with. He valued everything about her. She supported him every minute, every hour and every day they were together. She understood each of his needs and was probably the only person capable of handling his temperament and ego. He recognised that and knew he would not have coped without her.

And not everyone had Ilse, a woman who waited decades to be with him, who loved him unconditionally and was a serene companion for him in those later years.

And, of course, the first woman in his life, his mother, was dear to him. She had this to say when she travelled from Rome to join him on *This is Your Life*: 'The thing I remember best, the thing I've always known, success didn't and never will change you, my Rossano, you're the fine and humble son you've always been.'[362]

He deemed himself a lucky man and said so on many occasions. Decades before he died, he jokingly said that he would like the following written on his gravestone: "Here Lies a Man Who Was Happy."[363]

I think he achieved that.

Appendix 7

STAGE CAREER

Rossano is known to have performed in over two hundred stage productions but unfortunately my research failed to uncover the majority of those plays. Below is the list of the most prominent, including those where he won awards, listing the writer, location and role where known. I'd like to thank the Rossano Brazzi International Network who has this list on their website.

1928 – *Il Visconti la Pampini*. Florence, staged for charity. Rossano was twelve years old at the time.

1935 – *La Casa*, by Siro Angeli. Florence. Played the prodigal son.

1936–37 – Dopolavoro Ferroviario (After-work theatre company). Rome.

1937 – *La Trovatella*.

1937 – *I Giganti Della Montagna* by Luigi Pirandello.

1937 – *Vena d'oro*: Amateur Actor Society Contest. Rome. Won first place.

1938 – *Maschera di Carne*, by Mazzoncini. Florence. Played the thief who goes straight.

1938 – *La Nemica*, by Niccodemi. Rossano also used a piece from this to audition for Emma Gramatica.

1938 – *La Cena dell Beffe*, by Giordano for Ninchi's company. Rome. Played Giannetto.

1938 – *Caesar.* Not known if this is Shakespeare. Played Brutus.

1938 – *Aminta*, by Tasso, at the Boboli Gardens, Florence. Played Aminta.

1938 – *Ventaglio*. Venice.

1938–39 – *The Sacred Flame* by Maugham. Played the disabled son.

1940 – *The Jester*. Received the Italian critics award.

1943 – *Othello*, by Shakespeare. Received the Italian critics award.

1944 – *Les Mal Aimées/Malanime.* (Sartre.) Received Italian critics award.

1945 – *Francesca da Rimini*, by D'Annunzio. Received Italian critics award.

1946 – *Faust*, by Goethe. Received Italian critics award.

1946–47 – *Strange Interlude*, by O'Neill. Received Italian critics award.

1969 – *Mother Love*, by Maugham.

1974 – *La Donna del Mare*, by Ibsen.

FILM AWARDS

Like the stage, there is very limited information concerning the awards received for his films. This is the only information I was able to track down:

Best Foreign Actor Award in France but role unknown.

Best Foreign Actor Award in Germany for *Damals*, 1943.

Best Foreign Actor Award in Yugoslavia for *La Vendetta di Aquila Nera*.

Received a Tobis award for his role in *Ritorno*, 1940.

Awarded the Nastro d'Argento, Italy. Presented by the National Syndicate of Film Journalists.

Grolla d'Oro. One of Italy's oldest film awards but role unknown.

Volpi Cup for his role in *Noi Vivi* at the Venice Film Festival.

Romanzo d'Amore. Venice Film Festival.

Motion Picture Star of the Year and Special Achievement Award 1957. He received the Rudolph Valentino award in Lecca, Italy in 1979; previous recipients were Richard Burton, James Mason, Alain Delon and Marcello Mastroianni.

APPEARANCES IN FILM, TELEVISION AND TELEVISION DOCUMENTARIES.

This is a comprehensive, but not definitive list, mainly gleaned from the Rossano Brazzi International Network website plus a couple of newspaper obituary notices which listed his credits. Articles and interviews with Rossano which I have consulted, imply that the number of films he made was somewhere between 220 and 263. If the latter number is accurate, some are missing from the following list. The year of release is given after each title.

1938–1949

Il Destino in Tasca, 1938

Piccolo Hotel, 1939

Processo e morte di Socrate, 1939

Ritorno, 1939

Il Ponte di Vetro, 1940

È Caduta una Donna, 1940

Kean, 1940

La Forza Bruta, 1940

Tosca, 1940

Rigoletto, 1941

Il re si diverte, 1941

Il Bravo di Venezia, 1941

Noi Vivi/Addio Kira!, 1942

Una Signora dell'Ovest, 1942

I Due Foscari, 1942
Damals/L'accusata, 1942
La Gorgona, 1942
Il Treno Crociato, 1942
Redenzione, 1942
Le Baruffe Chiozzotte, 1943
Silenzio, sigira!, 1943
Maria Malibran, 1943
Piazza San Sepolcro, 1943
La Casa Senza Tempo, 1943
Malià, 1945
La Resa di Titì, 1945
I Dieci Comandamenti, 1945
Aquila Nera, 1946
Furia, 1946
La Grande Aurora, 1946
Eleonora Duse, 1947
Il Corriere del Re, 1947
Il Passatore, 1947
La Monaca di Monza, 1947
Il Diavolo Bianco, 1947
I Contrabbandieri del Mare, 1948
Little Women, 1949
Vulcano, 1949

1950–1959
Toselli, 1950
Bullet for Stefano, 1950
Gli Inesorabili, 1950
La Corona Nera, 1950
La Leggenda di Genoveffa, 1951
La Vendetta di Aquila Nera, 1951
Incantesimo Tragico, 1951
L'inguista Condanna, 1952
Prigioniera della Torre dei Fuoco, 1952

La Donna che Inventò l'Amore, 1952
Il Figlio di Lagardère, 1952
Il Boia di Lilla, 1952
Eran Trecento, 1952
Il Fuoco delle Vene, 1953
La Barriera delle Legge, 1953
C'era una Volta Angelo Musco, 1953
La Chair et le Diable, 1953
La Contessa di Castiglione, 1954
Angela, 1954
La Castiglione, 1954
Vengeance of the Musketeers, 1954
Il Terrore dell'Andalusia, 1954
Three Coins in the Fountain, 1954
The Barefoot Contessa, 1954
Summertime also known as *Summer Madness,* 1955

(*Summertime* became the star of the show again in 2003 at the Venice Film Festival. That particular festival shows only new titles, some of them yet to be released. But, in a break from tradition, they chose *Summertime* as the film to show on their last night – the gala night – in memory of Katharine Hepburn who had died that year. The film had been digitally restored and, after its screening at Venice, it was then shown at the London Film Festival later that year, introducing the movie to a whole new audience.)

Gli Ultimi Cinque Minuti, 1955
Television: *Rheingold Theatre,* "Big Nick" episode, NBC, 1955
Faccia da Mascalzone, 1955
Il Conte Aquila, 1955
Loser Takes All, 1956
Documentary: *Gina Lollobrigida,* 1956
Legend of the Lost, 1957
Le Medaglie della vecchia Signora, 1957
Television: *People are Funny,* 1957
Interlude, 1957

The Story of Esther Costello, 1957
South Pacific, 1958
> (*South Pacific* returned to the Broadway stage in 2008 and won a further seven Tony awards; more Tonys in total than any other musical at the time of publication.)

A Certain Smile, 1958
Television: *The Dinah Shore Show*, 1958
Count Your Blessings, 1959

1960–1969
Austerlitz, 1960
L'assedio di Siracusa, 1960
Television: *The Dinah Shore Show*, 1960
Television: *The June Allyson Show*, 1960
Television: *This is Your Life*, 1960
Light in the Piazza, 1961
Television: *The June Allyson Show*, 1961
Rome Adventure, 1962
Mondo Cane, 1962
La Rossa, 1962
Die Rote, 1962
Le lièvre et la tortue, 1962
Les quatre vérités (sketch), 1962
Dark Purpose, 1963
La Ragazza in Prestito, 1964
Un Amore, 1965
The Battle of the Villa Fiorita, 1965
The Christmas that Almost Wasn't, 1966
La Ragazza del Bersagliere, 1966
Per Amore… per Magia…, 1966
Television: *Run for your Life*, 1966
Television: *Melissa*, 1966
Documentary: *L'Alluvione di Firenze del 1966, 1967*
Documentary: *Flash 02, Spain*, 1967
The Bobo, 1967

Woman Times Seven, 1967
La Schiava del Paradiso, 1967
Gli Altri, Gli Altri… e Noi, 1967
Television: *Bob Hope Presents from the Chrysler Theatre*, 1967
Sette Uomini ed un Cervello, 1968
E Nata Una Donna, 1968
El Rey de Africa, 1968
Caccia ai Violenti, 1968
The Castle of Fu Manchu, 1968
Krakatoa, East of Java, 1969
The Italian Job, 1969
Salvare la Faccia, 1969
Vita Segreta di Una Diciottenne, 1969
Television: *Honeymoon with a Stranger*, 1969
Television: *The Survivors*, 1969–70
Television: *Mother Love*, BBC, 1969

1970–1979
The Adventurers, 1970
Television: *Coralba*, 1970
Intima Proibite di Una Giovane Sposa, 1970
Television: *The Name of the Game*, 1970
Mr Kingstreet's War, 1970
Beware of a Holy Whore, 1971
Vivi Ragazza Vivi, 1971
Il Sesso del Diavolo, 1971
Il Giorno del Giudizio, 1971
The Great Waltz, 1972
Il Aire y Fuego, 1972
Racconti Proibite… di Niente Vestiti, 1972
Television: *Senza Lasciare Traccia*, 1972
Capuccetto Rosso, Cenerentola… e voi cicCredte, 1973
Television: *Madigan*, episode "The Naples Beat", 1973
Morir Par Amar, 1973
Frankenstein's Castle of Freaks, 1974

Il Castello della paura, 1974
Il Cavalieri Costante Nicosia Indemontiato, 1975
Political Asylum, 1975
Il Tempo Degli Assassini, 1975
Gli Angeli Dalle Mani Bendate, 1975
La Farina del Diavolo, 1975
Giro Girotondo… con il Sesso è Bello il Mondo, 1975
I Telefoni Bianchi, 1976
Television: *Two Minute Warning*, 1976
Television: *Hawaii Five-O*, episode "You Don't See Many Pirates These Days", 1977
Television: *Police Woman*, episode "The Young and the Fair", 1978
Television: *Charlie's Angels*, episode "Terror on Skis", 1979
Mister Too Little, 1979
Fatti Nostri, 1979
Detras de esa Puerta, 1979
Television: *La Promessa*, 1979

1980–1995

Television: *Orient-Express*, 1980
Io e Caterina, 1980
Champagne… e Fagioli, 1980
Television: *A Time for Miracles*, 1981
Omen III, The Final Conflict, 1981
Television: *Fantasy Island*, episode "The Perfect Husband/Volcano", 1981
Anche i Ladri Hanno Un Santo, 1981
Il Paramedico, 1982
La Vocazione di Suor Teresa, 1982
Television: *The Love Boat*, episode "The Italian Cruise", 1982
Television: *Hart to Hart*, episode "Straight through the Hart", 1983
Fear City, 1984
Television: *The Far Pavilions*, 1984
L'elemento D, 1984
Television: *La Vallée des Peupliers*, 1985–86

The Final Justice, 1985
Formula for a Murder, 1985
Television: *Christopher Columbus*, 1985
Russicum: The Third Solution, 1987
Television: *La Collina del Diavolo*, 1988
Michelangelo and Me, 1989
Television: *Ruth Rendell Mysteries*, episode "Put on by Cunning", 1990
Fotogrammi Mortali, 1995

Appendix 77

ACKNOWLEDGEMENTS

It seems impossible to put into words how much Rossano's nephew, Carlo Fiorentini, has helped me in respect of bringing this biography to life. Without him, I could not have brought out Rossano's personality and humour. Carlo read everything and corrected me if he knew his uncle (or aunt) would say, do or react to something in a different way from how I had written it. Carlo had the last word on the content to ensure that I was as factually correct as I could be. My heartfelt thanks go to him. I'd also like to thank him for the wonderful drawings and paintings he supplied for the book.

Those thanks extend to Rossano's great-nephews, Ben, Sean and Eamon Kenny. Although only Ben met Rossano, the three boys have been on board with this biography since day one and clearly have great admiration for their great-uncle. Their only sadness is that their mother, Maria-Lidia, who was very close to Rossano and Lydia, is not alive to provide more details for me.

Duncan Scott, the man behind restoring *We the Living*. I contacted Duncan to interview him about Rossano and this film. Little did I know that a few months later I would be an Executive Producer on the restoration project. Thank you for your support, input and friendship. What an adventure we have had!

Thanks to Sarah Bairstow, my good friend, whose Italian translations came in very handy throughout the writing of this biography. Also, for

the sketches that she produced that brought out Rossano's personality perfectly.

My editor, Lorna Fergusson. For a writer, my English is poor and I can always rely on Lorna to whip a manuscript into shape.

Many more people have been involved in helping bring this biography together and I do hope that I haven't missed anyone out.

In no particular order:

Martin Stephens and Olivia Hussey who, as children, starred alongside Rossano.

Massimo Moretti at StudioCanal for allowing me to use so much material and photos from *Loser Takes All*.

Mitzi Gaynor.

Paulo Szot.

Dorothee Marciak.

The wonderful Georgia Cadinu, my travel guide in Rome. Not only did she show me places which were significant for Rossano, she had taken the trouble to read about him so knew exactly what I needed.

Alberto Beltrama, an employee at the Casa di Riposo actors' retirement home in Bologna who took time out to show me the archives.

Larry Verbit, the lawyer for the Ralph Edwards corporation, who oversees the *This is Your Life* programmes. He was a tremendous help in respect of what I could and couldn't use from this programme which was so rich with information.

Carmen Federici from the Museum of the Liberation of Rome. Thank you for checking your records and giving me background on some of the Resistance activities.

Luca Litrico for taking the time to chat with me about your uncle; for showing me around your wonderful fashion house and allowing me to view the fascinating archives and Rossano's beautiful jacket.

Fulvio Guatelli and Maria Rita Graziano from the Florence University Press.

Fulvio Palmieri, who opened up the Teatro Verdi in Florence in order for me to take some photos. Thank you also for presenting me with a book celebrating the history of that theatre.

Simon Elliot, UCLA Library, for digging deep into the archives to supply documents from the *This is Your Life* programme.

The priest at Chiesa di San Jacopo Soprarno, Florence, for opening the church where Rossano and Lydia renewed their wedding vows.

To Ervin Ukusik at Chiesa S. Teresa del Bambino Gesù, Rome. What a beautiful church you have and thank you for the photos.

Robert Coram – without you I would have absolutely nothing on the Caribbean scam. Your generosity is very much appreciated.

The staff at Cimitero Flaminio in Rome for supplying the exact locations of Rossano's and Lydia's tombs. I did get a little lost in this massive cemetery but your map helped.

Rioranna Salvadori, University of Florence archives. You worked tirelessly to seek out information for me and I appreciated your efforts very much.

Gareth Llewellyn, CEO of Renauld Sunglasses.

Ted Chapin, Rodgers and Hammerstein Organization.

Richard M. Haylor.

Cinecittá Film Studios.

Records Office, Bologna.

Records Office, Rome.

University of Washington Libraries.

Montadori Publishing Group.

Centre for Bibliographical Studies and Research, UC Riverside.

Gaetano Autiero and his son, Ciro.

Sam Neill.

The Vatican.

Raul Ferrari.

Anna Findlay.

Pat Bidmead.

Rod Stenning.

Peter and Cathy Barclay.

Julie King.

Joy Cross.

Stuart and Pat Tizzard.

Ralph and Anna Thorgood.

Marcia Pearson.

Amy Gulick.

Martine Star.

Legacy Tree Genealogists.

Finally, my thanks to Chris and Loretta at The Front Room in Penzance and the staff at The Morrab Library in Penzance. Both venues provided me with a haven to work in.

FURTHER SOURCES

All stories and anecdotes have been sourced from the family and from the following publications.

Books

 June Allyson: *June Allyson*

 Eric Braun: *Deborah Kerr*

 David Bret: *Mario Lanza: Sublime Serenade*

 Kevin Brownlow: *David Lean*

 Robert Coram: *Caribbean Time Bomb*

 Yvonne de Carlo: *Yvonne: An Autobiography*

 Diana Dors: *The A–Z of Men*

 Anne Edwards: *Katharine Hepburn: A Remarkable Woman*

 Roland Flamini: *Ava Gardner: A Biography*

 Brian Fleming: *The Vatican Pimpernel*

 George Hamilton: *Don't Mind if I Do*

 Warren G Harris: *Sophia Loren: A Biography*

 Mark Eden Horowitz: *The Letters of Oscar Hammerstein II*

 A E Hotchner: *Sophia, Living and Loving: Her Own Story*

 Shirley Jones: *Shirley Jones: A Memoir*

 Hank Kaufman and Gene Lerner: *Hollywood sul Tevere*

 Josh Logan: *Movie Stars, Real People and Me*

 Sophia Loren: *Yesterday, Today and Tomorrow: My Life*

 Jean Negulesco: *Things I Did and Things I Almost Did: A Hollywood Memoir*

Lawrence Quirk/William Schoell: *Joan Crawford: The Essential Biography*

Stephen Silverman: *David Lean*

William Simpson: *A Vatican Lifeline '44*

Renato Simoni: *Il Grande Eclettico*

Gregory Speck: *Hollywood Royalty*

Whitney Stine: *I'd Love to Kiss You: Conversations with Bette Davis*

Thomas Wiseman: *The Seven Deadly Sins of Hollywood*

Newspapers

Il Messagero

La Domenica del Corriere

La Repubblica

L'Unità

The New Yorker

San Bernardino Sun

Magazines

ABC Film Review

Anna Bella

Bolero

Cifra Crafica

Cine Illustrato

Cinelandia

Cinémonde

Cine-Revelation

Ciné Revue

Corriere della Sera

Correio da Manha

Eva Express

Film

Filmelandia

Gente

Grazia

Illustrated

Italian TV Times
La Settimana
Lectures d'Aujourd'Hui
Los Angeles Times
Luna Park
Manchete
Melodi
Movie
Mirror
New York Yesterday
Novella 2000
O Cruzeiro
OGGI
O Jornal
O Mundo Illustrado
Photoplay
Picturegoer
Pioneiro
Radiocorriere
Saturday Evening Post
Sneak Previews
Theatre Arts

Websites
 Archive.org
 Broadway World
 Cinema Retro
 Garboforever.com
 Wethelivingmovie.com

With thanks to The Rossano Brazzi International Network. I tried, repeatedly, to contact the owners of this site without success. Although I have not quoted verbatim from this site, I appreciate the occasional snippet of information that I came across.[364]

Appendix III

SOURCES

All anecdotes/stories were sourced either from the family or taken from a large volume of magazines and newspapers around the world, many of which are long since out of print. Some were simply clippings with no information on publication. Everything, aside from those acknowledged in the main text, is non-verbatim. The source of information is listed below together with, where possible, the author, month and year of publication.

ENDNOTES

Introduction
1 Glynis Johns, courtesy of StudioCanal.

Chapter One
2 Sorrisi E Canzoni TV 20 June 1976, Rossano Brazzi

Chapter Two
3 Sorrisi E Canzoni TV 20 June 1976, Rossano Brazzi. Also Ralph Edwards Productions.
4 Gente, 30 March 1962, Dia Gallucci.
5 Sorrisi E Canzoni TV 20 June 1976, Rossano Brazzi
6 Sorrisi E Canzoni TV 20 June 1976, Rossano Brazzi
7 Sorrisi E Canzoni TV 20 June 1976, Rossano Brazzi.
8 Ralph Edwards Productions.
9 Sorrisi E Canzoni TV 20 June 1976, Rossano Brazzi.
10 Sorrisi E Canzoni TV 20 June 1976, Rossano Brazzi.
11 O Mundo Illustrado 1959 by Mino Carta.
12 The Rossano Brazzi International Network site.
13 Glynis Johns, Courtesy of StudioCanal.
14 Bolero 17 July 1955, no author listed.
15 Saturday Evening Post 31 January 1959 by Robert Johnson. Sorrisi E Canzoni TV 27 June 1976 by Rossano Brazzi.
16 Sorrisi E Canzoni TV 27 June 1976 by Rossano Brazzi.
17 Gente 30 March 1962 by Dia Gallucci. The Brazzi family.
18 Grazia 20 November 1955 by Maria Martone.
19 Sorrisi E Canzoni TV 20 June 1976 by Rossano Brazzi. Anna Bella 18 August 1963 by Noemi Lucarelli.
20 Sorrisi E Canzoni TV 20 June 1976 by Rossano Brazzi.
21 Sorrisi E Canzoni TV 20 June 1976 by Rossano Brazzi
22 Sorrisi E Canzoni TV 27 June 1976 by Rossano Brazzi. The Brazzi family.
23 Bolero 17 July 1955, no author listed.
24 Ralph Edwards Productions.
25 The Rossano Brazzi International Network site. Saturday Evening Post 31 January 1959 vol.231, no.31 by Robert Johnson.

26 Information from University of Florence. Cinémonde October 1956 by Michel Gerac.
27 Sorrisi E Canzoni TV June 1976 by Rossano Brazzi. OGGI 05 November 1964 by Anita Pensotti. Gente 27 June 1991 by Matilde Amorosi.
28 Hollywood sul Tevere by Gene Lerner and Hank Kaufman.
29 Ciné Revue 13 March 1956 by Paolo Madonna. Cinémonde October 1956 by Michel Gerac. The Rossano Brazzi International Network site. US Photoplay August 1956 by Maria Russo. The Brazzi family.
30 US Photoplay August 1956 by Maria Russo.
31 OGGI 05 November 1964 by Anita Pensotti. The Rossano Brazzi International Network site.
32 OGGI 05 November 1964 by Anita Pensotti. Ralph Edwards Productions. US Photoplay October 1955 by Ed Meyerson. The Brazzi family.
33 O Mundo Illustrado 1959 by Mino Carta.

Chapter Three
34 US Photoplay October 1955 by Ed Meyerson. Saturday Evening Post 31 January 1959 vol.231, no.31 by Robert Johnson.
35 The Rossano Brazzi International Network site.
36 US Photoplay October 1955 by Ed Meyerson. US Photoplay November 55, no author listed.
37 The Rossano Brazzi International Network site. Ralph Edwards Productions.
38 Bolero 17 July 1955, no author listed.
39 OGGI 05 November 1964 by Anita Pensotti. Sorrisi E Canzoni TV 27 June 1976 by Rossano Brazzi
40 Sorrisi E Canzoni TV 27 June 1976 by Rossano Brazzi.
41 Sorrisi E Canzoni TV 27 June 1976 by Rossano Brazzi. The Rossano Brazzi International Network site.
42 Il Grande Eclettico by Renato Simoni.
43 The Rossano Brazzi International Network Site. Cine-Revelation magazine 13 March 1956 by Geneveive Gerald. Grazia 20 November 1955 by Maria Martone.
44 Gente 18 May 1979 by Roberto Tumbarello. Sorrisi E Canzoni TV 27 June 1976 by Rossano Brazzi.
45 Sorrisi E Canzoni TV 27 June 1976 by Rossano Brazzi.
46 The Tale of South Pacific, no author listed.

Chapter Four
47 Stampa Sera 20 May 1980 by Lamberto Antonelli. Archive.org.
48 La Settimana 24 August 1957 by Emilia Granzotto.
49 US Photoplay August 1956 by Maria Russo.
50 Sorrisi E Canzoni TV 27 June 1976 by Rossano Brazzi. The Brazzi family.
51 US Photoplay August 1956 by Maria Russo.
52 OGGI 05 November 1964 by Anita Pensotti.
53 OGGI 26 August 1978 by Roger Falk.
54 La Repubblica 27 December 1994 clipping. Ralph Edwards Productions.
55 The Rossano Brazzi International Network site.
56 OGGI 05 November 1964 by Anita Pensotti. Cinémonde 18 October 1956 by

Michel Gerac. The Brazzi family.
57 O Mundo Illustrado 1959 by Mino Carta.
58 US Photoplay August 1956 by Maria Russo.
59 Sorrisi E Canzoni TV 04 July 1976 by Rossano Brazzi.
60 Saturday Evening Post 31 January 1959 vol.231, no.31 by Robert Johnson.

Chapter Five
All quotes/anecdotes in this chapter are, with the exceptions shown, courtesy of
 Duncan Scott Productions and Duncan's website wethelivingmovie.com. All
 permissions received.
61 Saturday Evening Post 31 January 1959 vol.231, no.31 by Robert Johnson.
62 OGGI November 1964 by Anita Pensotti.
63 Anna Bella 18 August 1963 by Noemi Lucarelli.

Chapter Six
The "background" to Italy's role in the war in respect of changing sides was taken
 from two sources: Maria de Blasio Wilhelm: The Other Italy. Brian Fleming: The
 Vatican Pimpernel. I drew on these two books plus A Vatican Lifeline '44 for the
 overall scenario mentioned in descriptions and conversations.
The "conversations" between me, Rossano and Lydia have been approved by Carlo
 and are based on factual information.
64 A Vatican Lifeline '44 by William Simpson.
65 Sorrisi E Canzoni TV 04 July 1976 by Rossano Brazzi.
66 O Cruzeiro Mexico 1963 by Orlandino Rocha. The Brazzi family. The Rossano
 Brazzi International Network site.
67 The Brazzi family. Cinelandia 1963 by Tom Torres.
68 The Brazzi family. The Rossano Brazzi International Network site.
69 Sorrisi E Canzoni TV 04 July 1976 by Rossano Brazzi. Saturday Evening Post 31
 January 1959 vol.231, no.31 by Robert Johnson.
70 Saturday Evening Post 31 January 1959 vol.231, no.31 by Robert Johnson.
71 Saturday Evening Post 31 January 1959 vol.231, no.31 by Robert Johnson. The
 Brazzi family.
72 Sorrisi E Canzoni TV 04 July1976 by Rossano Brazzi. The Brazzi family.
73 A Vatican Lifeline '44 by William Simpson.
74 A Vatican Lifeline '44 by William Simpson.
75 A Vatican Lifeline '44 by William Simpson.
76 A Vatican Lifeline '44 by William Simpson.
77 Saturday Evening Post 31 January 1959 vol.231, no.31 by Robert Johnson.
78 Ralph Edwards Productions.

Chapter Seven
79 Cinelandia 1963 byTom Torres. Grazia 20 November 1955 by Maria Martone.
80 US Photoplay August 1956 by Maria Russo. The Brazzi family.
81 Sorrisi E Canzoni TV 27 June 1976 by Rossano Brazzi.
82 Saturday Evening Post 31 January 1959 vol.231, no.31 by Robert Johnson.
83 Cinelandia1956 Brazil no author listed.
84 US Photoplay August 1956 by Maria Russo.

85 Gente 18 May 1979 by Roberto Tumbarello.
86 US Photoplay October 1955 by Ed Meyerson.
87 Cinelandia 1963 by Tom Torres.
88 US Photoplay October 1955 by Ed Meyerson.
89 US Photoplay October 1955 by Ed Meyerson. US Photoplay November 55, no author listed.
90 OGGI 05 November 1964 by Anita Pensotti.
91 Sorrisi E Canzoni TV 04 July 1976 by Rossano Brazzi.
92 Saturday Evening Post 31 January 1959 vol.231, no.31 by Robert Johnson.
93 Sorrisi E Canzoni TV 04 July 1976 by Rossano Brazzi. US Photoplay October 1955 by Ed Meyerson. Gente 27 June 1991 by Matilde Amorosi.
94 Bolero 17 July 1955 no author listed.
95 Bolero 18 November 1962 no author listed. Cinémonde October 1956 by Michel Gerac. Sorrisi E Canzoni TV 04 July 1976 by Rossano Brazzi. Hollywood Royalty by Gregory Speck.
96 US Photoplay August 1956 by Maria Russo. Cine Universal Mexico June 1958 no author listed.
97 Hollywood sul Tevere by Gene Lerner and Hank Kaufman.
98 Cine Illustrato 07 May 1950 by Sandro Litta.
99 Cine Illustrato 07 May 1950 by Sandro Litta.
100 Saturday Evening Post 31 January 1959 vol.231, no.31 by Robert Johnson. Ralph Edwards productions.
101 Ralph Edwards Productions. Rossano Brazzi International Network site. US Photoplay August 1956 by Maria Russo. Pioneiro 1985, no author listed. Saturday Evening Post 31 January 1959 vol.231, no.31 by Robert Johnson. Illustrated July 23 1955 by Shiela Walsh. US Photoplay November 55, no author listed.
102 US Photoplay August 1956 by Maria Russo.
103 The Rossano Brazzi International Network.
104 Gente 17 March 1965 by Domenico Campana. Eva Express 28 January 1970 by Alberto Pacifici. Sorrisi E Canzoni TV 04 July 1976 by Rossano Brazzi. Saturday Evening Post 31 January 1959 vol.231, no.31 by Robert Johnson.
105 Gente 18 December 1968 by Dara Kotnik.
106 OGGI November 1964 by Anita Pensotti. Sorrisi E Canzoni TV 04 July 1976 by Rossano Brazzi. La Domenica del Corriere January 1950 by Art.
107 Gente 18 December 1968 by Dara Kotnik. Lectures d'Aujourd'Hui April 1958 by Roy Jefferson.
108 Cine Illustrato 1949 by Bob.
109 Cine Illustrato 1949 by Bob.
110 OGGI 05 November 1964 by Anita Pensotti.
111 US Photoplay/Movie Mirror February date unknown, no author listed. Archive. org.
112 Cine Illustrato 06 June 1949 by Bob.
113 Cine Illustrato 06 June 1949 by Bob.
114 Cine Illustrato 06 June 1949 by Bob.

Chapter Eight
115 OGGI November 1964 by Anita Pensotti.

116 Gente 27 June 1991 by Maiilde Amorosi.

117 La Repubblica 27 December 1994 clipping. Gente 27 June 1991 by Matilde Amorosi.

118 Cine Illustrato 07 May 1950 by Sandro Litta.

Chapter Nine

119 Melodi Sweden 1959, no author listed.

120 La Settimana 24 August 1957 by Emilia Granzotto. Ralph Edwards Productions.

121 Ralph Edwards Productions.

122 Hollywood sul Tevere by Gene Lerner and Hank Kaufman

123 Melodi Sweden 1959, no author listed.

124 Hollywood sul Tevere by Gene Lerner and Hank Kaufman.

125 OGGI November 1964 by Anita Pensotti. The Brazzi family.

126 OGGI November 1964 by Anita Pensotti.

127 Hollywood sul Tevere by Gene Lerner and Hank Kaufman.

128 Saturday Evening Post 31 January 1959 vol.231, no.31 by Robert Johnson.

Chapter Ten

129 Bolero 18 November 1962, no author listed.

130 The Seven Deadly Sins of Hollywood by Thomas Wiseman.

131 South Pacific Extra DVD Documentary, no author listed.

132 South Pacific Extra DVD Documentary, no author listed.

Chapter Eleven

133 Things I Did and Things I Think I Did by Jean Negulesco.

134 Saturday Evening Post 31 January 1959 vol.231, no.31 by Robert Johnson.

135 Ralph Edwards Productions.

136 Saturday Evening Post 31 January 1959 vol.231, no.31 by Robert Johnson.

137 US Photoplay October 1955 by Ed Meyerson.

138 Cinelandia 1955 by Rossano Brazzi.

139 Cinelandia 1955 by Rossano Brazzi. Grazia 20 November 1955 by Maria Martone.

140 Anna Bella 18 August 1963 by Noemi Lucarelli.

141 Grazia 20 November 1955 by Maria Martone.

142 Ciné Revue 13–30 March 1956. La Settimana 24 August 1957 by Emilia Granzotto.

143 OGGI 05 November 1964 by Anita Pensotti.

Chapter Twelve

144 Cinelandia 1956 no author listed.

145 Picturegoer 19 November 1955 by Margaret Hinxman.

146 Various internet sites. DVD extra that accompanies the film.

147 DVD extra that accompanies the film.

148 Some internet sites. DVD that accompanies the film. Grazia 17 March 1957 by Rossano Brazzi.

149 Ava Gardner: A Biography by Roland Flamini.

150 Some internet sites. DVD that accompanies the film. Grazia 17 March 1957 by Rossano Brazzi.

151 Grazia 17 March 1957 by Rossano Brazzi. Ciné Revue November 1956 by Alan Webb.
152 OGGI November 1964 by Anita Pensotti.
153 Some internet sites. TV documentary about Frank Sinatra.
154 OGGI November 1964 by Anita Pensotti. Gente 27 June 1991 by Matilde Amorosi.
155 OGGI 05 November 1964 by Anita Pensotti.
156 DVD extra that accompanies the film.
157 Hollywood Royalty, Gregory Speck.

Chapter Thirteen
158 Ciné Revue February 1955, author listed as R.F.
159 US Photoplay August 1956 by Maria Russo. Illustrated 23 July 1955 by Shiela Walsh. The Brazzi family.
160 Cinelandia 1959, no author listed. The Brazzi family.
161 I'd Love to Kiss You: Conversations with Bette Davis by Whitney Stine. Archive.org.
162 David Lean by Kevin Brownlow.
163 Picturegoer 05 March 1955 by Henry Toby.
164 Hollywood sul Tevere by Gene Lerner and Hank Kaufman.
165 Interview with Mitzi Gaynor on YouTube.
166 US Photoplay October 1955 by Ed Meyerson.
167 Cinelandia June 1958 by Harry Gris. Picturegoer 19 November 1955 by Margaret Hinxman.
168 US Photoplay October 1955 by Ed Meyerson.
169 Eva Express 28 January 1970 by Alberto Pacifici. Melodi Sweden 1959, no author listed.
170 Grazia 17 March 1957 by Rossano Brazzi.
171 Grazia 17 March 1957 by Rossano Brazzi. US Photoplay November 55, no author listed.
172 Grazia 17 March 1957 by Rossano Brazzi. Ciné Revue 13 March 1956 by Paulo Maddona. Melodi Sweden 1959, no author listed.
173 Bolero 18 November 1962, no author listed.
174 US Photoplay October 1955 by Ed Meyerson. Films in Review 1957 December Archive.org.
175 US Photoplay October 1955 by Ed Meyerson. Film 25 Sierpnia 1957 Polish clipping.
176 US Photoplay November 55, no author listed.
177 David Lean by Kevin Brownlow. Katharine Hepburn: A Personal Biography by Charlotte Chandler. Well documented online. Hollywood Royalty by Gregory Speck.
178 Katharine Hepburn: A Remarkable Woman by Anne Edwards. The Seven Deadly Sins of Hollywood by Thomas Wiseman.
179 Rossano Brazzi International Network site.
180 Ciné Revue 13 March 1956 by Paulo Maddona.
181 US Photoplay October 1957 No author found.
182 Cinelandia 1956, no author listed.

183 Cinelandia 1956, no author listed. US Photoplay February 1957 by Patty de Roulf.

184 US Photoplay August 1956 by Maria Russo. The Rossano Brazzi International Network. Cinémonde October 1956 by Michel Gerac. Cinelandia 1961 by Christopher Beal. US Photoplay January 1957 by Rossano Brazzi.

185 Theatre Arts January 1956 Archive.org, no author listed.

186 Hollywood sul Tevere by Gene Lerner and Hank Kaufman.

187 Hollywood sul Tevere by Hank Kaufman and Gene Lerner.

Chapter Fourteen

188 US Photoplay February 1957 by Patty de Roulf. Cinelandia 1957 author not known. Cinelandia February 1962 by Alexandre Marcos. Gente 27 June 1991 by Matilde Amorosi. Lectures d'Aujourd'Hui 02 April 1958 by Roy Jefferson.

189 Newspaper clipping, source unknown.

190 O Mundo Illustrado 1959 by Mino Carta.

191 US Photoplay October 1955 by Ed Meyerson.

192 US Photoplay October 1955 by Ed Meyerson. Photoplay November 1955, no author listed.

193 Bolero 18 November 1962, no author listed. US Photoplay February 1957 by Patty de Roulf.

194 US Photoplay February 1957 by Patty de Roulf. US Photoplay October 1955 by Ed Meyerson.

195 Saturday Evening Post 31 January 1959 vol.231, no.31 by Robert Johnson.

196 Cinelandia 1956, no author listed.

197 Eva Express 28 January 1970 by Alberto Pacifici. Gente 27 June 1991 by Matilde Amorosi. Gente 18 December 1968 by Dara Kotnik. The Brazzi family.

198 The Seven Deadly Sins of Hollywood by Thomas Wiseman. Gente 18 December 1968 by Dara Kotnik. The Brazzi family.

199 US Photoplay February 1957 by Patty de Roulf.

200 US Photoplay February 1957 by Patty de Roulf.

201 Illustrated July 23 1955 by Shiela Walsh. US Photoplay February 1957 by Patty de Roulf.

202 Gente 18 May 1979 by Roberto Tumbarello.

203 Cinelandia 1961 by Christopher Beal. US Photoplay February 1957 by Patty de Roulf.

204 Glynis Johns courtesy of StudioCanal.

205 Hollywood Royalty by Gregory Speck.

206 Hollywood sul Tevere by Gene Lerner and Hank Kaufman.

207 Shirley Jones: A Memoir by Shirley Jones.

208 Yvonne: An Autobiography by Yvonne de Carlo. Archive.org.

209 A–Z of Men by Diana Dors. Archive.org.

210 OGGI 26 August 1978 by Roger Falk.

211 Cinelandia 1956, no author listed. Cinelandia 1957 by Lloyd Shearer. Hollywood Royalty by Gregory Speck. Gente 27 June 1991 by Matilda Amorosi.

212 Macall's April 1958 vol.85. Archive.org, no author listed.

213 Cinelandia 1957 by Lloyd Shearer.

214 Cinelandia 1957 by Lloyd Shearer. San Bernardino Sun vol.10, no.42, 20 January 1957, no author listed.

215 US Photoplay February 1957 by Patty de Roulf.
216 US Photoplay August 1956 by Maria Russo. UK Photoplay October 1956 by Kathleen Allsop.
217 Cinelandia 1957 by Lloyd Shearer. Bolero 17 July 1955, no author listed.
218 US Photoplay August 1956 by Maria Russo.
219 US Photoplay August 1956 by Maria Russo.
220 Photoplay February 1957 by Patty de Roulf.

Chapter Fifteen

Permission has been given from Luca Litrico for everything aside from those publications mentioned below.
221 Anna Bella 18 August 1963 by Noemi Lucarelli. Illustrated 23 July 1955 by Shiela Walsh. The Brazzi family.
222 Cinelandia 1961 by Christopher Beal.
223 Ciné Revue 09 August 1957 by Monique Jamain. Luca Litrico.
224 Hollywood sul Tevere by Gene Lerner and Hank Kaufman.
225 Hollywood sul Tevere by Gene Lerner and Hank Kaufman.

Chapter Sixteen

226 Anna Bella 18 August 1963 by Noemi Lucarelli.
227 Eva Express 28 January 1970 by Alberto Pacifici. Garboforever.com 1969 by John Pasetti. Gente 27 June 1991 by Matilde Amorosi. Melodi Sweden 1959, no author listed.
228 Grazia 17 March 1957 by Rossano Brazzi. Ciné Revue November 1956 by Alan Webb.
229 StudioCanal, no author listed.
230 StudioCanal, no author listed.
231 StudioCanal, no author listed.
232 UK Picturegoer 19 Nov 1955 by Margaret Hinxman.
233 Glynis Johns courtesy of StudioCanal.
234 Hollywood sul Tevere by Gene Lerner and Hank Kaufman.
235 Anna Bella 18 August 1963 by Noemi Lucarelli.
236 Grazia 17 March 1957 by Rossano Brazzi.
237 Grazia 17 March 1957 by Rossano Brazzi.
238 Grazia 17 March 1957 by Rossano Brazzi.
239 Yesterday, Today, Tomorrow: My Life by Sophia Loren. Sophia Loren by Warren G Harris. 10 Things You Didn't Know About Sophia Loren (online). Sophia, Living and Loving: Her Own Story by A E Hotchner.
240 Hollywood sul Tevere by Hank Kaufman and Gene Lerner.
241 Newspaper clipping, source unknown.
242 Bolero 18 November 1962, no author listed.
243 Yesterday, Today, Tomorrow: My Life by Sophia Loren.
244 Sophia Loren: A Biography by Warren G Harris.
245 Sophia, Living and Loving: Her Own Story by A E Hotchner.
246 Yesterday, Today, Tomorrow: My Life by Sophia Loren.
247 La Settimana 24 August 1957 by Emilia Granzotto.
248 Grazia 17 March 1957 by Rossano Brazzi.

249 Rossano Brazzi Interntional Network.

250 Filmelandia Brazil November 1957, no author listed.

251 Gente 18 May 1979 by Roberto Tumbarello.

252 Crawford's Men by Jane Ellen Wayne. Archive.org. Joan Crawford: The Essential Biography by Lawrence Quirk and William Schoell.

253 US Photoplay February 1958 by Beverly Ott Archive.org.

254 Hollywood Royalty by Gregory Speck. Grazia 17 March 1957 by Rossano Brazzi. Gente 27 June 1991 by Matilde Amorosi. Gente 18 December 1968 by Dara Kotnick.

255 Gente 17 March 1965 by Domenica Campana. OGGI November 1964 by Anita Pensotti.

256 Gente 17 March 1965 by Domenica Campana.

257 US Photoplay October 1955 by Ed Meyerson.

Chapter Seventeen

258 La Settimana 24 August 1957 by Emilia Granzotto. The Brazzi family.

259 OGGI 05 November 1964 by Anita Pensotti. The Brazzi family.

260 OGGI 05 November 1964 by Anita Pensotti. Grazia 20 November 1955 Maria Martone.

261 Josh Logan, Movie Stars, Real People and Me by Josh Logan. Hollywood sul Tevere by Gene Lerner and Hank Kaufman.

262 Josh Logan, Movie Stars, Real People and Me by Josh Logan.

263 Ciné Revue 09 August 1957 by Monique Jamain.

264 Ciné Revue 09 August 1957 by Monique Jamain.

265 Ciné Revue 09 August 1957 by Monique Jamain.

266 DVD Extra for the film, South Pacific. Ralph Edwards Productions.

267 Cinema Retro (online).

268 Saturday Evening Post 31 January 1959 vol.231, no.31 by Robert Johnson. The Tale of South Pacific book, no author listed.

269 Movie Stars, Real People and Me by Josh Logan

270 Extra DVD that accompanied the film, South Pacific. The Tale of South Pacific, no author listed.

271 Extra DVD that accompanies the film, South Pacific. The Tale of South Pacific, no author listed.

272 Movie Stars, Real People and Me by Josh Logan.

273 Saturday Evening Post 31 January 1959 vol.231, no.31 by Robert Johnson.

274 Extra DVD that accompanies the film, South Pacific

275 Cinelandia November 1957, no author listed.

276 Broadway World Online, no author listed. Cinelandia November 1957, no author listed. Macall's April 1958 vol.85. Archive.org, no author listed.

277 La Settimana 24 August 1957 by Emilia Granzotto.

278 OGGI 05 November 1964 by Anita Pensotti.

279 Extra DVD that accompanies the film, South Pacific.

280 Paulo Szot.

281 Hollywood sul Tevere by Gene Lerner and Hank Kaufman.

282 UK Photoplay December 1961, no author listed.

283 Cinelandia June 1958 by Harry Gris.

284 Gente 17 March 1965 by Domenica Campana.

Chapter Eighteen
285 Cine-Revelation 13 March 1958 by Genevieve Gerald.
286 Saturday Evening Post 31 January 1959 vol.231, no.31 by Robert Johnson.
287 Saturday Evening Post 31 January 1959 vol.231, no.31 by Robert Johnson. Newspaper clipping, no source.
288 No Bed of Roses by Joan Fontaine. Archive.org.
289 Hollywood sul Tevere by Gene Lerner and Hank Kaufman.
290 Deborah Kerr by Eric Braun.
291 Deborah Kerr by Eric Braun.

Chapter Nineteen
292 US Photoplay August 1956 by Maria Russo.
293 Gente 28 December 1979 by Ornella Ripa.
294 Gente 28 December 1979 by Ornella Ripa.
295 Cine-Revelation 13 March 1958 by Genevieve Gerald.
296 Cinelandia 1961 by Christopher Beal.
297 Don't Mind If I Do by George Hamilton.
298 Cinelandia 1961. US Photoplay August 1956 by Maria Russo.
299 Luna Park 23 August 1962 author listed as C.M.
300 O Cruzeiro Mexico 1963 by Orlandino Rocha.
301 Correio da Manha 1963 Brazil, no author listed.
302 'Tis Herself by Maureen O'Hara. Archive.org.
303 Martin Stephens.
304 Olivia Hussey.
305 'Tis Herself by Maureen O'Hara. Archive.org.
306 Gente 28 December 1979 by Ornella Ripa.
307 The Making of The Christmas That Almost Wasn't, source unknown.
308 Cifra Grafica Spain by Fernando Montejano.
309 Rossano Brazzi International Network.
310 Cine Illustrato 07 May 1950 by Sandro Litta.
311 Original Power of Attorney Held by the Author. Novella 2000 17 December 1967 by Ornella Ripa.

Chapter Twenty
312 Gente 18 May 1979 by Roberto Tumbarello.
313 The Seven Deadly Sins of Hollywood by Thomas Wiseman.
314 Dorothea Marciak.
315 Magazine clipping, source unknown. Lectures d'Aujourd'Hui 02 April 1958 by Roy Jefferson.
316 US Photoplay August 1956 by Maria Russo.
317 OGGI 03 February 1970 by Tommaso Ferrara.

Chapter Twenty-One
318 Macall's 1958 vol.85. Archive.org, no author listed.
319 Cine-Revelation 13 March 1958 by Genevieve Gerald.
320 Mario Lanza: Sublime Serenade by David Bret. Archive.org.
321 Anna Bella 18 August 1963 by Noemi Lucarelli.

322 OGGI 03 February 1970 by Tommaso Ferara.
323 Eva Express 07 February 1980 by Alberto Pacifici.
324 Magazine clipping, source/date unknown, by Franca Zambonini. Eva Express 28 January 1970 by Alberto Pacifici. Lectures d'Aujourd'Hui by Roy Jefferson.
325 Sam Neill.
326 Gente 28 December 1979 by Ornella Ripa.
327 Saturday Evening Post 31 January 1959 vol.231, no.31 by Robert Johnson.
328 The Seven Deadly Sins of Hollywood by Thomas Wiseman.

Chapter Twenty-Two
329 Hollywood Sul Tevere by Gene Lerner and Hank Kaufman.
330 Rossano Brazzi International Network. The Brazzi family. *Information regarding the remainder of this chapter was sourced from Corriere della Sella 04 May 1994 and 06 May 1983, L'Unità 04 June 1983 by Fabio Zanchi plus YouTube documentary about the political upheaval in Italy during 1980s.

Chatper Twenty-Three
Information in this chapter is sourced from Caribbean Time Bomb by Robert Coram and L'Unità 04 June 1983 by Fabio Zanchi.

Chapter Twenty-Four
331 Radiocorriere 05 October 1985 by Dante Guardamagna. Rossano Brazzi International Network. The Brazzi family.
332 The Rossano Brazzi International Network. The Brazzi family.
333 Gente 18 December 1968 by Dara Kotnik.

Chapter Twenty-Five
334 OGGI 14 November 1984 by Roberto Tumbarello. Gente 27 June 1991 by Matilde Amorosi.
335 Gente 27 June 1991 by Matilde Amorosi.
336 Novello 2000 February 1977, no author listed.
337 OGGI 09 October 1991 by Gabriella Montali.
338 Pioneiro 1985, no author listed. Gente 16 November 1984 by Matilde Amorosi.
339 OGGI 14 November 1984 by Roberto Tumbarello.
340 OGGI 14 November 1984 by Roberto Tumbarello.
341 OGGI 14 November 1984 by Roberto Tumbarello.
342 Gente 16 November 1984 by Matilde Amorosi.
343 OGGI 09 October 1991 by Gabriella Montali. OGGI 14 November 1984 by Roberto Tumbarello.
344 Gente 16 November 1984 by Matilde Amorosi.
345 Gente 16 November 1984 by Matilde Amorosi. Gente 29 August 1986 by Matilde Amorosi.
346 Gente 29 August 1986 by Matilde Amorosi.
347 The Rossano Brazzi International Network.
348 Eva Express 28 January 1970 by Alberto Pacifici.
349 Cifra Grafica Spain by Fernando Montejano.
350 Gente 18 December 1968 by Dara Kotnik.

351 OGGI 09 October 1991 by Gabriella Montali. Gente 27 June 1991 by Matilde
 Amorosi.
352 The Seven Deadly Sins of Hollywood by Thomas Wiseman.
353 OGGI 09 October 1991 by Gabriella Montali.
354 OGGI 09 October 1991 by Gabriella Montali.
355 OGGI 09 October 1991 by Gabriella Montali.
356 The Rossano Brazzi International Network. Georgio Cadinu.
357 OGGI 09 October 1991 by Gabriella Montali. Cifra Grafica Spain by Fernando
 Montejano. Illustrated 23 July 1955 by Shiela Walsh.

Chapter Twenty-Six
358 The Rossano Brazzi International Network.

Chapter Twenty-Seven
359 The Rossano Brazzi International Network.
360 Ralph Edwards Productions.
361 Glynis Johns courtesy of StudioCanal.
362 Ralph Edwards Productions.
363 Cinelandia 1963 by Tom Torres.
364 The Rossano Brazzi International Network

Printed in Great Britain
by Amazon